MW00786111

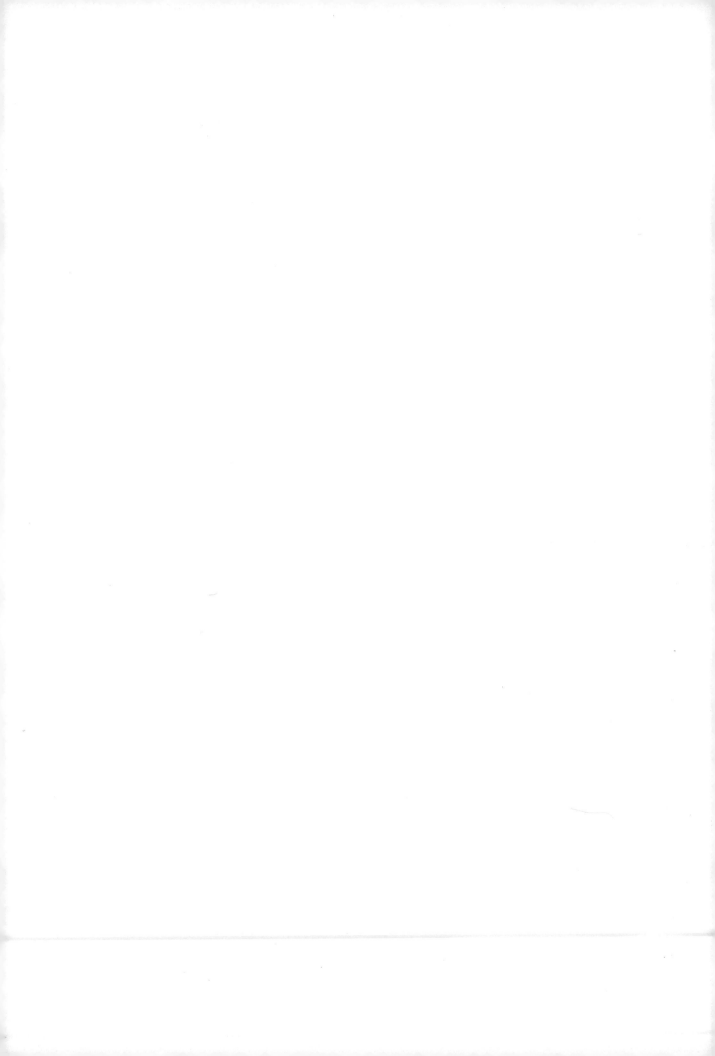

BUILDING THE BOOK

BUILDING THE BOOK FROM THE ANCIENT WORLD TO THE PRESENT DAY

How Manuscript, Printed, and Digital Texts Are Made

Barbara Heritage
Ruth-Ellen St. Onge

Illustrated from the teaching collections of
Rare Book School at the University of Virginia

The Legacy Press

2022

© 2022 Barbara Heritage and Ruth-Ellen St. Onge
The Legacy Press • Ann Arbor, Michigan • www.thelegacypress.com

All rights reserved • Manufactured in the United States of America
Printed by Sheridan Books, Inc. on acid-free paper.
Designed by Cathleen A. Baker.

Heritage, Barbara and Ruth-Ellen St. Onge
Building the Book from the Ancient World to the Present Day:
How Manuscript, Printed, and Digital Texts Are Made./
Includes bibliography and index.

ISBN: 9781953421104 (hardcover)
Library of Congress Control Number: 2022942847
Distributed by the University of Virginia Press.

Exhibition held at The Grolier Club
**Building the Book from the Ancient World to the Present Day:
Five Decades of Rare Book School & the Book Arts Press**
28 September to 23 December 2022

Frontispiece
Commercially made fishing tackle box adapted by
Terry Belanger to contain various typographical materials.

TABLE OF CONTENTS

FOREWORD

In 1971, I was invited to teach a course in descriptive bibliography at Columbia University's graduate School of Library Service (SLS), after sudden illness forced its instructor, Professor Alan T. Hazen, to retire. A year later—fifty years ago—SLS Dean Richard L. Darling offered me an assistant professorship at the school with a brief to develop a master's-level concentration in rare books, special collections, and antiquarian bookselling.

The dean turned over a vacant office in the school's fifth-floor Butler Library administrative suite for our use as a bibliographical laboratory. The university library lent us an assortment of equipment acquired in the 1930s, when several librarians in the rare book department had set up a small hand-printing operation called the Book Arts Press (BAP). We borrowed not only its equipment but also its name, the original BAP having become dormant by the early 1950s.

Another resource was available for the new program: in the years between the two world wars, Mary M. Shaver-Brown and Mary Louisa Sutliff both taught courses in the history of the book at the school for which they independently developed collections of interesting old books and other items useful for classroom show-and-tells. The combined collections were eventually donated to SLS and housed within the non-circulating graphic arts collection in Butler's SLS library.

During the two decades that followed my 1972 appointment, my primary concern was the SLS rare book program. The principle that underlay its development was a simple one: to teach the history of books as physical objects—as things you can pick up and hold in your hand. Its pedagogical preoccupation was quite literally to rub students' noses in books and to find ways to study the physical book directly from books, rather than from pictures of them in other books, or via 35mm slides or 16mm films, or using photocopies or other facsimile formats.

Clearly the best way to teach books as physical objects is to have a lot of them at hand to teach with. But doing so with rare books is challenging because of their scarcity, fragility, and replacement value. A further problem at Columbia at this time was that the university library's rare book department was ill equipped either physically or temperamentally for hosting student classes. If we wanted to teach with old books not available in the Shaver/Sutliff collection, we needed to develop our own resources.

Building the collection proceeded on several fronts. We began the systematic acquisition of leather and cloth bindings. Since we weren't interested in the subjects of these books but only in their covers, this collection grew rapidly: books—even old ones—can often be acquired cheaply, if their authors are sufficiently obscure or

lackluster, or if their subject matter is sufficiently boring or irrelevant. Similarly, we collected prints of all periods as examples of various illustration processes; because their subjects didn't matter, this collection also grew quickly.

We put together paper and typography packets, each containing a dozen or so samples of a particular kind of paper, or representative of a particular kind of typeface or printing process. We collected examples of different sorts of books (or parts of books): an almanac, a Big Little Book, a colonial edition, deckle edges, an ex-lib copy, a fore-edge painting, galley proofs, and so on. We commissioned a special hand papermaking mould from Tim Moore that was designed to show techniques of construction and the difference between antique laid, double-faced laid, and wove paper. We persuaded Stan Nelson to make us a hand type mould (and show us how to use it). We bought whole leather and parchment skins: sheep, calf, goat, and deer. We assembled a collection of descriptive bibliographies old and new, good and bad, and shelved them next to copies of books that were described therein.

An unusual feature of some of these agglomerations was the presence of multiple copies: sometimes as many as ten or more of the same (or nearly the same) book. The duplication was valuable not only for facilitating group viewing in the classroom, but also for demonstrating the bibliographical principle that with books *almost exactly the same* can be another way of saying *quite different.*

The resources of the program were continually enhanced by the generosity of various antiquarian-book dealers, collectors, and institutions. Bruce McKittrick (an early graduate of the program) sent us various illustrated books (or parts of books) rescued from a dumpster after a basement-cleaning operation in Philadelphia. Dr. Kenneth Rapoport gave us dozens of older books, some of them in collectors' bindings and (an uncommon circumstance with BAP books) in collectors' condition. Jonathan A. Hill provided a steady stream of books in interesting bindings. Kenneth W. Rendell gave us an enormous collection of manuscript fragments, printed ephemera, and nineteenth- and twentieth-century autographs. The Baltimore printer Maurice Annenberg donated forty-eight drawers of wood type.

The library of Union College gave us (through the good offices of Ruth Ann Evans) the two defective volumes it owned of the three-volume folio Hamburg Polyglot Bible, published in 1596. Many of its woodcuts had been scissored out; the paper was in terrible condition, and the contemporary calf-over-wood-board bindings were a mess. We made good use of this gift: sets of leaves, assembled in groups for the various teaching packets, served to provide examples of late-sixteenth-century paper, chain lines and watermarks, wormholes, damp staining, woodcuts, decorative initials, rules, various kinds and sizes of type—we constantly discovered new uses for leaves from these two volumes, and, even with slightly less than two thirds of the whole work present, we had a great many leaves to work with. Our attitude towards the books in our collection resembled that of the Bedouins toward their camels: very little went to waste.

A game-changing gift came in 1989: books and printed ephemera from the private library of the San Garde family in Lancashire, bequeathed to the Bodleian Library at Oxford in the understanding that the library would give away unwanted

items. The collection included hundreds of odd volumes in leather and cloth, incomplete books of all kinds, maps, prints, early Penguin mass-market paperbacks in dustjackets, disbound Elseviers and incomplete Baskervilles, Edwardian novels in decorated bindings, and so on, and on, and on, from which we were allowed to choose nearly a thousand items, shipped gratis (airmail!) in twenty-one large cartons to New York through the kindness of Jack Walsdorf and Miles Blackwell of B. H. Blackwell Ltd.

The physical arrangements of the BAP collection, much of which was housed in lockable glass-fronted bookcases in various classrooms on the fifth floor of Butler Library, were intended to support both classroom and independent study. We generally shelved books by date (rather than by author or subject), to show the chronological development of parchment, leather, cloth, and paper bindings. We filed most of the prints by technique (rather than by artist or engraver or subject or publisher or date) to facilitate the identification of illustration processes. Other collection arrangements assisted the study of various formats, genres, materials, physical features, and circumstances of publication.

In my own courses, I taught descriptive bibliography: the physical description of paper, type, composition, illustration, printing, and binding, as well as the circumstances of publication, distribution, and use. Other instructors associated with and teaching in the rare book program between 1972 and 1992 included Paul N. Banks, Gary Frost, and Nicholas Pickwood (book conservation); Susan E. Davis and Robert Sink (archives); Kenneth A. Lohf and William L. Joyce (rare book librarianship); Marion Schild (rare book cataloging); G. Thomas Tanselle (analytical bibliography and textual editing); and Susan Otis Thompson (history of the book).

We were lucky in our students: word got around about the new program, the first of its kind in an American library school. Columbia is an expensive university in an expensive city, but ambitious students with rare book interests increasingly preferred if feasible to come to SLS rather than attend schools with more general programs in academic librarianship. Enrollment was brisk: by the mid 1970s, there were about twenty students annually entering the one-year program. The Book Arts Press outgrew its original quarters in Room 512 Butler Library and moved over to the other end of the fifth floor to the much larger Room 502, a classroom formerly used by Columbia's ROTC program.

Dean Darling and Associate Dean Carol Learmont (in charge of SLS fundraising) generously allowed us set up our own, independent friends' group to support the purchase of the paper, type, ink, blank printing blocks and plates, etching and engraving tools, printing manuals, and books and equipment needed at the Book Arts Press, and to buy an assortment of tired but good old books useful for teaching bibliographical format and collation. The Friends of the Book Arts Press subsidized a busy schedule of free public lectures on bibliographical subjects, generally at least a dozen of them during each academic year. Many of the guest lecturers were notable British scholars whose presence helped make the program more widely known. Friends' income also supported the purchase of additional fonts of metal type, cheaply available in New York in the 1970s, when printing firms and typographic houses, shifting from letterpress to offset, sold off their metal type (and the cases they came in) at bargain prices.

In 1982, SLS inaugurated post-master's programs in book preservation and conservation, directed by Paul Banks, further increasing the number of students interested in rare books; and in 1983, we established a summer institute called Rare Book School (RBS): intensive five-day non-credit courses on subjects relating to rare books, taught by leading experts in their field. Admission was competitive, with each course limited to sixteen students (later reduced to twelve). In the first year, we offered eight courses: on early printed books, the sixteenth-century book, the nineteenth-century book, the history of binding styles, the identification of illustration processes, rare book librarianship and cataloging, and book preservation and conservation. The total possible enrollment was 120 students; 112 attended. In the following year, we expanded the curriculum to twenty courses (most of them again fully enrolled), and the school has offered at least that many courses annually, ever since—in 2022, forty courses were offered.

Tuition income from RBS students enabled us to purchase additional teaching materials. Former students were encouraged to join the Friends of the Book Arts Press: by 1990 there were more than 500 Friends: Good, Very Good, Close, and Best Friends in various giving categories. Robert Wedgeworth succeeded Richard L. Darling as the dean of SLS in 1985; like his predecessor, he was enormously supportive of RBS.

It was all great fun, while it lasted.

But in 1990, the Trustees of Columbia University voted to close the School of Library Service (the world's oldest, founded by Melvil Dewey in 1884) in part because of their assumption that education for low-paying and low-status professions was most appropriately carried out by state-supported, public universities. Thus ended the SLS master's degree concentration in rare books, special collections, and the antiquarian book trade. Over its twenty-year run, about 450 students took one or another of the program's courses, about half of whom could be (and still are) described as "die-hard rare-book types." Their impact on American librarianship over the past fifty years has been noticeable.

In 1992, the school's preservation and conservation programs moved to the University of Texas at Austin; and RBS and most of its collection moved with me to the University of Virginia (UVA), where I accepted an appointment as University Professor and Honorary Curator of Special Collections. In Charlottesville, thanks especially to the support of John T. Casteen III (president of UVA from 1990 to 2010), the School prospered. The UVA library and university librarian Karin Wittenborg were generous in coping with the School's ever-expanding space needs in Alderman Library, and in facilitating the heavy use of the library's own special collections material in RBS classes.

In 1999, we began using Rare Book School as our primary name, with Book Arts Press thereafter used as the imprint on publications. We started to offer classes in satellite locations, first at the Huntington Library and at Princeton University, and soon thereafter in Baltimore (at the Engineers Club), New York (at the Morgan Library), and Washington, DC (at the Freer Gallery of Art). In 2004, we hired our first full-time curator of collections, Barbara Heritage. In 2005, with the opening of UVA's new special collections library, we were given a 3,000-square-foot storage

space and work space in the subbasement of Alderman Library, recently emptied with the opening of UVA's new special collections library building.

I retired as director of the School in 2009, when I was very ably succeeded by Michael F. Suarez, S.J. Since coming to UVA, the RBS collection has continued to grow vigorously, reflecting the increasing diversity of its course offerings. We have never come up with convincing estimates of the total number of items in the RBS collection, but we do have one firm figure: in 1992, we moved twenty tons of stuff from Columbia to UVA (much of that total, to be sure, was lead printing type). About 10,000 students have thus far taken courses at Rare Book School—at Columbia, at UVA, and at satellite locations around the country. (In 2022, RBS external courses were based in Cambridge, Chapel Hill, New Haven, New Orleans, New York City, Philadelphia, Princeton, and Upperville, VA.)

RBS and its collections (currently comprising more than 100,000 items) are shortly to move into greatly improved quarters on the second floor (windows!) of UVA's newly renovated Alderman Library. To be honest, good as they are, the RBS collections come from the lower end of the vineyard: they cannot compete either in size or market value with the rare book collections in great research libraries here and abroad. Why do schools like RBS need their own collections, especially if they are located at universities already in possession of major rare book holdings?

One answer is that the parts of a book can be more useful than their sum. In the classroom, passing out individual prints removed from a defective copy of a book is a far better way to teach illustration processes than using a single, intact copy of the book from which the illustrations came. The prints in our 520 illustration packets are individually protected by clear polyester folders; they are not in danger of wearing out, as would certainly be the case if the complete books from which they came were passed around. The same is true of the sheet music, paper, and typography packets. Similarly useful is a large collection of detached cloth covers, the detritus of several research libraries' preservation microfilming projects.

Over the years (now decades), we have been able to assemble a collection of several hundred older books used by students in descriptive bibliography laboratories learning how to determine format and collation. Each year, several students may examine a single one of these examples, and wear is inevitable. The books were acquired as defective copies or odd volumes, and some of them are eventually used up in the cause of bibliographical education. No library's special collections could responsibly let their materials be used the way that the RBS teaching method requires.

Another reason why RBS needs its own collection is to help solve the problem of the thirty-second question: in class, a student asks a question relating to the physical aspect of a book. If the right book or object is immediately at hand on a table in the classroom, the instructor can efficiently field the query by going over to it, holding it up, and perhaps passing it around while parsing it. Lacking the object, the instructor can: (1) refer the student to an online source for information about the object; (2) suggest that the student visit a nearby library where such objects may be found; (3) arrange for a class trip to that library, to visit the object. But *it's a thirty-second question*—interesting, but perhaps a bit off track, meriting

only a quick answer now. At RBS, the idea is to have as many as possible relevant objects *right in the classroom,* in case such a question comes up.

The implications of this strategy for setting up an RBS course classroom are mind boggling; some individual courses have a pull-list of more than 500 books and related objects. (Gerald Cloud once described his staff duties during an RBS session in Charlottesville, when there were half a dozen different courses going on at the same time, as like moving an antiquarian book shop via the NYC subway system—at rush hour, invisibly.) The good is the enemy of the best: at RBS, the best is twelve students sitting around a table with the most knowledgeable instructor in the course's subject, surrounded by piles of relevant stuff.

One result of the School's ambitions is that being an RBS collections curator is not for the faint-hearted: there are about eighty current courses in the current RBS catalog. My congratulations and warm thanks go to Barbara Heritage and Ruth-Ellen St. Onge for their hard work in putting the present exhibition together and writing this catalogue—especially right now, when a considerable part of the School's collections and archives are in off-site storage during the ongoing top-to-bottom renovation of Alderman Library. I particularly admire (and envy) the authors' ability to describe non-Western teaching materials, many of them recently given to RBS by Soren Edgren. For obvious reasons, I was delighted when Irene Tichenor (SLS '72), chair of the Grolier Club's Committee on Public Exhibitions, suggested that Rare Book School and the Book Arts Press mark the fiftieth anniversary of their joint existence by mounting an exhibition on pedagogical resources for teaching the building of the book.

The field of education for rare books and related subjects is an expanding one. RBS is the first, and largest, and—forgive me—the best stand-alone school, but there are now excellent ones organized on our principles in California, the United Kingdom, France, and in Australia and New Zealand. And there's a whole lotta teaching goin' on in rare books and special collections departments within academic libraries and related institutions. But this being said, the RBS collections are probably the most heavily used anywhere.

<div align="right">

Terry Belanger
Founding Director of Rare Book School
University Professor Emeritus, University of Virginia
Charlottesville, Virginia
May 2022

</div>

INTRODUCTION

We have all been taught how to read books. But what can we learn by looking closely at their material forms? What can be gleaned, for instance, from examining an original specimen of ancient papyrus—or by studying rubbings of a Chinese book engraved on stone—or by feeling in one's hands the heft of a piece of beech once used in a medieval European bookbinding? No catalogue can convey the kind of tactile knowledge—or the sheer visceral excitement—that comes with handling original objects from history firsthand, as one does at Rare Book School (RBS). This catalogue, nevertheless, aims to illustrate many of the methods and techniques used at RBS to teach professional curators, librarians, conservators, and antiquarian booksellers how to analyze books as physical objects—that is, how to identify, date, and describe their substrates, letterforms, formats, printing surfaces, bookbindings, as well as marks of use, production, and ownership. At the same time, this kind of analysis can illuminate humanistic inquiry, crossing borders and time periods to tell the larger story of the book as it reflects human society and culture at different times and in various parts of the world. Indeed, the more we learn to look at books as objects, the more we understand how their material forms are expressive not only of their manufacture, but also of the myriad communities and social networks from which they emerge—whether an ancient Egyptian farm, an early modern Tibetan monastery, a nineteenth-century prairie schoolhouse, or a turn-of-the-millennium Canadian home with its own desktop computer. By turning our attention to the material contours of artifacts, we gain insight into how cultures and individual lives alike shape books, even as books give shape and meaning to them—relationships that are preserved, in large part, only by surviving material witnesses.

To "read" a book in this way, it is necessary to be able to interpret the many and varied parts that make up the whole—a whole that, in itself, can be difficult to delineate. Traditional definitions of the book (i.e., of the kind found in the *OED*) would circumscribe it as "a portable volume consisting of a series of written, printed, or illustrated pages bound together for ease of reading." But not all books are portable—neither are they necessarily bound—nor are they all, as a matter of course, written, printed, or illustrated. The shapes of books are as varied as are the many different communities who create them. We use the term "book" loosely, then, to refer to objects that fall within a variety of bookmaking traditions, past and present, as well as to gesture toward more unusual objects that invite themselves to be considered as books—sometimes in deliberately self-conscious and provocative ways. What constitutes a book can be elusive—the

term is up for debate and discussion—and, as the curators of this collection, we have attempted to welcome such questions even while documenting more well-established forms.

The objects shown within these pages shed light on a spectrum of approaches to bookmaking. Our work is not—and cannot be (for reasons of scale and scope)—representative of books as they operate in the world at large, but rather as they are reflected in the teaching collections of Rare Book School. RBS's approach to the teaching the history of the book is unusual in its practice: a single week-long course can make use of a hundred artifacts a day in service of conveying the hands-on skills necessary for identifying various bookbinding, illustration, papermaking, and printing processes. Our classrooms include not only a plethora of bookish specimens, but also loupes, magnifying glasses, tape measures, hand-held microscopes, light sheets, and related instruments that allow students to identify features of books that often go undetected, whether watermarks, bookbinder's signatures, or the grain pattern of a particular kind of bookcloth. When we began working on this exhibition, we searched for an analogy that would readily convey this particular (and somewhat idiosyncratic) way of teaching the history of the book. RBS's popular film, *The Anatomy of the Book* (1991), was written and produced by RBS's founding director, Terry Belanger, and it aimed at instructing audiences about the different bibliographical formats underlying Western hand-press period codices. Yet, in more recent years, RBS's course offerings have expanded to encompass books made in other regions of the world and over broader time spans. The School's teaching collections have grown in tandem with these new courses to include numerous examples of books that cannot be so easily "anatomized" according to rigorous and well-known bibliographical protocols formulated by Fredson Bowers, Philip Gaskell, and others. And so our present work incorporates established bibliographical terminology, even as it seeks both to build on that foundation and describe objects that embody a more diverse variety of approaches to bookmaking.

While preparing this exhibition, we reflected anew on the intricate and layered process of constructing a book. Just as buildings are not fashioned solely by architects, books are not created by authors alone. Books are assembled and modified by many hands—by individuals including, but not limited, to: papermakers, parchment makers, ink makers and manufacturers, calligraphers, typographers, punch cutters, compositors, software engineers, authors, scribes, printers, publishers, patrons, editors, illustrators, block cutters, platemakers, etchers, colorists, tanners, bookbinders, sewers, designers, booksellers, distributors, collectors, readers, reviewers, and censors—not to mention the traces of the work of conservators, curators, and preservation librarians that accompany such objects. We found the concept of building to be a useful analogy for interpreting the various stages of this labor—and, in formulating our chapter titles, we sought terms that could be applied to books created in different regions of the world throughout time. Substrates serve as the "foundations" for books—the material (e.g., papyrus, parchment, paper) conveying a book's text. Letterforms present the text to the world in a certain style or face, usually in handwritten, printed, or digital forms (though other forms are included, such as stencil). Formats determine how

those letterforms are arranged and how those substrates are rolled, folded, cut, or coded—as well as the order in which that work happens and how the book is operated. In a sense, format can be likened to the engineered structure underlying a building that allows it to function soundly and practically. Printing surfaces—although not in themselves parts of books—are akin to the construction equipment necessary for assembling a building; the crane and bulldozer are not part of the building's structure, but they are essential for understanding how it came to be made. With respect to books, this equipment includes the woodblocks, copper plates, lithographic stones, and computer hardware, as well as the various printing presses, printers, copiers, and related tools, required for the activity of making an impression. Bindings are not unlike the exterior of a building; they announce a book's presence in the world. Marginalia and annotations can be compared to the signage, as well as the flyers and posters, that populate a building, as Kyle Dugdale (a professional architect, as well as an alumnus of RBS) has pointed out.[1]

And so you will find within these pages images of materials, supplies, and tools ranging from plant fibers and animal skins to glass negatives and photopolymer plates—from woodblocks and metal printing type to floppy disks and digital devices. These materials appear alongside books made from papyrus, palm leaves, parchment, paper, ivory, textiles, and plastic—books appearing in bindings intended only for temporary use, and those housed in luxurious enclosures, as well as more experimental designs—including, in one instance, a used shoe housed in a shoe box.

The books that we have selected are not always beautiful—and many of them are not particularly rare in terms of financial value. Our "treasures" are not of the kind usually exhibited by rare book libraries and great museums. What is "rare"—that is, special—about this collection is that it is meant to be handled and inspected by students with the larger aim of educating future generations and advancing research into the material culture of the book, so as to preserve its history. The survival of these histories cannot be ensured by digitization alone, as much of what these objects have to teach us is carried within the very materials of the original artifacts themselves. By learning to read the book as a material object, we are able to see more deeply not only into how such objects are made—and when and where they were made—but also into the very heart of human history. This is what is rare about Rare Book School. This is what we hope to convey in these pages. And this is what we celebrate, as we mark the anniversary of Rare Book School, as it originated at Columbia University and then came to the University of Virginia.

. . .

Many visitors to Rare Book School inquire about its history—much of which our School's founding director, Terry Belanger, has touched on in his foreword. RBS is an international educational institute associated with the University of Virginia. Beginning in 1972 as a series of workshops organized under the auspices of the Book Arts Press of Columbia University's School of Library Service, RBS was established as such in 1983, when Belanger began organizing five-day courses open, by competitive application, to professionals, students, and enthusiasts

alike. Limited to twelve students per class, the courses were and continue to be taught by world-renowned experts on the history of books and printing. This innovative approach to teaching bibliography and the history of the book would later garner recognition from the MacArthur Foundation, which awarded Belanger its so-called "genius" grant in 2005, with the following commendation of his achievement: "Raising the profile of the book as one of humankind's greatest inventions and as an integral part of the history of technology and human communication." Today, the School is directed by Michael F. Suarez, S.J., who has considerably broadened the scope and scale of RBS's activities, particularly in the humanities, through a number of grant-funded initiatives and partnerships that have helped make the School's course offerings more accessible to early career professionals and enthusiasts. Thanks to Suarez's leadership, about a third of the School's students are able to attend its programs on scholarships or fellowships—opportunities that are vital to the work of many new librarians, curators, archivists, booksellers, collectors, academics, and conservators. RBS's teachings collections are an essential part of their education in learning how to interpret and care for the historical record.

RBS's collections, as you will have read in Terry Belanger's foreword, were very modest in the beginning. Belanger used to joke that, in its early days, the School's principal resource was a pair of two extension cords. By the time RBS moved to the University of Virginia in 1992, the Mayflower bill of lading showed that the collections had grown to weigh twenty tons. We estimate that today RBS's teaching collections include approximately 100,000 items, including printed books, manuscripts, historical tools and equipment, ephemera, and realia. The chronological scope of the collection is broad, including materials from antiquity to the present day. We would judge that the majority of the teaching collections, however, date from the eighteenth and nineteenth centuries. Every summer, approximately 5,000 items are used in RBS courses taught in Charlottesville, while RBS courses in other locations (e.g., New York, Philadelphia) make use of collections from partner institutions, such as the Beinecke Library (Yale University), Firestone Library (Princeton University), the Grolier Club (New York), Houghton Library (Harvard University), and the Kislak Center for Special Collections (University of Pennsylvania).

Since 1992, RBS has worked closely with colleagues at the Albert and Shirley Small Special Collections Library at the University of Virginia to provide RBS students and faculty members with the opportunity to view and work with UVA's collections. This long-time collaboration is reflected in the two items on loan from the Small Special Collections Library included in the exhibition: a rare fifteenth-century Korean typographic edition of the Chinese philosophical work *Chung sŏl* with twelve different ownership seals, representing more than four centuries of provenance, as well as a fine sixteenth-century Daoist work annotated by a Qing dynasty landscape painter. UVA brought these items into its collection in 2022 as part of a landmark acquisition: the Guanhailou Collection assembled by Soren Edgren, an internationally recognized expert in East Asian printing who has taught for RBS since 2014. The hands-on, teaching portion of Edgren's collection was donated to RBS by him and his wife, Xia Wei; for nearly

a decade, Edgren meticulously packed and transported these materials—many of which are also featured in the book—to RBS every summer for classroom instruction. Now they are enfolded within the School's teaching collection for broader use and research. We are deeply grateful to Xia Wei and Soren Edgren for their generous gift, which helps us to teach, in new and powerful ways, how printing was invented in East Asia long before Gutenberg's own achievement in the fifteenth century.

RBS collections are significant not only for what they contain, but also for how they are organized and interpreted. During his tenure at RBS, Terry Belanger created many different teaching kits and sets in the "monomaniacal pursuit of excellence," to use Belanger's own phrase—a practice that he continues as an RBS faculty member and donor to RBS's teaching collections. Belanger teaches the history of book illustration processes, but, remarkably, he does not use any slides or PowerPoints in his courses. He teaches with only original specimens. And instead of passing one copy of an illustrated book around the classroom, he makes use of broken and disbound copies, specifically acquired for teaching, that he repurposes into teaching "packets" containing thirteen examples—one copy for every student and the course instructor—so that everyone in an RBS course can study original examples simultaneously. Belanger also applied this approach to paper specimens, typography, printed sheet music, and maps. Rather than simply handing students a reference work, such as Carter's *ABC for Book Collectors*, Belanger created the collection "3-D Carter," which includes physical specimens of books that exemplify Carter's terms, from "advance copy" to "Yapp edges." Belanger's three-dimensional interpretation of Carter thus allows students to examine a re-backed book or a sophisticated copy directly rather than just reading about it.

Many other RBS faculty members have had key roles in forming and interpreting collections for use in the classroom. Several generations of bibliographers, notably Richard Noble and David Whitesell, have meticulously collated and described a collection now numbering more than 700 volumes for instruction in the course "The Introduction to the Principles of Bibliographical Description." In this class, affectionately known as "DesBib," students each handle dozens of antiquarian volumes while putting into practice the bibliographical methods developed by Fredson Bowers and Philip Gaskell, among others. Over the years, other RBS faculty members have suggested custom-commissioned items for the collection. For example, many years ago, Barbara Shailor consulted with Belanger about the creation of a set of parchment quires exemplifying the different pricking and ruling techniques common in European medieval manuscripts—a teaching kit that has proven useful for many RBS courses. In the pages ahead, you will see these and many other bespoke teaching kits and packets that draw on five decades of research and knowledge from talented and dedicated members of the RBS community.

The history of the book is very long, and RBS's teaching collection cannot encompass all of its elements—particularly forms of the book from the ancient world. Our faculty makes use of ready-made replicas when necessary to provide examples of older formats (e.g., wax tablets) that can be handed around and

discussed in class. We have included examples of these replicas and models in our catalogue, because they are very much a part of the story of teaching and understanding how books are made. But, of course, the majority of the objects represented here are originals, which we have cared for in our roles as the collection's long-standing curatorial team.

During our own time at RBS—which spans two decades (2002 to the present)— we have fostered close working relationships with the School's teaching faculty, as well as its students who continue to contribute their own insight and experience to our programs. One of our primary goals during the last decade has been to build a more inclusive collection in collaboration with the RBS community. At the same time, we have sought to expand that community by inviting individuals— visiting fellows, makers, artists, scholars, religious practitioners—to present their work at RBS and also to interpret items we use in our classes. Their insights have deepened our own understanding of RBS's teaching collection and of what it means to be a curator in the twenty-first century. Just as books and collections are created through the collaborative effort of many individuals, it takes a joint commitment to interpret, preserve, and safeguard textual culture. We recognize that some past collecting and institutional practices must be remediated in order build a more ethical and equitable approach to studying the book. For instance, when conducting research on RBS's ancient papyrus fragments—items that have been part of the School's collection now for more than thirty years—we engaged in a dialogue with papyrologists, who were mindful of the ethical implications that come with working on these particular kinds of textual artifacts. (Indeed, we have been careful to observe the standards and guidelines established by The American Society of Papyrologists.) These consultations reinforced for us the importance of documenting provenance in order to address longer histories of looting and the depredation of cultural artifacts by Western institutions and private collectors. By the same token, we have intentionally highlighted works by women and people of color as part of our narrative. Even now, the School's collections do not sufficiently represent the contributions of these groups to humanity's shared cultural heritage. Our efforts in these areas are ongoing, and they are informed by our collaborations with students, fellows, faculty members, and community members alike.

In writing the present work, we have consulted with numerous RBS faculty members, past and present, as well as makers who fashioned works now in our teaching collections. We have reconnected with lecturers and experts who have worked in the School's collections, and we have communicated with former research fellows and consultants, who have contributed additional expertise to our project. We have sedulously updated our catalogue records along the way to help ensure that their observations are documented, even as we have scoured reference books and analyzed our own collections with renewed scrutiny— sometimes making exciting discoveries along the way, sometimes finding errors in our records (e.g., the medieval board that, well, was not so medieval after all).

The process of creating this exhibition—in addition to fulfilling our daily responsibilities at RBS—has been an experience like no other. It has been both

grueling and illuminating. But we see this work as a testament to what we love most about working in the collection. There is nothing like being immersed among historical artifacts and their unusual forms, which express the art, craft, and great skill of those who have come before us, and who have made their own mark in the world. And, as part of our curatorial work, we have had the pleasure of speaking with, and learning from, living makers and artists who are, even now, giving new shape to history of the book. We feel deeply inspired by these experiences, which have allowed us to see ourselves as part of this living history, and we feel grateful to have had a hand in bringing these works together as part of a growing whole. The activities of collecting and curating take the form of real care and love—and become acts of sharing instead of having—when our work is reciprocal and community oriented. When we open a book, we also open up a part of ourselves. Ultimately, books can move us, inspiring new possibilities and ways of living and being in the world. We hope that, as you leaf through the pages ahead, you will be surprised, shaken, and struck by some of what you see, as we have been.

Barbara Heritage
Associate Director & Curator of Collections

Ruth-Ellen St. Onge
Associate Curator & Special Collections Librarian
Rare Book School at the University of Virginia
Charlottesville, Virginia
May 2022

1. Dugdale, Kyle. "Bibliographical Architectures." In "Objects of Study: Teaching Book History and Bibliography Among the Disciplines." Eds. Barbara Heritage and Donna A. C. Sy. 2022. Unpublished MS.

ACKNOWLEDGMENTS

Many individuals assisted us by lending their guidance and expertise to this project. At the same time, imperfection creeps into even the most well-intentioned productions. Any errors found within these pages are entirely our own.

We want to express our sincere gratitude to our director, Michael F. Suarez, S.J., for supporting us throughout the many stages of this project. We also express our heartfelt thanks to the following individuals, with whom we consulted while preparing our descriptions for this exhibition:

Mohsen Ashtiany
Hosea Baskin
Lajos Berkes
John Bidwell
Erin C. Blake
Priya Chandrasegaram
Jeremiah Coogan
Albert Derolez
Consuelo Dutschke
Lisa Fagin Davis
William Fleming
Mirjam Foot
Matthew G. Kirschenbaum
Peter Koch
Karen Limper-Herz
Maria Lin
Beth McKillop
Julia Miller
Sharon Liberman Mintz
Barry Moser

Paul Needham
Naomi Nelson
R. Stanley Nelson
Will Noel
Benjamin J. Nourse
Todd Pattison
David Pearson
Nicholas Pickwoad
Barbara Shailor
Marianna Shreve Simpson
Geshe Ngawang Sonam
Amanda K. Sprochi
Peter Stallybrass
Donna A. C. Sy
Jan Storm van Leeuwen
David Vander Meulen
David R. Whitesell
John Windle
Andreas Winkler
Heather Wolfe

We have, in addition, relied heavily on the publications and scholarship of RBS faculty members, past and present, as is reflected in our citations.

A significant portion of the School's collections were donated to our program—contributions that are amply reflected in this catalogue. Our collection has also benefited from grants from the Pine Tree Foundation, as well as the B. H. Breslauer

Foundation. Additional key support has come from Florence Fearrington, an RBS alumna and past member of RBS's Board of Directors.

We wish to thank, in particular, Molly Schwartzburg and Holly Robertson of the University of Virginia's Albert and Shirley Small Special Collection Library for facilitating the loan of two important objects from the University's recently acquired Guanhailou Collection.

We also want to acknowledge RBS's Pine Tree-Fearrington Rare Materials Cataloger, Lindsay M. Borman, as well as past catalogers Lucy J. Kelsall and JP Mongeau, whose detailed descriptions contributed to this project. Similarly, many of the School's part-time collection assistants conducted research on items represented here and/or made special enclosures for items. We thank, in particular, Louise Brosnan, Maria Degtiarenko, Scott Ellwood, Sarah Hale, Amira Hegazy, Kirsten Heimrich, Will Norton, Nina Thomas, Roger Williams, and Elizabeth Zhang.

Our current part-time collections assistant, Alexander Pawlica, was instrumental in drafting the glossary for this book, and he provided additional support in helping us prepare the text.

Our photographer, Will Kerner, was gracious in making many visits to shoot items for the show. His good humor and insight were a boon, as was his skill in capturing images of the collections.

Jason Coleman of the University of Virginia Press offered invaluable guidance along the way.

We are grateful to the members of the Grolier Club's Committee on Public Exhibitions, as well as the Grolier Club's staff, who assisted with organizing and planning the exhibition; these include Shira Buchsbaum, Eric Holzenberg, Amanda Domizio, Ann Donahue, Chris Loker, Marie Oedel, Jennifer Sheehan, and Irene Tichenor. We are also thankful to Anne Chesnut, who designed our exhibition materials.

Last but not least, three individuals in particular have gone above and beyond the call of duty during this project:

Cathleen A. Baker, who closely read and commented on our text, and whose book historical and bibliographical knowledge has greatly enhanced this work.

Soren Edgren, who not only shared his deep expertise in the realm of Asian printing, but who also donated many of the Chinese, Japanese, and Korean materials represented in the catalogue—and who advised us on matters of terminology and description.

Terry Belanger, who tirelessly and fearlessly worked his way through our manuscript, providing instructive advice at every turn. Terry, you continue to inspire us, and your devotion to teaching and collecting is unparalleled.

I. OVERVIEW: THE CHANGING FORM OF THE BOOK

Books have existed for millennia—and the technologies for making them have varied across cultures and time. Many of the inventions associated with bookmaking originated in East Asia, which gave birth not only to paper, but also to the world's earliest printed books and documents. The book has continued to transform in step with technological innovation and cultural change.

The following artifacts, which are part of Rare Book School's teaching collections, offer a sense of how the book as a physical object has developed among various societies around the world over the course of more than two thousand years.

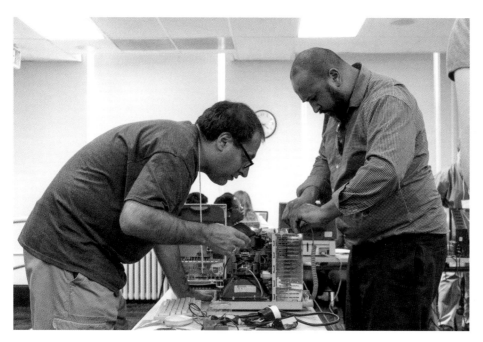

RBS faculty member Matthew G. Kirschenbaum and volunteer Peter Kionga-Kamau repair a legacy Apple computer in preparation for a classroom exercise for the course "Born-Digital Materials in Special Collections," co-taught with Naomi Nelson. Photograph by Shane Lin, 2019.

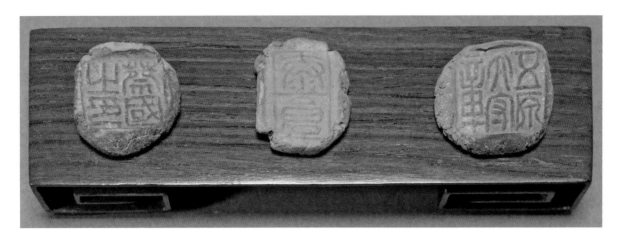

Three *fengni* (封泥) clay discs, Eastern Han dynasty, ca. 200 CE. Each seal impression is about the size of a coin. Gift of Xia Wei and Soren Edgren. Wooden display stand on loan.

1.1
Three Ancient Seal Impressions from the Han Dynasty

These three *fengni* (封泥) clay discs come from the Eastern Han dynasty (25–220 CE). Made circa the second century, the seal impressions bear the names of institutions and officials: the Seal of the Cai State (蔡國之印), Tai Granary (泰倉), and Seal of the Governor of Wuyuan (五原太守章). The clay seal impressions, which were used to secure and authenticate documents, offer a glimpse into China's ancient culture of text-bearing objects. Donated by RBS faculty member Soren Edgren, a specialist in the history of the book in China, they are among the earliest artifacts held in RBS's teaching collection.

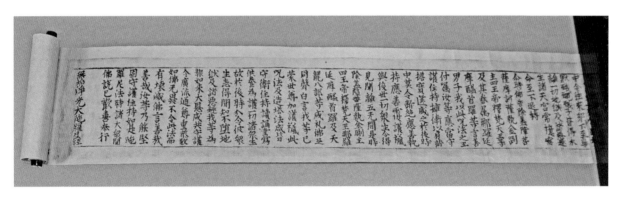

Great Dhāraṇī Sūtra of Immaculate Pure Light (*Mugu chŏnggwang tae tarani kyŏng: Wugou jingguang da tuoluoni jing*, 無垢淨光大陁羅尼經). Facsimile. Seoul: Dongguk University, [1986]. Gift of Xia Wei and Soren Edgren.

1.2
The World's Earliest Known Printed Text: Korean Scroll (ca. 751)

Likely the earliest extant printed work in the world, the *Great Dhāraṇī Sūtra of Immaculate Pure Light* (Kor. *Mugu chŏnggwang tae tarani kyŏng*; Ch. *Wugou jingguang da tuoluoni jing*, 無垢淨光大陁羅尼經; Sansk. *Raśmivimalaviśuddhaprabhā-dhāraṇī*) was discovered inside the Sŏkkat'ap (Śākyamuni Pagoda) at Pulguksa Temple, Kyŏngju, in October 1966.[1] This *dhāraṇī* sūtra—containing sacred Mahayana Buddhist recitations intended to promote purification and protection—had been transliterated into Chinese from Sanskrit by a monk at the end of the seventh century, a process described in more detail below with respect to the *hyakumantō*

darani, which was derived from the same source. The woodblock-printed scroll's Chinese text includes special characters created during the reign of the Tang Empress Wu (624–705)[2]—but the artifact appears to have been produced in the Silla kingdom (Korea), because of its sturdy paper made from the paper-mulberry plant (Kor. *tak*) and also owing to its contemporary Tang-style script, as shown in this high-quality photo-facsimile used in RBS classes. The text almost certainly was printed before 751, when the temple and pagoda were constructed. The scroll was not intended for ready access or reading, but rather for incorporation within the sanctified structure of the stone pagoda (*stūpa*) with other relics and religious artifacts when the monument to Śākyamuni Buddha was consecrated. Circumambulating the pagoda in which it was held would have conferred merit—a practice continued in Buddhist temples today.

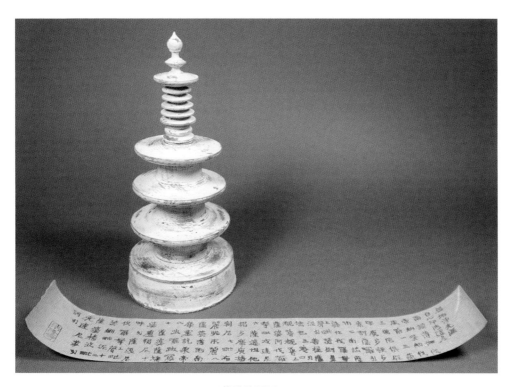

Japanese dhāraṇī. *Hyakumantō darani* (百萬塔陀羅尼). A photo-facsimile of the 764–770 *Jishin'in* (自心印) text of the *Muku jōkō dai daranikyō* (無垢淨光大陀羅尼經) printed on Japanese paper (2 x 10.6 in.), plus a replica of the wooden pagoda in which it was rolled up and enclosed; the full height of the pagoda measures 8.3 in. Produced by Hōryūji Temple (Nara) in the mid-twentieth century. Gift of Xia Wei and Soren Edgren.

Among the oldest surviving examples of printing, the *hyakumantō darani* were commissioned by Empress Shōtoku from 764 to 770. The dhāraṇī were sacred texts rolled for storage within small wooden pagodas that served as an East Asian version of Indian *stūpas*—monuments to Śākyamuni Buddha. The scroll featured here contains the *Jishin'in* (自心印) from the text of the *Muku jōkō dai daranikyō* (無垢淨光大陀羅尼經). Although printed in Japan, most likely from woodblocks, the text is a Chinese phonetic transliteration of the *Great Dhāraṇī*

1.3
Hyakumantō Darani, 764–770

Sūtra of Immaculate Pure Light, or the *Raśmivimalaviśuddhaprabhā-dhāraṇī*, as originally recorded in Sanskrit. This artifact, along with its textual transmission, illustrates how sacred texts spread through Asian culture along with new printing technologies. The pagodas, which measure only 22 cm. (8.7 in.) high, were almost certainly intended for placement on Buddhist altars. Although a million copies were said to have been commissioned—100,000 for each of ten main temples—fewer than 50,000 are now extant at Hōryūji Temple in Nara, where this twentieth-century replica, used in RBS classes, was produced.

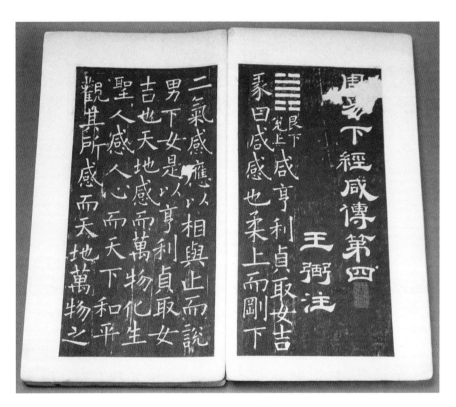

Ink-squeeze rubbing album. *Zhouyi, juan 4* (周易卷四). Kaicheng Stone Classic edition (唐開成石經). Single volume containing about eighteen rubbings from the Chinese classic *Yijing* (易經), or *Book of Changes*, as engraved on stone between 833 and 837. Gift of Xia Wei and Soren Edgren.

1.4
Carved in Stone:
Yijing (易經)
(ca. 835)

This album contains an ink-squeeze rubbing from a stone engraved between 833 and 837 during the Tang dynasty (618–907 CE). The stele is part of a group known as the Kaicheng Stone Classics (唐開成石經)—twelve classic works carved into 114 large, vertical tablets that were erected by order of the Wenzong Emperor in the courtyard of the Imperial Academy in Chang'an, the Tang capital, where they served as an accurate and accessible reference for students. The text featured here is from the Chinese classic *Yijing* (易經), or *Book of Changes*, popularly referred to as the *I Ching*. The titles are in *lishu* (隸書) clerical script, and the main text is in *kaishu* (楷書) standard script, following the popular style of Ouyang Xun (歐陽詢), a Chinese calligrapher, politician, and writer (557–641). The Stone Classics not only canonized foundational texts and letterforms; they also offered

durable surfaces to facilitate rubbings that could then be bound into a scroll or album format—a process closely related to the history of woodblock printing as it developed in China. Based on their physical characteristics as well as those of the album they are bound in, these particular rubbings appear to have been made in the eighteenth century during the Qing dynasty (1644–1911/12).

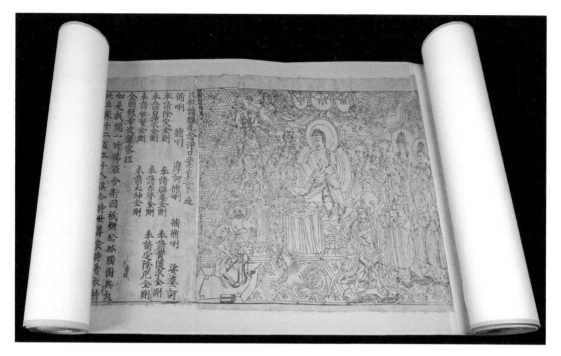

Twentieth-century photo-facsimile of *The Diamond Sūtra*. Beijing: National Library of China Press, n.d. Gift of Xia Wei and Soren Edgren. The original surviving scroll is in the British Library (Or. 8210/P.2).

1.5 Earliest Extant Printed and Dated Book (868 CE)

A copy of *The Diamond Sūtra* (金剛般若波羅蜜經) was discovered in 1900 in the Mogao Caves of Dunhuang, China. The so-called "Library Cave" contained thousands of key religious, and some secular, documents that had been sealed off around the eleventh century. Commonly referred to in English as *The Diamond Sūtra*, the text's Sanskrit title, *Vajracchedikā-prajñāpāramitā-sūtra*, is translated as the "Diamond-Cutter Perfection of Wisdom Sūtra"; its meaning is more accurately rendered, though, as "The Perfection of Wisdom that Cuts Like a Diamond/ Thunderbolt."[3] It is part of the ninth section of the *Mahā-prajñāpāramitā* sūtras— oral teachings originally given by the Buddha to 1,250 monks at Jetavana.[4] The text teaches the perfection of wisdom by cutting through the delusions of ignorance with diamond-like insight into the nature of reality as it is.

The printing of this Chinese translation was commissioned in 868 CE, as documented in its colophon: "On the fifteenth day of the fourth moon and ninth year of Hsien-thung (+868), Wang Chieh reverently made this for blessings to his parents, for universal distribution."[5] The block-printed scroll is the earliest known printed book with a dated colophon—and it stretches more than seventeen feet long. This rare, high-quality replica used for teaching at RBS is opened to show the scroll's frontispiece.

Tangshi sanbaishou (唐詩三百首). Produced by the Yangzhou Guangling Guji Keyinshe. 2 vols. Nanjing: Jiangsu guji chubanshe, 1998. Limited edition, no. 243 of 300 copies. Gift of Xia Wei and Soren Edgren.

1.6
The Invention of
Movable Type

According to Shen Kuo's *Dream Pool Essays* (夢溪筆談), during the Qingli reign (1041–1048), a commoner named Bi Sheng (畢昇) invented movable type by carving individual characters into pieces of clay that were fired to hardness—approximately four hundred years before Gutenberg invented movable type in the West. Inspired by this account of Bi Sheng's invention, Wang Zhen created a font of more than 30,000 sorts of hand-carved wood type at the end of the thirteenth century to print the *Annals of Jingde County*, which contained more than 60,000 characters. From the late fifteenth century during the Ming dynasty (1368–1644), the Chinese cast types from bronze, tin, and lead. Additionally, about one hundred books have been identified as being printed with wooden type. This printing was dominated by private, non-commercial publishing and never threatened the role of xylographic printing in China. By the Qing dynasty (1644–1911), movable wooden type was more widely adopted by government offices, as well as by schools and specialized publishing enterprises. The Qing court sponsored two large printing projects in the eighteenth century: one using around 250,000 characters of bronze type and the other using a similar number of wood type.

The earliest extant book printed with metal type, *Pulcho chikchi simch'e yojŏl* (佛祖直指心體要節), was printed in Korea in 1377 from cast bronze sorts. Movable metal-type printing flourished in Korea throughout the fifteenth century and continued until the nineteenth century. There is textual evidence, documented in

colophons, that cast metal type was made in Korea as early as the 1230s, and a few individual sorts of type that date from the Koryŏ era (918–1392). As RBS faculty member Beth McKillop points out, the early kings of the Chosŏn period (1392–1910) showed great interest in printing books from bronze types. In China, movable metal type was used during the Ming and Qing dynasties. Nevertheless, such productions constituted only a small proportion of Chinese publications owing to the nature of the Chinese writing system and economic conditions. Woodblock printing remained the dominant means of producing texts in China and persisted until the late nineteenth century, when machine printing presses were introduced to China from Europe and Japan. With the arrival of these presses, Western-style movable type began successfully competing with woodblock printing.

RBS's teaching collection includes replicas of early clay, ceramic, wooden, tin, and bronze sorts of type, as displayed here; each sort was used to print a different chapter of this poetry anthology, which also contains a chapter printed via woodblock.

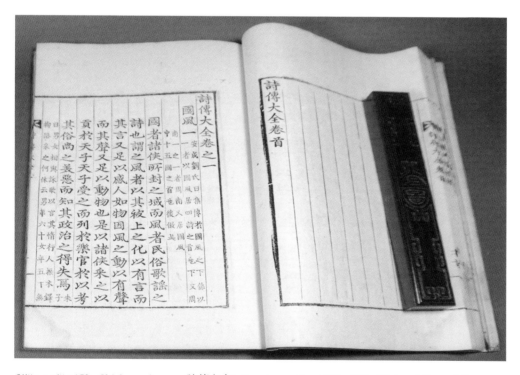

Sijŏn taejŏn (Ch. *Shizhuan daquan*, 詩傳大全). Seoul, ca. 1675. Gift of Xia Wei and Soren Edgren.

This large-format copy of *Sijŏn taejŏn* (Ch. *Shizhuan daquan*, 詩傳大全) consists of a collection of commentaries on the Chinese classic *Book of Odes*, as compiled at the early Ming Court by Hu Guang (1370–1418) and others. The third king T'aejong (r. 1400–1418) of the Chosŏn dynasty ordered the first official casting of bronze types in 1403, and metal movable-type printing of Chinese scholarly texts prevailed at court throughout the dynasty. These books were printed for limited circulation among ministers and administrators, and were not intended for the book trade—and thus were free from the economic constraints of the

1.7
17th-Century
Korean
Typographic
Edition

publishing marketplace. (Commercial printing developed much later in Korea.) This particular typographic edition was printed by the Korean government circa 1675 from the 1668 *musinja* (戊申字) bronze movable type font, which was modeled after the fifteenth-century *kabinja* (甲寅字) font of 1434. The first volume is illustrated with woodcuts. The book's unusually large format indicates its non-commercial origin.

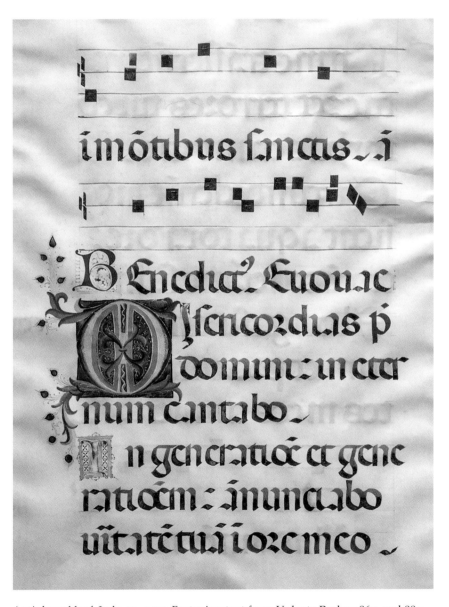

Antiphonal leaf. Italy, ca. 1450. Featuring text from Vulgate Psalms 86:1 and 88:2.

1.8
Italian Antiphonal
Leaf (ca. 1450) This manuscript leaf, measuring more than 16 in. tall by 12 in. wide, comes from an Italian antiphonal, a liturgical book that takes its name from the *antiphons*—short sacred verses sung before or after a chanted psalm or canticle. Antiphonals were used, however, for all music sections performed during the divine offices of Roman Catholic religious rites. All medieval Christian monasteries and most Christian

churches in the West would have owned both an antiphonal and a gradual, the latter comprising all the sung parts of the Mass. Written and illuminated on parchment, this leaf features text from Psalms 86 and 88 from the Latin Vulgate translation of the Bible. The text and music notes were written large enough to be used by several choristers at once. Although the provenance of this particular leaf is unknown, its decorative elements, its four-lined red staves, and its other physical characteristics point to a mid-fifteenth-century Italian origin—a period contemporary with Gutenberg's printing activities in Germany. The yellow-colored inner lining to the decorative initial *M* indicates that the leaf may have been made in Florence.

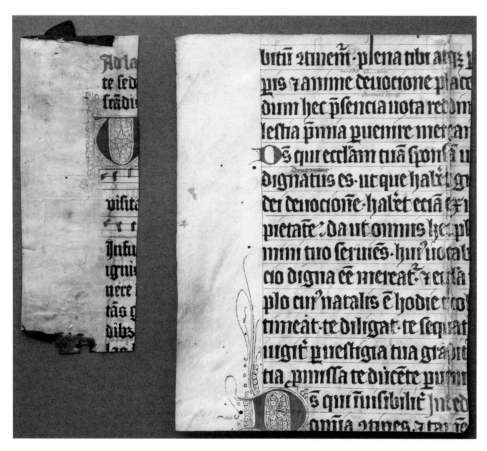

Left: Fragment of folio 126r [*Psalterium*]. Mainz: Fust and Schöffer, 1459. Right: Manuscript fragment. Germany, ca. 1450–1475.

This fragment comes from the second dated work printed with movable type in the West. Only thirteen copies of the 1459 Mainz psalter are known to survive. Printed on vellum by Johann Fust and Peter Schöffer shortly after Johann Gutenberg's publication of the 42-line Bible, the 1459 psalter—like its immediate predecessor, the 1457 psalter—contains a colophon describing how its elaborate two-color initials and rubrics were printed in blue and red without the aid of a pen via a method later referred to as "jigsaw printing." Both the 1457 and 1459 Mainz psalters were designed to accommodate music; blank spaces were left for

1.9
A Rare Fragment: The 1459 Mainz Psalter

staves, and notes of plainchant could be added by hand as printing them proved too difficult, even for these remarkable innovators. The 1459 psalter contains twenty-three lines per page—an increase from the 1457 psalter, which included just twenty lines per page. (The 1459 psalter was printed for Benedictine monks and was arranged for use in monastic services, whereas the 1457 psalter was intended for use in non-monastic churches.)

This fragment, with its printed blue-and-red initial, was originally part of the 126th leaf of the psalter; its text, which appears on the recto of the leaf, comes from "Veni, Creator Spiritus," one of the most widely used hymns in the Catholic Church. The hymn was sung during Vespers and Pentecost, and also for confirmations, dedications of churches, and ordinations.

RBS's Mainz psalter fragment had, at one time, been repurposed for use in a bookbinding. The fragment emerged in the 1920s, when the celebrated London-based antiquarian book dealer, E. Ph. Goldschmidt, replaced the deteriorating binding of the book in which it had been used as a part of the lining. Goldschmidt gave this and other binding waste fragments to his junior employee, Robert O. Dougan, who kept them throughout his subsequent career as a librarian at Trinity College, Dublin, and then as Librarian of the Huntington Library in San Marino. After Dougan's death in 1999, the box of manuscript scraps was given to RBS through the good offices of the Los Angeles antiquarian bookseller Muir Dawson.

The scraps arrived in Charlottesville, Virginia, on 17 July 1999 while James Mosley, a leading type historian, and Albert Derolez, an internationally renowned codicologist, were each preparing to teach their upcoming courses at RBS. RBS's founding director, Terry Belanger, emptied the box of scraps before the two renowned scholars, who began identifying the fragments. Mosley immediately identified the printed Mainz psalter fragment, which Belanger later paired with a fifteenth-century manuscript fragment from the Dougan hoard as part of a teaching kit called "Manuscript vs. Print." The difference between the two fragments can be difficult to distinguish without close inspection; the designs of printed books and manuscripts from this period closely resemble one another, largely owing to economic factors and the bookmaking technologies available at the time.[6]

A forme of type. Type cast ca. 1970. Quarto format; set from *The Printer's Grammar* in Charlottesville, ca. 2000.

A "forme" is an arrangement of lead type prepared for printing on the bed of a relief printing press, as introduced in the West during the fifteenth century. A compositor imposed the type on a flat surface into the desired format for printing, and then secured the arranged type with "furniture" (i.e., wooden or metal spacing material) and wedges, locking them up into a "chase," or metal frame, to prevent individual sorts of type from shifting during the printing process. "Quoins," or short wedges, helped secure the forme tightly within the chase; the compositor drove the quoins into place with a mallet and "shooting stick." Formes can be quite heavy, as we have learned when moving this one from one RBS classroom to another (it weighs about 50 pounds). In his autobiography, Benjamin Franklin boasted that while he was printing in London, he occasionally "carried up and down stairs a large Form of Types in each hand, when others carried but one in both Hands"—risky business, given that dropping a forme could require many hours of additional labor in resetting the type. Indeed, Franklin mentions on a separate occasion having accidentally "reduc'd to Pie" (that is, "pied" or disarrayed) his type one night while working late on a folio—a blunder that required him to distribute the sorts of type and to recompose the forme well into the early hours of the next day.[8]

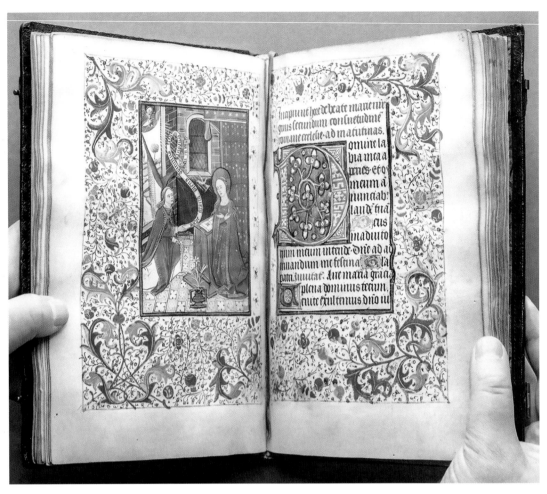

[Book of Hours; Use of Rome.] Ghent, ca. 1470. Gift of Hans and Eva-Maria Tausig.

1.11
A Late Medieval Manuscript Book of Hours

Books continued to be made in manuscript after the advent of printing in the West. This Book of Hours, produced in Ghent circa 1470, is a Roman Catholic devotional book centered on the Hours of the Virgin—a series of prayers popular among lay audiences, including women, who wished to incorporate spiritual practice into their daily lives. It is written in a Gothic bookhand also known as *textualis* or *textura*. It contains six large initials on burnished gold facing six full-page miniature paintings made by Willem Vrelant (d. 1481) or by an assistant or collaborator in his circle. (Vrelant was one of the most prolific and commercially successful illuminators of the time.)[7] In the past at RBS, faculty member Albert Derolez used this manuscript to illustrate how styles from different centuries intermix: the decorated initials harken back to the fourteenth century, even as the acanthus leaves in the border decoration are a contemporary fifteenth-century feature. The yellow rubrication, which is used to emphasize portions of the text, appeared in Flanders, but was of Italian influence. Derolez also noted how this particular Book of Hours has unusually large margins, with evidence of its original gilding and gauffering barely discernible, but still traceable, on its edges. The manuscript was rebound in the nineteenth century, but was not trimmed, as was usually the case.

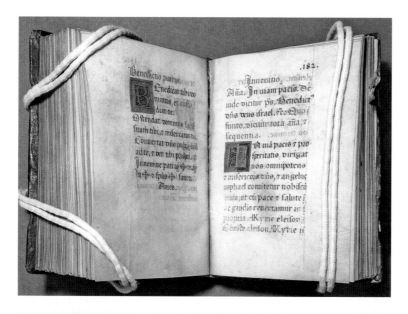

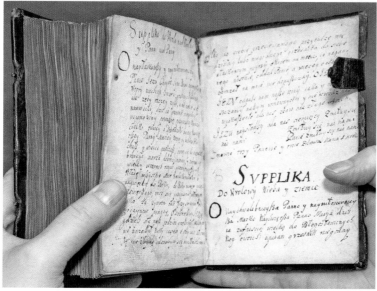

[*Alphabetum aureum and other prayers.*] Italy, ca. 1500. Purchased with funds provided by the B. H. Breslauer Foundation.

A complete, early sixteenth-century manuscript codex bound in a contemporary or near contemporary binding, this compilation of Christian liturgical and devotional texts exemplifies how books continue to acquire layers of interventions from different readers as they move through time and space. The main text, written on parchment, rubricated, and featuring decorated initials, was produced in Italy. The book's final leaves—made from paper and likely added later—are written in several different hands in both Latin and Polish. The Polish-language supplications, asking for help and forgiveness for a sinner who is close to death, were probably written by Stanislaus Golian, a wine dealer based in Krakow whose name appears in the final leaves of the text along with the date of 1616. A later owner's notes (dated 1824) are tipped into the front of the book.

<div style="text-align: right">

1.12

A Manuscript
with Many Lives

</div>

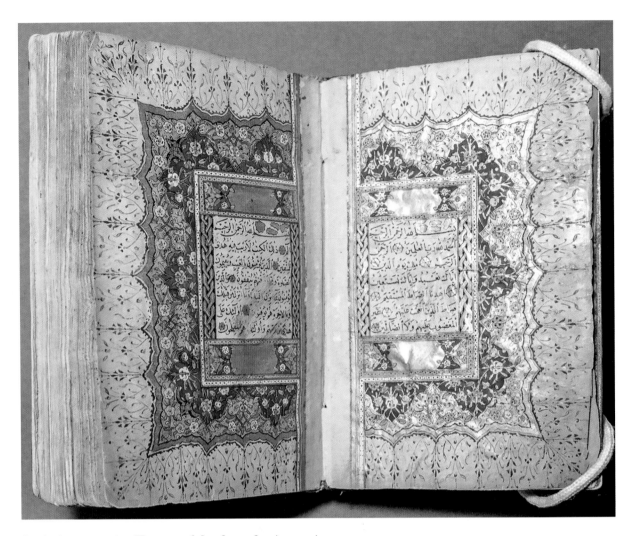

Qur'anic manuscript. [Damascus]: [n.p.], ca. 1800 (1200 AH).

1.13
Qur'anic
Manuscript Codex
from the Ottoman
Empire

This manuscript opens with a full-page illumination in gold and colored inks that contains the Qur'an's first *sura*, *al-faitha*, known in Turkish as a *serlehva*. The manuscript does not include the full text of the Qur'an. The book is also lacking a colophon, making it somewhat difficult to date; but, judging by its stylistic presentation, it was probably produced at the beginning of the nineteenth century. In addition to its beautiful and delicate script and illuminations, the book has many features that help teach students about scribal and binding practices in the Islamic world. The stamped and gilt binding, lacking a fore-edge flap, corresponds to the Type III style of Islamic binding identified by codicologist François Déroche.[9] In her course on the history of bookbinding, RBS faculty member Karen Limper-Herz draws students' attention to the characteristic mandorla-shaped central panel and stamped pendants and corner pieces of the covers to show students how decorative techniques from Islamic bookbinders were adopted by binders in Europe.

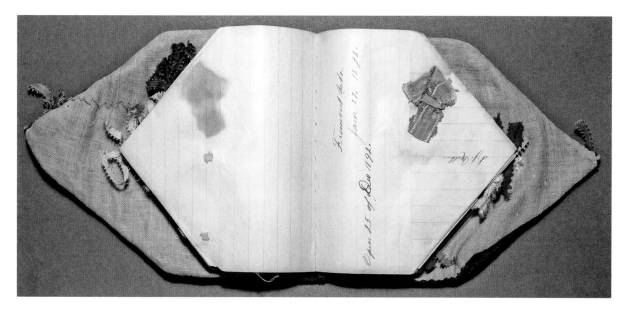

[Friendship album.] Fremont, Nebraska, ca. 1892.

Unique, handmade books often challenge our assumptions about how texts are made, and they can also be difficult to describe according to the usual methods of bibliographical description. These kinds of artifacts attest, however, to the power of books in the lives of individuals who, throughout history, felt compelled to fashion their own reading materials. Bound in velvet, the intricate folded paper leaves of this friendship album are too fragile to be opened today—more than a hundred years after they were crafted by an unidentified person living in Fremont, Nebraska. The book was repurposed from a commercial notebook, whose leaves have been folded into triangular shapes; each ruled leaf has been sealed with ribbons, buttons, thread, and even a toothpick. Each folded, paper leaf also includes handwritten instructions—whether to open a leaf on a specific day during the year 1892, or when the recipient is feeling a certain way ("Open when feeling down hearted"), or after a specific event ("Open when you get to California").

1.14
Unfolding
Friendship

These miniature books were published by the Training Division of the Kingsport Press of Kingsport, Tennessee, as student exercises in 1929 and 1930. Each example measures less than an inch tall and a little more than half-an-inch wide. The first presidential miniature produced by the Kingsport students was *The Addresses of Abraham Lincoln* (1929), which contains four complete speeches. The text is presented in approximately fifty words per page composed in ten lines of what appears to be two-point-sized type. The next cohort of graduates upstaged those of the preceding year by issuing *Extracts from the Autobiography of Calvin Coolidge* (1930) in what appears to be an even *smaller* typeface: about sixty words per page composed in twelve lines. Experiments in striking and casting two-point type had been successfully accomplished in the nineteenth century.

1.15
Miniature Books
by Printers-in-
Training

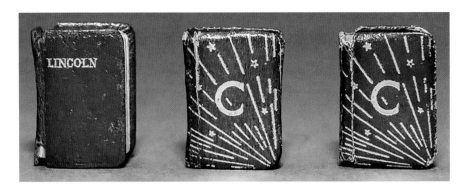

Training Division of the Kingsport Press. *The Addresses of Abraham Lincoln; Extracts from the Autobiography of Calvin Coolidge.* Tennessee: The Kingsport Press, 1929, 1930.

In this case, however, the Kingsport students created their miniature books using more modern and less labor-intensive technologies: they first composed and printed their texts in regular-sized (e.g., 10- or 12-point) type, and then they photographically reduced the appearance of the printed sheets—a process that enabled them to print the resulting miniature text via offset lithography.

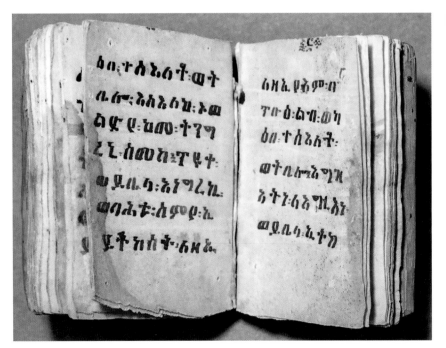
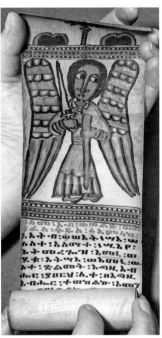

Ge'ez manuscript codex and scroll. Ethiopia, ca. 1950. Gift of Joan and Don Fry.

1.16
Living
Manuscript
Cultures

In present-day Ethiopia, scribes continue to produce scrolls and codices using techniques similar to those practiced by their ancestors in centuries past. This manuscript codex and scroll, written on parchment and housed in leather two-piece cases, may appear to be ancient, but, in fact, they were probably produced during the twentieth century. Both bear text written in Ge'ez, the liturgical language of the Ethiopian Orthodox Church, while the scroll is illuminated with the image of

an archangel. Such books serve as amulets; they are traditionally carried on one's person to promote good health and to provide spiritual protection.[10]

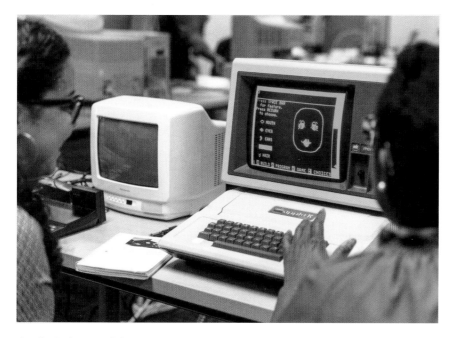

Apple II Plus. Model no. A2S1048. 1981. Gift of Bruce and Mary Crawford.

The Apple II was launched in 1977. Its interior hardware was engineered by Steve Wozniak, and its exterior case was designed by Jerry Manock. Unlike other home computers produced at that time, the Apple II could display color; and the Apple II Plus, next in the series, had improved graphics. Apple developed a word processor (Apple Writer) and desktop publishing software (The Print Shop) for computers in its series. Today librarians and curators grapple with how to retrieve and preserve version of books in their early, electronic forms from older computers. RBS faculty members Matthew G. Kirschenbaum and Naomi Nelson include this machine in their course on born-digital materials to teach students how to operate and access programs as part of a lab exercise teaching best practices on the use and documentation of legacy computer hardware and content.

1.17
Apple II Plus

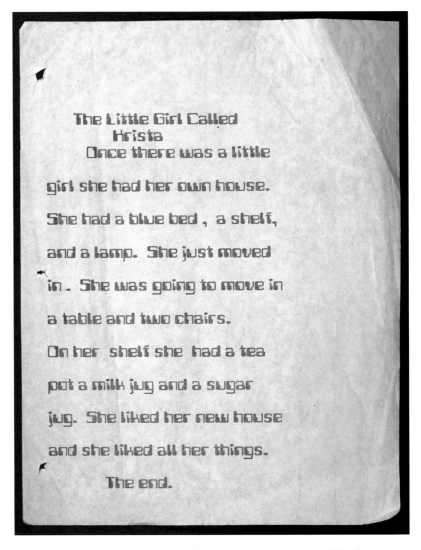

"The Little Girl Called Krista." Redbridge, Ontario, ca. 1987. Gift of Ruth-Ellen St. Onge.

1.18 Desktop Publishing

In the 1980s, the home computer enabled individuals to design and print their own texts, leading to the desktop publishing revolution. This one-page short story was composed by a six-year-old girl on a Commodore 64C home computer in about 1987. The Commodore 64C came bundled with GEOS (Graphical Environment Operating System), a third-party system that included a paint program, geoPaint, and a graphical word processor, geoWrite. The child used the latter program to create a story, "The Little Girl Called Krista," composed in the digital font Cory, and then printed on a dot-matrix printer. The characteristic punch holes of the vertical sides of the dot-matrix printer paper have been removed.

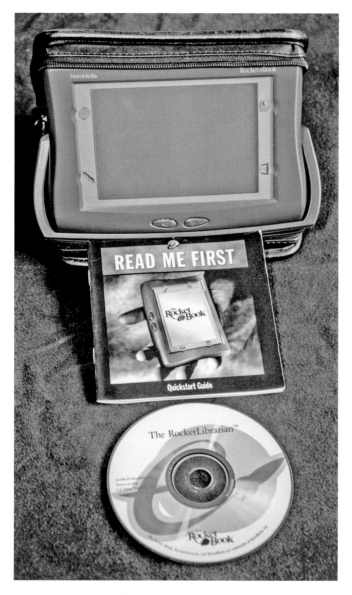

NuvoMedia, Inc. Rocket E-Book, 2000. Gift of Jennifer Burek Pierce.

The Rocket E-Book, or Rocketbook, was one of the first portable e-readers, along with the SoftBook. It was developed in 1997 by Martin Eberhard and Marc Tarpenning, founders of NuvoMedia, Inc. The Rocketbook, priced at $169, required users to download books from the Internet via their home computers. The device had enough storage for 4,000 pages of text, and it allowed users to annotate and mark their favorite passages. Barnes & Noble and the publishing giant Bertelsmann were early major investors in the project, along with Cisco. Owing to this support, NuvoMedia was able to negotiate innovative e-book contracts with major U.S. book publishers. The Rocketbook was even featured on Oprah's "O List" in the first issue of *O: The Oprah Magazine*. This initial success was short-lived; Eberhard and Tarpenning sold NuvoMedia to Gemstar in 2000, which ended production of the Rocketbook in 2003.

1.19
Rocket E-Book

I. Endnotes

1. There has been some debate as to where this scroll was printed. Some Chinese scholars and critics have made the case that this *dhāraṇī sūtra* was printed in Tang China and exported to the Silla kingdom for ceremonial use; see, for example, Tsien, Tsuen-Hsuin. *Paper and Printing*, vol. 5, part 1. In *Science and Civilisation in China*. Ed. Joseph Needham. Cambridge: Cambridge University Press, 1987, 322. Yet such claims—based on paper, printing style, transmission history, etc.— cannot be proven, and the fact remains that no other copies of the scroll have been found in a Tang dynasty tomb. Ongoing scholarly research into the scroll suggests that this *dhāraṇī sūtra* was printed in Korea, not China. The National Museum of Korea issued a report in 2009 that was based on excavation work carried out at the pagoda and that supports the scroll's origin as Korean. RBS's faculty members who specialize in this area of study find the report convincing and credible. See *Bulguksa Seokgatap relics; Sŏkkat'ap yumul;* 석가탑유물. [Seoul]: Kungnip chungang pangmulgwan: Taehan pulgyo Chogye-jong, 2009. It should be added, however, that the text of the scroll was certainly based on an earlier edition from China.

2. McBride, Richard II. "Practical Buddhist Thaumaturgy: The 'Great Dhāraṇī on Immaculately Pure Light' in Medieval Sinitic Buddhism." *Journal of Korean Religions* 2, no. 1 (March 2011): 51.

3. *"Vajracchedikāprajñāpāramitāsūtra."* In *The Princeton Dictionary of Buddhism*. Eds. Robert E. Buswell Jr. and Donald S. Lopez Jr., 953. Princeton; Oxford: Princeton University Press, 2014.

4. Nakamura, Hajime. *Indian Buddhism: A Survey with Bibliographical Notes.* Delhi: Motilal Banarsidass Publishers, 1980, 160.

5. Tsien, *Paper and Printing*, 151.

6. Margaret M. Smith discusses these factors in her book chapter, "The Design Relationship between the Manuscript and the Incunable," which challenges the frequently made argument that incunables "imitated" manuscripts. She shows that, on the contrary, "in most cases there were simple economic reasons behind the apparently imitative features, which are among the debts of early printed books to manuscripts." See Smith, Margaret M. *A Millennium of the Book: Production, Design & Illustration in Manuscript & Print, 900–1900.* Eds. Robin Myers and Michael Harris, 25. Winchester, U.K.; New Castle, DE: St. Paul's Bibliographies and Oak Knoll Press, 1994.

7. "Willem Vrelant." Getty Museum Collection: <https://www.getty.edu/art/collection/person/103K95>; accessed 24 May 2022.

8. Franklin, Benjamin. *The Autobiography of Benjamin Franklin.* New Haven: Yale University Press, 2003, 99, 119.

9. The Type III style of binding appeared on the scene in the seventeenth century (11 AH). AH denotes "Anno Hegira" and is often used in addition to Western Gregorian calendar dates when identifying and describing Islamic manuscripts and bindings. Déroche, François and Annie Berthier. *Manuel de codicologie des manuscrits en écriture arabe.* Paris: Bibliothèque nationale de France, 2000.

10. Derillo, Eyob. "Traveling Medicine: Medieval Ethiopian Amulet Scrolls and Practitioners' Handbooks." In *Toward a Global Middle Ages: Encountering the World through Illuminated Manuscripts.* Ed. Bryan C. Keene, 122. Los Angeles: J. Paul Getty Museum, 2019.

II. SUBSTRATES

Every text is created on a substrate, or surface, that makes it visible to the world. Whether wax tablets, palm leaves, or papyrus rolls from antiquity—or composite screens of e-readers displaying data inscribed on memory disks and hard drives—substrates carry the languages, pictures, and codes that give books their physical forms. Although they are often taken for granted as the inconspicuous background upon which any text is presented, substrates indirectly convey information vital to identifying when and how books and other textual artifacts were made. The following items are used in instruction in Rare Book School classes ranging from specialist courses, such as the history of papermaking, to wide-ranging surveys, including "The History of the Book, 200–2000."

RBS faculty member Timothy Barrett leads a Japanese papermaking demonstration to provide historical context for the course "The History of European & American Papermaking," co-taught with John Bidwell. Photograph by Shane Lin, 2019.

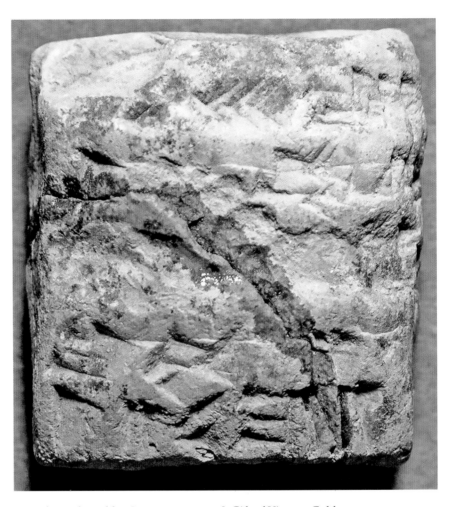

Cuneiform clay tablet, [ca. 1900–1700 BCE]. Gift of Vincent Golden.

<table>
<tr><td>2.1</td><td></td></tr>
<tr><td>Clay Tablet</td><td></td></tr>
</table>

2.1
Clay Tablet This small squarish clay tablet bears on three of its faces the characteristically wedge-shaped cuneiform writing system first developed by the Sumerians. For a long time, it has lived in RBS's "Ancient Writing Materials" box, along with a label reading "Old Babylonian, 1900–1700 BC." The text is difficult to make out, however, as the tablet was broken and glued back together at some point in its history. It was recently identified as an Ur III period administrative tablet by Amanda K. Sprochi, an RBS alumna who is a cataloger at the University of Missouri and who has a background in Near Eastern Studies. Authentication methods for this and other material objects are taught by RBS faculty members Ray Clemens and Richard Hark in their course "Scientific Analysis of the Book." Although we were relieved to learn that RBS's example is likely authentic, "there are more fakes in circulation than genuine articles," as has been pointed out by a Middle Eastern Antiquities specialist from the British Museum.[1] To complicate matters further, the forging of cuneiform documents did not only take place in our modern era—it was practiced as early as the Neo-Babylonian period.[2] The small tablet serves as multi-faceted teaching example of one of the earliest forms of written communication, the use of clay as substrate, and of the potential presence of fakes and forgeries on the antiquarian market.

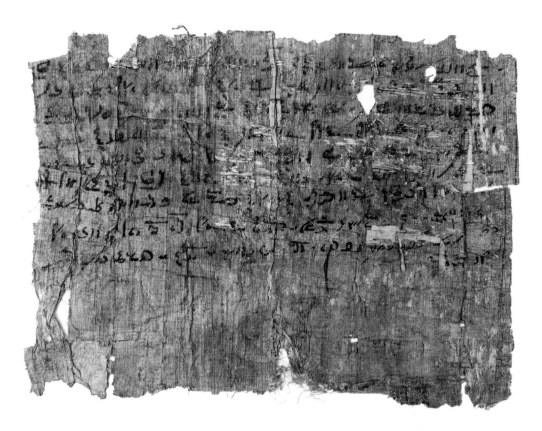

Cartonnage papyrus fragment no. 2, ca. 300 BCE. Gift of Kenneth W. Rendell.[4]

This Egyptian papyrus fragment, donated to RBS some decades ago by Kenneth W. Rendell, was probably made in the third century BCE. Created from the white pith of the stem of the plant, papyrus was the principal substrate used for writing in the ancient Mediterranean world. It was first developed in Egypt as early as 2900 BCE. In his work *Naturalis Historia*, Pliny the Elder describes how the use of papyrus for writing replaced wax tablets. To make papyrus, the pith was taken from the stems and cut into thin strips; the strips were first laid vertically with a second layer placed horizontally at a ninety-degree angle to the vertical strips. These were fused together in a method still not entirely understood by conservators,[3] but likely entailing water and some form of pressure. The upper surface formed the recto and the lower surface the verso. Papyrus most commonly appeared in the form of a roll, with individual sheets joined together using a flexible, starch-based paste—the left sheet always pasted over the right.

Written in Demotic—a language that reads horizontally from right to left—the fragment contains an agricultural account presented in two columns on its recto (i.e., along the fibers) that includes amounts of wheat as well as harvest dates, for example "Month 4 of the Harvest Season [Mesore], day 30." Later, when this account was no longer needed, the papyrus was recycled, and its verso was used for a literary narrative entailing a crime that appears to include mention of the Egyptian sun god, Re. The papyrus was then, yet again, recycled and mixed with plaster to form papier mâché. It was almost certainly soaked in water to resolve it back to its earlier state—as the smearing of letters indicates.

Bamboo documents. Six bamboo slips (each 22 cm.) with Qin dynasty writing. Replica produced ca. 1990 for the Hubei Provincial Museum. Gift of Xia Wei and Soren Edgren.

2.3
Written on
Bamboo

Bamboo served as a principal substrate in East Asia before the invention of paper. In 1975, six bamboo slips were excavated at Yunmeng, Hubei (湖北雲夢出土秦簡). The fragment, bearing writing from the Qin dynasty, has been dated to the third century BCE. It was part of a larger cache of 1,100 bamboo tablets consisting of legal and historical materials.[5] This replica of the fragment was produced during the 1990s by the Hubei Provincial Museum.

Modern facsimile of a Roman wax tablet, with wooden stylus. Gift of Terry Belanger.

Wax tablets were portable writing surfaces used in ancient world for ephemeral activities: making notes, recording the figures of business accounts, etc. They consisted of thin planks of slightly recessed wood filled with soft materials, such as lead or melted wax—the latter hardened to provide a smooth surface for incising (and erasing) with a stylus. Tablets were of different sizes; those small enough to fit in the hand were known as *pugillares*. Two or more tablets could be joined together, so as to contain two (diptych), three (triptych), or multiple (polyptych) wax-filled boards. The replica here is a diptych, or "double-leaved" tablet.

Various forms of wooden tablets, with or without wax, have been made in North Africa, Europe, and Asia for millennia; and they have been used by societies for recording texts from as early as the Bronze Age through the nineteenth century (as is readily shown by the Tibetan *samta* described later in these pages). The wax tablet of the Eastern Mediterranean is often described as a forerunner of the codex. Indeed, the word "codex" derives from the Latin *caudex*, the word used for a block of wood. But, as J. A. Szirmai has pointed out, "the crude methods connecting the rigid elements of a set of tablets (using hinges, metal rings, or lacings) have nothing in common with the structures employed to join the leaves of a codex."[6]

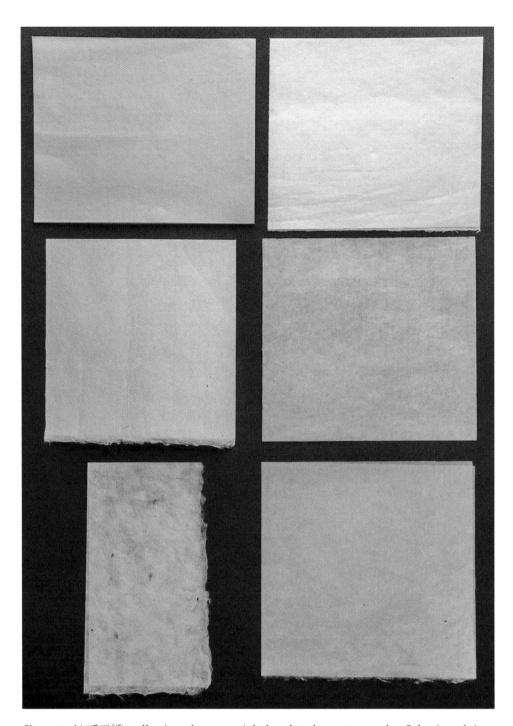

Shougongzhi (手工紙), collection of twenty-eight handmade paper samples. Selection of six Chinese, Japanese, Korean, and Tibetan examples of paper suitable for manuscript copying or woodblock printing. Gift of Xia Wei and Soren Edgren.

2.5
The Invention
of Paper

It is often written that paper was invented in China circa 105 CE by a court official named Cai Lun. Yet examples of early hemp paper survive in China from as early as the second century BCE. Between the third and sixth centuries CE, when mulberry bast and other plant fibers began to be used as an ingredient for papermaking, paper superseded silk and bamboo as the principal substrate in

the East—nearly one thousand years before paper began to be made in twelfth-century Moorish Spain. In Central Asia, a floating mould using wove mesh was commonly used—an ancient form of papermaking that carries forward to the present day. These modern-day handmade paper specimens from China, Japan, Korea, and Tibet consist of materials used for nearly two millennia for writing and woodblock printing.

Handmade specimens (all produced ca. 1970):
Upper left: China (Fujian), *maobianzhi*, bamboo, laid.
Upper right: China (Anhui), *xuanzhi*, blue sandalwood, laid.
Middle left: Korea, paper-mulberry, laid.
Middle right: China (Yunnan), *mianzhi*, paper-mulberry, laid.
Lower left: Tibet (Nepal), daphne, wove.
Lower right: Japan, paper-mulberry, laid.

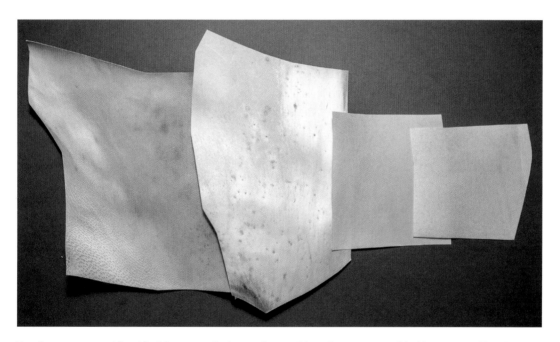

Parchment scraps identified by animal: sheep, deer, calf, and goat. Assembled by RBS staff, n.d.

Parchment is made from animal skin that has been soaked in lye to loosen hair and to help dissolve its fatty tissues, after which the skin is scraped thin and dried under tension. The result is a translucent or opaque substrate with a pale, cream-colored surface. Often made from calf, sheep, or goat, parchment can be created from other animal skins, including deerskin, as shown. Differences in hair follicle patterns can be helpful in distinguishing between animals. Recent innovations in DNA testing have also helped to date and localize skins. During its initial development, one DNA-based identification of parchment was described in 2007 by RBS lecturer Timothy Stinson, an early adopter and innovator of the process.[7] Stinson, now an associate professor of English at North Carolina State University, published his findings in 2009 and 2011. Researchers

2.6
Parchment
Samples Identified
by Animal

in the Archaeology Department of the University of York developed a non-invasive peptide fingerprinting technique that has since led to collaborations with other universities as part of the "Books and Beasts" project. The process entails gathering protein by way of an electrostatic charge created by gently rubbing a PVC eraser along the surface of a parchment leaf; the material is then sent for protein mass spectrometry, which is able to detect the peptide sequences from the collagen gathered as part of the rubbings.[8] The "Books and Beasts" project has led to the identification of hundreds of skins using this non-invasive process, and findings yielded by the technique continue to inform the work of RBS faculty members, including Peter Stallybrass.

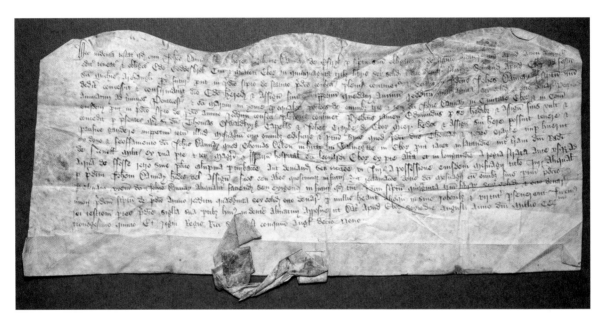

Yorkshire indenture written in Latin. England, 1395. Gift of Kenneth W. Rendell.

2.7 A Medieval Indenture from England

A sturdy substrate, parchment was often repurposed for bookbinding, and old documents, including indentures, were sometimes reused.[9] Indentures are deeds created by two or more parties who frame a contractual, legal agreement expressing their intentions. Note the document's wavy, jagged, toothed top edge (hence the term "indenture"). This feature served as a security device: two identical, handwritten legal agreements (or more, in the case of other examples) would have been written on a single piece of parchment and would have been cut apart—the interlocking toothed edges allowing the pieces to be refitted to guarantee their authenticity. This contract, written on parchment and dating from the reign of Richard II (1367–1400), transferred land rights in Yorkshire from Edmund Goddesbroke to Lord Thomas Oswaldkyrk Cappells and John Crayle. The appended tag at the bottom of the document would have carried a hard-wax seal, which is no longer attached. Seals are easily damaged over time, owing to the brittle nature of their wax, and they may crumble and eventually break off from an indenture. But seals were also sometimes intentionally removed from documents by collectors who specifically sought them.

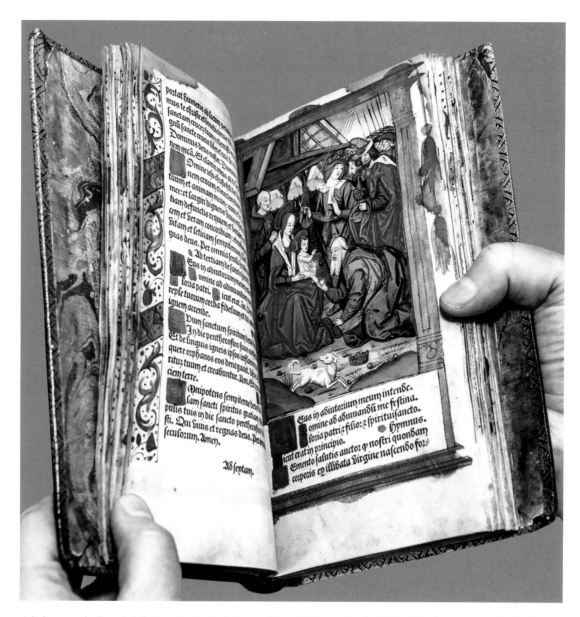

A la louenge de dieu et de la tressaincte et glorieuse vierge Marie. . . . Paris: Gilles Hardouyn, 1510. Gift of Hans and Eva-Maria Tausig.

This Book of Hours may appear, at first glance, to be a manuscript, but it was printed with movable type on parchment by Gilles Hardouyn in Paris during the first decade of the sixteenth century. Illuminated in gold and various colors by a contemporary hand, it contains numerous overpainted illustrations, including forty-seven printed metalcuts with hand coloring. RBS's collection includes leaves from another Book of Hours that features the same metalcuts—yet uncolored and printed on paper. (The paper copy would have sold for a lower price, as paper was cheaper than parchment.)

2.8

Printing on Parchment

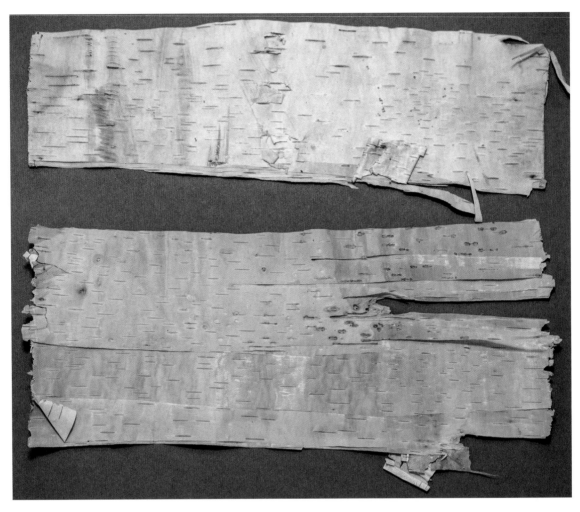

Sections of *wiigwaas* (birch bark). Harvested in Northern Ontario, Canada, in 2021.

2.9
Wiigwaas

For many centuries, *wiigwaas* (birch bark) has been used by the Anishnaabeg (Ojibwe, Algonquin) and Cree to create scrolls inscribed with pictographs recording sacred texts; the scrolls would have been used as memory aids by tribal instructors, teaching orally. As established in the "Protocols for Native American Archival Materials" (2007), original birchbark scrolls are culturally sensitive artifacts. Therefore, in recent years, there has been increasing pressure on their present possessors (both individual and institutional) to return sacred textual artifacts to their communities of origin. This new, uninscribed birch bark is from the traditional territory of the Anishinaabeg people, within lands protected by the Robinson Huron Treaty of 1850 and used by the members of Nipissing First Nation. Birchbark documents have been produced in many regions in the past (e.g., first-century Afghanistan, early modern Russia, Central Europe), and they are still in use in present-day India and Nepal.

Demonstration paper mould made for RBS by Timothy Moore, 1986.

In 1755 or thereabouts, all paper in the West was made using hand-held papermaking moulds, whose grid-like wire surfaces left telltale impressions in the resulting sheets: easily seen chain lines located more than half an inch apart, crossed at a ninety-degree angle by fainter and more closely set wire lines. The result is called "laid" paper. This process began to change when John Baskerville commissioned the papermaking firm of James Whatman to make a special paper smooth enough to display his own typography to the best advantage.[10] The paper was later referred to as "wove" because of the fine copper-wire mesh used to create it. In 1986, RBS commissioned the papermaker Timothy Moore to create a hybrid paper mould, showing the difference between these two "laid" and "wove" surfaces. More recently, RBS faculty member Cathleen Baker has suggested that the earliest Baskerville wove papers may have been made with a textile, rather than a woven copper, screen that was attached on top of a laid cover.

2.10

Dating Paper:
Laid and Wove

Publii Virgilii Maronis Bucolica, Georgica, et Aeneis. Birmingham: John Baskerville, 1757.

2.11
First Wove Paper in the West: Baskerville's Virgil

The 1757 Baskerville edition of *Publii Virgilii Maronis Bucolica, Georgica, et Aeneis* was the first book in the West to contain wove paper. Commissioned from James Whatman as previously described, the paper lacks any watermarks; the attempt to create a smoother, more opaque surface lacking chain lines would have appealed to those particularly interested in the design of books (as well as those in search of smooth drawing papers).[11] At the same time, as John Bidwell notes, this early wove paper exhibits noticeable defects in its sheet formation: shadow marks left by the wooden ribs of the mould where the paper pulp drained more slowly.[12] Yet, despite its relative advantages and disadvantages, this innovation in papermaking went largely unnoticed. Cathleen Baker writes: "Almost immediately after its publication, this book was proclaimed for its production values, particularly the typography, inking, and presswork. However, the new kind of paper—wove—that was used in this book, reportedly the first made in the West, was not commented upon."[13] Baker observes that the difference would have been difficult to discern without a strong light source. Baskerville's Virgil, furthermore, contains a mixture of wove and laid sheets. The reasons underlying this mixture of sheets—and whether the paper mould in fact contained a metal mesh screen or a cloth surface (as suggested by Baker)—are still being evaluated.

Raw cotton, cotton rag, wheat straw . . .

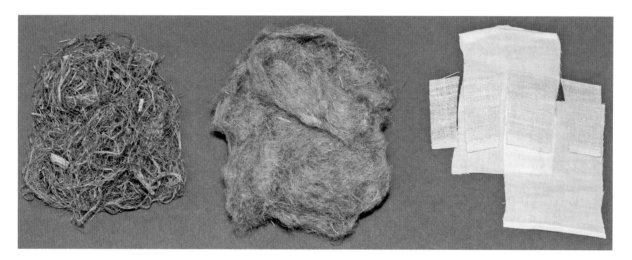

Russian hemp, line flax, and linen rag. All provided by Twinrocker Handmade Paper.

Until the commercial development of wood-pulp paper in the nineteenth century, paper in the Middle East, Europe, and North America was made with the fibers of various plants including flax, hemp, and cotton. However, these were not processed in their raw state. Rather, used linen, hempen, and cotton rags and new cuttings were gathered and repurposed for the manufacture of paper. These fiber samples were assembled for use in RBS courses by Twinrocker Handmade Paper's Kathryn and Howard Clark in the 1980s at the request of Terry Belanger.

2.12
Plant Fibers
for Papermaking

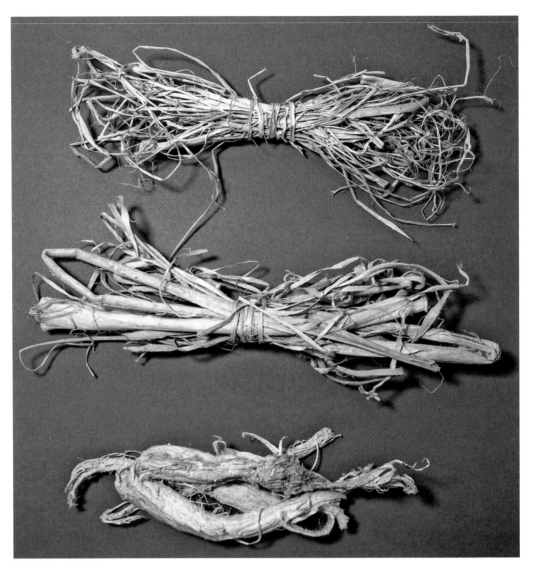

Dried Nepalese and Tibetan plants used for paper. Gift of Timothy Barrett.

2.13
Plant Fibers from
Tibet and Nepal

Various plants indigenous to the Himalayas are the primary raw material used for papermaking in the region. The fiber *kyem shog* was used to make paper currency in Tibet in the early twentieth century. The bast fiber *dug re chag* (*Wikstroemia chamaejasme*) is used exclusively for papermaking. The inner white bark of *lotka* (Nepali for *Daphne bholua*) also provides bast fiber. Unlike Western paper or paper from Japan, individual sheets of Tibetan paper are glued together in layers and polished to form a thick leaf.

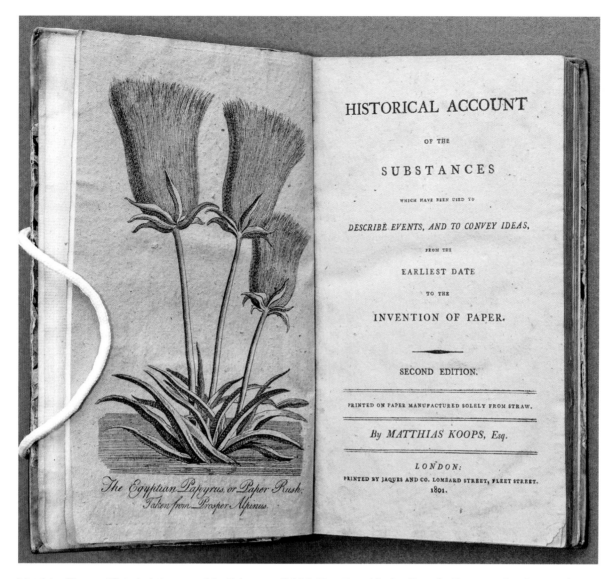

Matthias Koops. *Historical Account of the Substances Which Have Been Used to Describe Events, and to Convey Ideas, from the Earliest Date to the Invention of Paper.* London: Jaques and Co., 1801.

Matthias Koops (active 1789–1805) was one of the first people in Europe to make paper on a commercial scale from raw fibers, including straw, hale, thistles, and different types of bark. He was granted three English patents in 1800 and 1801. His book on the history and production of paper was printed on sheets made entirely of straw, which imparted a distinctly yellow hue to its leaves.

2.14

Straw Paper

Watermark paper specimen: Lion with sheaves and staff standing on a platform within a circle topped by a crown. London, ca. 1813.

**2.15
Watermarks
as Evidence:
Lion with
Sheaves and
Staff within a
Circle Topped
by a Crown**

This undated one-leaf document bears a substantial clue as to when it was made. Using either a light sheet or a handheld light wand, one can discern a watermark of a lion with sheaves and staff standing on a platform within a circle topped by a crown. Watermarks are distinguishing designs incorporated into the wire mesh of paper moulds. Starting in the seventeenth century, they often include a countermark on the opposite site of the mould to signify a papermaker's name or initials, and/or the place or date of the particular paper's manufacture. As a rule of thumb, watermarks commonly occur in laid paper; they less frequently appear in wove paper for printing books.[14] John Bidwell, who taught for many years at RBS, discusses the how the "close scrutiny of watermarks and other manufacture can reveal bibliographical evidence that will help to date and localize a document or to interpret its significance."[15]

This particular watermark closely resembles an 1813 design documented by W. A. Churchill as being produced by Messrs J. Dickinson & Co., a papermaking firm in England. John Dickinson, the founder of the company, patented a continuous, mechanized papermaking process in 1809 that rivaled Henry Fourdrinier's machine, patented earlier in 1806. This particular watermark design, however, circulated during the late eighteenth century well before such inventions were introduced, and the paper displayed here was likely made with a handheld paper mould. The content of the document helps confirm its origin: it is an estimate for painting woodwork and distempering ornamental ceilings for a "Mr Carpue of Dean St[reet] Soho." This location was, in fact, a famous anatomical school that operated in London during the period in question. The school was run

by the anatomist, Joseph Constantine Carpue (1764–1846);[16] he helped found the field of modern-day plastic surgery, and he was also known for buying cadavers from London "body snatchers."

This particular watermark carries some additional significance within the bibliographical community. Terry Belanger began using the design in 1984 to illustrate a Rare Book School flyer within a year of founding the School.[17] The image—now known to many as "the RBS lion" or as simply "the lion"—has been used to decorate RBS mugs, T-shirts, tape measures, and other notions. It continues to serve as the School's informal mascot.

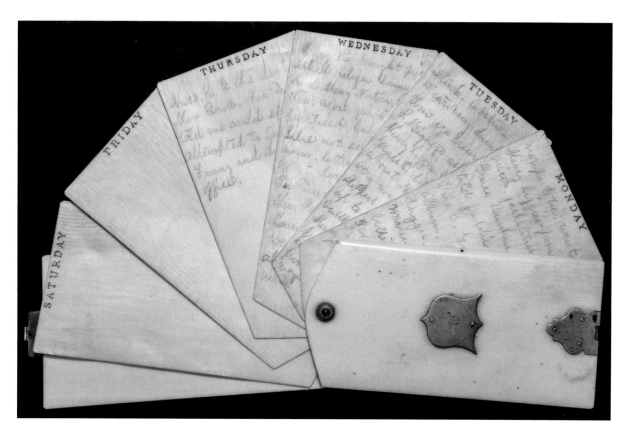

Ivory memorandum book. North America, ca. 1800.

This memorandum book, which was probably made in America during the nineteenth century, features thin, erasable ivory leaves with hand-engraved headlines designating six days of the week. Sunday is not featured—presumably, in observation of the sabbath. Nevertheless, the owner has designated "Sunday" as part of a list on the back of the leaf for "Monday," and has recorded in pencil a number of tasks completed that day: "wrote letter. washed, planned about pieces, went meeting [etc.]." Before the leaves in such books were erased, the notes they contained were sometimes transferred to paper in notebooks and ledgers, in order to create a more permanent record of their contents. Benjamin Franklin is known to have sold books of this kind, as well as other erasable tablets.[18]

2.16
Erasable Ivory
Memorandum
Book

Theatre Brighton, August 26, 1801. Mr. Sedgwick's Benefit. Brighton: Printed by W. and A. Lee, 1801.

2.17
Silk Fabric as
Substrate

The printing of images onto silk and other fabrics using wooden blocks began in China before 220 CE. Nearly two thousand years later, silk was occasionally used during the nineteenth century as a substrate for printed broadsides, as well as theater and concert programs, in Europe and North America. This letterpress-printed broadside on silk announces a theatrical and musical benefit produced by the notable singer Thomas Sedgwick in Brighton, England. It was produced by the local printers William and Arthur Lee, who established their shop in the newly fashionable resort town in 1789.

Sefer Torah Scroll Fragment 5. Aleppo, Syria, ca. 1850.

This fragment from a Torah scroll is written in Hebrew script on *gevil*: parchment **2.18**
made from the whole (rather than split) hide of an animal skin that was prepared *Gevil* גויל
for writing on the hair side only. The darker brown color of the parchment is
produced by the mixture of salt, flour, and gall-nut water applied to the hide.
Scribal evidence indicates that this fragment from the Book of Exodus was in the
process of being written but was never completed. In 2017, visiting RBS research
fellow Sharon Liberman Mintz examined RBS's small collection of Torah and
Esther scroll fragments and identified this example as having been produced in
nineteenth-century Syria.

Indenture for property purchase. Middlesex, England, 1812.

2.19
Afterlives
of Parchment:
19th-Century
Indenture

Parchment is often thought of as an early substrate—one frequently associated with medieval artifacts. Yet examples can be readily found from later periods. This English indenture, an April 1812 contract relating to the purchase of land in Harrow, Middlesex County, is made from sheepskin. Measuring 60 cm. tall by 72 cm. wide (23.3 by 28.2 in.) when fully opened, the document features the wavy edge that was commonly used as a security device for earlier documents, such as the medieval indenture previously described. In later periods, as documents grew longer and more complex, the practice was no longer practical, in part owing to the limited size of parchment made from animal skin. And so the wavy edge of this particular indenture is purely decorative.

Samta. Tibet, ca. 1850.

Samta are wooden tablets made from small wooden planks with recessed, black-inked writing surfaces. They were once used in Tibet for daily notetaking—typically by those learning to write or by those who wished to record short entries or memoranda—owing to the high cost of paper in the region. The black surface of the tablet was coated with a thin layer of oil and covered with ash before writing. The light-colored ash adheres to the oil, allowing the user to inscribe text on the surface with a wooden stylus. The writing can then be wiped away and the layers of oil and ash reapplied to create a fresh writing surface.

2.20

Samta

Two-sheet papermaking mould. [Wookey Hole, England], ca. 1900. Gift of Calvin P. Otto.

This two-sheet papermaking mould, also referred to as a "divided mould"[19] or "end-to-end two-sheet mould,"[20] allowed Western papermakers to create two single sheets of paper simultaneously. Introduced in Holland before the eighteenth century,[21] two-sheet moulds allowed two sheets of paper to be made at once, either end to end or side by side. These moulds substantially increased the number of sheets produced, but were more challenging for vatmen to use. The size of the paper made was limited both to how far a vatman's arms could stretch and to the

2.21

Two-Sheet
Papermaking
Mould

size of the vat itself. In Asia, larger floating moulds that could be used in streams and rivers were common, as documented by Dard Hunter, Elaine Koretsky, Agnieszka Helman-Ważny, and others.[22]

Cathleen A. Baker. Sample specimens and descriptions from *Paper & Mediums Study Collection*. Ann Arbor, MI: The Legacy Press, 2015.

2.22

Machine-Made Wood Pulp Book Paper

These detailed reports published in 2015 analyze specimens of two book papers made primarily with wood pulp. The first specimen (shown above), which dates from 1886, shows the strong discoloration and brittleness often seen in aged, machine-made, ground-wood-pulp paper bleached with chlorine. In contrast, a specimen of machine-made, chemical-wood-pulp paper created in 2007 is in excellent condition; it is likely to remain so for a long time, primarily because it lacks the extremely light-sensitive and destructive lignin found in ground-wood pulps. Deterioration of paper may be caused by chemicals used in production, as well as by a variety of environmental factors, including humidity, heat, and air pollution.

Charles Dickens. *Our Mutual Friend.* "The Oxford India Paper Dickens." London: Chapman & Hall, ca. 1890.

"India paper" is a term for machine-made paper inspired by handmade paper produced in India and measuring approximately a third of the thickness of usual European book papers. In 1874, Henry Frowde, an employee of Oxford University Press, came across a Bible printed in 1842 by his firm, OUP, on a supply of paper brought to Oxford from India in 1841 by an Oxford graduate. OUP began experiments at their paper mills in Wolvercote to try and replicate the remarkably thin, high-quality Indian paper. In 1875, they succeeded by creating a similar paper by machine that was suitably thin and opaque, and OUP used the new paper to print a Bible, which sold more than 250,000 copies. Following that, OUP used India paper to print other works of notable cultural stature in a portable format—including the volumes of Dickens, featured here, which were marketed as the Oxford India Paper Dickens. (The copy of *Our Mutual Friend* pictured contains 959 pages—but the text block measures only 1.5 cm. thick, or just more than half an inch.) In the early 1900s, similar experiments spread among paper manufacturers throughout Europe.

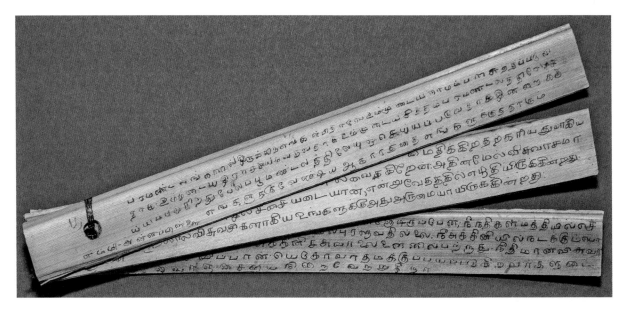

Ola leaf manuscript. Sri Lanka, ca. 1975.

2.24
Ola Leaf

Palm leaves were first adopted for use in South Asia as early as the fifth century BCE, but they continue to be used today for certain texts. Writing is inscribed into the surface of a dried leaf using a stylus; the leaf is then sprinkled with pigment that is wiped into the recessed letters and then cleaned off the surface, leaving a readable text. In Sri Lanka, *ola*, or palm leaves, were traditionally used for Buddhist texts; however, our example contains a Christian prayer in Tamil, one of the world's longest surviving classical languages. Palm leaves are treated with various medicinal oils to protect them from insect damage. In Sri Lanka, the oils of local plants *dorana* (*Dipterocarpus glandulosus*) and *hal* (*Vateria copallifera*) are used to help preserve ola leaf manuscripts. The significant manuscript culture of Sri Lanka has been threatened not only by environmental factors, such as humidity, heat, and insect damage, but also by the sale of ancient manuscripts to tourists and collectors from the West. We suspect that, based on the quality of execution, the RBS ola leaf manuscript was probably created as a souvenir intended for the tourist trade.[23]

2.25
Measuring the
Thickness of Paper

The micrometer on display can be used to measure paper within one-thousandth of an inch (1 mil.). In 1987, David Vander Meulen (now a member of Rare Book School's faculty) described in detail his analysis of paper as part of his larger work documenting thirty-three different editions of Alexander Pope's landmark poem, *The Dunciad*—a study that, at the time, entailed the examination of 800 individual copies and that has since expanded to about 1,000 individual copies.[24] As Vander Meulen recalls, "I realized that it was the paper which was the dominant physical element of each volume, but it was also the ingredient which had been least noticed—and hence which might produce the richest new clues about production."[25] In addition to gauging paper thickness across copies,

David Vander Meulen. *Where Angels Fear to Tread: Descriptive Bibliography and Alexander Pope*. Washington, DC: Library of Congress, 1988. VIS Micrometer. Made in Poland, n.d.

Vander Meulen measured spaces between chain lines and wirelines, documented watermarks, and recorded the overall dimensions of leaves. Drawing on this new evidence, he discovered how changes were made to the text of the poem during its printing, as well as how a copy had been silently altered by the noted collector (and forger) T. J. Wise, who had surreptitiously added a leaf to a copy of *The Dunciad* from a different copy that had been produced in a smaller format—presumably, to supply a gap where one had been missing. Because the new leaf was not as large as the others, Wise had the book trimmed and rebound to hide his intervention before selling the book to the noted collector John Henry Wrenn. Vander Meulen was able to detect the difference, however, owing to the chain lines of the added leaf, which differed from those of its neighbors.[26] The micrometer, in the end, proved less helpful in detecting meaningful variants. As Vander Meulen notes: "Though the average thickness of a large number of samples of the same paper differed from the average thickness of another variety, the variation within the same paper . . . was too great to use the result as a trustworthy means of discriminating varieties."[27]

Claire Van Vliet. *Dido and Aeneas. An Opera Perform'd at Mr Josias Priest's Boarding-School at Chelsey by Young Gentle-women, the Words by Mr. Nahum Tate; the Music Composed by Mr. Henry Purcell.* Newark, VT: Janus Press, 1989.

2.26
Paper Pulp
Painting

In the twentieth century, book artists began using colored paper pulp to create designs on the surface of freshly made sheets of handmade paper. This technique, developed by Claire Van Vliet and others, entailed the application of pigmented pulp either freely or using a stencil onto a freshly formed handmade paper substrate. Van Vliet's edition of *Dido and Aeneas*, which celebrates the 300th anniversary of Henry Purcell's opera, shows off the technique to dramatic advantage. This complex accordion-fold book, which incorporates Nahum Tate's libretto, creates a multi-dimensional, stage-like backdrop for each act of the opera. The book was published with an accompanying compact disc featuring a performance of the opera. The work was hailed by *The Washington Post* as a "triple-media triumph" when it was exhibited at the National Museum of Women in the Arts.[28]

Amazon. Kindle: Amazon's Wireless Reading Device, 2007.

When the Kindle was first launched in 2007, Amazon CEO Jeff Bezos pronounced: "It is not written anywhere that books shall forever be printed on dead trees."[29] The book could also now appear on a digital screen via new E Ink technology rather than on paper. E Ink technology was commercialized in 1997 by two MIT undergraduate students, J. D. Albert and Barrett Cominsky. E-reader screens using the technology are made up of layers of electrodes, transparent micro-capsules, positively charged white pigments, negatively charged black pigments, and transparent oil, sandwiched between two layers of plastic. First-generation Kindles cost their original owners $399, or about $540 in 2022 USD. The devices included 250 megabytes of storage (enough for about two hundred text-only books), and they came with a head-phone jack for audio files.

2.27
First-Generation
Amazon Kindle

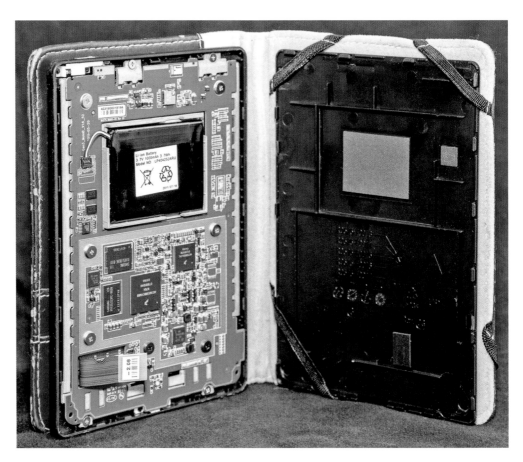

Kobo Touch E-Reader, 2011. Gift of Ruth-Ellen St. Onge.

2.28
The Hard Drive
as Substrate

Hard drives consist of a substrate as well as a magnetic medium on which data (e.g., e-books) are stored. This dismantled 2011 Kobo Touch was marketed by Toronto-based Kobo Inc., and it included a virtual onscreen keyboard and a 2GB internal SanDisk memory card. SanDisk memory cards are block-accessible memory devices that operate like the hard-disk drive of a personal computer. They may be electrically erased and reprogrammed.

This kind of object may lead one to ponder the comparative durability and accessibility of media over the long term. Book historians can still readily handle and interpret texts written hundreds or even thousands of years ago on paper, parchment, papyrus, and stone—but in the future, will individuals be able to access born-digital texts stored on hard drives and memory cards with the same ease?

1. Simpson, St John. "Fake antiquities made for unsuspecting collectors." The British Museum Blog. 5 May 2020: <https://blog.britishmuseum.org/fake-antiquities-made-for-unsuspecting-collectors/>; accessed 15 December 2021.

2. Michel, Cécile. "Cuneiform Fakes: A Long History from Antiquity to the Present Day." *Fakes and Forgeries of Written Artefacts from Ancient Mesopotamia to Modern China*. Berlin: De Gruyter, 2020, 25–60.

3. Rebecca Capua, Associate Paper Conservator for the Metropolitan Museum of Art's Sherman Fairchild Center for Works on Paper, writes: "While the arrangement is clear, the exact method of papyrus-making is, unfortunately, undocumented by the ancient Egyptians, and therefore some of the details of the procedure have been pondered over by modern scholars. . . . It is generally accepted that no adhesive was used; however, using more damp or pre-soaked strips of papyrus leads to better adhesion between the layers, perhaps by facilitating physical bonding as the moisture causes the parenchyma cells to swell and then lock into each other upon drying. Some modern researchers have found that pressing until dry is critical for sheet formation, but Pliny claims that sheets were pressed together and then dried in the sun; the exact method of pressing and drying by the Egyptians is unknown." See "Papyrus-Making in Egypt." March 2015. The Metropolitan Museum of Art: <https://www.metmuseum.org/toah/hd/pyma/hd_pyma.htm>; accessed 12 February 2022.

4. In documenting and publishing this papyrus, we are observing the ethical guidelines set forth by the American Society of Papyrologists. See the Society's 2022 statement on professional ethics: <https://www.papyrology.org/ethics-statement/asp-statement-on-professional-ethics>; as well as the Society's 2007 resolution concerning illicit trade in papyrus: <https://www.papyrology.org/resolutions.html>; accessed 5 April 2022. Although the original provenance of the fragment is unknown, it probably came from another collector before being obtained by Rendell. In cataloging this ancient fragment, we enlisted the guidance of Dr. Andreas Winkler, a papyrologist at the Freie Universität Berlin.

5. Tsien, *Paper and Printing*, 30.

6. Szirmai, J. A. *The Archaeology of Medieval Bookbinding*. Aldershot, U.K.: Ashgate Publishing, 1999, 3.

7. An audio recording of Timothy Stinson's lecture is available as a podcast. See "Sheep: What DNA Can Reveal about Medieval Manuscripts and Texts," Rare Book School Lecture 504, 15 October 2007 on the Rare Book School website: <https://rarebookschool.org/programs/lectures/>; accessed 12 February 2022.

8. See "'Books and Beasts' Medieval Manuscript Mystery Solved." Cambridge University Library [ca. 2015]: <https://www.lib.cam.ac.uk/news/books-and-beasts-medieval-manuscript-mystery-solved>; accessed 21 February 2022.

9. In a guest post for "The Collation," Megan Hefferman describes an example of an indenture (MS X.d. 515 [11a,b]) repurposed for a bookbinding. See "Histories and Communities of Books." 23 March 2017. The Collation: Research and Exploration at the Folger: <https://collation.folger.edu/2017/03/histories-communities-books/>; accessed 22 July 2022.

10. John Bidwell writes that wove paper "could display the sharp contrasts and brilliant letterforms fashionable in the neoclassical period." He notes that although "bibliographers have been hard pressed to explain why and how [wove paper] was invented . . . they all agree on the main sequence of events and on the parties responsible, James Whatman I and II." See Bidwell, John. "Wove Paper in England and France (1999)." In Bidwell, John. *Paper and Type: Bibliographical Essays*. Charlottesville: The Bibliographical Society of the University of Virginia, 2019, 33–34.

11. Bidwell, "Wove Paper in England and France," 33.

12. Bidwell, "Wove Paper in England and France," 34.

13. Baker, Cathleen A. "The Wove Paper in John Baskerville's Virgil (1757): Made on a

Cloth-Covered Laid Mould." In *Papermaker's Tears: Essays on the Art and Craft of Paper*. Vol. 1. Ed. Tatiana Ginsberg, 3. Ann Arbor, MI: The Legacy Press, 2019.

14. See Carter's entry for "watermark." Carter, John. *ABC for Book Collectors*. Eds. Nicolas Barker and Simran Thadani. New Castle, DE: Oak Knoll Press, 2016, 258.

15. Bidwell, John. "The Study of Paper as Evidence, Artifact, and Commodity (1992)." In *Paper and Type: Bibliographical Essays*. Charlottesville: The Bibliographical Society of the University of Virginia, 2019, 3.

16. Carpue resided at No. 72 Dean Street from 1806 to 1833. Although the site is now demolished, it was carefully documented in *Sheppard's Survey of London*: "The Pitt Estate in Dean Street: No. 72 Dean Street." In *Survey of London*. Ed. F. H. W. Sheppard. Vols. 33 and 34. London: 1966, 213–214. British History Online: <http://www.british-history.ac.uk/survey-london/vols33-4/pp213-214>; accessed 29 May 2022.

17. For a short history of how RBS adopted the watermark, see "The RBS Lions" in the March 2008 edition of the Book Arts Press Address Book. Charlottesville: Book Arts Press, 2008, 347–349.

18. Green, James N. and Peter Stallybrass. "Benjamin Franklin: Writer and Printer." The Library Company of Philadelphia: <http://librarycompany.org/BFWriter/writer.htm>; accessed 12 February 2022. Green and Stallybrass both teach for RBS.

19. See chapter eight of Hunter, Dard. *Papermaking: The History and Technique of an Ancient Craft*. New York: Dover Publications, 1978. Note: The Dover publication is an unabridged republication of the second edition of Hunter's work as published by Alfred A. Knopf in 1947.

20. Bidwell, John. "The Size of the Sheet in America: Paper-Moulds Manufactured by N. D. Sellers of Philadelphia (1977)." In *Paper and Type: Bibliographical Essays*. Charlottesville: The Bibliographical Society of the University of Virginia, 2019, 194–195.

21. Paper evidence suggests that side-by-side moulds were in use in Holland before the eighteenth century—a history traceable owing to the fact that the chain lines in these moulds run parallel to the longer edges. It is more difficult to confirm when exactly end-to-end two-sheet moulds came into use, as the chain lines run parallel to the short sides of the mould, as with single moulds. Philip Gaskell cites the *Encyclopédie méthodique* (Paris, 1788) as establishing the use of end-to-end moulds in France by 1788. Gaskell, Philip. *A New Introduction to Bibliography*. Winchester, U.K.; New Castle, DE: St Paul's Bibliographies and Oak Knoll Press, 1995, 63–65.

22. Papermaking with floating moulds required that pulp be poured onto the mould rather than dipped into a vat, as Dard Hunter describes in his passage, "The Moulds of Siam, Burma, Nepal, Bhutan, and Tibet." Hunter, *Papermaking*, 111–114.

23. We are most grateful to Priya Chandrasegaram for her assistance in identifying and translating the Tamil text.

24. Vander Meulen, David. *Where Angels Fear to Tread: Descriptive Bibliography and Alexander Pope*. Washington, D.C.: Library of Congress, 1988, 22. Vander Meulen estimated his current tally at 1,000 copies in an email to Barbara Heritage on 30 May 2022.

25. Vander Meulen, *Where Angels Fear to Tread*, 14–15.

26. Vander Meulen, *Where Angels Fear to Tread*, 18.

27. Vander Meulen, *Where Angels Fear to Tread*, 16–17.

28. Burchard, Hank. "Artist's Bookkeeping." *The Washington Post*, 6 January 1995: <https://www.washingtonpost.com/archive/lifestyle/1995/01/06/artists-bookkeeping/532eac54-1136-4ad6-9b59-0d76a0543063/>; accessed 12 February 2022.

29. Stone, Brad. *The Everything Store. Jeff Bezos and the Age of Amazon*. New York: Little Brown and Co., 2013, 255.

III. FORMATS

How are the substrates of a book put together to make a whole? How are they assembled? From scrolls to zip disks, and from miniature codices to double-elephant folios, the structures of books not only provide evidence of how, where, and when they were made, but also a sense of their intended use. The following items from RBS's teaching collection convey the many ways that book formats have changed over time in various regions around the globe. But their physical structures also reflect how the forms of books themselves are shaped by communities and societies, even as books effect their own meanings in the world.

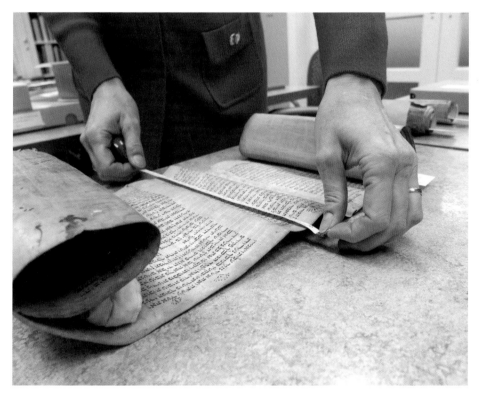

RBS research fellow Sharon Liberman Mintz measures an Esther Scroll fragment. Photograph by Barbara Heritage, 2018.

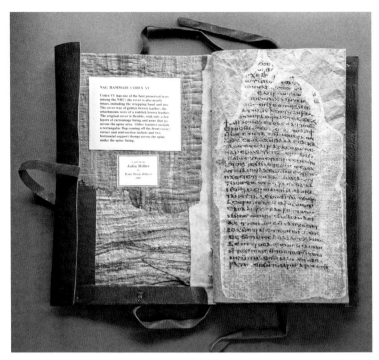

Julia Miller. Binding model of Nag Hammadi Codex VI, 2007. Gift of Julia Miller.

3.1
Codex

In the ancient world, the term *caudex*, later *codex*, originally signified "a block of wood" or "log." "Codex" later came to refer to a block of wood that had been sawn into planks for making *tabulae* or tablets, as described in an earlier chapter. In late antiquity, the word began to be used with reference to books, manuscripts, and documents more generally—including ledgers and account books—even as codices themselves began to be fashioned in papyrus or parchment, or (much later) in paper. Yet these structures—connected with metal hinges or rings or leather lacings—had little to do with the codex format used for bookmaking as we know it.[1]

The Western codex form—that is, the single quire and the multiple quire—is first found in the Coptic books of Eastern Christianity. Leaves from early codices survive from as early as the second century CE. But the earliest surviving intact codices found to date were made around the third and fourth centuries CE.[2] The most notable of these consist of a group of thirteen papyrus codices discovered in 1945 near the village of Nag Hammadi in Egypt; they are known as the Nag Hammadi codices, and they reside in the Cairo Museum.

The book shown here is a replica of Nag Hammadi Codex VI. The model was created by the bookbinding historian and book conservator Julia Miller in 2007 for RBS's teaching collection. The original Codex VI, a single-quire papyrus manuscript bound in a limp leather flap binding, contains Coptic translations of early Christian and Gnostic texts, as well as a Gnostic treatment of Plato's *Republic*, copied out between 350 and 400 CE. Miller bound a single quire in limp goatskin in the same manner as the original to recreate its structural features. (For practical reasons, Miller used paper in place of the original papyrus.) As with the original manuscript, the sheets of this replica are folded in half (i.e., into bifolia). They are attached together with tackets—that is, rolled leather thongs—that are

laced into holes pierced through both the entire quire and binding structure, and that are tied off on the outside of the leather spine. (The inner structure includes quire stays, or short leather guards, that protect the holes made to the centermost opening of the quire from tearing.) J. A. Szirmai notes that the Nag Hammadi codices constitute only a proportion of single-quire codices extant from this period; at least forty-five more examples of single-quire manuscripts dating from the third and fourth century are known. Only a few of the bindings remain, however, whereas the majority of the Nag Hammadi bindings survive intact.[3]

Michael Gullick. "No. 1: Catch-all bifolium" and "No. 4: Ink ruling (calf-skin)." RBS Manuscript Quires Showing Basic Medieval Pricking and Ruling Techniques. Commissioned by RBS in 2002.

The term "quire" in its early use referred to a gathering of four parchment or paper sheets,[4] each folded once and nested to form a booklet of eight leaves, or sixteen pages. (An individual sheet folded in half, consisting of two leaves joined at the fold, is commonly referred to as a "folio" or "bifolium;"[5] a traditional quire, therefore, contained four such bifolia.) Once sheets were cut and arranged into quires, each bifolium needed to be prepared for writing. Medieval scribes routinely employed pricking and ruling marks that served as guides for copying out their texts in a neat and legible manner.

In 2002, at the suggestion of RBS faculty member Barbara Shailor, RBS commissioned Michael Gullick, a British historian and calligrapher, to create a hands-on teaching set of quires illustrating various pricking and ruling techniques commonly found in European medieval manuscripts. Knowledge of such markings can help localize and date a document, as seen in the examples shown. Example 1 is a "catch-all" bifolium made from calf parchment. The outer fore-edges of the

3.2
Medieval
Manuscripts in
Quires

bifolia are each pricked with an awl in a vertical row (one row per each page) at carefully measured intervals to demarcate horizontal rulings made either in blind with a sharp point or in lead or crayon. These horizontal rulings, in turn, serve as guides for scribes when copying out their texts. This example is point ruled on the hair side of the parchment, and the ruling pattern is typical of eleventh- and twelfth-century manuscripts. In contrast, Example 4 is ruled in ink, following a pattern commonly found in thirteenth- and fourteenth-century manuscripts.

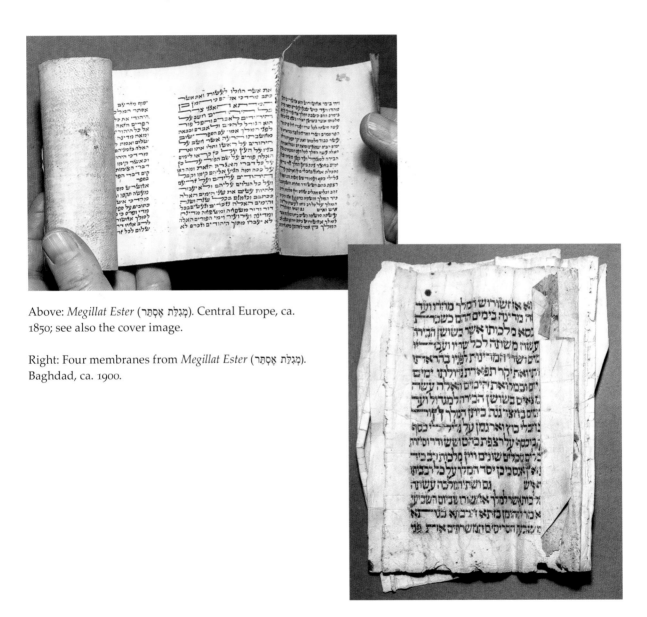

Above: *Megillat Ester* (מְגִלַּת אֶסְתֵּר). Central Europe, ca. 1850; see also the cover image.

Right: Four membranes from *Megillat Ester* (מְגִלַּת אֶסְתֵּר). Baghdad, ca. 1900.

3.3
Scroll
The Book of Esther from the Hebrew Torah is traditionally copied on and read from a parchment scroll wound onto a single rod. *Megillat Ester* is read annually at the festival of Purim. These two Esther scrolls have a varied provenance attesting to the rich diversity of communities in the Jewish diaspora. The first is a complete nineteenth-century scroll from Central Europe; the second is an incomplete scroll from Baghdad made at the turn of the twentieth century.

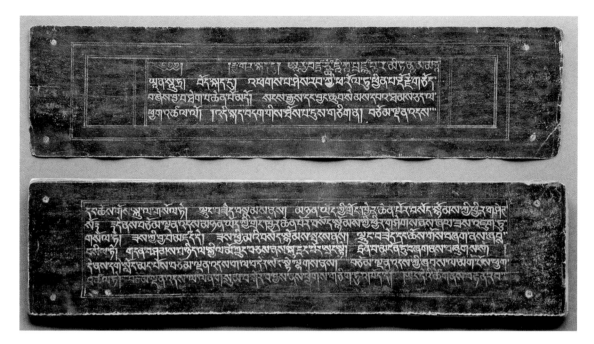

Diamond-Cutter Sūtra. [Mongolia], ca. 1920.

The Tibetan word *pecha* (Tib. *dpe cha*, དཔེ་ཆ་) is generally used to signify a book, and yet the term also describes a very specific format commonly used for Tibetan texts: oblong-shaped, loose paper leaves housed between unattached wooden boards, stiffened paper, or some other firm material, and then wrapped within a cloth, which is secured with a cord. Larger canonical texts would be wrapped in cloth first, then encased between heavy boards that were tied with cords or straps. The format was influenced by the loose-leaf palm manuscripts, or *pothi* (Oriya; Sansk. *pustaka*), of ancient India, where Buddhism began. Yet unlike Indian *pothi*, which were strung together on holes bored through the centers of the leaves, Tibetan *pechas* were never made from palm leaves and were entirely unbound; they were first created from birch bark and later made from paper.[6] Different from Western codices, which are generally held in the hands of readers, the loose leaves of *pechas* easily remain open within containers or *shokali* (Tib. *sho ka li*, ཤོག་ཀླེ་), which can also serve as reading stands. Using these stands frees up the hands, which may be needed to hold ritual items, such as a rosary of prayer beads (Sansk. *mala*; Tib. *ʼphreng ba*, འཕྲེང་བ་), a bell (Tib. *dril bu*, དྲིལ་བུ་), a two-headed drum (Sansk. *damaru*; Tib. *da ma ru*, ཌ་མ་རུ་ or *rnga chung*, རྔ་ཆུང་), a scepter (Sansk. *vajra*; Tib. *rdo rje*, རྡོ་རྗེ་), or other instruments used as part of religious practice.

This particular *pecha*, which is featured in RBS's course "The History & Culture of the Tibetan Book," is commonly referred to as the *Diamond Sūtra*—more accurately translated from the Sanskrit as "Diamond-Cutter Sūtra," as described earlier. The manuscript, which appears to have been made in Mongolia, is a luxurious production, copied out in colored inks probably made from a number of precious substances, such as silver, gold, coral, pearl, turquoise, lapis lazuli, mother-of-pearl, copper, and steel, in keeping with Mongolian practice. The tiny piercings visible in the four corners of the leaves are not commonly found in

3·4
The Diamond Sūtra: A Tibetan *Pecha*

pechas—especially not in more costly productions, such as this one. RBS faculty member Benjamin J. Nourse believes that this manuscript may have been stitched together for the sake of convenience during transport, perhaps as in expedient measure during a period of social tumult or political upheaval. (Buddhist practice was largely restricted or banned when Mongolia was a communist-ruled country from 1921 to 1992.)

Quarto sheet from *Hymne, louanges et prières, prononcés par le Révérend Grand-Rabbin des Israélites Portugais à Amsterdam.* Amsterdam: Belinfante et Comp., 1811. Gift of Jon Lindseth.

3.5 Folio, Quarto, Octavo, Duodecimo

The terms "folio," "quarto," "octavo," and "duodecimo" are often associated with the size of European and North American books—"folio" often serving as an umbrella term for large books, with "quarto," "octavo," and "duodecimo" indicating successively smaller-sized books. In terms of codicological and bibliographical format, however, these terms refer not to the generic size of a book, but rather to the number of times that a full sheet of parchment or paper (or similar substrate) was folded to create a gathering for a codex. A sheet folded in half once creates a folio of two leaves and four pages; and a quarto, folded twice, results in four leaves or eight pages, as can readily be seen in the example of this unfolded quarto sheet featuring a hymn printed in Hebrew and French. Formats such as sextodecimos (16mos),

tricesimo-secundos (32mos), and sexagesimo-quartos (64mos) also circulated—the smallest known, according to Philip Gaskell, being a 128mo printed by the Plantins in the sixteenth century.[7]

A. Folio: Joao da Silveira. *Commentariorum in Apocalypsim.* Venice: Domenico Louisa, 1728. Gift of the University of Kansas.

B. Quarto: Charles Rollin. *Storia Romana.* Naples: A. Cervone, 1761. Gift of Olga Ragusa.

C. Octavo: Jean Racine. *Oeuvres diverses de Jean Racine, enrichies de notes et de préfaces.* Vol. 7. London [false imprint]: [n.p.], 1768.

D. Duodecimo: Horace. *Hekeldichten Brieven en Dichtkunst.* Amsterdam: d'Erven J. Ratelband en Compagnie, Hermanus Uitwerf, 1737.

Thomas Wentworth. *The Earl of Strafforde's Letters and Dispatches, with an Essay Towards His Life by Sir George Radcliffe. From the Originals in the Possession of His Great Grandson the Right Honourable Thomas Earl of Malton.* London: Printed by William Bowyer, 1739.

3.6
Warehoused
Book in Sheets
from the Bowyer
Printing House

This eighteenth-century book in sheets was folded and stored shortly after it was assembled from printed heaps, but before it was fully collated and the leaves properly folded for binding. How do we know? The topmost sheets for the second volume were visited by bookworms, which damaged the leaves while also creating an indelible pattern of holes in the paper—and providing a key to their original order. Additional offsetting from one sheet to another, in addition to staining and tearing, provide rich evidence confirming the sequence of leaves in the stored,

folded pile. Notably, the title pages for the book's two volumes do not appear on top of the stack. Instead, these were laid safely inside, perhaps to protect them from possible soiling and other damage. The book's lavish dedication, printed in both relief and intaglio, was also nested within a quire, again for safekeeping.

Officium Beatiae Mariae Virginis. Antwerp: Plantin, 1677.

Imposition schemes of miniature books are notoriously complex, and it is challenging to decipher their format via chain lines, watermarks, and signatures. RBS has yet to acquire a hand-press period miniature book in sheets, but this is the closest example. The unopened, untrimmed leaves of this Plantin Press Book of Hours allow us to see the book's large original margins, thus offering a clue as to the dimensions of the sheets of paper on which it was printed. In many cases, full margins, such as these, would have been cut down when the book was bound.

3.7
Format in
Miniature

One of the largest books ever published in multiple copies, the plates that accompany the five-volume text for John James Audubon's *The Birds of America* were printed on sheets of handmade paper measuring about 40 by 30 in. as part of a project to document the actual size and appearance of birds within their native habitats. The sheets used to produce the book needed to be large enough to accommodate the size of even the largest birds—including the flamingo, which just fits (with its neck folded down, closely examining its feet). Although Audubon's work is referred to as a "double elephant folio," this name has to do with the sheet size itself, not the book's bibliographical structure: the sheets were not folded in half and sewn through the fold, as is the usual practice with books in folio format. Instead, whole, unfolded sheets were used and sewn together by overcasting the left edges of the sheets. Per Audubon's original plan, subscribers would have received five plates at a time, five times a year.[8] Ultimately, he issued 435 plates between 1827 and 1838. The enormous sheet size and heft of the prints proved challenging in transporting them not only across the Atlantic, but also within the continental United States itself.

This illustration of *Canada Goose* is a 1985 restrike from the original aquatint copper plate engraved by Robert Havell Jr. (1793–1878) in London in 1834 for the first edition of *The Birds of America* after a painting by John James Audubon (1785–1851).[9] The restrike—one of 125 copies published by Alecto Historical Editions—was printed directly from the original plate in color *à la poupée* (as opposed to the hand coloring used throughout the original edition): oil-based pigments in various colors were carefully applied to the relevant parts of the plates and then printed in a single impression—a technique that Audubon had wished to use but found impossibly expensive to execute. The print was donated to RBS along with *Arctic Long-spur* (original edition), *Red-tailed Hawk* (Bien lithograph edition), and several full-size photolithographic reproductions of other birds—a gift that seeded a larger collection, assembled by RBS's founding director, Terry Belanger, to illustrate the various printing processes used for reproducing Audubon's original hand-colored, aquatint plates. Despite its gigantic size, the print continues to travel from classroom to classroom at RBS—and, in 2022, to New York (its first "migration" north in many years).

John James Audubon. *Canada Goose*. London; New York: Editions Alecto; New York Museum of Natural History, 1985. No. 67 of 125 printed. Gift of Robert and Nancy Braun.

Reconstructed sheet from *Six Months in a Convent, or the Narrative of Rebecca Theresa Reed. . . .*
Boston: Russell, Odiorne & Metcalf, 1835. On loan from Todd Pattison.

3.9
An American
Bestseller in
Sheets

Rebecca Reed's narrative *Six Months in a Convent* was an American bestseller in 1835. The publishers anticipated its popularity and had the text stereotyped to allow for additional copies to be printed with speed and ease. RBS faculty member Todd Pattison reconstructed a sheet of the book to teach students about format and gatherings in American nineteenth-century publishers' bindings and specifically about the bindery of Benjamin Bradley, in which hundreds of women workers folded and bound the printed sheets of Reed's memoir. The imposition of the printing was such that two signatures of the book were printed on each sheet of paper, which was then cut into the separate signatures—one with sixteen pages, and the other with eight pages.[10]

Rhein-Panorama von Mainz bis Cöln. Eisenach, Germany: Wilhelm Scütz, Grossherzogl. S. Hofbuchbinderei, Prägeanstalt, Photo-Lithogr. Kunstanstalt, [1883].

This book, made in the *leporello* format, presents a panoramic view of the Rhine. (The terms "accordion book" or "concertina" are often used interchangeably for this style of book structure, given its pleat-like folds.) Opening the book's covers reveals a continuous ninety-two-inch strip that traces the flowing path of the great European river.

Despite its title, the *Rhein-Panorama* is more of a bird's-eye view than a true panorama, which would afford a 360-degree view of the landscape. Panoramic keepsakes and related printed matter became popular in the nineteenth century. They can be tied to the rise of tourism, on one hand, and the emergence of balloon flights, on the other. The publisher of the *Rhein-Panorama* also produced postcards. The trilingual letterpress pamphlet that accompanies the lithographic river map suggests that it was intended for travelers from across Europe. This *leporello*-format book is used in RBS courses as an example of books that resist traditional bibliographical description.

3.10
A Format
that Flows

Alan Moore and Dave Gibbons. *Watchmen*. New York: DC Comics Inc., 1987. Gift of Paul Romaine.

3.11 Until recently, bibliographical research has tended to focus on books printed and
Watchmen published before World War II, but there is an increasing awareness that biblio-
"Witness" graphical methods can be equally helpful for understanding how late-twentieth-
century, machine-press books were produced. The outer right-hand corner of
one of the leaves of the mass-market paperback edition of the 1987 graphic novel
Watchmen features a *témoin* (French for "witness")—an accidentally folded corner
of a bookblock leaf that survives uncut and untrimmed.[11] Here the *témoin* shows
the extent to which the bound leaves were trimmed during the manufacturing
process—thus helping to indicate the leaf's original size.

Clark Coolidge. *On the Slates*. New York: Flockophobic Press, 1992.

Published in 1992, *On the Slates* is a book—but one that immediately announces itself as something apart from a typical codex. Indeed, the professed aim of the Flockophobic Press was to "celebrate non-narrative writing in stunning objects that happen to be books."[12] Reminiscent of Dadaist works from the early half of the twentieth century, Clark Coolidge's experimental language poem is printed on loose leaves of paper the same size as U.S. paper currency, wrapped with an actual U.S. dollar bill overprinted with the address of the Flockophobic Press, and tied with a shoestring—this nestled within one smelly, used men's shoe, which is wrapped in thin, white tissue paper within a shoebox. Designed by A. S. C. Rower and issued as number 150 in an edition of 250, this artist's book is one of many productions created in the twentieth century by various book artists whose work challenged assumptions about bookmaking and publishing. RBS's collection contains a classroom set of thirteen variant "copies" of this unusual work.

3.12
Experimentation:
An Artist's Book
from the
Flockophobic
Press

Edward Bateman. *Gutenberg.* Salt Lake City: Book Arts Studio, University of Utah, 2002. No. 13 from an edition of 24.

3.13
Zip Disk
Artist's Book

Edward Bateman's artist's book *Gutenberg*, contains thousands of pages of electronic texts, accompanied by eight pages of letterpress text. Four printed leaves are encased in a binding of two zip disks on which are stored electronic versions of the following canonical texts (listed in this order): *The Odyssey, The New Testament, Tao Te Ching, The Canterbury Tales, Huckleberry Finn, A Tale of Two Cities, The Tempest, Pride and Prejudice,* and *Hamlet.* Although it is possible to insert these disks into a zip drive, one would have to dismantle the book to do so.

Developed in 1994, zip disks were still commonly used to store electronic files when Bateman created *Gutenberg* in 2002. Yet, as he points out in his accompanying text, the physical components of the disks would begin to break down within five years of their production. Thus, as Bateman writes, "the books will begin to disappear." Bateman predicts that, after the data has broken down, his letterpress text itself "will be the book." And so Bateman's limited edition demonstrates that texts reproduced on paper via the printing of movable type will last much longer than electronic texts stored "as magnetic fields in a coating of iron oxide."[13]

1. J. A. Szirmai makes this point, and he also notes that there is no evidence for *pugillares membranei*, or parchment notebooks, of the ancient Romans contributing to the codex format. See Szirmai, *Archaeology of Medieval Bookbinding*, 3–4.

2. Szirmai, *Archaeology of Medieval Bookbinding*, 7.

3. Szirmai draws on and cites Eric Turner's estimate for this purpose. See Szirmai, *Archaeology of Medieval Bookbinding*, 11.

4. Gatherings of five bifolia—that is, ten leaves or twenty pages—were also common. See Barbara Shailor. *The Medieval Book: Illustrated from the Beinecke Rare Book and Manuscript Library*. 1988. Toronto: University of Toronto Press, 2002, 13. First published by Yale University Library.

5. Barbara Shailor uses the term "folio" to refer to "a single sheet . . . folded once"; see Shailor, *Medieval Book*, 13. Some medievalists, however, refer to one half of a bifolium (i.e., one leaf of the bifolium) as a "folio"—terminology that is at odds with standard bibliographical usage. We use the term "bifolium" simply to avoid such confusion.

6. Helman-Ważny, Agnieska. *The Archaeology of Tibetan Books*. Leiden: Brill, 2013, 48–55.

7. Gaskell, *New Introduction to Bibliography*, 107.

8. Audubon calculated sales for the project in five numbers per year, with each number consisting of five plates—for a total of twenty-five plates. See Fries, Waldemar H. *The Double Elephant Folio: The Story of Audubon's Birds of America*. Chicago: American Library Association, 1973, 26. Audubon documents the reason for this figure in his own correspondence: "I cannot publish more than five numbers annually, because it would make too heavy an expense to my subscribers, and indeed require more workman than I could find in London." See Audubon, Maria R. *Audubon and His Journals*. New York: Charles Scribner's Sons, 1899, 61.

9. "Canada Goose," National Gallery of Art 1945.8.201: <https://www.nga.gov/collection/art-object-page.32342.html>; accessed 8 March 2022.

10. Pattison, Todd and Elizabeth DeWolfe. "Female Labor and Industrial Growth in Nineteenth-Century American Bookbinding." In *Suave Mechanicals: Essays on the History of Bookbinding*. Vol. 7. Ed. Julia Miller, 461–506, 475. Ann Arbor, MI: The Legacy Press, *2022*.

11. See "témoin" in Ligatus's Language of Bindings Thesaurus (LoB): <https://www.ligatus.org.uk/lob/search?search_api_fulltext=temoin>; accessed 24 June 2022.

12. See the catalogue entry for the V&A's copy of *On the Slates*: <https://collections.vam.ac.uk/item/O1293849/on-the-slates-artists-book-coolidge-clark/>; accessed 24 March 2022.

13. Bateman, Edward. *Gutenberg*. Salt Lake City: Book Arts Studio, University of Utah, 2002, [6].

IV. LETTERFORMS

Letterforms not only carry language, but also bear the story of the cultures and technologies that produced them. They convey a sense of how aesthetic values and the presentation of information itself are both shaped by processes that are not readily apparent to the untrained eye. Through the close inspection of their forms, as well as the study of the tools and machines that make them possible, we can learn to discern how letterforms were made and how they continue to make meaning in the world.

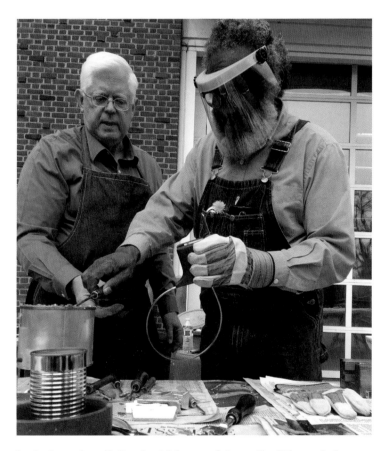

Invited speakers R. Stanley Nelson and Amos Paul Kennedy Jr. practice hand typecasting at the RBS Presswork symposium "Making & Teaching: Printing Technologies at Work." Photograph by Barbara Heritage, 2019.

Inkstone, ink stick, brush (硯, 墨, 筆).

1. Natural inkstone (12.5 x 6.8 cm.), Japan.

2. Ink stick (9 x 2 cm.), partially used, made by Yidege, Beijing.

3. Two small writing brushes, made in Shanghai and Huzhou.

Gift of Xia Wei and Soren Edgren.

4.1
Inkstone,
Ink Stick,
and Brush
(硯, 墨, 筆)

This modern-day inkstone, brush, and ink stick are three of the proverbial "Four Treasures" of the classical Chinese scholar's studio (文房四寶)—paper being the fourth "treasure." Common desktop utensils, inkstones, brushes, and ink were used to produce manuscripts and to annotate texts. Inkstones can be compared to Western inkwells, in that both hold ink, but an inkstone also provides a surface for grinding ink and may additionally serve as a paperweight. Water is dripped onto the slightly concave surface of the inkstone and is rubbed with a solid ink stick to create liquid ink, which is pushed or drained into the shallow reservoir or well for use. More luxurious stones were delicately carved with various designs. Ink sticks, such as the partially used one shown here, often display fine examples of calligraphy, and can include elaborate images—features that are prized by collectors. Ink in the form of ink cakes first appeared in the Han period (206 BCE–220 CE), and ink sticks began to be used during the Tang dynasty (618–907 CE). Brushes were used for writing on bamboo and silk before the invention of paper, with the earliest examples surviving from the third and fourth centuries BCE. The handles of brushes were most often made from bamboo, and the hair commonly came from animals such as goats, weasels, and rabbits.

Oak gall, ca. 2005.

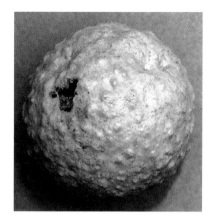

The growth of oak galls on the buds and bark of oak trees is caused by chemicals injected by the larvae of gall wasps. Powdered oak galls, which are rich in tannic acid, are mixed with copperas (an iron-sulphate solution) to produce a dark purple or black liquid ink suitable for writing with a pen or brush. (As this ink ages, it tends to change color to a rusty brown.) Iron-gall ink was widely used in Europe and the Middle East from the eleventh century (and perhaps even earlier) into the twentieth century. Students in Heather Wolfe's RBS course, "The Handwriting & Culture of Early Modern English Manuscripts," learn how to create iron-gall ink during the class's handwriting lab—an exercise that helps students understand and interpret how early modern English manuscripts were produced.

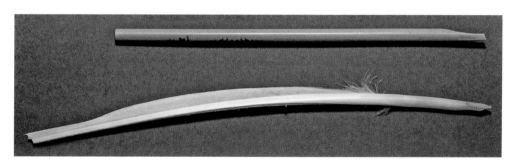

Qalam, or reed pen, made from bamboo, ca. 2020. Goose-quill pen hand cut by Dennis Ruud, ca. 2018.

In the ancient world, scribes used brushes for writing texts in China and Egypt. Then reed pens were developed to write on papyrus before being used later to write on parchment. Pens made from the quills of bird feathers were used at a somewhat later period, perhaps in the seventh century CE. (An early reference to a quill pen occurs in the writings of Isidore, Bishop of Seville [560–636 AD].[1]) Quill pens were the most frequently used writing implement in the West until the early nineteenth century. Although quills are no longer routinely used for writing (except in penmanship exercises, such as those taught at RBS), scribes and artists continue to employ brushes and reed pens for making calligraphic works. Reed pens remain the traditional tool used for Arabic calligraphy—and brushes remain popular for Chinese and Japanese calligraphy.

Japanese manuscript sūtra fragment (弘仁時代寫經). Kōnin period (810–824). Gift of Xia Wei and Soren Edgren.

4.4
A Buddhist Sūtra Fragment from 9th-Century Japan (弘仁時代寫經)

This manuscript fragment, which dates from Japan's Kōnin era (810–824), contains a portion of text from one of the *prajñāpāramitā* sūtras, a body of Buddhist teachings focusing on the perfection of wisdom as realized through *śūnyatā*, or emptiness. Hand copied onto fine, ninth-century paper, the elegant script was made with a brush, and the writing appears in the standard format of seventeen characters per column. Copying sūtras was considered a meritorious practice among Buddhists, and the *prajñāpāramitā* sūtras were among those most copied at the time. The characters here are a Japanese semi-cursive variation of script associated with the Tang sūtra-copying style, which remained dominant throughout the Heian period.

Illuminated MS leaf on parchment. The Flight into Egypt, semi-grisaille. Bruges, ca. 1470.

The writing on this parchment leaf, made in Bruges around 1470, is in a transitional *bâtarde* hand often used for luxury manuscripts. It contains a text from Compline, a Roman Catholic prayer that was traditionally performed at the end of the day, and it features a seven-line historiated initial enclosing a scene of Joseph and Mary's flight from King Herod into Egypt. The semi-grisaille painting within this initial is largely composed in subdued grey colors, and the letterform surrounding it is painted in blue pigment with white tracery. The burnished gold bordering the letter would have sparkled in candlelight.

 Historiated (i.e., story-telling) initials were used in the European illumination as early as the eighth century, with the St. Petersburg Bede (MS. lat. Q.v. I. 18, St. Petersburg, Publichnaja Biblioteka) being one of the earliest known in the West. It is not known when or why this particular leaf was removed from its codex.

4.5
Historiated
Initial from a
15th-Century
Book of Hours

As Christopher de Hamel notes in his RBS lecture, *Cutting Up Manuscripts for Pleasure and Profit*, illuminations were removed from manuscripts from at least the fourteenth century on, particularly for the reuse in ornamenting other manuscripts. According to de Hamel, collecting medieval manuscript miniatures as specimens of painting, such as the one found on this leaf, began at the end of the eighteenth century with the Gothic Revival. The pursuit of collecting entire leaves, even those without significant illumination, began by about 1900—a destructive practice fostered by the antiquarian book trade that flourished in the 1960s and that continues today, despite efforts to discourage it.[2]

RBS Manuscript Fragment 331. "A black girle to a faire Boy," poem. England, ca. 1655.

4.6 17th-Century Scribally Circulated Text These poems—"A black girle to a faire Boy" and "The Aunsw'r"—were copied out in an italic letterform that includes some characteristics of secretary hand. (Note the use of the raised *e* throughout.) The poems, written by Henry Rainolds and replied to by Henry King, address the topic of interracial love. First published in print in *The Academy of Complements* (London, 1646), the poems were copied, usually together as a pair, into numerous miscellanies and commonplace books during the seventeenth century.

Sefer Torah Scroll Fragment 1. Aleppo, Syria, ca. 1850.

This fragment of a Torah scroll contains the text of Numbers 5:6 to 7:10. It is written in square Hebrew script with black ink on *gevil*, a type of parchment made from a whole hide and prepared for writing on the hair side only. While examining this particular Torah scroll, RBS Research Fellow Sharon Liberman Mintz pointed out that there is scribal evidence indicating that the text was never completed; the scribe did not write out the name of God in the text but rather left four short strokes to indicate where God's name would be inserted. This omission was likely the result of rules governing the writing of Torah scrolls, which required that scribes be in a state of purity before inscribing God's name. To achieve this, the scribe would immerse himself in a *mikvah*—a ritual bath.

4.7
Fragment from an Uncompleted Torah Scroll

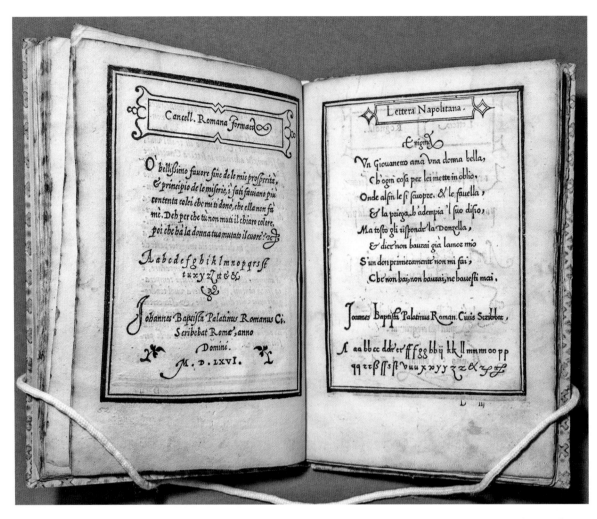

Giovanni Battista Palatino. *Compendio del gran volume de l'arte del bene et leggiadramente scrivere tutte le sorti di lettere e caratteri.* Venice: Aluise Sessa, 1588.

4.8
Cancellaresca
Romana

This book, published in 1588, is a later edition of an early and important 1540 manual on handwriting by Giovanni Battista Palatino (ca. 1515–ca. 1575). It contains eighty-four full-page woodcuts. (Earlier editions may have been printed with relief metalcuts.) In it, the Italian calligrapher presented some of the world's alphabets, including Hebrew, Greek, Latin, and Arabic, as well as many of the scripts used in the European courts and chancelleries of his day. Here Palatino reproduces in woodcut his manuscript specimen of Cancellaresca Romana script; the text is an excerpt from Boccaccio's novel *Il filocolo* (1335–1336).

Leaf from Maximilian I and Melchior Pfintzing. *Theuerdank*. Augsburg: Johann
Schönsperger, 1517. Gift of Don Fry.

The bespoke metal type used to print Emperor Maximilian I's 1517 *Theuerdank* **4.9**
is the oldest, and perhaps the most beautiful and elaborate, manifestation of the **Fraktur**
Fraktur typeface. Fraktur was derived from a calligraphic script; it belongs to the
blackletter family of letterforms commonly used in the German speaking regions
of Europe. The large assortment of swashes recalls the flourishes of manuscript
calligraphy. In this case, they were achieved by using additional, special sorts of
type that could extend the descenders of individual letters. The type is thought
to have been designed by the Viennese court secretary, Vincenz Rockner, and to
have been cut by Jost de Negker.

Psalterium harmonicum, Ebraicè, Græcè, Latinè, et Germanicè. Nuremberg: Elias Hutter, 1602. Gift of Jon Lindseth.

<table>
<tr><td>4.10
Five Fonts for
Five Languages</td><td>Elias Hutter (1553–1609), professor of Hebrew, produced various polyglot versions of Biblical texts. In this 1602 book, he presents the Psalms in transliterated Hebrew, Hebrew, Greek, Latin, and German, with each language requiring separate typefaces. The numerous diacritical marks used in Hebrew and Greek required typefounders to cast fonts containing a larger than usual number of sorts. Hutter also innovated a new Hebrew typeface intended to allow students to learn the language with greater ease.</td></tr>
<tr><td>4.11
Type Case</td><td>Before the rise of automated typesetting (e.g., Linotype and Monotype), movable type was arranged and housed in wooden type cases with dozens of small compartments or "boxes," each devoted to a specific letter or "sort" of type. The type cases shown follow a pattern common in eighteenth-century English printing offices. They form a "divided lay," which distributed a font (English, "fount") into two separate cases: one for lowercase letters, and one for capitals—hence the terms "lowercase" and "uppercase." In addition to housing sorts for lowercase letters, the lower case of the divided lay included compartments for punctuation, quads, and</td></tr>
</table>

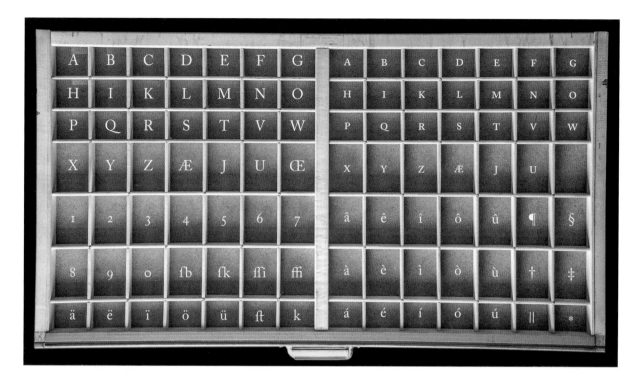

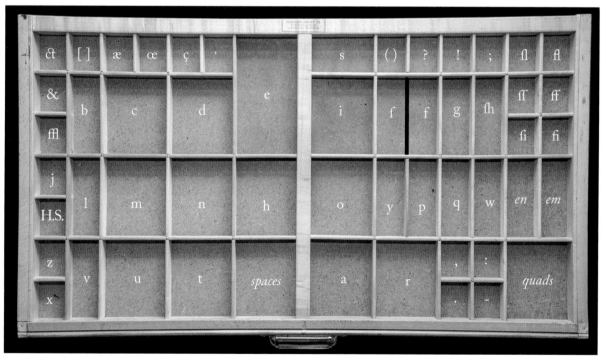

Divided lay, ca. 1900. (The black divider is present in the traditional case illustrated in Gaskell, *A New Introduction to Bibliography*, 37.)

spacers (in italics above). Positioned above it within the larger type frame, the upper case contained more regular, square compartments for full capital letters, small capitals, ligatures, accented characters, etc.

R. Stanley Nelson. Hand-held type mould. Columbia, MD, 1985.

4.12
Facsimile
Type Mould

In 1985, RBS commissioned R. Stanley Nelson, who worked in the Division of Graphic Arts at the Smithsonian Institution's National Museum of American History, to create a type mould for hands-on teaching and instruction. This facsimile was modeled on a thirty-point, sixteenth-century mould of French design that Nelson studied at the Museum Plantin-Moretus in Antwerp in 1982. The mould breaks into two halves that can be adjusted to accommodate matrices of different widths, which are held in place by a curved spring.

4.13
From Punch to
Printing Type

This kit provides a step-by-step look at how R. Stanley Nelson created a lowercase letter *e* for a typeface he designed called Robin. The process entailed creating a punch to form a matrix into which type metal was poured. To create the punch, he began by using a soft steel rod (1) that he shaped, using files to make one end mirror smooth. Creating a counterpunch (CP) to form the letter's bowl (3), he shaped the outside contours of the *e* using gravers and files. After hardening the punch in a hot fire, he struck it into a small copper bar. The bar was then filed down, with its sides adjusted so that the sort produced would be properly centered, creating a matrix (M) that could be inserted into a hand-held mould. Molten type metal was dropped into the mouth of the type mould using a ladle

R. Stanley Nelson. "From Punch to Printing Type" teaching kit. Columbia, MD: 1985. Custom enclosure created by Amira Hegazy, ca. 2018.

and near-simultaneous upward jerking motion that forced the molten metal into the recesses of the matrix. The resulting sort was cast (6), the jet removed (7), and the surface finished and dressed with any remaining rough edges planed down (8). In 1985, RBS produced an educational video, *From Punch to Printing Type*, illustrating this complex process.[3]

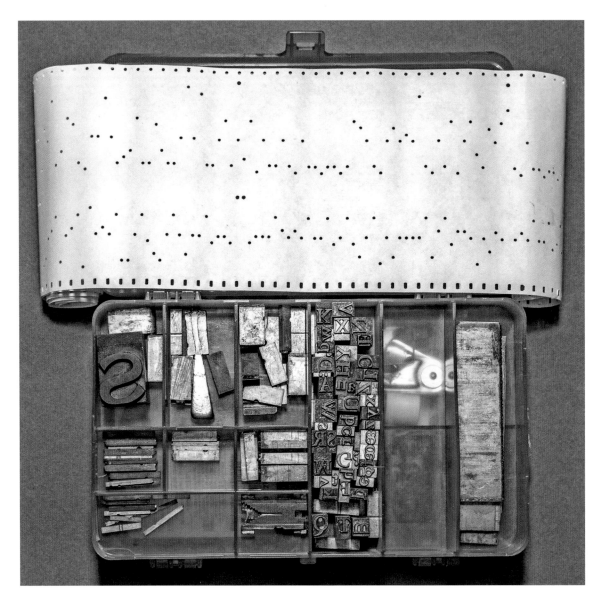

Commercially made fishing tackle box adapted by Terry Belanger to contain various typographical materials.

4.14
Fishing for Type

What do fishing tackle boxes have to do with letterforms? Terry Belanger adapted these pre-made compartmented plastic boxes into kits to teach the history of typography. Each kit includes a selection of materials, ranging from seventeenth-century foundry type and a sort of wood type to Linotype mats and slugs, Monotype sorts and rolls,[4] and unfinished hand-cast examples made using the replica hand type mould described above. Note how the unfinished sort of type still includes the jet of metal that resulted from metal being poured into the inner chamber of the mould; each jet would have been broken off, the flat surfaces of the shank smoothed, and the foot of the sort finished with a narrow-toothed plane to remove the burr of the jet.[5] The kit contains a single-sheet description of the contents of the box—now well worn after decades of use by RBS faculty members and students.

Introductory Typography Packet. Assembled in 2006 by Christopher Adams for "Introduction to the History of Typography," taught by R. Stanley Nelson from 2003 to 2006.

4.15
Introductory
Typography
Packets with
Practice Quiz

These specimens come from a set of thirteen custom type packets that allow twelve students and an instructor to compare original examples of Western typefaces spanning from 1471 to 1956. The specimens were taken from antiquarian books that were in disrepair and whose broken spines readily allowed their leaves to be reused for educational purposes. The instructor packet includes a quiz with a range of examples. Of the two specimens shown, one was printed in London in 1505 and the other in Basel in 1535. We challenge our readers to discern which is which.

4.16
Engraving
Letterforms:
Pine's *Horace*

John Pine (1690–1756) was one of England's foremost engravers. His fully engraved edition of the Latin poet Horace's works was painstaking and costly to produce—a book, that as RBS's director, Michael Suarez, has pointed out, displays its own virtuosity through its richly and meticulously illustrated plates.

A great admirer of fine printing, Pine attempted to improve on contemporary letterpress work in his engraved edition of Horace. Theodore Low De Vinne characterizes the book as a "stinging rebuke to the wretched typography of his time."[6] Although both volumes were fully engraved, Pine had the book's extensive text composed in type first, so that an impression could be transferred to copper plates for engraving, while also leaving ample room for the many headpieces, ornamental initials, vignettes, and tailpieces that distinguished Pine's edition of Horace from other prior productions. Even as these decorative elements were clearly inspired by sources on classical antiquity, the exquisite beauty and brilliancy of Pine's engraved letterforms "struck a new note," according to the type historian

Quinti Horatii Flacci opera. London: John Pine, 1733–1737; *Select Fables of Esop and Other Fabulists.* Birmingham: John Baskerville, 1761.

Daniel Berkeley Updike, and "may have had a good deal to do with the taste for more 'finished' types" toward the end of the eighteenth century.[7] The typographer Beatrice Warde noticed similarities between Pine's calligraphic, engraved letterforms and the type of John Baskerville (1706–1775).[8] Alfred W. Pollard noted that it "is probable" that Baskerville's types—which featured thin upstrokes and thick downstrokes—were influenced by books such as Pine's *Horace*.[9] Indeed, Baskerville praised Pine's *Horace* in a letter written to the bookseller and publisher Robert Dodsley, describing the execution of the engraved letterforms as "neat" but quibbling about the proportion: "The Letter is Suppos'd rais'd, consequently the side next the light is express'd by a very faint Line, its opposite very strong, like the light & Shadow in a picture."[10]

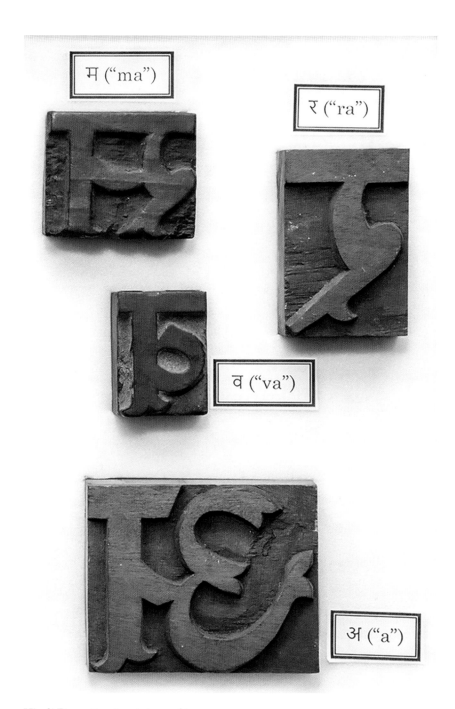

म ("ma")

र ("ra")

व ("va")

अ ("a")

Hindi Devanāgarī script wood type, ca. 1950.

Devanāgarī script (देवनागरी), one of the most widely used writing systems in the world, was developed from the Brahmi script that first appeared circa 3 BCE. It is now used for writing Hindi and many South Asian languages. The mid-twentieth century Devanāgarī wood type in the RBS collection may have been used for printing signage or newspaper headlines. Some of the wood type sorts show traces of make-ready—pieces of paper pasted to their feet to help raise them on the bed of the press in order to produce a clearer impression.

4.17
Devanāgarī Script
Wood Type

Stenciled choir leaf. Ilbenstadt, Germany, ca. 1725.

4.18
18th-Century
Stenciled
Choir Leaf

This choir leaf was stenciled by hand letter by letter. In his blog, past RBS faculty member James Mosley describes how stencils were commonly used during the seventeenth and eighteenth centuries to produce large liturgical books as well as other items, such as playing cards.[11] The use of a stencil is indicated by the presence of broken strokes around the bowls of letters (such as *a*, *b*, *d*, and *o*), caused by the need for the stencil to have bridges to prevent fully enclosed shapes from falling out. Another indication of the use of stencils is the inconsistent baseline of the letters, caused by the imperfect lining up of successive stencils. Stenciled liturgical books were often made in monastic settings,[12] presumably because printing or purchasing color-printed books of this size would have been overly costly and impractical for such communities.

"Irish Gentleman" initial letter sheet. A collection of initials cut from hand-press period books and divided into categories, including factotum, arabesque, grotesque, etc. Compiled into a teaching aid ca. 1985. Donated by Noel Jameson.

Headpiece from John Milton's *Paradise Lost*. London, 1741. Donated by Noel Jameson.

In the 1980s, the Dublin antiquarian bookseller Noel Jameson donated cutouts of decorative initials and headpieces to RBS. The initials were removed from books and pasted into a large scrapbook by an unidentified nineteenth-century collector known in RBS circles simply as the "Irish Gentleman." Terry Belanger organized the initials into a classroom set of nine packets to teach students about the various kinds of decorative initials found in books produced during the hand-press period. Note the identical borders of the factotum initials, which were made using the same woodcut block; the mortised block included an empty central square hole that allowed for the insertion of different individual sorts of metal type, which could be interchanged as needed.

The headpieces, which were cut out from volume one of a 1741 London edition of *Paradise Lost* translated into Latin by Joseph Trapp, appear to have been cast from ornamental woodcuts. If you look closely at the corners of the ornamental headpieces, you can see evidence of the nails used to mount the thin, cast metal plates (termed "dabs" in English; *clichés* or *polytypes* in French) onto wooden blocks, to bring them up to type height—a technique described by James Mosley in his past classes at RBS.

4.19
Decorative
Initials and
Headpieces

Leaf from George Bickham's *The Universal Penman*. London: Bickham (later issues by Henry Overton and Robert Sayer), 1733–1741.

4.20
Round Hand
George Bickham's famous writing book, *The Universal Penman*, was first published in parts in London between 1733 and 1741. It provided models of round hand calligraphy for aspiring scribes to emulate at a time when clear and elegant handwriting was an important skill for many trades. The two hundred plates feature Bickham's engravings of his own work, as well as samples contributed by twenty-two writing masters of the day, including Joseph Champion, who lettered "The Writing Master's Invitation and Instruction."

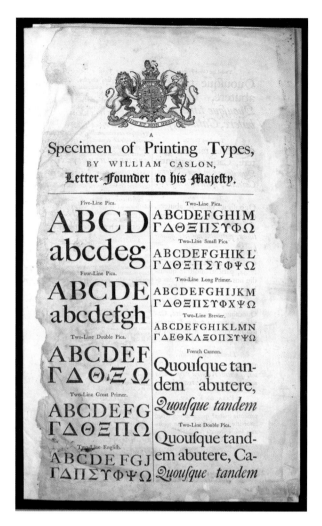

A Specimen of Printing Types by William Caslon, Letter-Founder to His Majesty. London: Caslon, [1786].

The first leaf of this eighteenth-century type specimen issued by the foundry of William Caslon includes larger display faces, while the remaining leaves feature a total of ninety flowers and 114 fonts of varying sizes (Roman and Italic, Greek, Hebrew, Syriac, Arabic, Armenian, Samaritan, Gothic, Coptic, Aethiopic, Etruscan, Saxon, and blackletter). William Caslon (1692–1766) was one of the first major successful type founders in England, a nation which had previously relied on type imported from Dutch foundries. He issued his first type specimen before 1734; this specimen, however, dates from the latter part of the Caslon firm's activities. It was reproduced in E. Chambers's *Cyclopædia* in 1786. The Caslon foundry, managed by Caslon's son, grandson, and their wives (including Elizabeth, the widow of William Caslon II), "brought a greater consistency of style to printing in Great Britain and British North America for nearly fifty years,"[13] until public taste shifted toward the neoclassical typography of Baskerville. There is an adage: "when in doubt, use Caslon."[14] After a lull at the end of the eighteenth century, the type foundry's faces would go on to be revived with great success in the 1840s, 1890s, and the twentieth century.

4.21
A Specimen of Types by William Caslon

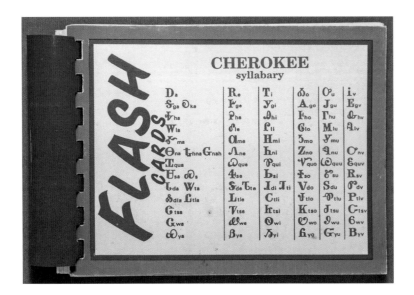

Cherokee Syllabary Flash Cards. Tulsa, OK: Cherokee Language & Culture, 1998.

4.22 Cherokee Syllabary

Sequoyah (ca. 1770–1843) began developing a writing system for the Cherokee language in 1809. He perfected the eighty-six-character Cherokee syllabary by 1821 and then presented it to the Cherokee National Council. Within three years, the easy-to-learn syllabary was widely adopted by members of the Cherokee Nation for reading and writing in manuscript. A few years later, the syllabary was used to create a font of type for printing. These late twentieth-century flash cards attest to the living legacy of Sequoyah's innovation.

Ebony-handled dip pen, ca. 1850.

4.23 19th-Century Ebony-Handled Dip Pen

Dip pens have nibs whose capillary channels readily allow them to be charged with ink, so as to make refilling the pen less frequent. Although they were used in the ancient West, dip pens with metal nibs became increasingly popular in the nineteenth century. This mid-nineteenth-century example, with its ebony handle, has a metal fitting that readily accommodates a gilt J nib made by C. Brandauer and Co. of Birmingham, England. Other fittings and nibs could be attached to the handle to allow for different lines and effects.

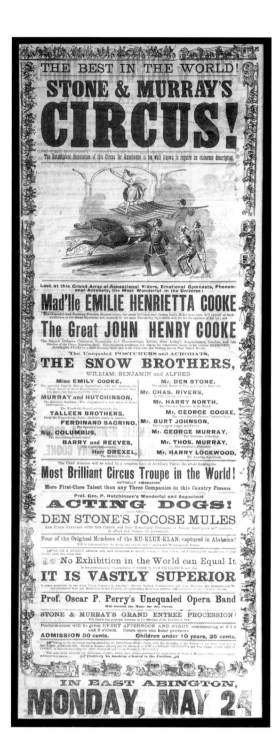

The Best in the World!
Stone & Murray's Circus!
[Philadelphia], ca. 1869.
Gift of Patricia Otto.

Darius Wells (1800–1875) of New York City found the means to mass produce wooden letters in 1827 by using a lateral router. Large metal type was unwieldy, extremely heavy, and difficult to lock into type formes; wood type provided a cheap and durable alternative. Wood type was not generally employed in book printing, as very large types were not needed for printing hand-held volumes. But it was frequently and widely used in display advertising, including large broadsides, playbills, and posters that would be read at a distance, such as this advertisement for Stone & Murray's Circus.

4.24
American
Wood Type

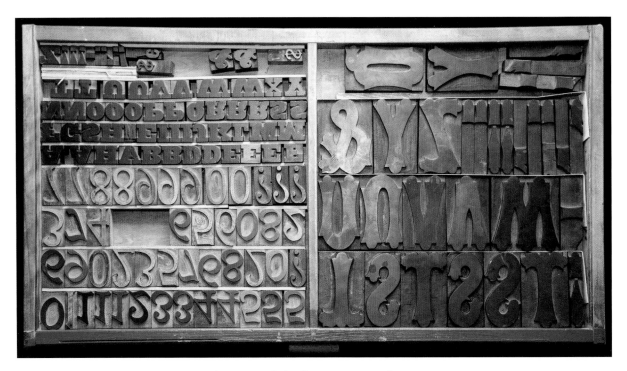

Wood type. [Baltimore], early twentieth century. Gift of Maurice Annenberg.

4.25
Annenberg
Wood Type

These sorts are drawn from a double case containing forty-eight drawers of wood type donated in 1974 to RBS (then the Book Arts Press at Columbia University) by the Baltimore printer Maurice Annenberg (1907–1979). They are often used for printing demonstrations, workshops, and instruction in RBS courses, such as "The History of 19th- and 20th-Century Typography & Printing," taught by Katherine McCanless Ruffin and John Kristensen.

4.26
Wood Type in
Contemporary
Letterpress and
Book Arts

Although the commercial use of wood type declined—and then largely disappeared—in the twentieth century with the advent of photographic printing processes, today it is enjoying a resurgence among book artists and fine-press printers. In 2019, the letterpress printer and artist Amos Kennedy offered a wood-type printing workshop at RBS as part of the School's "Making & Teaching: Printing Technologies at Work" Presswork Symposium. Kennedy produced this poster using RBS's Annenberg wood type, and delivered a keynote lecture that discussed his community-based approach to printing. Kennedy argues that printed posters placed in public spaces are visual, tangible, and even confrontational texts, and that they are a much more powerful means of communication than ephemeral online media.

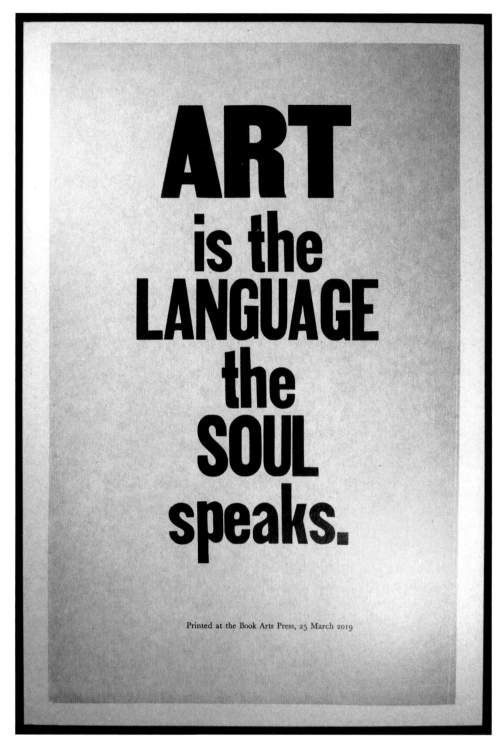

Amos Paul Kennedy Jr. *ART is the LANGUAGE the SOUL speaks*. Poster. Charlottesville: Book Arts Press, 2019.

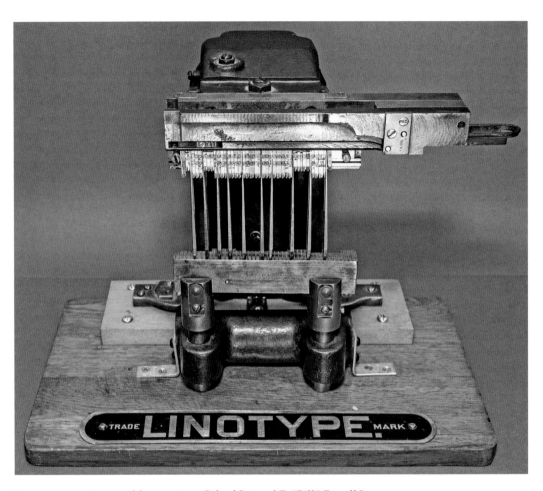

Linotype matrix assembler, ca. 1925. Gift of Samuel F. "Bill" Royall Jr.

4.27

Heart of Linotype

Mechanical typesetting became widespread toward the end of the nineteenth century. In 1884, Ottmar Mergenthaler patented technology that allowed text to be cast line by line instead of letter by letter, and a machine was introduced in the office of the *New-York Tribune* in 1886. RBS's teaching collection includes several internal components of a Linotype machine, thanks to the good offices of Samuel F. ("Bill") Royall Jr (d. 2002), who shared his knowledge about letterpress printing for many years as a volunteer at RBS. In the 1990s, he dismantled his commercial printing firm's then-obsolete Linotype machine, cutting it up into several sections in order to facilitate the demonstration of its various functions. Shown here is the matrix assembler, much more visible than it would be in a complete machine. Usually accompanying the matrix assembler, with its row of matrices ready for casting a line of type, are some loose Linotype matrices, together with the spacers used to separate the words in the line. The brass matrices were put into position for casting by using a keyboard resembling a typewriter on which an operator would type out a text for printing. The text was set into justified lines, with each full line of text then cast in hot metal, creating a solid metal line of type (as the "Linotype" name suggests). The resulting metal "slugs" would have been tied up and placed by hand on the bed of a press for printing. Linotype was primarily used for composing newspapers, magazines, and less expensive books, such as paperbacks.

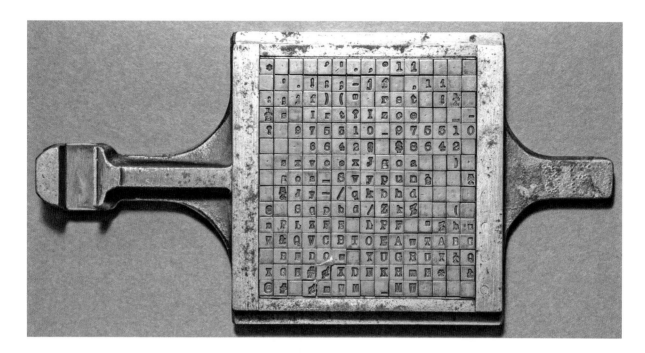

Monotype matrix case produced in Philadelphia by the Lanston Monotype Machine Company, ca. 1920.

Detail from *Specimen Book of 'Monotype' Printing Types.* Vol. 2. London: The Monotype Corporation Limited, ca. 1973.

Tolbert Lanston (1844–1913) invented the Monotype typecasting machine, patented in 1898, which produced individual sorts of type (as opposed to Linotype's lines of type). The machine included a keyboard used to input the desired text and to create a punched paper tape, akin to a player piano roll, as described earlier. The typecaster used the information on the tape to operate a Monotype casting machine, which produced individual sorts of metal type cast from a rectangular array of bronze matrices fixed in a holder called the matrix case. Shown here is a relatively early version of a Monotype matrix case, containing 225 matrices for a font of type presented in fifteen rows and fifteen columns. The arrangement of characters in the matrix case would vary by typeface. This matrix case contains a 10-point font of Typewriter. The letterforms it can produce are shown in this 1973 Monotype specimen book. Monotype was primarily used for book printing and fine press work in contrast to the periodicals and inexpensive, mass-market books printed from Linotype.

4.28
Monotype

Anna Simons. *Titel und Initialen für die Bremer Presse.* Munich: Bremer Presse, 1926.

4.29 Modern Calligraphy and Letterform Design

The German scribe and calligrapher Anna Simons (1871–1951) had to complete her training at the Royal College of Art in London, because, at the time, women were not admitted as full-time students to German arts and crafts schools. She designed titles and initials for many of the fine press books issued by Bremer Presse of Willy Wiegand (1884–1961). Her letterforms, hand drawn and cut in wood, served as the Bremer Presse books' only ornamentation. Simons maintained that calligraphy held an important role in book design: "Hand-drawn initials must be regarded as the chief means for giving an individual note to the typography of a book."[15] Here you see her rounded, interlocking letters designed for Bremer Presse's 1921 Italian-language edition of Dante. Unfortunately, the offices of Bremer Presse in Munich, along with much of Simons's original calligraphic and typographic work, were destroyed by fire during World War II.

Russell Maret. "A Selection of Digital Alphabets Designed by Russell Maret for Printing Letterpress." In *Visionaries and Fanatics and Other Essays on Type Design, Technology, and the Private Press*. Ann Arbor, MI: The Legacy Press, 2021. The type specimen is included only with the hardcover edition of the book.

4.30 Digigraphic Lettering

According to contemporary artist and printer Russell Maret, "digigraphic lettering," or letterforms created via computer software, can be as variable as calligraphy while also affording the precise reproducibility of typography. The digital types designed by Maret and showcased in this printed specimen (including Hybrid II, Peter Sans Italic, Roma Abstract, and Hungry Dutch) are intended to be printed letterpress from a photopolymer plate. They were created by the artist specifically for use in his private press publications.

Amira Hegazy. *Sorehead: A Font Painted by Jesse Howard for His Prophetic and Polemic Signs.* Chicago: Statement Press, 2019.

4.31
Digital Typeface
Design

Directly inspired by the sans-serif gothic style of wood type, Jesse Howard (d. 1983), a Missouri-based, self-taught artist, created distinctive, polemical, and text-laden signs. He became famous in the art world in 1968 after being featured in Gregg Blasdel's article, "The Grassroots Artist," which was published in *Art in America*. Using Adobe Illustrator and Fontself Maker, contemporary artist Amira Hegazy traced individual letters that Howard had hand-painted on signs. Maintaining the artist's irregular punctuation, orthography, and placements, she created a new font dubbed Sorehead. A digital download of Sorehead is available with the purchase of the printed specimen book.

1. "Pen." In *The Grove Encyclopedia of Materials and Techniques in Art*. Ed. Gerald W. R. Ward, 481–482. Oxford: Oxford University Press, 2008.

2. de Hamel, Christopher. *Cutting Up Manuscripts for Pleasure and Profit*. The Sol. M. Malkin Lecture in Bibliography [Rare Book School]. First published in 1995. 3rd printing. Charlottesville: Book Arts Press, 2000.

3. Nelson, R. Stanley. *From Punch to Printing Type: The Art and Craft of Hand Punchcutting and Typefounding*. 1985. 46 minutes. Book Arts Press Video Productions, distributed by RBS. A detailed description of cutting a counterpunch and then a punch by hand, preparing it for use, making a strike and justifying it, and casting type using a hand-held type mould. Featuring Stan Nelson of the Division of Graphic Arts, The National Museum of American History, The Smithsonian Institution. Directed by Peter Herdrich. Available on DVD.

4. Monotype rolls are akin to player piano rolls. Made of paper, the roll contains perforated holes that convey data keyed to specific letters.

5. Philip Gaskell provides a detailed explanation of this process. See Gaskell, *New Introduction to Bibliography*, 10–11.

6. De Vinne, Theodore Low. *A Treatise on Title-Pages, with Numerous Illustrations in Facsimile and Some Observations on the Early and Recent Printing of Books*. New York: The Century Co., 1902, 72.

7. Updike, Daniel Berkeley. *Printing Types: Their History, Forms, and Use*. Vol. 2. Cambridge: Harvard University Press, 1922, 138.

8. Clayton, Ewan. "John Baskerville the Writing Master: Calligraphy and Type in the Seventeenth and Eighteenth Centuries." In *John Baskerville: Art and Industry of the Enlightenment*. Eds. Caroline Archer-Parré and Malcolm Dick, 116. Liverpool: Liverpool University Press, 2017.

9. Pollard, Alfred W. *Fine Books*. New York: G. P. Putnam's Sons, 1912, 300.

10. Letter from John Baskerville to Robert Dodsley dated 19 October 1752. *The Correspondence of Robert Dodsley, 1733–1764*. Ed. James E. Tierney. 1988. Cambridge: Cambridge University Press, 2004, 146.

11. Mosley, James. "*Lettres à jour:* Public Stencil Lettering in France." *Typefoundry: Documents for the History of Type and Letterforms*. 23 March 2010: <https://typefoundry.blogspot.com/2010/03/lettres-jour-public-stencil-lettering.html>; accessed 12 February 2022.

12. See Hindman, Sandra. "Choir Book" (Gradual): <https://www.textmanuscripts.com/medieval/gradual-choir-book-141593>; accessed 8 March 2022.

13. Mosley, James. *A Specimen of Printing Types by William Caslon, London 1766. A Facsimile with an Introduction and Notes by James Mosley*. London: Printing Historical Society, 1983, 3.

14. Dowding, Geoffrey. *An Introduction to the History of Printing Types: An Illustrated Summary of the Main Stages in the Development of Type Design from 1440 Up to the Present Day; an Aid to Type Face Identification*. London; New Castle, DE: The British Library & Oak Knoll Press, 1998, 63. First published in 1961 by Wace and Co., London.

15. Simons, Anna. "Lettering in Book Production." In *Lettering of To-day*. London; New York: The Studio Limited; Studio Publications, 1937, 57–89, 61.

RBS students Kara M. McClurken (Director, Preservation Services, University of Virginia Library) and Barbara Heritage examine a woodblock in the course "The History and Culture of the Tibetan Book," co-taught by Benjamin J. Nourse and Kurtis Schaeffer. Photograph by Shane Lin, 2018.

V. PRINTING SURFACES

Substrates, formats, and letterforms are all elements of the physical book that readers can see and touch. What cannot be so readily seen in books are the various kinds of equipment used to make them: for example, the blocks, plates, and stones that, when inked, transmit texts and images via relief, intaglio, or planographic processes onto a substrate. Relief printing surfaces—such as an individual sort of printing type or a carved woodblock—bear three-dimensional texts and images that, when printed, press into substrates. Intaglio printing surfaces—such as an engraved copper plate—carry texts and images incised into their surfaces that, when pulled though a press, sit on top of substrates. Planographic printing surfaces—such as lithographic stones—transfer texts and images from their flat planes onto the faces of substrates, and thus lack the dimensionality of relief and intaglio printing. Stencils, on the other hand, allow one to ink through a cut-out surface. Other methods, such as inkjet and photography, entail no traditional printing surfaces (e.g., blocks, plates, stones) at all.

These distinct printing technologies vary in terms of the time, cost, equipment, and labor that they require—and some of these processes are easier to replicate than others. Each technology leaves its own discernible traces, providing information not only about how and when books were printed, but also about the different communities who made them.

**5.1
Illustration
Toolkits**

A variety of tools were used to create relief and intaglio printing surfaces in Western books during the handpress period. This illustration "toolkit" is one of a seven identical sets used in RBS courses. It includes an assortment of woodblocks, metal plates, and hand-held instruments integral to various illustrations processes.

The kit contains a piece of cherry plank used for making woodcuts, which were prepared with small knives and gouges—a practice that began in Europe around 1400 but that was first developed in East Asia during the late 600s.[1] Block cutters worked in relief, leaving the top surface of the original block intact only in areas where a design was intended for printing.

Copper plates came into use later in the fifteenth century in the West for making intaglio illustrations. The image intended for printing was incised into the plate, which was engraved with burins that had a sharpened, lozenge-shaped or triangular point that removed the metal from the plate in V-shaped trenches. The plate was heated, inked, and wiped, with only the remaining ink in the plate's grooves transferred to paper when printed.

Etching, a new form of intaglio illustration, was developed around 1500 as illustrators sought for a faster, less laborious process.[2] Etchers covered the surface of their plates with a quick-drying, acid-resistant "ground," usually a paste of lead white mixed with linseed oil or wax,[3] and then used tools akin to this modern-day etching needle to incise images through the coating into the plate, so as to expose the bare metal. They then submerged the plate into a bath of acid, which ate into the uncoated areas of the copper plate, creating lines below the plate's surface that varied in width and depth according to the time the plate was left in the acid. The lines of the resulting image, when printed, showed the effects of the acid's "bite"; deeper bites resulted in darker lines and effects. The comparative ease of etching as opposed to engraving readily allowed for a greater freedom of line and variety in line depth, including more varied contrasts in terms of

tone. Other tools, such as this roulette used for stippling, could create patterns through the ground that were spread over larger areas. This technique became popular only in the mid-eighteenth century and onward.

Alternatively, the surface of the copper plate itself could be roughened to create a raised surface that would retain ink. Beginning in the mid-seventeenth century, mezzotints were created by systematically and repeatedly pitting the surface of a copper plate, so as to raise fragile burrs of metal over its entire surface. The use of a mezzotint rocker like the modern one shown here enabled the process. The burrs on the roughened surface retained ink that, when printed, resulted in a rich, velvety black. Tonal images were created by leveling down and removing these burrs with scrapers, creating tones in grey; burnishers could be used to polish the copper entirely, which resulted in pale grey, almost white, highlights in print.

Drypoint, an intaglio method, used a tool with a needle-like point that, when pressed and drawn directly on the plate, lifted the metal without removing it—the resulting burr creating a scratched effect when printed. The fragility of the drypoint burr allowed only a small number of good impressions to be made from a plate.

The woodblocks and metal plates in the kit vary in terms of their thickness—a visible contrast that is suggestive of the varying methods and labor required to make an impression from them. Relief and intaglio processes required different printing equipment, as well as related, but distinct, skill sets. During the hand-press period, intaglio prints were made on rolling presses, as opposed to wooden platen presses (often referred to as "common" presses). Rolling and platen presses were typically owned by different printing houses located apart from one another. Woodblock printing was generally a more economical method, as it allowed illustrations (in the form of type-high blocks) and movable type to be printed simultaneously on the same press, whereas engraving text on metal plates was time consuming and the copper more costly. Because intaglio illustrations were produced apart from letterpress text and on different paper, they were frequently sewn or tipped into printed books. Fully engraved books were generally more uncommon, except in certain cases, such as music, numismatics, emblem books, and other heavily illustrated genres produced during the handpress period. Although relief processes were generally less expensive in terms of cost, intaglio processes produced finer lines and more detailed images that were difficult, if not impossible, to achieve using woodcuts.

Woodblock printing was revived toward the end of the eighteenth century with wood engraving, which was accomplished by engraving on the endgrain of wood. (RBS's kit includes a composite block of endgrain maple showing how pieces of endgrain wood were glued together to form larger blocks.) Wood-engraved illustrations were created using a fine-pointed graver—a modified form of the burin typically used for intaglio engraving. This relief process combined the best of both worlds: wood engraving offered a more nuanced range of tone than was possible with the usual woodcut, and these relief blocks could be printed alongside movable type on platen presses. In the nineteenth century, additional developments in intaglio printing followed—including steel engraving and zinc etching.

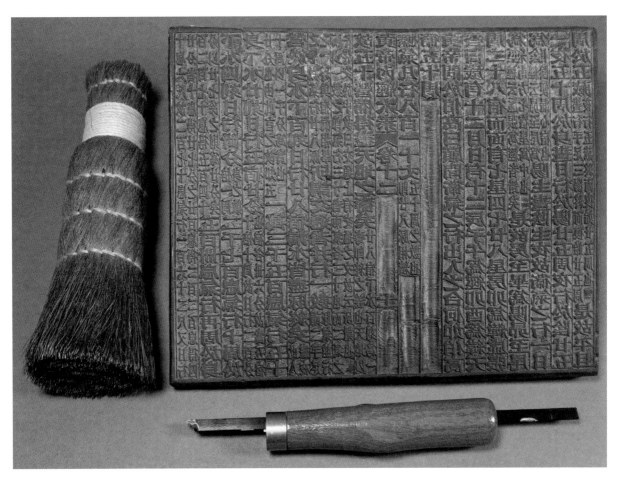

From a box of block-cutting, printing, and ink-squeeze rubbing tools: a knife for woodcuts (拳刀) and a round coir inking brush (圓墨刷); together with a Qing dynasty textual woodblock for a traditional medical text. *Huangdi neijing taisu* (黃帝內經太素). Double-sided original woodblock (*juan* 12, folios 11 and 12), 17.8 × 24.8 cm., eighteen columns of twenty-five characters. Late-nineteenth century. Gift of Xia Wei and Soren Edgren.

5.2
Qing Dynasty
Woodblock
and Tools

Invented circa 700, woodblock printing was the dominant form of printing in China until the end of the nineteenth century. This double-sided woodblock was used to print a classic medical text: *Huangdi neijing taisu* (黃帝內經太素), or *The Grand Basis of the Yellow Emperor's Inner Canon*. Woodblocks were commonly made from planks of jujube or pear wood—jujube being the higher quality and more expensive of the two. Block-cutters made characters and images by hand with knives such as the modern tool shown here. Printers used round coir brushes, also shown, to ink the relief letterforms on the blocks for printing. They would then pull a piece of paper tightly over the block and use a rectangular brush, or print burnisher, to make an impression. The paper would be peeled off the block to dry.

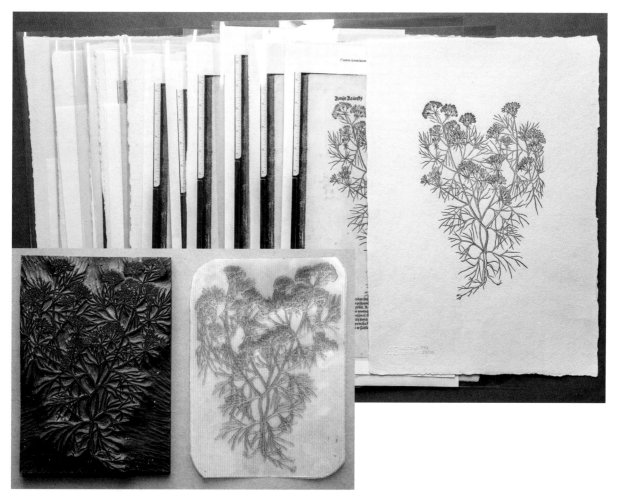

Georgio Liberale and Wolfgang Meyerpeck. Woodcut block illustrating cumin made for Pietro Andrea Mattioli's *De materia medica*. Prague, 1562. Gift of Virginia Gardner; Mattioli restrike polymer plate, 2018. Top: RBS Illustration Packet 89 L 05a, "Virginia Gardner Mattioli restrikes."

RBS's original woodcut block of cumin is a teaching powerhouse used in fourteen different classes. It comes from a set of large botanical woodcut blocks designed by Georgio Liberale and Wolfgang Meyerpeck for use in an herbal, *De materia medica*, originally written in late antiquity by the Greek physician Dioscorides and then later published in the sixteenth century with a commentary written by Pietro Andrea Mattioli (1501–1577). The illustrated text with Mattioli's commentary was first published in Prague in 1562 and then in a Latin edition printed in Venice in 1565. In the early sixteenth century, the woodcut was the primary illustration process for books in Europe, although it was generally superseded by intaglio copper engravings for upmarket work in the seventeenth century. The excellent Mattioli woodcut blocks were used as late as the eighteenth century in Henri Louis Duhamel du Monceau's *Traité des Arbres et Arbustes* (1755). Many of the 110 surviving Mattioli blocks, including the RBS block, bear manuscript labels in the hand of Duhamel. The block was given to the School by Virginia Gardner, a collector and antiquarian book dealer, who also furnished RBS with a teaching set of restrike prints of the block produced in the late 1980s by Alecto Historical

5.3
Botanical
Woodblock
Illustration in
Early Modern
Europe

Editions. In 2018, RBS staff scanned a restrike print of the block and used the resulting image to create a photopolymer plate, now used to teach students about the techniques of forgery and facsimiles in the antiquarian book trade in a course taught by RBS faculty member Nick Wilding.

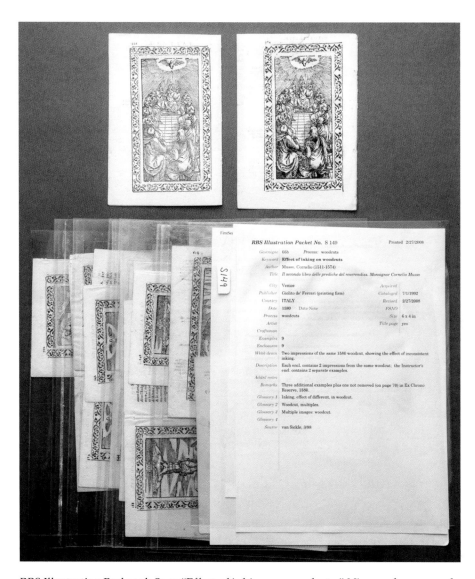

RBS Illustration Packet 5b S149 "Effect of inking on woodcuts." Nine enclosures each containing two specimens from *Il secondo libro delle prediche del reverendiss. Monsignor Cornelio Musso*. Venice: Giolito de' Ferrari, 1580. Packet created by Terry Belanger in Charlottesville, 1992.

5.4
The Effect
of Inking on
Woodcuts

This illustration packet is one of hundreds that were created for hands-on use in RBS courses. Each packet typically contains thirteen original specimens of a particular process (e.g., illustration, papermaking, typography, etc.), often taken from broken or defective books purchased by or donated to the School. Every illustration packet is intended to illustrate a specific technology or technique pertaining to the history of illustration processes as described in Bamber Gascoigne's *How to*

Identify Prints. This packet, 5b S149 "Effect of inking on woodcuts," corresponds to entry 5b in Gascoigne, which discusses sixteenth-century developments in the production of European woodcuts. This packet is meant to provide additional context for how woodcuts were printed, and it contains disbound, conjugate (i.e., joined) leaves from the second book of sermons of Monsignor Cornelio Musso, printed in Venice by the firm of Giolito de' Ferrari in 1580 paired with leaves from a later production that uses the same woodblocks. Each enclosure in the packet contains not one but two impressions of the same woodcut illustration to show how differences in inking and printing on the common press affected the look of the printed page—as these examples readily show. Although wear to woodblocks over time can also alter the appearance of illustrations, here the heavy use of ink is evident both on the illustrated page and in the letterpress text.

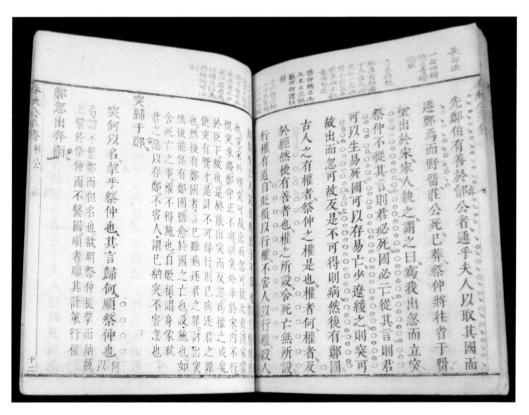

Chunqiu Gongyang zhuan (春秋公羊傳) [*Gongyang Commentary on the Spring and Autumn Annals*]. Huzhou: Min Qiji, 1621. Gift of Xia Wei and Soren Edgren.

5.5 Ming-Era Three-Color Printing

Printing in two colors (red and black) began in China during the mid-Yuan period (1271–1368). But multicolor printing with three or more colors became popular only during the late Ming dynasty (1368–1644). Min Qiji (閔齊伋) was from one of two lineages of publishers who specialized in color printing during this time. Min Qiji published this copy of the *Gongyang Commentary on the Spring and Autumn Annals* (春秋公羊傳) in Huzhou in 1621. The text is printed in black, with blue and red used for punctuation and for marginal and interlinear notes via the *taoban* multiblock technique; separate blocks were cut to print each color.

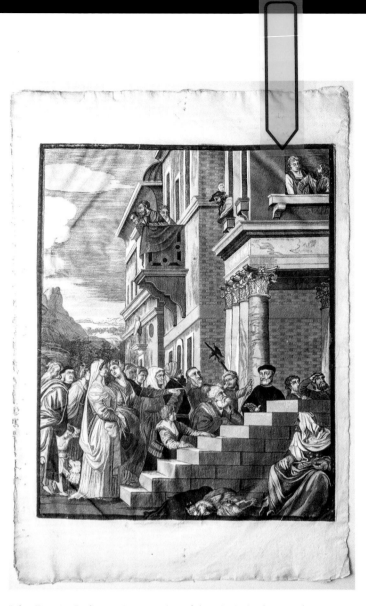

John Baptist Jackson. *Presentation of the Virgin in the Temple*. Venice:

5.6
Chiaroscuro and
Its Revival

In Europe, the first book illustrations printed in color began to be made in the late fifteenth century. Bright colors were inked separately on their own blocks and then printed side by side, as with Erwin Ratdolt's edition of *Passau Missal* (1498). But another technique was emerging. Resembling Renaissance wash drawings, *chiaroscuro* ("light-dark") prints were created from two or more blocks in which the color block (or blocks) provided tone. Areas cut from the tone blocks provided highlights by allowing the color of the paper to show through. The colors used for the process usually were of similar subdued tones, and further nuances in shading were created by allowing these colors to overlap. The earliest chiaroscuro woodcuts date from the first quarter of the sixteenth century, when the process was initially developed by Lucas Cranach the Elder in Wittenberg and then by Ugo da Carpi in Venice. Lighter tone blocks, cut to reveal white highlights, were usually printed first with a dark line block printed last. The highly specialized process required careful registration, and so chiaroscuro prints were created only in small numbers—one of the reasons they remain both valuable and scarce today.[4]

J. Baptist Pasquali, 1742. Each sheet is 28.25 in. tall by 20 in. wide.

The process was later revived in the eighteenth century, and these two prints, created by John Baptist Jackson (1701–1780), are fine examples of the technique as it was later practiced. While earlier chiaroscuros imitated drawings, Jackson attempted to emulate oil paintings. Titled *Presentation of the Virgin in the Temple*, these two prints are the right and center sheets of a large triptych that dates from 1742 and that Jackson cut after a painting by Titian. The triptych itself is part of a series of twenty-four chiaroscuro woodcuts made by Jackson after the works of Venetian master painters. This set of prints required four blocks, which were used to print four colors: light greyish umber, medium brown, dark grey, and dark brown. Detail from the right plate is reproduced in Bamber Gascoigne's *How to Identify Prints* (21b, Plate 80). RBS faculty member Terry Belanger displays the book and original prints side by side to demonstrate how photographic processes sometimes drastically alter the appearance of illustration processes, and how reproductions also have difficulty capturing subtle aspects of printed color, as well as the three-dimensionality of printed surfaces—important qualities apparent in this stunning original example.

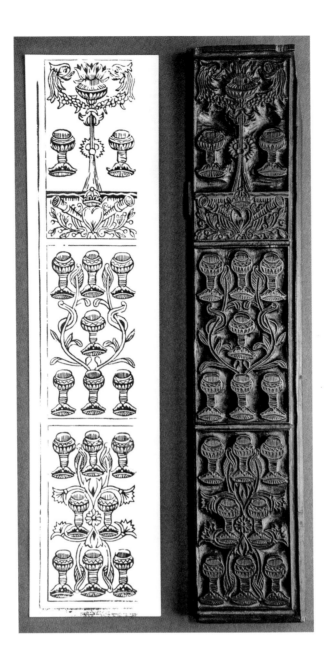

Woodcut block of three tarot cards. [France?], ca. 1700.

5.7
18th-Century
Woodcut of Tarot
Cards

In Europe, woodcut was the main illustration technique used for printing ephemera, such as playing cards, broadsides, and labels, before the advent of chromolithography in the nineteenth century. This woodcut block of three tarot cards—the Two of Cups, the Six of Cups, and the Eight of Cups—was produced in a style reminiscent of the Tarot de Marseille, an early modern seventy-eight-card deck popular in France. The block, which has long been in the RBS teaching collections, has a complex history. It was possibly part of a much larger block, depicting many more cards. At some point after the large block was no longer used for printing, it was repurposed as a cabinet door; traces of where the hinges were mounted are evident on one of the long edges of the block. For reasons unknown, the door was eventually removed from the cabinet and sawn into our strips, one of which appeared in a flea market in the 1990s. The block was proofed on a Vandercook press by RBS volunteer Samuel F. "Bill" Royall.

Jean-Michel Papillon. Thirteen proof impressions of woodcuts or wood engravings made for an almanac (*Étrennes spirituelles dédié[es] a M. Le Dauphin*). [Paris], 1733. Purchased with funds provided by the B. H. Breslauer Foundation and with funds donated by Terry Belanger.

These relief proof impressions, intended for inclusion in an eighteenth-century almanac, were cut, printed, assembled, and then labeled in manuscript by Jean-Michel Papillon (1698–1776), an esteemed French woodcut artist and printer, whose *Traité historique et pratique de la gravure en bois* (1766) was a well-known manual on how to prepare relief woodcuts. In his treatise, Papillon derided Dutch engravers of his day who claimed to have used a burin—usually used applied to metal—to engrave the endgrain of wood. Yet the proofs shown here may offer a more nuanced view of this history. In 2017, RBS acquired the proofs from Nina Musinsky, an antiquarian bookseller, who, in consultation with Terry Belanger and Barbara Heritage, suspected that they may, in fact, be examples of Papillon's own experimentation with endgrain wood engraving—several decades before the technique was popularly revived by Thomas Bewick in England. Thanks to RBS faculty member Roger Gaskell, who uses the proofs in his course, "The Illustrated Scientific Book to 1800" (co-taught by Caroline Duroselle-Melish), RBS was also able to acquire the 1730 *Petit almanach de Paris*, in which five of the proof cuts appear. Gaskell believes that the proofs are extremely fine woodcuts rather than wood engravings. Regardless of the technique Papillon used, these illustrations are a testament to his virtuosity in cutting the block and to his skill as a printer.

5.8
Virtuoso
Woodcuts or
Early Examples of
Wood Engraving?

Original woodblock of a horse race attributed to Thomas Bewick. [Newcastle], ca. 1800. Purchased with funds donated by Florence Fearrington through the good offices of Terry Belanger.

5.9 Thomas Bewick's Wood-Engraving Method

In the late eighteenth century, Thomas Bewick (1753–1828) revived the technique of working the endgrain cut of woodblocks, rather than the side-grain (plank) block, using his own version of the burin more typically used for copper engraving. This technique allowed for a much higher level of detail than was possible with woodcuts. Endgrain wood-engraved blocks were cheaper to produce than copper engravings, and, unlike intaglio plates, they could be printed along with accompanying type on a relief printing press using just a single impression. The proliferation of wood engraving in the nineteenth century led to a dramatic increase in the number of illustrated books and magazines. This small block depicting a horse race, possibly cut by Bewick or perhaps by someone in his workshop, exemplifies his small, finely executed vignettes. RBS's teaching collections include several books illustrated by Bewick, as well as this illustration packet, which was created from a disbound 1823 copy of Aesop's *Fables*, containing headpieces and vignettes by the noted wood engraver. The packet includes an example of Bewick's famous mark: an engraving of his thumbprint.

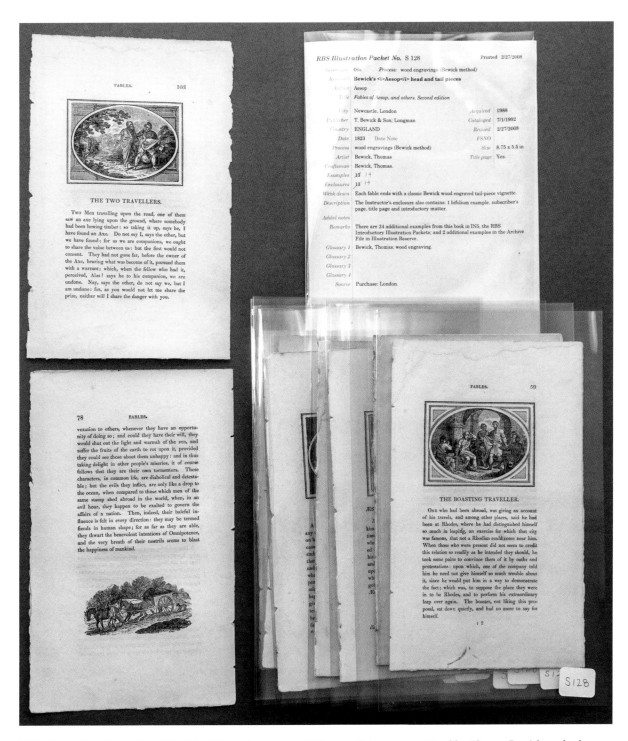

RBS Illustration Packet S 128 6a: *The Fables of Aesop, and Others, with Designs on Wood by Thomas Bewick.* 2nd ed. Newcastle; London: E. Walker for T. Bewick and Son; Longman and Co., 1823.

Katsushika Hokusai. *Hokusai manga* (北斎漫画). Vol. 2. Nagoya: Eirakuya Tōshirō, [1814 (Bunka 11)–1878 (Meiji 11)]. Gift of Vincent Golden.

5.10
Three-Color Woodblock Printing in Edo and Meiji Japan

The series *Hokusai manga* reproduces original drawings by the famed artist Katsushika Hokusai (1760–1849); the drawings were collected by his students and reproduced in a series of fourteen volumes from 1814 to 1878. Although the word *manga* now refers to the Japanese equivalent of comic books, at the time it denoted a drawing manual or copybook that set out a range of images for the use of students training to be painters. The original blocks would have been made from cherry wood. Each color in the final image required inking on separate blocks; if different colors could be applied in small, discrete areas on one block, more than one color could be printed at once.

It can be difficult to distinguish between editions of woodblock-printed books. To identify any precise edition or printing of *Hokusai manga*, one would need to compare as many copies as possible, looking for changes, as well as potential damage, to the woodblocks. The images in RBS's copy appear worn and fuzzy, but this could be owing to haphazard inking and printing or to unsized paper rather than wear to the surface of the blocks.

Tsangnyön Heruka (*Gtsang smyon he ru ka*, གཙང་སྨྱོན་ཧེ་རུ་ཀ). *The Life of Milarepa* (*Rnal 'byor gyi dbang phyug dam pa rje btsun mi la ras pa'i rnam thar thar pa dang thams cad mkhyen pa'i lam ston*, རྣལ་འབྱོར་གྱི་དབང་ཕྱུག་དམ་པ་རྗེ་བཙུན་མི་ལ་རས་པའི་རྣམ་ཐར་ ཐར་པ་དང་ཐམས་ཅད་མཁྱེན་པའི་ལམ་སྟོན). [Püntsok Chöding Ling (*phun tshogs chos lding gling*), ca. 1700–1900.]

Woodblock printing continued to persist in Asia through the nineteenth century. This *pecha* contains *The Life of Milarepa* (Tib. *Mi la ras pa'i rnam thar*, མི་ལ་རས་པའི་རྣམ་ཐར), a biography originally composed by Tsangnyön Heruka circa 1488. Widely republished over the course of centuries, it remains among the most popular pieces of Tibetan literature in print today. The biography tells the story of Jetsun Milarepa (1028/40–1111/23), a yogi who achieved enlightenment in one lifetime after renouncing and overcoming many misdeeds he committed early in life. The book opens with woodcut images that pay homage to the historical lineage masters who transmitted Buddhist teachings to Milarepa: from Tilopa to Naropa, and then Marpa to Milarepa. Milarepa himself is depicted as he usually appears—with a hand cupped to his ear.

5.11

A *Pecha* Printed in a Monastery

According to RBS faculty member Benjamin J. Nourse, this edition, which is undated, was likely cut in Mongolia in the eighteenth or nineteenth century, given the stylistic presentation of the text, as well as the various individuals mentioned in the book's colophon. (The first known Mongolian translation of the text dates from 1618.) Nourse and our consultant, Geshe Ngawang Sonam, a Buddhist scholar-monk who serves as a translator for His Holiness the Dalai Lama, both agree that the text was likely produced at the monastery where the book's colophon was written: Püntsok Chöding Ling (Tib. *phun tshogs chos lding gling*). According to Nourse and Sonam, the monastery where a colophon was written is usually the same place as a book's production.[5]

Wood-engraved block used to print Rudolph Erich Raspe's *Aventures du baron de Münchhausen*. Traduction nouvelle par Théophile Gautier Fils. Illustrées par Gustave Doré. Paris: Furne, Jouvet et Cie, éditeurs, [1866]. Purchased in part with funds donated by Terry Belanger.

5.12
Chalked
Wood Engraving

Gustave Doré (1832–1883) was one of the most prolific and successful book illustrators of the nineteenth century. Although the bulk of his illustrations were reproduced via wood engraving, Doré himself was not trained in the technique. Instead, he drew his illustrations directly on the endgrain woodblocks using gouache and wash before handing them over to wood engravers. This wood-engraved block was used to illustrate a version of Rudolph Erich Raspe's eighteenth-century English picaresque novel, *Baron Munchausen's Narrative of His Marvellous Travels and Campaigns in Russia*, translated into French by the son of Doré's friend, Théophile Gautier. Both the text and images of the book were stereotyped by the Crété firm. The block in RBS's collection was covered in white chalk when the School acquired it. The chalking would have been done after the block had served its printing purposes, probably by a later collector, in order to show its design more clearly. If the chalk is not washed off promptly, it hardens and becomes difficult to remove, and the block can no longer be printed effectively: it becomes an artifact of printing history.

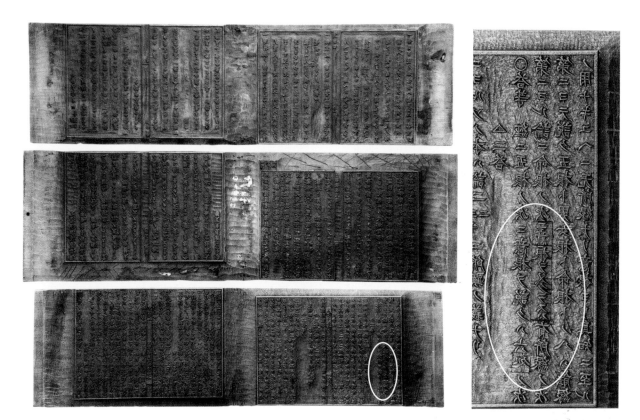

Block 2, Japanese Woodblocks. Housen Yotsutsuji. *Lecture on the Seventy-Five Dharmas* (*Shichijūgo hō myōmoku kūgi*, 七十五法名目講義), [1885]. Folios: 65–68 of vol. five.

This double-sided block is among the many created for the fifth volume of Housen Yotsutsuji's *Lecture on the Seventy-Five Dharmas* (*Shichijūgo hō myōmoku kūgi*, 七十五法名目講義), published in 1885.[6] Printing in Japan did not entail the use of a press, as it did in the West. Instead, carved blocks were given to a printer (*surishi*), who inked the block, laid a sheet of paper on it, and rubbed the paper with a disc-shaped, hand-held tool called a *baren* to take an impression. The third- and fourth-most columns from the right-hand side of the lowest block have been corrected (circled). That the text here was edited—and cut out of the block and replaced with pieces of wood with new characters—is apparent not only in the visible replacement of wood, but also in the irregular alignment of the printed characters.

5.13
Corrected
Japanese
Woodblock
(七十五法名目講義)

Thomas Teller. *Stories about the Elephant, Told by a Father to His Son.* New Haven, CT: S. Babcock, n.d. [ca. 1845 based on an internal date from an advertisement].

5.14
Stories about the
Elephant:
Wood Engraving
and Stereotyping

In 2004, RBS acquired this set of wood-engraved blocks on eBay, one of the School's main sources for obtaining printing surfaces, which are not generally sold as such in the antiquarian book trade. The blocks were unmarked and without any stamping, writing, or labels indicating their origin. Yet a residue of what appeared to be plaster of Paris remained within some of the deeper grooves of the blocks, offering a clue about their history.

Stereotyping is a process that was practiced as early as the seventeenth and eighteenth centuries. The name comes from the Greek words *stereos* ("fixed") and *typos* ("form"). Stereotyping originally entailed applying plaster onto a relief printing surface to make a cast of the image. Type metal was then poured into the resulting mould to create a solid, relief printing plate that effectively replicated the original image from which it was cast. This plaster-based process was time consuming. In the 1830s, a faster process was introduced: dampened papier-mâché was beaten onto the relief surface to form a "flong," which, when dry and hard, was then filled with type metal to create a plate.

Eleven wood-engraved blocks of elephants.

The blocks are all small, and they all depict elephants (including some at play)—details that indicated to us that they were created for a nineteenth-century children's book. By searching for children's books with "elephants" in the title that had been produced during the 1830s, '40s, or '50s, we quickly found the book in question: Thomas Teller's *Stories about the Elephant, Told by a Father to His Son*, published circa 1845 in New Haven, Connecticut. The little volume, which was bound in illustrated, blue paper wrappers, survives in very few numbers, owing to the manner in which children usual "read" and consume their books! The first edition, published in 1831, is held by only three libraries listed in WorldCat. Our later edition is one of ten known surviving copies. Fortunately, a copy was on the market when we made our search in 2004—and both the book and its original wood-engraved blocks were united after more than 150 years.

G. G. Green. *Green's Atlas and Diary Almanac*. Woodbury, NJ: G. G. Green, 1881; Smith Brothers. Nineteen-section wood-engraved block. Commissioned by G. G. Green of Woodbury, NJ.

5.15
Nineteen-Section
Wood-Engraved
Block with
Evidence of
Electrotyping

This wood-engraved block was used as the border for the color-printed cover of a late-nineteenth-century American almanac. Made at the order of publishers G. G. Green of Woodbury, New Jersey, the relief block was cut by Smith Brothers of Philadelphia, as can be seen by examining the lower right-hand corner of the block. The almanac was printed by McCalla & Stavely, a reputable printing firm also located in Philadelphia. The block is a composite of nineteen different pieces of endgrain wood. Endgrain wood is necessarily smaller than plank—and therefore, the pieces needed to be joined in some fashion to create a larger printing surface. A careful inspection of the back of the block reveals the smaller individual pieces that constitute it. Industrial-grade metal staples join each outer block to its neighbors. The inner blocks are presumably held together by the pressure of the outer blocks and perhaps also with an adhesive glue of some kind.

It is doubtful, however, that this block ever spent much time on the bed of a printing press. Its surface is covered in graphite, which indicates that an electrotype plate was made from the block. Electrotyping, a process that was developed in 1838 by the Prussian scientist Moritz von Jacobi, reproduced the surface of a plate in the following way: wax was used to take an impression of the relief printing surface. According to nineteenth-century electrotyping manuals, in advance of making a waxen mould, workers applied graphite with a soft brush to both the waxen case (to prevent the warmed wax from spreading) and to the relief printing surface, to prevent the wax from adhering to it.[7] Once an impression was taken, workers then applied graphite, as well as a preliminary coating of copper sulfate, to the waxen mould to render its surface conducive to electricity.[8] The resulting graphite- and copper-coated waxen mould was then submerged into an acid bath containing a sheet of copper, and, over time, the waxen cast thoroughly coated in copper via electrolysis as a current from a battery was run through the bath. The resulting relief copper shell formed the surface of

a new durable printing plate; after being removed from the wax, its back was filled with lead alloy (a mixture of lead, tin, and antimony) to strengthen the shell and to prevent the copper from bending or buckling. The thin plate was then mounted to a wooden block using nails to make the whole type high for printing.

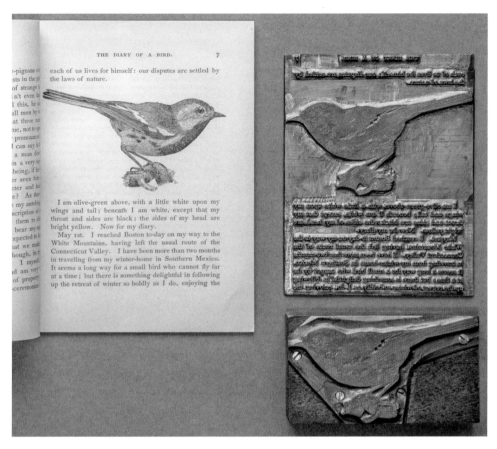

H. D. Minot. *The Diary of a Bird Freely Translated into Human Language*. Boston: A. Williams, 1880; accompanied by electrotype blocks and stereotypes plates. Gift of the Massachusetts Historical Society through the good offices of Jeremy Dibbell.

5.16 Stereotypes from Electrotypes: *The Diary of a Bird* (1880)

Stereotype printing persisted after the invention of electrotyping, as this set of late-nineteenth-century plates and blocks readily shows. Although electrotypes were harder wearing and more capable of rendering fine detail than stereotypes, stereotype plates were still easier to make—and thus likely more practical for this particular publication: Henry Davis Minot's *The Diary of a Bird Freely Translated into Human Language*, an "entertaining" piece of "bird-gossip"[9] written from the perspective of the black-throated green warbler depicted on the book's cover. The narrative advocates for more stringent legislation to protect game birds, waterfowl, and other classes of birds. Minot (1859–1890) was a passionate amateur ornithologist, and he (or his family) likely funded the publication of the book. Before writing *The Diary of a Bird*, Minot authored a lengthy, illustrated book on the land and game birds of New England just a year after beginning his studies at Harvard College (which he soon abandoned in favor of a career in managing and investing in railroads).[10]

Two woodcuts were made for *The Diary of a Bird*: one of the warblers mentioned and another of an owl. These were electrotyped in Boston by the Photo-Electrotype Company, whose name appears blind stamped on the sides of both blocks (along with an 18 May 1875 patent date). Each of these electrotype blocks would have been positioned alongside composed metal printing type for their respective pages in the book. A mould was then made from either a flong or plaster of Paris, and workmen poured type metal into the mould, making a stereotype plate for each page. If you look closely at the surface of the stereotype plates, you can see the residual impressions of the nails used to affix the copper shells of the electrotypes to their wooden bases that were inadvertently captured as part of the stereotyping process.

It appears that the blocks and plates were retained by Minot, who paid the Boston printing firm of Alfred Mudge and Son to print "100 more cards" of the warbler electrotype, as we learn from reading the wrapper that once enclosed the block. The additional cards were made perhaps as keepsakes or as promotional material to accompany the book, which sold for 25 cents. Single copies could be mailed to purchasers by A. Williams & Co. for an additional "nine three-cent stamps."

5.17
Electrotype
Plates for
Lola Ridge's
*The Ghetto and
Other Poems* (1918)

RBS's teaching collection includes an entire set of the electrotype plates used to print Lola Ridge's first published work, *The Ghetto and Other Poems* (1918). Born in Ireland, Ridge (1873–1941) immigrated first to New Zealand and then to the United States, where she became a prominent avant-garde Modernist poet. Her close friends included poets Hart Crane, Marianne Moore, Jean Toomer, and William Carlos Williams. *The Ghetto*, which describes the lives of Jewish immigrants in New York City's Lower East Side, was published by the New York firm of B. W. Huebsch, who had brought out the work of D. H. Lawrence and James Joyce prior to Ridge's work. Ridge's poetry has been described as "the nearest prototype in her time of the proletarian poet of class conflict, voicing social protest or revolutionary idealism."[11] But the socialist ideals that defined her work also contributed to its neglect, owing to the historical erasure of women who expressed dissident political opinions.[12]

The electrotype printing plates for *The Ghetto* are still housed in their original wooden boxes in the order in which we believe they were stored by the printer. The plates were electrotyped from individual, hand-set, page-long arrangements of type—a technical process described earlier in this chapter.[13] These particular plates are especially useful for teaching, as they readily show both the copper printing surfaces that resulted from the electrotype process and also the lead-based metal used to fill in the backs of the copper shells that were routed out to make them well below type high. The plates appear to have been made for an early—if not the very first—printing of *The Ghetto*, as they bear repairs that correlate to corrections listed in the erratum sheet tipped into this uncorrected first edition. Pages 34 and 35 exhibit two substantive revisions. On page 34, the first line of the fourth stanza, "She—diffused like a brown beetle—" was corrected to

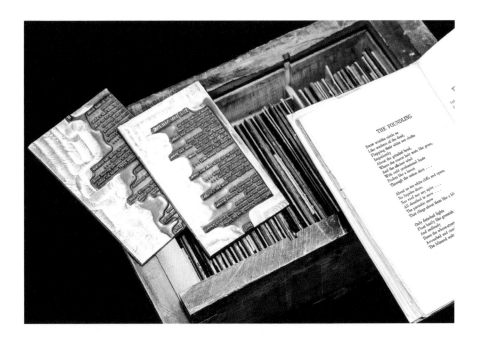

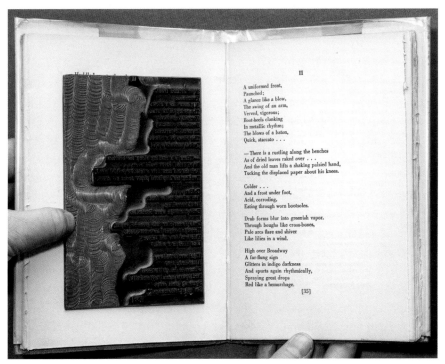

Lola Ridge. *The Ghetto and Other Poems*. New York: B. W. Huebsch, 1918; accompanied by electrotype plates, ca. 1918, for *The Ghetto*. Gift of Smith College through the good offices of Martin Antonetti.

read "She—diffused like a broken beetle—". On page 35, the last line, "Red like a hemorrhage" was altered to read "Red as a hemorrhage". The original text that needed to be replaced was chiseled out of the copper shell, and new electrotyped text soldered in its place, as is revealed by a mark on the lead-based backing plate.

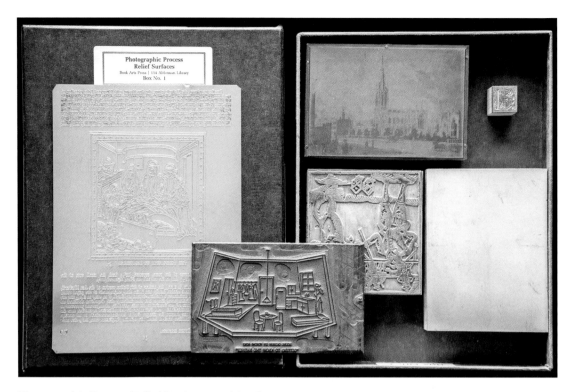

Photographic Process Relief Surfaces teaching kit.

5.18 Among the many custom-made teaching aids at RBS is a set of twelve kits that contain a range of relief printing surfaces made using different photographically assisted processes. Each kit includes at least one process line block, halftone block, and photopolymer plate (as well as a small electrotype block and zinc tint block), along with labeled printed proofs for each, thus allowing each student in RBS classes to compare these various forms.

Photomechanical Printing: RBS's Photographic Process Relief Surfaces Kits

Photomechanical printing emerged through a series of innovations and experiments in the middle of the nineteenth century.[14] The process entailed transferring a photographic image to a light-sensitized surface, with the non-printing background washed and/or etched away. This innovation provided a mechanical means for reproducing original artwork by allowing artists' own handwork to appear in print without the intervention of an interpretative engraver. Although these processes were largely used in relief printing, plates for intaglio and lithographic printing could be created via photomechanical processes as well.[15]

Building on developments in the previous decades, around 1870, process line blocks began to incorporate elements of etching. Workers covered the surface of a zinc or copper plate with a light-sensitive gelatin solution. When a photographic negative of an illustration was placed onto the coated plate, light passed through the semi-transparent areas of the negative that conveyed the image of the artwork, thereby causing the gelatin on the plate underneath to harden in the likeness of the photographic image. These solidified areas were then inked up and washed in warm water to remove the unexposed, soluble gelatin.[16] By dusting the design on the plate with powdered bitumen and then

Photographic Process Relief Surfaces
Box No. 1

heating the plate, the relief areas of the artwork became fully acid resistant. When the plate was submerged in nitric acid, the relief image remained.[17] The gelatin solution was then removed, and the plate could then be mounted onto a base in order to make it type high for letterpress printing. The process relied on the replication of pure lines of black against a white background, however, which made it difficult to replicate graduated shades and tones.[18]

By the 1890s, this problem was largely solved with the common manufacture of relief halftone blocks. The process was largely invented by Georg Meisenbach, who patented the process in 1882; it was further refined by others throughout the 1880s.[19] Workers followed a similar process to create the plates, but the process also entailed photographing artwork through a ruled glass screen that was inserted between the lens of the camera and directly in front of the photographic plate inside the camera.[20] The screen broke up the continuous tone of an image into smaller segments of pure black dots of varying sizes—thus creating the illusion of greys and graduated tone when seen at a distance. As Gascoigne notes, the process persisted in bookmaking through the 1960s, and many newspapers continued to use line blocks until the 1980s.[21]

The production of photopolymer plates, described in detail below, further simplified these processes with the introduction of light-sensitive plastics that cross-link (i.e., harden) with exposure to UV radiation.

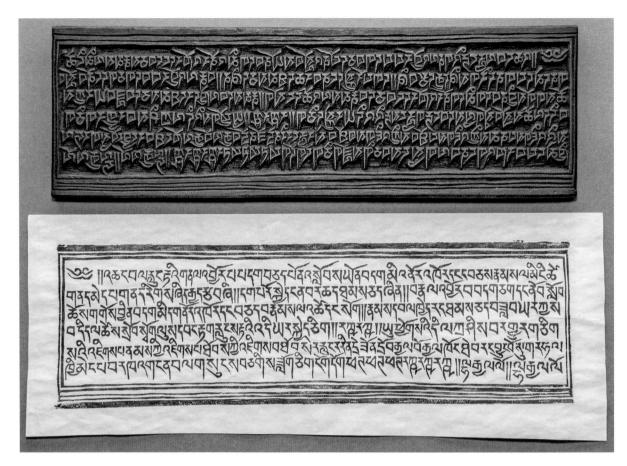

Tibetan woodblock, ca. 1940.

5.19
Tibetan
Woodblock

This wooden printing block, cut with Tibetan characters, contains the text of a "wind horse" (Tib. *rlung rta*, རླུང་རྟ་)—a prayer for success that is meant to remove obstacles. The block is very rudimentary in its both its orthography and execution in wood. It contains many spelling errors—facts that strongly suggested to our consultant, Geshe Ngawang Sonam, that the block was probably made in a small Tibetan village, rather than a publishing house. The text may even have been copied down from an oral recitation. The text was recited as part of a ritual that concludes with the following words: "May the Gods be Victorious!" (Tib. *lha rgyal lo*). The block likely dates from the twentieth century.

Curved electrotype relief printing plate used to print page sixty-six of the 19 February 1972 edition of the *Saturday Review*. New York: Saturday Review, 1972.

During the mid-twentieth century, books, magazines, and large-run work tended to be printed from electrotype plates.[22] This curved electrotype plate was used in February 1972 to print p. 66 of the *Saturday Review* (1921–1986), an American weekly magazine that had reached its highest circulation of 660,000 in 1971. The thin electrotype plate, faced with nickel or chrome, is mounted onto a heavier metal surface that can withstand the pressure of printing. It includes a letterpress halftone reproduction of a photograph of General George S. Patton Jr., the subject of the article. The color covers and advertisements in the magazine were also printed via letterpress halftone. By the 1970s, relief printing as well as the processes of electrotyping and stereotyping were on the wane: the last relief printing presses used to produce newspapers were delivered by manufacturer Heidelberg in the 1980s.[23]

5.20
Curved
Electrotype
Relief Printing
Plate

Photopolymer plate for the Spring 1997 issue of the *Quarterly News-Letter of The Book Club of California*. Gift of Peter Koch; QuarkXPress for Macintosh. Denver, CO: Quark, Inc., 1986–1993.

5.21
Photopolymer
Plates for
The Book Club of
California's
News–Letter

These photopolymer plates, made for the 1997 Spring issue of the *Quarterly News-Letter* of The Book Club of California, are part of a full set composed by the printer Peter Koch using the program QuarkXPress on a Macintosh computer. Koch printed the plates on a 1960s Heidelberg KSBA 18 by 23 in. cylinder press.

Photopolymer plates first came into use in 1974. The new technology harnessed light-sensitive plastics, or photopolymers, for preparing letterpress, offset, and flexographic printing plates.[24] The photosensitive plastic hardens when exposed to UV radiation through a photographic negative, which, in this case, was generated by outputting a computer-generated digital file to film. The background of the negative must be sufficiently opaque so that light passes through only the transparent portions of film, representing the composed text and images intended for printing. Then the plate is washed with water, rinsing away the soluble polymer, and thus lowering the unexposed areas of the plate even as the hardened parts of the plate remain, creating a raised relief surface that can be inked and printed. The relief surface can be further strengthened with additional exposure to light. The reverse surface of the plate is made of

mechanics sculpture at the intersection of Battery, Bush, and Market streets. The author-artist uses this monument as a pivotal point for the book, with a first drawing of it in its pool and the background as it appeared before the earthquake of 1906; an overlay shows it surrounded by rubble. Segedin uses it again several times, associating it with the four buildings. Reproduced here in full color are over thirty exquisitely rendered architectural drawings with almost as many architectural details that are reproduced in black line on inter-leaved pages. These remarkable renderings are reminiscent of the great renderings made by Samuel Chamberlain while he was teaching at MIT. But this is too long ago for our artist; his education was at California Polytechnic University in 1958. He notes in the colophon that he developed the story while working as a draftsman at Skidmore, Owings and Merrill's San Francisco Office.

This a most handsome book, one worthy of a place in our collection. Our sincere thanks to Larry Segedin. (Publisher: Stackwell Books, 3879 Lurline Drive, Honolulu, Hawaii 96816; telephone 808-737-17874.)
— *Albert Sperisen*

Jack Lloyd has just given The Book Club a book by his father, the late Lester Lloyd, long active in the book community. *Mackenzie & Harris* was Mr. Lloyd's last project, and his family was pleased that he was able to see a copy of the book before his death, on October 16, 1996. The book is a history of the type-founding firm of MacKenzie and Harris. This copy is one of a very few bound with a half-leather spine and silk over boards, the rest being in cloth. The book chronicles the existence of the most important typefounding company in San Francisco, and the life of long-time member and former Book Club President Carroll T. Harris. It will add greatly to our printing history collection and will be a valuable supplement to Mr. Harris's oral history.
— *Barbara Land*

Some time ago, we acquired *Contemporary Designer Bookbinders: An Illustrated Directory*, a major reference work of international scope, and one including some familiar names and faces. The editor is Philip Ward, founder of The Private Libraries Association. This fine reference is shelved in our library; copies may be ordered from The Oleander Press, 17 Stansgate Avenue, Cambridge, CB2 2QZ, England. The price is US $45.00.

Confessions of a Lapsed Handpress Printer
Richard-Gabriel Rummonds

Back in 1977, when I was still a printer and first starting to give talks about my work on the handpress in public, I would often mention, partly in jest and partly to shock, that for me, printing was an erotic experience; however, I could just as easily have said that it was a religious one since both of these experiences are deeply imbued with implications of ecstasy, with something beyond our immediate control, perhaps even mystical.

I was an early convert to the handpress even though I began my printing career on a small, table-top Superior press in Quito, Ecuador, in 1965, and over the next three years gradually upgraded my printing equipment, initially to a Replex proof press and then to a Vandercook. Even though I was already familiar with *livre d'artiste* from my college days at Syracuse University in the late 1940s, I was not aware of handpresses or the books produced on them until Armando Braun Menéndez, the scholar and bibliophile, introduced me to the world of private presses in his library in Buenos Aires in 1967. As I sat in awe, he regaled me with a succession of incredibly beautiful books, many of which were printed in Argentina on a handpress by Francisco Colombo and his sons, Emilio and Osvaldo. These books not only sparked my imagination but also revealed to me a subliminal glimpse of a centuries-old technology that I would fervently embrace one day in the not-too-distant future.

By 1968, after a five-year absence, I was once again living in Manhattan, working as a book designer at Random House/Knopf and trying to assemble a print shop. In my spare time, I continued to seek out all the information I could about private presses. Lewis Stark and Philomena Houlihan at the New York Public Library inundated me with the works of the great English and German handpresses — Kelmscott, Doves, Ashendene, Bremer, and Cranach — as well as a number of books printed by American handpress printers such as Lewis and Dorothy Allen and William Everson. Later that year, in November, at a Columbia University reception for the late German/Italian handpress printer Giovanni Mardersteig, I became engaged in a long conversation with his son Martino, who worked with his father at their commercial press, the Stampe-

metal or plastic, so that it can be affixed to a type-high base suitable for printing on the bed of a press; Koch used a magnetic base block, as the reverse surface of these particular plates are metal. Alternatively, photopolymer plates could be attached to cylinders for printing.

Initially developed for large-scale industrial printing, photopolymer plates began to be used by fine and private press printers with the rise of desktop publishing, which itself replaced earlier, more specialized composition and image-editing systems, and eventually photomechanical reproduction processes.[25] Koch used QuarkXPress 3.3 to compose his text, set in Monotype Poliphilus and Blado. He donated these photopolymer plates and proofs to RBS in 1997—but for many years the School lacked a copy of the original software used to produce the plates, as RBS's collecting focus had largely been on the printing surfaces themselves. A recent search on eBay changed that, and RBS was able to acquire a copy of QuarkXPress 3.3 in its original box, along with the original floppy disk and manual. By pairing these materials together, we are now able to teach another important aspect of how the plates were made, and to demonstrate how desktop publishing became integral to certain aspects of letterpress printing.

Progressive proofs, created in 1992, from Gaylord Schanilec's *Farmers: Wood Engravings, Interviews*. Stockholm, WI: Midnight Paper Sales Press, 1989.

5.22
Progressive Proofs of a Six-Color Wood Engraving

Contemporary wood engraver and fine press printer Gaylord Schanilec (b. 1955) created a suite of progressive proofs of all of the blocks included in his limited-edition fine press book *Farmers* specifically at the request of RBS founding director Terry Belanger. Each interview in *Farmers* is accompanied by a two-page wood engraving printed from six separate endgrain maple blocks. The progressive proofs illustrate how Schanilec printed this illustration of a grain harvester successively in yellow, green, grey, blue, orange, and black inks. When

HERMAN SCHANILEC JR

printing, Schanilec progressed from light to dark colors, which made cleaning the rollers of the press easier. In his memoir, *My Colorful Career* (1996), Schanilec reflects on how separating color from a reference photograph is a complex process, made even more difficult for him owing to his unusual visual perception of color, which led him to work primarily in black and white in the early phases of his career. In *Farmers*, he sought to achieve a heightened sense of depth and "concentrated on one layer of a color's effect upon another."[26]

Barry Moser. Resingrave block and print of Job created for the *Pennyroyal Caxton Bible*. West Hatfield, MA, 1999. Gift of Barry Moser and Elizabeth Medaglia.

5.23
Original Block
Engraved by Barry
Moser for the
*Pennyroyal
Caxton Bible* (1999)

Published in 1999, the *Pennyroyal Caxton Bible* was the first Bible fully illustrated by a single artist since Gustave Doré's *La Grande Bible de Tours* (1866). It was an immense and expensive enterprise that took four years to complete. Barry Moser (b. 1940), who conceived of and designed the book, oversaw every detail and stage of its production, even commissioning from Zerkall Paper Mills in Germany a new paper called Zerkall Bible, which included watermarks of Moser's own design. Moser, a world-renowned illustrator, artist, and book designer, is especially known for his expertise in wood engraving. Yet he was not able to source enough "good boxwood blocks" for his ambitious project—and, as he recounts in his unpublished memoir, "Bookwright," he had "never been satisfied with maple or other alternatives."[27] He was soon introduced by a friend to a new material, Resingrave (a cast polymer resin recently invented). As Moser writes: "Resingrave meets the gravers with a crisp bite like bone, very much like good boxwood. In fact, it rather resembles bone, given its whiteness and solidity."

In 2022, Moser and RBS alumna Elizabeth Medaglia jointly donated an original Resingrave block cut for the *Pennyroyal Caxton Bible* to RBS, along with a full set of prints created for the Bible, along with "outtakes" that did not make it into the final production. The gift complements the copy of the Pennyroyal Caxton Bible donated to RBS in 2014 by Bruce and Suzie Kovner, who were instrumental

in financing Moser's project. Moser's engraved image of Job and Elihu is striking, powerfully depicting Job's profound despair and abject misery. The contemporary feel of the engraving is arresting and original in its depiction of this well-known Biblical subject.

Mo Yan. *Da Feng*. Beijing: Zhuyu Shanfang, 2015. (大風。莫言著。2015年北京煮雨山房刻本。) No. 70 of 274 copies. Woodblock-printed edition. One vol., thread-bound. Cloth case. Gift of Xia Wei and Soren Edgren.

The book is a limited edition of *Da Feng*, a previously unpublished short story by the Nobel laureate Mo Yan (莫言). It features unusual illustrations; printed in red, the woodcuts are based on original handmade papercuts. The book was produced and published by Zhuyu Shanfang studio, the xylographic workshop of the late Jiang Xun (姜尋)—a talented poet and painter, book collector, bookshop owner, and award-winning book designer, who unexpectedly died in 2022, but whose work is remembered.

5.24
Woodcuts from Papercuts:
Da Feng (2015)

Abraham Bosse. *Traicté des manieres de graver en taille douce sur l'airin.* Paris: Chez ledit Bosse, en l'Isle du Palais, à la Rozerouge, deuant la Megisserie, 1645. Gift of Jeremy Norman.

5.25
Abraham Bosse's
Guide to Etching
and Intaglio
Printmaking

Abraham Bosse (1604–1676), a French Huguenot artist and printmaker, was a prolific and skilled etcher, who among many other etchings, created the famous frontispiece of Hobbes's *Leviathan* in 1651. His *Traicté des manieres de graver* (1645) was the first European manual on intaglio printmaking. In it, Bosse helped popularize techniques first developed by his mentor Jacques Callot (ca. 1592–1635). Bosse describes the etching process step by step: how to 1) use etching to imitate the engraved intaglio line; 2) prepare copper plates, formulate hard and soft grounds, and transfer images to the prepared plate and then cut into the ground with needles and an *échoppe* (a pencil-like steel cylinder with its working end beveled diagonally to form an oval face); 3) bathe the plate with an acid solution (as shown in the image here); and 4) construct and operate an intaglio printing press. In the RBS course "Book Illustration Processes to 1900s," students follow many of the same steps of etching described by Bosse. After copying an image into a ground-covered plate with an etching needle, the students' plates are etched in an acid bath. Students then print their plates on a rolling press.

Bosse's treatise was often edited, translated, and copied in both printed and manuscript form for decades and then centuries after it was first published. This illustration also reminds us of the use of children as workers in the hand-press period (and indeed, for long afterwards). Early modern European printing houses were also often family-run enterprises: Bosse's daughter is said to have been a skilled artist; she may have been an intaglio printer, as well.[28]

A fragment of a copper plate with a 1674 John Ogilby map engraved on the recto (above) and a right-reading text and heraldic images on the verso. London, ca. 1698. Gift of Terry Belanger.

The development of intaglio printing techniques in sixteenth-century Europe was a boon for mapmakers, who could incorporate a much greater level of detail into their engraved plates than was possible when working with the woodcut technique. Copperplate engravings and etchings were easier to alter than completed woodblocks. This modest fragment of copper plate bears a portion of a cartouche of the map of Ipswich completed under the supervision of John Ogilby (1600–1676) in 1674 and finally published in 1698. Ogilby is a fascinating figure who had several careers before becoming a cartographer and publisher of maps in his late sixties. The map of Ipswich was part of his ambitious and uncompleted project to map all of Britain, which took on the form of his *Britannia* (1675), the first modern European road map. Only two of the 102 map plates associated with the *Britannia* project were signed.[29] This modest fragment of a massive cartographical endeavor has another tale to tell: the reverse side of the copper plate was used by an apprentice to practice engraving heraldic coats of arms, capitals, and round hand. The text is right reading and therefore not intended to be printed; it mentions the pewterer Robert Oudley, who was active in London during the early eighteenth century. Engravers who specialized in printmaking also often trained in the engraving of other metal objects and utensils, such as gunstocks and tableware.

5.26
Map Engraving

Jacques Daran. *Observations chirurgicales sur les maladies de l'urèthre, traitées suivant une nouvelle méthode.* Paris: De Bure, 1748.

5.27
Color Mezzotint

In the early 1700s, working from Isaac Newton's theories of color division, the engraver Jacob Christophe Le Blon (1667–1741) devised a three- and four-color printing technique using mezzotint engraving and blue-, yellow-, red-, and black-inked plates. Jacques Gautier (later known as Gautier d'Agoty, 1717–1785) briefly worked as an assistant to Le Blon in 1738. When Le Blon died in 1741, Gautier acquired his royal privilege for color printing and began claiming that he, rather than Le Blon, had invented the four-color printing technique. His royal privilege gave him the exclusive right to produce color prints in anatomy, botany, and natural history. He displayed his printing talents in a large and impressive volume of anatomical plates initially created with the surgeon J. F. Duverney (1661–1748) and published between 1745 to 1775. Although they are visually striking, his plates "were neither anatomically correct nor useful to physicians."[30] RBS purchased this book about the illnesses of the urethra, which includes a color mezzotint plate by Gautier depicting a cross-section of the male genital organs. RBS collections staff created a custom enclosure that enabled the print to be kept flat so that it would not be damaged by being repeatedly unfolded in the classroom setting.

"Mrs. Clive, in the Character of Phillida." From the painting by G. Schalken, engraved by John Faber. London: E. Evans, 1734.

Mezzotint is an intaglio process developed by the German Ludwig von Siegen (ca. 1609–ca. 1680) and others in the mid-seventeenth century. The technique involved the use of tools to create a roughened surface of minute pits, ridges, and burrs on the surface of the copper plate. The primary tool used to prepare a mezzotint plate was a rocker—a spade-like tool with a curved, toothed edge. Once "rocked," sections of the plate that were to be printed in lighter tones were smoothed away with scrapers and burnishers. When printed, the rocked portions of the plate held the ink and printed a deep, velvety black, while the burnished portions printed in a range of subtle tones difficult to achieve via other intaglio techniques. The surfaces of mezzotint plates are fragile and easily damaged, and the number of good impressions that can be made from a plate is limited (generally to one or two hundred printings at the most). For this reason, the technique was only occasionally used for book illustrations, where five hundred or one thousand copies or more were typically needed. The most common use of mezzotint was in making portraits intended for framing.

5.28
Mezzotint
Printing Plate

This mezzotint portrait of the British stage actress Catherine Clive, née Raftor (1711–1785), was engraved by John Faber (ca. 1695–1756), a mezzotint engraver whose father also specialized in the technique. This particular copper printing plate is in high demand in RBS courses, as it is the School's only pre-1800 mezzotint printing surface; early printing plates rarely survive, and most of the extant ones have long since been acquired by institutions.

William Cooke's *Medallic History of Imperial Rome*. London: James Dodsley, 1781. Etched copper printing plate, ca. 1781; one from a set of fifteen printing plates in the RBS teaching collection used to print illustrations in Cooke's *Medallic History of Imperial Rome*.

5.29
18th-Century
Etched Copper
Printing Plates

This intaglio copper plate is one from a larger set that was used to print illustrations of coins accompanying William Cooke's *Medallic History of Imperial Rome* (1781). Published after the death of the author, the illustrations were etched rather than engraved. Etching required less skill and was less time consuming than engraving. Even so, Cooke's son, who oversaw the publication of the *Medallic History* after the death of his father, wrote in his preface that the plates were expensive to produce. The plates are unsigned, and it is likely that they were based on drawings made by Cooke Sr., who viewed the coins in the homes of various English collectors of his day. Although etched copper printing plates eventually wear out after repeated printing, one of the fifteen copper plates from RBS's set continues to be printed successfully to this day as part of a hands-on demonstration for RBS's course, "The Illustrated Scientific Book to 1800," taught by Caroline Duroselle-Melish and Roger Gaskell.

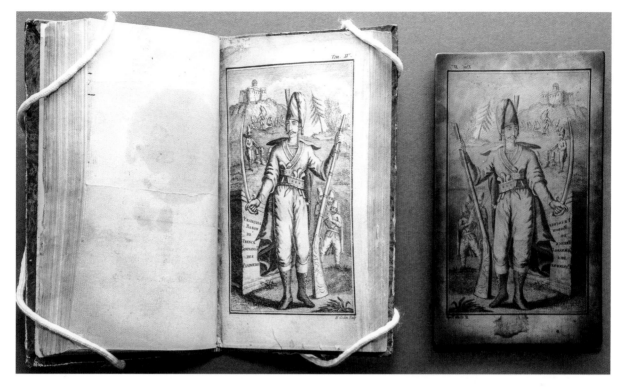

Friedrich von der Trenck. *La vie de Frédéric, Baron de Trenck, traduite de l'Allemand, par M. Le Tourneur, suivie des Mémoires de François Baron de Trenck, son Cousin Germain.* 3 vols. in 2, with a 4th volume, *Mémoires de François Baron de Trenck. . . .* Berlin and Anvers: C. N. Spanoghe, 1788. Purchased with funds donated by Peter Drummey.

RBS owns two of four copper printing plates created to illustrate a 1788 edition of the adventures of the Prussian Baron Friedrich von der Trenck (1726–1794). In RBS courses, faculty members use these printing surfaces to teach students how to distinguish engraving from etching. By examining the lower, left-hand corner of this particular printing plate, produced for the frontispiece of volume four of the book, one can observe the difference between the heavy, blunt lines of etching and smoothly tapered lines of engraving. The men depicted in the background are etched, and the shaded areas of the Baron's trousers are engraved.

5.30
Etching and Engraving on Copper Plates

Like mezzotint, aquatint is an intaglio printing process in which the surface of the printing plate is distressed in order to achieve gradations of tone. Rather than using a rocker, however, the plate was prepared either by sprinkling fine particles of rosin ("dust ground"), which were melted onto the warmed plate so as to leave bare areas of metal around the particles, or by coating the plate with a resin dissolved in spirits ("spirit ground"), which, when dried, reticulated, leaving squiggly areas of metal uncovered. The plate was then immersed in an acid bath; the exposed metal was bitten by the acid in order to produce a selectively roughened surface that would catch ink. The technique was most common in Europe from the 1770s to the 1830s.

5.31
Alken Aquatints

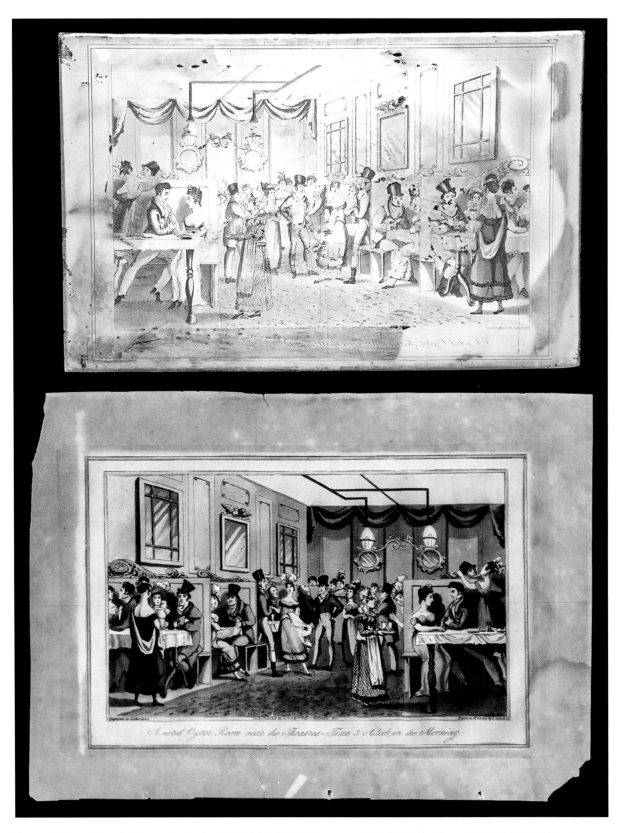

Samuel Alken Jr. and Thomas Sutherland. *A Noted Oyster Room near the Theatres—Time 3 O'Clock in the Morning.*
London: Thomas Kelly, 1823, with the plate used to print it. Purchased with funds donated by Florence
Fearrington through the good offices of Terry Belanger.

To identify an aquatint, one looks for varying levels of graining in the image caused by the different levels of etching; the grain will appear as small islands of white in a black sea. RBS owns a set of eight steel-faced copper aquatinted plates "engraved" by Thomas Sutherland from drawings by the British sporting artist Samuel Alken Jr. (1784–1825), who, like his father Samuel Alken Sr., specialized in hunting and sporting scenes.

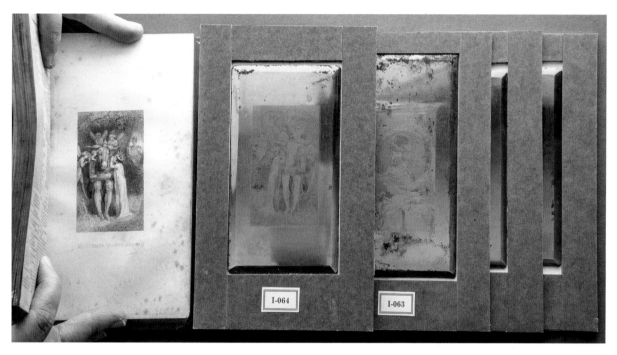

The Works of Shakespeare. New York: Leavitt & Allen Brothers, n.d., [ca. 1870]. Steel-faced printing plates corresponding with the Leavitt & Allen edition. N.d.

5.32
Steel-Faced
Printing Plates
Illustrating
*The Works of
Shakespeare*

This steel-faced printing plate illustrates a scene from *A Midsummer Night's Dream*, as it appeared in a mid-nineteenth-century American edition of *The Works of Shakespeare.* It is one from a larger set of steel plates used to illustrate the edition. A related technique, steel engraving began to be used in book illustration during the first quarter of the nineteenth century for various reasons. One had to do with the relative limitations of using copper for very large printing runs. Copper yielded hundreds of good impressions before exhibiting wear to the plate while steel yielded thousands of impressions—even tens of thousands—before any discernible alteration.[31] With the constantly accelerating growth of the literate public during the late eighteenth century and throughout the nineteenth century, there was increased demand for illustrated books affordable to middle-class readers. Steel plates helped meet that demand, and developments in metallurgy allowed steel to be softened for engraving and then re-hardened for massive print runs on powerful presses.

Another reason had to do with visual appeal. Although initially developed for high-quality, security printing in the 1790s in America and France, the fine lines that made steel-engraved banknotes hard to counterfeit also had aesthetic value

and offered new possibilities in terms of illustration. Charles Warren successfully engraved and printed the first illustrated plate in England in 1818; an image of Minerva, the plate itself was made from an old saw blade.[32] Steel engravings were used for book illustrations from the 1820s onward. Although more expensive, the process allowed for extremely fine line work and tonal range that set the process above and apart from its chief competitor, relief wood engraving. The illustration from *A Midsummer Night's Dream* shown here displays the characteristic cool, silvery tones and intricate line work that are hallmarks of the process.

The production of steel-engraved plates was a time-consuming and challenging endeavor, given the hard nature of the material, but its economic advantages were so clear that commercial copperplate intaglio work largely disappeared by the middle of the nineteenth century. In 1858, however, a new development emerged: copper plates could be engraved and then electroplated with a thin coating of iron—a process referred to as "steel-facing."[33] The process saved time and cost, and it readily allowed the surfaces of plates to be renewed when the coating wore down. The printing plate displayed here is likely steel faced, based on a close inspection of another plate in the set where copper is showing on the plate's non-printing side. It is also beginning to show its age—evident where the plate is starting to rust.

5.33
Baxter Print

George Baxter (1804–1867) was a prolific London-based printer and artist who patented a new color printing process that combined intaglio and relief techniques. In his preface to *The Pictorial Album* (1837), the first book to feature examples of his new process, Baxter explains the multiple steps involved in producing what came to be known as Baxter prints: "The first faint impression, forming a ground, is from a steel-plate; and above this ground, which is usually a neutral tint, the positive colors are impressed from as many woodblocks as there are distinct tints in the picture" (xii–xiii). Baxter describes his pictures as "imitative paintings" and "designs, executed in oil colours." The prints were sometimes used for book illustration, but larger examples intended for framing and hanging on the wall were ubiquitous in mid-nineteenth-century England.

This illustration of the Boa Ghaut, a picturesque ravine in what is now Myanmar, is reproduced in Bamber Gascoigne's *How to Identify Prints* (plate 99) to illustrate Baxter's process.

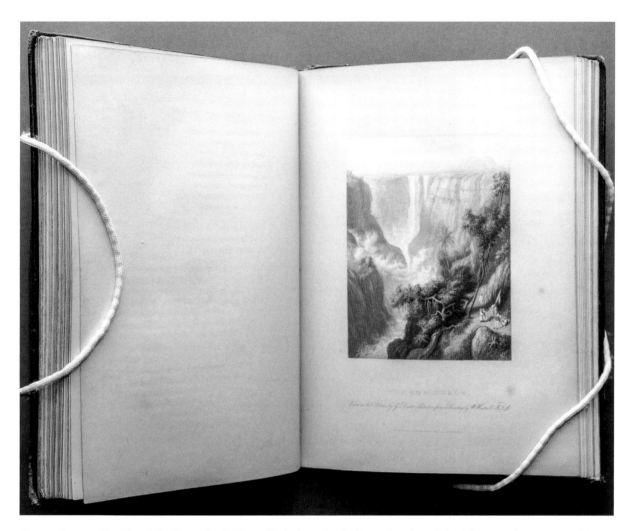

George Baxter. *The Pictorial Album; Or, Cabinet of Paintings, for the Year 1837. Containing Eleven Designs, Executed in Oil Colours, by G. Baxter, from the Original Pictures, with Illustrations in Verse and Prose.* London: Chapman & Hall, Strand, [1837].

Lithographed facsimile of a letter in Greek, signed by the president and four members of the Philomuse Society of Athens, 14 August 1819.

5.34
Lithographed
Letter (1819)

This document, written in Greek, is a lithographed facsimile of an original letter signed by the president and four members of the Philomuse Society of Athens on 14 August 1819. It was sent to the Society's subscribers, informing them that a separate branch of the Society was to be established in London.[34]

Lithography, from the Greek *lithos* "stone" and *graphein* "to write," was an entirely new printing process discovered by Aloysius Senefelder in Munich in 1798 after a series of preliminary trials at relief etching on stone.[35] It was a planographic process—one that used a flat printing surface, as opposed to processes entailing print areas raised above (relief) or below (intaglio) the non-printing surface. Initially searching for a way to print his own writing and then music (as commissions from others) by etching on stone, Senefelder realized

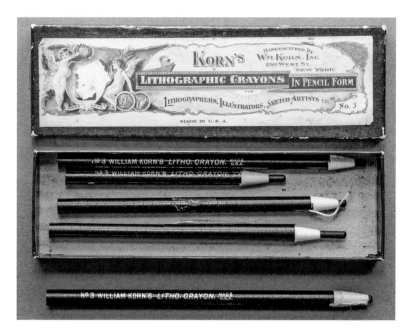

Box of Korn's Lithographic Crayons, No. 3. New York: Wm. Korn, Inc.,
ca. 1950.

that he could harness the physical properties of oil and water, which repel one
another. His process involved drawing an image on a smooth but porous, water-
attracting stone with greasy ink. By etching the stone with a mild acid solution
to slightly lower the non-printing, hydrophilic parts, he found that printing ink
adhered to the greasy ink and was repelled from rest of the dampened surface.
Fine-grained Bavarian limestone was ideal for the process.

The new process allowed printers to replicate music (which, prior to
lithography, was usually engraved, owing to its complex overlapping staves and
notes) and handwriting, as well as original drawn artwork, in a cheaper and faster
form than engraving.[36] A further advantage, as Senefelder discovered early on,
was that texts could be readily transferred to the surface of a stone. After writing
onto transfer paper with a pen and specially formulated greasy ink, the paper
could then be applied facedown onto the stone, and the resultant wrong-reading
text could be inked and printed, creating a right-reading document. This process
was considerably less time consuming than engraving or cutting text in reverse,
as with intaglio and relief processes. Other supplies, such as greasy crayons, were
used early on by Senefelder for lithography—particularly in imitation of chalk
drawings.[37] (The crayons shown here are later twentieth-century examples.)
Transparent transfer paper allowed workmen to copy manuscripts and artwork
before the invention of photography.[38]

In this case, the lithographed Greek letter reflects the look and feel of a
handwritten document, as do the signatures of the Society's president and
other leading members. At the same time, the lithographic process also readily
captured the Greek language's complex orthography, which would have proved
more time consuming (and, therefore, expensive) to set in type, given its many
diacritical marks.

Hero jam jar labels. Esslingen am Neckar, Germany, ca. 1950. Proofs commissioned from Hans Ulrich in 2006 by RBS.

5.35
Lithographic
Stone and Seven-
Color Progressive
Proofs for Hero
Jam Jar Label

Zinc and aluminum plates increasingly replaced stone for most lithographic printing by 1900. Nevertheless, lithographic printing with stone persisted in some regions and industries into the twentieth century. This particular lithostone dates from the twentieth century and comes from the Steindruckerei of Hans Ulrich, a lithographer who lived in Esslingen am Neckar (a town in southern Germany not far from Bavaria, where the best limestone for lithography was sourced). At Terry Belanger's request, Ulrich created these progressive proofs for use in RBS courses. The color-separation instructions featured on the surface of the stone are a telling example of how the painstaking process of creating a multi-color lithograph was carried out. As Ulrich wrote in his 2006 letter to Belanger, it was a "specimen" that he personally hoped would "open the eyes of many people for the hard work of the lithographers of former times."

The lithostone shown here contains seven different color separations for a single, multi-color label that was produced en masse and applied to jars of Hero red raspberry jam. (Each color separation seen here would have been transferred from this "mother" stone to its own respective printing surface or "daughter" stone.) Each of the colors featured on this label for red raspberry jam required its own particular design, as is apparent when studying the various configurations of the label. For example, the word "Hero" appears within a blue oval visible on just one version of the label as presented on the stone; this is because the particular

blue (*Schildblau*) used to print the oval was not intended to mix or overlap with any of the other colors in that particular area.

The first layer in the color separation, a pale red (*Rot I*), underlies all of the succeeding colors: yellow (*Gelb*), blue (*Blau*), red II (*Rot II*), sign blue (*Schildblau*), grey (*Grau*), and, lastly, black (*Schwarz*). Each color was printed successively, in this exact order, from the various daughter stones onto one large sheet of paper. The overprinting that surrounds the label would not have been present when producing the labels commercially, as each color separation component would have been ganged up in a series on its own printing surface, as described earlier (i.e., a daughter stone for printing the red I separation, a daughter stone for printing the yellow separation, etc.). Thus, the first full sheet printed would have contained rows of the label printed in its yellow color-separation component. Then this same sheet would be used to print the red I layer, and so on, with the final layer being printed in black.

As you see in the final proof, all seven colors are lined up vertically on the left side of the level with the registration marks, which were necessary for ensuring that the colors properly overlapped as part of the printing process. The numbers running vertically on the right side of the final label reflect the exact mixtures for each successive color of ink. After going through all seven rounds of carefully registered printing, the sheet would be cut, resulting in a stack of multi-color labels.

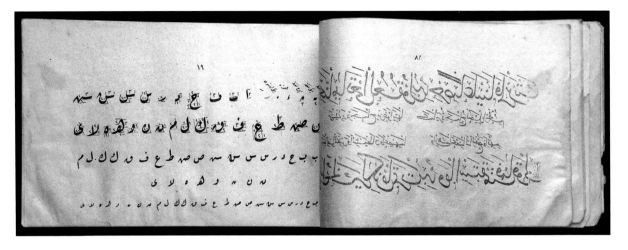

Mehmed İzzet Efendi. [*Ottoman Calligraphies* (خطوط عثمانية). Istanbul: Osmanh Kutuphanesi, 1323 AH (1905/1906 CE).]

5.36
Lithography and Arabic Letterforms

The written word and calligraphy are of central importance in Islamic cultures. A reverence for handwritten texts and the characteristics of Arabic script (in which letterforms may change shape depending on where the letter appears in a word) inhibited the growth of letterpress printing in regions where Islam was the dominant religion. Though the new planographic technology of lithography was used primarily for pictorial and cartographical texts in Europe, in Arabic-speaking regions it flourished after the 1820s as the main process by which hand-written texts were reproduced in the form of books and newspapers. This writing manual by the Turkish calligrapher Mehmed İzzet Efendi (1841/1842–1903) is printed via lithography. It includes instructions about how to write in several different Arabic scripts whose intricate forms would be difficult to reproduce via metal movable type.

5.37
Mass-Market Chromolithography

The House of Beadle and Adams was the first American publisher to issue dime novels in continuous series and at a fixed price. Although they are listed as being part of Beadle's Frontier Series on the cover, these two novels were published by the Arthur Westbrook Company, which had bought the original Beadle stereotype plates and stock from the M. J. Ivers Company in the early 1900s. Both novels are reprints of dime novels first published in the 1860s and 1870s. *The Mountain Demon* was written by Edward Willett (1830–1889), one of Beadle and Adams's most prolific authors. In the late nineteenth century, dime novels were celebrated—and condemned—for their lurid covers.

In earlier editions, these dime novel covers were printed in relief color, but the firm turned to chromolithography by the end of the nineteenth century. Here is the stone used to print the black outlines of the title and the outlines and tones in the illustration. The completed covers include four to five separate colors, each of which would have been printed with a separate stone. Lithographic stones must be stored very carefully to avoid any contamination or damage to their printing

Lithographic stone used to print the covers of Edward Willett. *Davy Crockett's Boy Hunter,* no. 11; and John F. Cowan. *The Mountain Demon,* no. 16. Cincinnati: Arthur Westbrook Company, 1908. Gift of Terry Belanger.

surfaces. Even though this stone is cracked, scratched, and smeared, it serves as an important teaching tool, especially because it is only one of a few of RBS's thirty-plus lithographic stones that were used for printing books (as opposed to producing stationery, billheads, labels, and other packaging).

Nathaniel Hawthorne. *Transformation: Or, the Romance of Monte Beni.* 2 vols. Leipzig: Bernhard Tauchnitz, 1860. (2 copies: RBS-4177 Ex Libris Ava Stewart; and RBS-4558 Ex Libris Emma Danforth Wiley, with earlier ownership inscription: Emma M. Wiley | Idaho Springs | Colorado. | Rome. October 16. 1889.)

5.38
Tauchnitz and
Hawthorne's
Transformation

Starting in the 1840s, books began to be illustrated with photographs that were tipped in or otherwise bound into books.[39] Within two decades, publishers and booksellers started capitalizing on additional developments in photography—primarily the availability and affordability of albumen prints—as we see here with Tauchnitz's two-volume publication of Nathaniel Hawthorne's *Transformation: Or, the Romance of Monte Beni* (published in America under the title *The Marble Faun*). The novel takes place in Rome and contains many detailed descriptions of the city's art and architecture based on Hawthorne's observations while living in Italy during the late 1850s.

In Italy, the novel was marketed to the tourist trade as an extra-illustrated travelogue or souvenir. According to William B. Todd and Ann Bowden, Hawthorne's *Transformation*, which was issued as volumes 515 and 516 of Tauchnitz's "Collection of British Authors," enjoyed "enormous sales" and was issued in four, nearly identical editions.[40] As early as 1854, the Florence-based firm of Alinari had begun photographing Italian artworks and sites of interest with an eye to tourism.[41]

Although Tauchnitz's productions were relatively inexpensive reprints, Italian booksellers and bookbinders capitalized on both of these readily available albumen photographs and tourists' interest in souvenirs, and they offered more expensive customized copies—allowing purchasers to select from a range of photographs and bindings suited to their individual budgets and tastes. Copies ranged from containing fewer than twenty photographs to more than one hundred images.[42] A custom binding could cost five times the price of the book itself—and photographs could amount to more than six times the cost of the text if a customer ordered a large number (e.g., a hundred).[43] Some readers annotated their copies as they visited galleries and historic sites, thus further personalizing their books as a kind of travel album—as examples in RBS's own teaching collection readily show. The majority of extant copies are bound in parchment with red and gold stamping on their covers and with decorative endpapers.[44]

RBS's teaching collection includes sixteen copies of Tauchnitz's *Transformation*, a number that allows students to compare differences among bindings and illustrations, as well as ownership inscriptions. Many of RBS's copies were purchased by or for women travelers visiting Florence and Rome during the 1880s. No two versions are identical. The volumes displayed here, for example, depict the same statue: the Capitoline Museum of Rome's *Faun of Praxiteles*, which inspired Hawthorne's novel.[45] One reader's copy contains an image with the statue's genitalia covered with a fig leaf, while another copy's image remains uncensored.

Above: John H. Lovell, *The Flower and the Bee. Plant Life and Pollination*. Illustrated from Photographs by the Author. New York: Charles Scribner's Sons, 1918.

Right: John H. Lovell. Glass plate negative of "White Snowberry," ca. 1916. Gifted in part by Lux Mentis Booksellers.

5.39
Glass Plate
Negative

RBS has a collection of nearly 150 glass plate negatives originally owned by John H. Lovell (1860–1839), a field naturalist who illustrated his book on plants and pollination with his own photographs. Gelatin dry plates, such as the one used to produce this negative of "White Snowberry," were the first photographic negative materials to be mass produced. Lovell exposed his plates either in the field or in his studio and then developed them in his dark room. The photographic prints were then used as the basis for the relief halftone blocks used to print the illustrations in his books. In his preface to *The Flower and the Bee* (1918), Lovell notes that "most of the photographs are natural size, except in the case of the larger flower-clusters, and have been taken on panchromatic plates to preserve in monochrome the proper color values," adding that "a small stop and a long exposure have been employed to secure details."

William Blake. *Songs of Innocence and of Experience*. London: Trianon Press, 1955. Gift of an anonymous donor, through the good offices of John Windle.

Pochoir is French for "stencil," a thin sheet of cardboard, metal, or plastic that enables workers to create color through a design cut out in the material. The example shown here is one of eighteen metal stencils created to produce the 1955 Trianon Press facsimile of *Songs of Innocence and of Experience*, an illustrated work of poetry originally printed in 1789 and 1794 by William Blake (1757–1827).[46]

Not only a poet, Blake was also an artist and engraver whose innovation in the realm of printing anticipated technologies only fully developed in the century following his own invention—a form of relief etching. As with the manufacture of photographic process relief line blocks developed later in the nineteenth century, relief etching relied on an acid-resist process to lower the non-printing surface of metal plates, so as to create a raised printing surface (as opposed to incised grooves below the surface of the plate, as is the case with intaglio processes, such as etching and engraving). Blake not only printed his own work in multiple colors via this process; he and his wife, Catherine, additionally hand colored and

5.40
20th-Century
Pochoir and
William Blake

Original proof and stencil used for "The Nurse's Song." Gift of John Windle.

bound copies of *Songs of Innocence and of Experience*, thus creating tiny editions of remarkable, vibrantly colored books unlike any others of the time.[47]

The twentieth-century Trianon Press Blake facsimiles were intended to reproduce as closely as possible Blake's intricate process. The black outlines were printed via collotype (a photolithographic process), and then watercolors were applied by hand by using as many as thirty stencils per plate. Blake did not use stencils, however, as his work was largely made to order in very small runs—but the Trianon Press made use of *pochoir* given the size of this edition: 526 copies. This page, reproducing "The Nurse's Song," was made with eighteen stencils that appear to have been created, in part, using printed proofs from the Trianon Press edition. Workers first placed the proofs on top of the aluminum sheets and then proceeded to cut away the area intended for stenciling; these were then used to hand color the leaves of the edition. Creating the stencils directly from the proofs undoubtedly helped to ensure the proper alignment and registration of the stencils.

Souvenir Edition. U.S.N. "General M. L. Hersey." Bremerhaven-New-York 1–11 Sept. 1950, produced on board USN *General M. L. Hersey,* 1950. Gift of Jon Lindseth.

RBS possesses seven booklets that were written and duplicated via mimeograph on board transport ships by displaced persons (DPs) en route to North America and Australia from Europe after World War II. Mimeograph machines, which duplicate typescript texts via stencil, allowed for the quick and cheap reproduction of texts. "Mimeos" were also used by individuals living in DP camps in Europe after the war to print camp newspapers and educational materials. This souvenir issue marks the voyage of the USN *General M. L. Hersey* from Bremerhaven in West Germany to New York. The ship was carrying 1,368 passengers (594 men, 501 women, and 273 children) of a variety of religious faiths (Christian, Jewish, Muslim) from many different countries in Europe. The booklet includes several illustrations signed "L Krstich," as well as mimeo reproductions of typescript and hand-written texts in sixteen languages, including Latvian, Yiddish, and Polish.

These particular mimeo publications were collected by Prof. Mark Wyman, author of the 1988 book *DP: Europe's Displaced Persons, 1945–1951.* Wyman received the examples from Dr. Visvaldis Janavs (1921–1910), a Latvian doctor who, also displaced from his homeland, worked as a medical escort officer for the International Refugee Organization before immigrating to South Dakota.

5.41
Shipboard
Mimeograph
Souvenir Booklets

Metal and paper masters used to duplicate *The Selected Works on Wing Theory of Sergei A. Chaplygin*. English translation from the original Russian by Maurice A. Garbell. San Francisco: Garbell Research Foundation, 1956. Gift of Vic Zoschak.

5.42
Multigraph
Duplicator

Throughout most of the twentieth century, the Addressograph-Multigraph Corporation manufactured a variety of duplicating and printing machines designed for use in offices. The Multigraph duplicator was designed for print runs of up to about 2,500 copies, using paper masters for shorter runs and zinc or aluminum masters for longer runs. "DupliMAT" paper masters were made from a strong, specially treated paper on which one could place copy for duplication. The company also produced zinc and aluminum masters. Shown here are the paper and metal masters used to run off a list of publications available from a firm owned by the aeronautics engineer Maurice Gerbell (1914–1990), whose office, established in San Francisco in 1939, published a series of monographs on aerodynamics and related subjects, including this translation of Sergei A. Chaplygin's works on wing theory.

These masters, along with the mimeograph booklets described above, are examined by students in Brian Cassidy's RBS course, "Identifying and Understanding Twentieth-Century Duplicating Technologies."

1. Edgren, J. S. "The History of the Book in China." In *The Oxford Companion to the Book*. Eds. Michael F. Suarez, S.J., and H. R. Woudhuysen, 1:353. 2 vols. Oxford: Oxford University Press, 2010.

2. Ad Stijnman writes that the process appeared by the mid 1490s. Stijnman, Ad. *Engraving and Etching 1400–2000: A History of the Development of Manual Intaglio Printmaking Processes*. London; Houten, Netherlands: Archetype Publications in association with HES & de Graaf Publishers, 2012, 45.

3. Metzger, Christof. "The Iron Age: The Beginnings of Etching about 1500." In Jenkins, Catherine, et al. *The Renaissance of Etching*, 25. New York: The Metropolitan Museum of Art, 2019.

4. Walter L. Strauss writes: "Most artists shied away from the extraordinary difficulty of designing and then printing chiaroscuro works. It was practiced only by those who, endowed with a special skill and predilection for this medium, combined artistic talent with mechanical craftsmanship and were patient enough to continue in that vein. . . . As a consequence, the total number of chiaroscuro prints produced by the artists of the sixteenth and seventeenth centuries in Germany and the Netherlands is relatively small." Strauss, Walter L. *Chiaroscuro: The Clair-Obscur Woodcuts by the German and Netherlandish Masters of the XVIth and XVIIth Centuries*. Greenwich, CT: New York Graphic Society, 1973, xiii.

5. We have not yet been able to trace the monastery or its author, Lhündrup Depa (*lhun grub bde pa*)—nor the individual who provided funding for the production, Chöjé Gelek Gyeltsen (*chos rje dge legs rgyal mtshan*).

6. Lin, Maria. "Japanese Woodblocks." RBS Teaching Guide. Charlottesville: 2017.

7. Partridge, C. S. *Electrotyping: A Practical Treatise on the Art of Electrotyping by the Latest Known Methods*. Chicago: The Inland Printer Co., 1899, 69.

8. Partridge, *Electrotyping*, 85.

9. J. A. A. "Minot's Diary of a Bird." In "Recent Literature." *Bulletin of the Nuttall Ornithological Club* 5, no. 2 (April 1880): 112.

10. "Henry Davis Minot Papers." Massachusetts Historical Society Collection Guide to the Collection: <https://www.masshist.org/collection-guides/view/fa0286>; accessed 25 February 2022.

11. "Lola Ridge." In *Gale Literature: Contemporary Authors*. Farmington Hills, MI: Gale, 2000. Gale Literature Resource Center (2022) : <https://link.gale.com/apps/doc/H1000082869/GLS?u=viva_uva&sid=bookmark-GLS&xid=3f5a24bd>; accessed 18 February 2022.

12. See Terese Svoboda's "Why Has the Poet Lola Ridge Disappeared? On the Historical Erasure of Political Women Artists." Lit Hub. 6 April 2018: <https://lithub.com/why-has-poet-lola-ridge-disappeared/>; accessed 18 February 2022.

13. See entry 5.15: Nineteen-Section Wood-Engraved Block with Evidence of Electrotyping (p. 120).

14. Bamber Gascoigne discusses Firmin Gillot's process, patented in 1850, of creating a line block from a zinc plate using a transfer process unassisted by photography that was made acid-resistant—thus creating a relief surface. He also discusses Samuel Rogers's process of making a hand-drawn negative on glass—described in *The Pleasures of Memory* (1865)—and then using the glass negative to expose light-sensitive gelatin coated in a thick layer on a rigid plate. See Gascoigne, Bamber. *How to Identify Prints: A Complete Guide to Manual and Mechanical Processes from Woodcut to Inkjet*. New York: Thames and Hudson, 1986, 33 c–d.

15. For a discussion of photogravure and rotogravure, see Gascoigne, *How to Identify Prints*, 38–39.

16. Geoffrey Ashall Glaister describes the solidified areas as being inked before rinsing and dusting. See "line block" in Glaister, Geoffrey Ashall. *Encyclopedia of the Book*. 2nd ed. Intro. Donald Farren. New Castle, DE; London: Oak Knoll Press and The British Library, 1996, 291.

17. See Glaister, *Encyclopedia of the Book*, 291. Gascoigne discusses an earlier cold-rinse process that entailed electrotyping. See Gascoigne, *How to Identify Prints*, 33 h–i. A warm-rinse version of the process that required electrotyping was also in use by the 1860s. See Gascoigne, *How to Identify Prints*, 33 d.

18. There were various attempt to achieve tone using line blocks, including artists' false halftones and printers' false halftones. See Gascoigne, *How to Identify Prints*, 33 g.

19. See "half-tone process" in Glaister, *Encyclopedia of the Book*, 213–215. Geoffrey Wakeman discusses a short-lived rival process, also patented in England in 1882, called the "luxotype." See also "half-tone blocks" in Wakeman, Geoffrey. *Victorian Book Illustration: The Technical Revolution.* Newton Abbot, U.K.: David & Charles, 1973, 138–140.

20. A mathematical formula was used to determine the distance between the halftone screen and the plate within the camera. See the American Photoengravers Association. *The Art of Photoengraving.* N.p.: American Photoengravers Association, 1952, 14–15.

21. Gascoigne, *How to Identify Prints*, 34.

22. See Polk, Ralph W. *The Practice of Printing.* Peoria, IL: The Manual Arts Press, 1926, 103.

23. *Handbook of Print Media: Technologies and Production Methods.* Ed. Helmut Kipphan. Berlin: Springer Verlag, 2001, 386.

24. Robertson, Gordon L. *Food Packaging: Principles and Practice.* 2nd ed. Boca Raton, FL: CRC Press, 2006, 176. This work contains a detailed summary of technological innovations in industrial printing.

25. According to Helmut Kipphan, desktop publishing became a "serious alternative" for pre-press production beginning in the 1980s, as a result of "the development of personal computers (PC) with full graphic capacity (e.g., Apple Macintosh), workstations, professional layout, graphic, and image processing software, the page description language PostScript, and high-resolution laser imagesetters with raster image processors (RIP)." By the 1990s, he notes that desktop publishing had "almost completely replaced the specialized composition and image editing systems as well as photomechanical reproduction." Kipphan, *Handbook of Print Media*, 27–28.

26. Schanilec, Gaylord. *My Colorful Career. With a Foreword by Henry Morris.* Newtown, PA: Bird & Bull Press, 1996, 36.

27. Moser, Barry. "Bookwright." Unpublished manuscript. Northampton, MA: 2022. We are grateful to Moser for sharing his unpublished book manuscript with us, and for granting us permission to cite from it.

28. Goldstein, Carl. *Print Culture in Early Modern France: Abraham Bosse and the Purposes of Print.* Cambridge: Cambridge University Press, 2012, 17.

29. Gregory King, who managed the printing office, claimed to have directed the engraving and said he engraved three or four of the maps himself. The map of Ipswich was only engraved in 1698, however, for a later edition of *Britannia.* The fragment could be from the 1698 edition, or it could be from a pirated edition, as Ogilby's maps were frequently copied. See Harley, J. B. "Introduction" to John Ogilby. *Britannia. London 1675.* Amsterdam: Theatrum Orbis Terrarum, 1970, xviii.

30. Rifkin, Benjamin A. and Michael J. Ackerman. *Human Anatomy: From the Renaissance to the Digital Age.* Biographies by Judith Folkenberg. New York: Abrams, 2006, 187.

31. Basil Hunnisett writes that a copper plate yielded "a maximum of 750 to 800 good impressions" and required "careful handling to preserve its clarity." Also, according to Hunnisett, only 130 "satisfactory" mezzotint prints could be made from copper plates before exhibiting wear in the printing process, which required special care. Meanwhile, Hunnisett cites a case in which 200,000 impressions were taken with a steel plate; he hastens to follow that "nothing like this number was needed at one time, but the two advantages of many more 'proof' impressions and the possibility of printing from plates time and again over a long period were considerable ones for the book trade." See Hunnisett, Basil. *Steel-Engraved Book Illustration in England.* London: Scolar Press, 1980, 187, 63, 24–27.

32. Hunnisett, *Steel-Engraved Book Illustration in England*, 18.

33. Hunnisett, *Steel-Engraved Book Illustration in England*, 33, 197–198.

34. The British antiquarian bookseller Simon Beattie, who sold the letter to RBS, writes: "It was probably printed at the instigation of the Earl of Guildford, the leading phil-hellene of his day, and first president of the Philomuse Society, founded in Athens in 1813–4 and dedicated to the education of Greek youth, to be sent to existing and/or new subscribers. It informs English members of the society that a separate branch is to be set up in London." Beattie notes that it is an early example of English lithography. See Simon Beattie's entry "All Greek" (29 September 2017) on his "Blog: Rare books, manuscripts, music, ephemera. . . .": <https://simonbeattie.co.uk/blog/archives/2366/>; accessed 27 February 2022.

35. Senefelder documented his discovery as taking place in 1798; see Twyman, Michael. *Lithography, 1800–1850*. London: University of Oxford Press, 1970, 11. Senefelder's experimentation with attempts at relief etching began in 1796; Simon Schmidt of Miesbach, according to his own testimony, had printed from relief-etched stone in Munich in the late 1780s (Twyman, *Lithography*, 6–7). For a summary of the invention, see Glaister, *Encyclopedia of the Book*, 298–299. Both Glaister and Twyman note that Senefelder only began using the term later in 1808 (see Twyman, *Lithography*, 4).

36. Twyman, *Lithography*, 3, 10.

37. Twyman, *Lithography*, 69.

38. For descriptions of transfer papers and methods, see Gascoigne, *How to Identify Prints*, 20 a. Also see "transfer" and "transfer paper" in Glaister, *Encyclopedia of the Book*, 483.

39. William Henry Fox Talbot's *The Pencil of Nature* (London: Longman, Brown, Green & Longmans, 1844–1846) is usually credited as the first illustrated book containing photographs; it contains salt prints. In 1843, Anna Atkins's book, *Photographs of British Algae*, contained cyanotypes, which created negatives of objects by placing them between glass and light-sensitive paper without the use of a camera. See Adam Silvia's "Photographically Illustrated Books and Photobooks," Library of Congress (2017): <https://www.loc.gov/rr/print/coll/photographically-illustrated-books-and-photobooks.html>; accessed 25 June 2022.

40. These constituted four different settings of type. See Todd, William B. and Ann Bowden. *Tauchnitz International Editions in English, 1841–1955: A Bibliographical History*. New York: Bibliographical Society of America, 1988, 123–24.

41. See Mills, Victoria. "Photography, Travel Writing, and Tactile Tourism: Extra-Illustrating The Marble Faun." In *Travel Writing, Visual Culture, and Form, 1760–1900*. Eds. Mary Henes and Brian H. Murray, 68. Basingstoke, U.K.: Palgrave Macmillan, 2016.

42. According to Susan S. Williams, most copies of Hawthorne's novel that were sold in this manner include between fifty and a hundred photographs, although she notes that some contain more than two hundred images. The copies in RBS's collection include a smaller number on average—suggesting that Williams's average may be higher than is actually representative. See Williams, Susan S. *Confounding Images: Photography and Portraiture in Antebellum American Fiction*. Philadelphia: University of Pennsylvania Press, 1997, 166.

43. Williams lists the costs of one purchaser as follows: "the book itself cost four lire, the bindings twenty, and the hundred photographs twenty-five lire." Williams, *Confounding Images*, 166.

44. Other novels marketed in this manner include Macaulay's *Lays of Ancient Rome*, Bulwer Lytton's *Last Days of Pompeii*, and George Eliot's *Romola*—also represented in RBS's teaching collection.

45. At the time, the Capitoline statue had not been photographed, and images of a similar faun at the Vatican were circulating. See Hawthorne's letter to Henry Bright. Hawthorne, Julian. *Nathaniel Hawthorne and His Wife: A Biography*. 2 vols. Boston and New York: Houghton, Mifflin, and Co., 1891, 2:255.

46. The publishing history of *Songs of Innocence and of Experience* is complex. Blake published *Songs of Innocence* first in 1789 (before *Songs of Experience*), and he continued to print both

Songs of Innocence and *Songs of Experience* separately even after combining the two in 1794. The William Blake Archive offers a detailed account of the various combinations of plates making up extant copies. The Trianon Press edition was based on the Lessing J. Rosenwald copy, sometime referred to as Copy Z, which was printed in 1826; the copy is held by the Library of Congress (call number PR4144.S6 1826). See "Songs of Innocence and of Experience (Composed 1789, 1794)": <http://www.blakearchive.org/work/songsie>; accessed 15 May 2022.

47. Copy Z, on which the Trianon facsimile was based, was colored by Blake's own hand, according to its original owner, Henry Crabb Robinson, who was a friend of Blake; the inscription is reproduced in the Trianon Press facsimile.

VI. BINDINGS

Bookbindings are the most public-facing components of books. Like the façade of a building, a book's covers announce its identity in the world, while also offering the text a practical form of protection. Bindings have sometimes been likened to mere containers or envelopes for their texts—comparisons that assume no relationship between the two. Yet bookbindings and their contents in many ways are inseparable. As Mirjam Foot has persuasively argued, "bindings are an essential part of book production, if we consider its full cycle from reader to writer."[1] Foot, who taught at Rare Book School from 1993 to 2002, likens the longer history of bookbinding to a "mirror of society" that reflects how books were sold and received, how they were valued, how they were used, and, ultimately, what they meant to individuals.

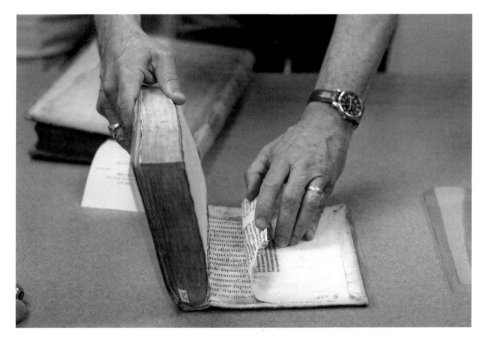

RBS faculty member Martin Antonetti examines manuscript waste in a binding as part of a classroom exercise for "The Printed Book in the West to 1800." Photograph by Shane Lin, 2019.

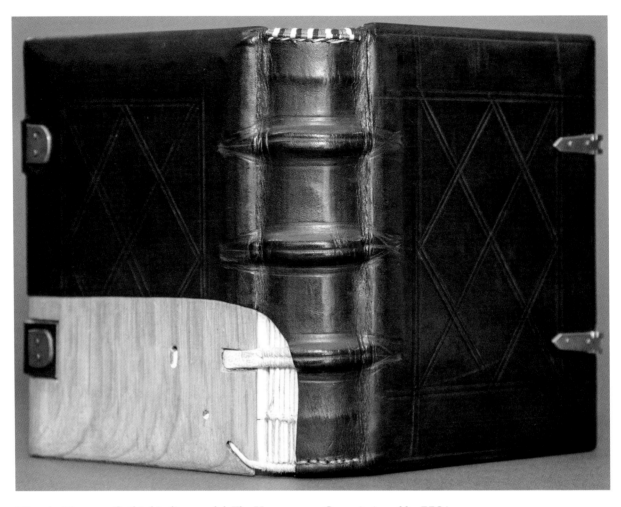

Winecke Meeuws. Gothic binding model. The Hague, 2004. Commissioned by RBS in 2004.

6.1
Gothic Binding
Model

This model, created by Dutch book conservator Winecke Meeuws, illustrates the binding of a typical book produced in Europe between the mid-twelfth and early fifteenth centuries. The book is bound in calfskin burnished with an agate stone and blind tooled by Meeuws with a bone folder. (Medieval bookbinders would have used a different tool.) Meeuws's model leaves part of the binding exposed, free of leather, to reveal the underlying sewing structure. The spine is slightly rounded, the boards beveled toward the spine, and the outer fore-edges fastened with brass clasps. In original examples, the text block would have parchment leaves; but to keep expenses within reason, Meeuws used paper to create the text block for her binding model. RBS uses this model, as well as several others, to teach students about the structures of medieval bindings. Actual medieval bindings are rare and extremely valuable, and they cannot be routinely handled in classroom settings.

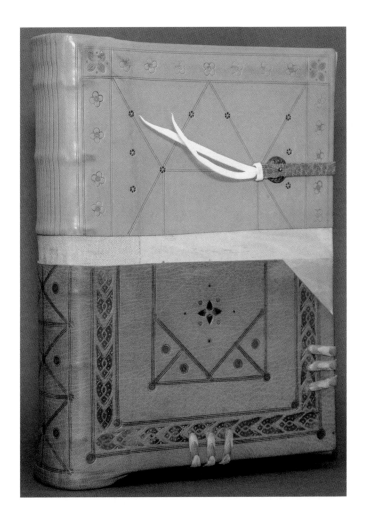

Gary Frost. Cutaway model showing (upper half) seventeenth-century Armenian and (lower half) thirteenth-century Greek binding structures. Made using stamping tools and metal fittings produced by Shanna Leino, 2001.

6.2 Two-in-One Binding Model

Book conservator Gary Frost created this binding model, whose upper half demonstrates features of seventeenth-century Armenian bindings while the lower half exhibits features of thirteenth-century Greek bindings. Although centuries separate the two binding styles, they both feature unsupported sewing, sewn-on wooden boards, and blind tooling. Greek-style bookbindings developed in the late Byzantine period (900–1400 CE). They are characterized by projecting endbands, boards cut to the same size as the text blocks, and grooves cut into the edges of the boards. The fastenings, visible on the lower portion of Frost's binding, often take the form of interlaced or braided leather straps laced through one board and attached to metal ring clasps that fit over metal edge pins on the other board. Armenian bookbindings (represented in the upper portion of this model) are distinguished by their inclusion of a fore-edge flap attached to the back cover and made of the same leather as the cover and blind-tooled in the same style. The leather on the spine is tooled with thin, vertical fillets meant to aid in opening the book. Inside, Armenian books use cloth as pastedowns, unlike the parchment or paper more often seen in early printed books. Frost created his model by referring to exemplars MSS 130, MSS 132, and MSS 996 from the Goodspeed Collection of New Testament Manuscripts at the Regenstein Library of the University of Chicago.

Late medieval and early modern binder's boards. Gift of the late antiquarian bookseller B. H. Breslauer.

<p style="margin-left:2em;">6.3
Wooden
Binder's Boards</p>

Beginning in the early Middle Ages[2] and through the 1500s, most European bookbindings that were intended to last were made from wooden boards.[3] Readers at the time had few books compared to what we have today; but they used them intensively and reread them often. The rigidity of the wood, when fastened with clasps, not only protected the book, but also helped to keep the parchment leaves inside from cockling, as it is prone to do with changes in temperature and humidity. Wooden boards continued to be used beyond the sixteenth century in Germanic regions; elsewhere in Europe, they were increasingly limited for binding religious texts, such as lectern bibles.[4]

Bookbinders generally sourced the wood locally: in Germany and Italy, beech was commonly used, while English and Dutch boards were frequently made from oak.[5] The edges of the earliest wooden boards were square, but, by the fifteenth century, they were beveled—and were sometimes adjusted to

accommodate clasps and catch plates, as can be seen in the larger of these two examples from RBS's teaching collection, where the board still retains bits of metal along its tapered edges. Although the board is worn, a close study of its construction by those with expertise in the history of bookbinding offer some insight into its possible origin. The positioning of the nail holes and slots for the clasps indicate that the original fastenings ran from the book's lower cover to its upper cover—also suggesting that the binding was possibly German or Dutch, according to past RBS faculty member Mirjam Foot. She also notes that the style of the beveling itself, which is more prominent at the head and tail than at the fore-edge and spine, points to the fact that the board dates from at least the fifteenth century. Its five sewing supports are cords made of hemp or flax; used in Carolingian bindings, they were reintroduced as a substitute for thongs made from animal skin in the fifteenth century.[6] The lacing-in channels are uneven in length—also a feature of German and Dutch bindings. The remnants of leather, which appears to be sheep, show that the binding was probably half or quarter bound; the remains of a manuscript end-leaf stub could have been used as board stabilizer. Our best guess, in close consultation with past and present RBS faculty, is that the board likely was made for a binding in the sixteenth century either in the Netherlands or Germany.[7]

The narrower fragmentary example is a board made of beech that was originally used on a late medieval binding. Despite the fact that less than half of the original board survives, much can be gleaned from what remains. The five split-strap alum-tawed sewing supports sit in rectangular channels that are secured in place with wooden wedges. Past RBS faculty member Nicholas Pickwood notes that, when the board was later reused in the sixteenth or seventeenth century, it was attached to a book block sewn on four double sewing supports using a tightly twisted cord frequently found in German bookbinding. Additional features suggest that the binding comes from Germany, such as the pairs of holes drilled at right angles to the spine edge of the board, as well as the small tapering grooves cut in the outer surface of the board at the head and tail of its back edge (which, according to Pickwoad, were probably made for the cores of stuck-on endbands sewn with a secondary sewing).

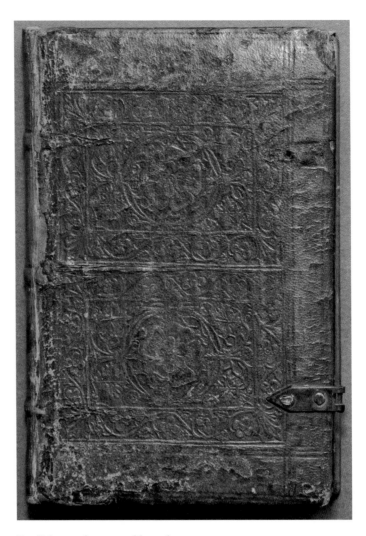

English panel-stamped board, ca. 1500.

**6.4
Panel Stamp
Binding from
Tudor England**

This binding specimen is the upper board of an English panel-stamped binding probably made just before the reign of Henry VIII (1491–1547; King of England: 1509–1547). The wooden board, retaining one original brass clasp, is covered in calfskin. Salvaged during the early twentieth century, it was later attached to a new binding, probably as an act of preservation; the later spine and lower cover are also bound in calfskin to match the older leather. The binding was owned by E. Gordon Duff (1863–1924), a bibliographer and librarian who was an expert on early English printing and bookbinding. The front pastedown of the binding contains a description in Duff's handwriting.

The blind-stamped design features two large Tudor roses surrounded by borders of intertwining foliage and flowers made by a panel stamp. Panel stamps carried representational images—such as these roses—or more abstract designs, and they typically were rectangular in shape, measuring between about 2 to 7¾ in. long.[8] Unlike smaller stamps and rolls, which are applied to bookbindings by hand, panel designs required additional pressure, owing to their size and the large surface area they covered; a press was required to imprint the stamp into the

leather. The advantage was that a panel stamp allowed for a large area of the cover to be decorated at once—a much faster method of embellishing a binding than creating designs using numerous small, individual tools. Panel stamps were first used in the Netherlands in the late fourteenth century, and they began to be used in England during the final quarter of the fifteenth century, circa 1495; their use continued until the second quarter of the seventeenth century.[9] This is a relatively early English example, frequently used for teaching at RBS.

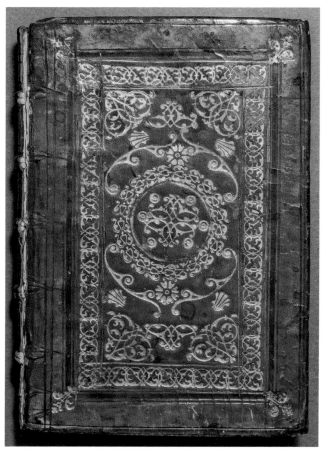

Pub. Terentii Aphri comoediae VI. . . . Lyon: Sebastian Gryphius, 1534. Gift of Mary Ann O'Brian Malkin.

At first glance, this sixteenth-century calf binding (probably French) looks impressive, but as RBS faculty member David Whitesell points out in his teaching notes, it is relatively shoddy work. The tooling is uneven in depth, the design was not laid out symmetrically, and, on the lower cover, a curved tool in the lower left-hand corner of the panel was stamped in the wrong area. The binder unsuccessfully attempted to cover up the mistake by removing the gold leaf. Additional shortcuts taken by the bookbinder in creating the binding's structure have caused it—after more than four centuries—to become very fragile. Books like this can be shown in class but are not handled directly by students in order to avoid further damage.

6.5
All That
Glitters. . . .

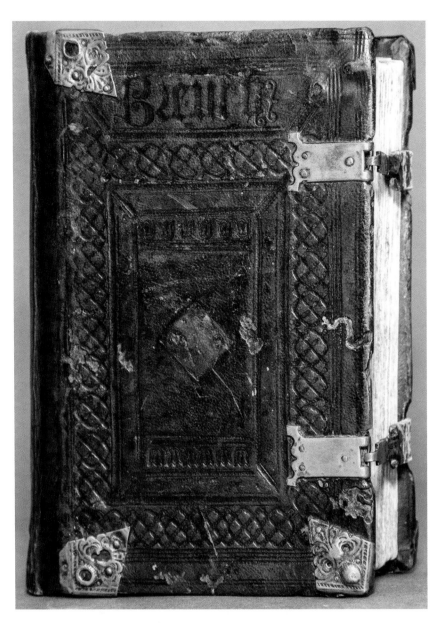

Breviarium s[ecundu]m chorum Pataviensis Ecclesie nuper impressum cum quotationibus in margine. [Venice]: [Peter Liechtenstein for] Leonardi Alantse bibliopole Vienne[n]sis, [1508]. Gift of George Arnstein.

6.6
Metal Furniture and Blind-Tooled Titling

This small, sixteenth-century octavo breviary, containing the liturgical service of the Roman Catholic Church, has multiple points of interest; it is used in eight different RBS courses. Printed throughout in red and black, it includes metal-cut decorated initials. The binding features blind-tooled decoration as well as an abbreviated title stamped on the top half of the upper cover. The book retains almost all its original brass furniture: bosses, corner pieces, and clasps. This metal furniture ensured that the book could withstand heavy use. The leather and tooling on the spine, however, are not original; at some point in the past century, the book was rebacked, and the tools used on the spine do not match those applied to the upper and lower covers.

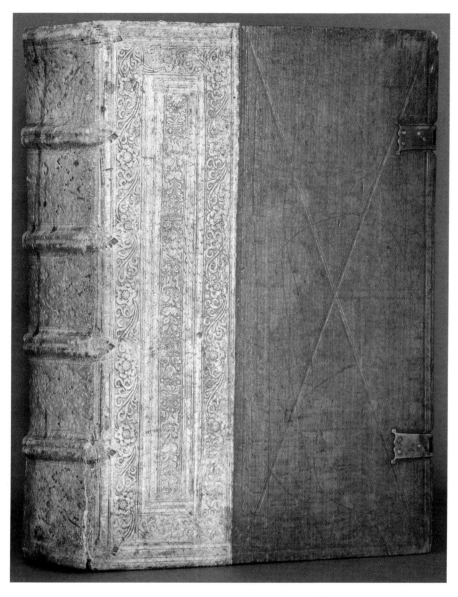

Lodovicus Caelius Rhodiginus. *Sicuti antiquarum lectionum commentarios concinnarat olim vindex Ceselius. . . .* Venice: In Aedibus Aldi, et Andreae Soceri, 1516. Gift of Jeremy Norman.

Pigskin was prepared in a different manner from other leathers used in bookbinding. It was usually tawed (softened and bleached using aluminum salts) rather than tanned (treated with an infusion of tannin-rich bark or similar agents). Pigskin was used as a binding leather primarily in German-speaking lands in the late Middle Ages and Renaissance and also in regions bordering on Germany, including Austria, Switzerland, and northern Italy (as is the likely case for this binding of an Aldine edition printed in Venice). Pigskin is most often white or grey in color; it can be identified by the visible follicle pattern of the pig's bristles, resembling three dots in the shape of an equilateral triangle. This book is half bound in blind-stamped, alum-tawed pigskin. The book's partially exposed wooden boards bear remnants of clasps visible on their fore-edges.

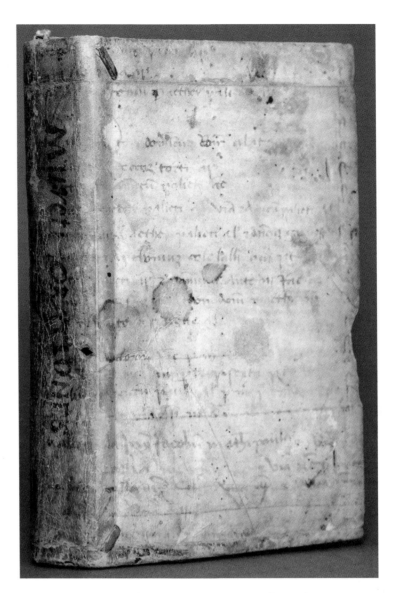

Marc-Antoine Muret. *Orationes. XXIII: Earum index statim post praefationem continetur: Eiusdem interpretatio quincti libri Ethicorum Aristotelis ad Nicomachum: Eiusdem hymni sacri, et alia quaedam poematia.* Venice: Apud Aldum, 1576.

6.8
Limp
Parchment
Binding

The Italian printer and publisher Aldus Manutius (d. 1515) is celebrated for issuing small, handy editions of classics written by ancient Roman and Greek authors as well as by contemporary humanist scholars. This later Aldine edition of a volume of the speeches by the French humanist Marc-Antoine Muret is bound in a limp parchment binding that was inexpensive and that could withstand regular handling. The binding also would have been easy to replace with a more elaborate binding if the owner wished. The endband cores have been laced in and through the parchment at head and tail, adding additional stability to the binding. The parchment is manuscript waste, now illegible, although some of the letterforms appear to correspond to those of late-medieval Italian scribes. The spine title, "Mureti Orationes," is hand lettered in ink.

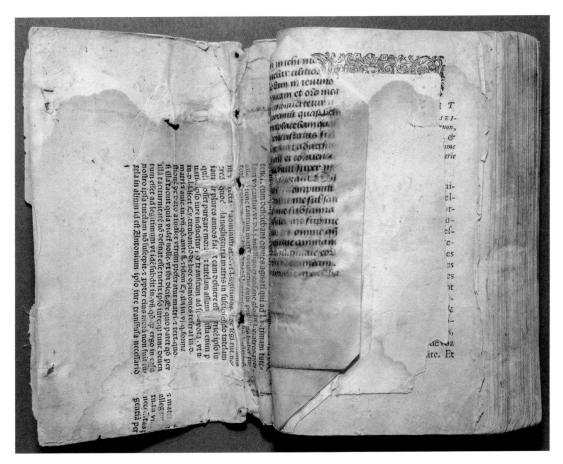

Ollenix du Mont sacré [Nicolas de Montreux]. *Les Bergeries de Julliette*. Vol. 2. [Lyon: Jean Veyrat, 1592.]
Gift of Louis H. Silverstein.

This odd volume from a popular French five-volume pastoral novel is an early example of a French laced-case binding with a cover lining that once had a full cover of parchment—an inexpensive form that, as past RBS faculty member Nicholas Pickwood writes, emerged during the last quarter of the sixteenth century in response to "a worsening of economic conditions across Europe and a general rise in prices" that began in the 1550s.[9] As Pickwood points out, there was an increasing shift away from books bound in boards toward limp parchment bindings, which were faster and cheaper to make; this kind of binding became a standard structure used throughout the seventeenth century in the French retail booktrade.

Although this particular volume's parchment cover no longer remains, the fragmentary nature of its interior allows for a close inspection of the book's original cover lining.[10] Pickwood notes that the lining is made from at least three paste-laminated sheets of printed waste, with each slip laced through three holes perpendicularly to the spine. The cover lining was then covered with a piece of white handmade laid paper that was likely applied to prevent the printed waste (which came from an Italian book of canon law) from showing through the book's thin parchment cover. Also visible is a separately sewn parchment guard made from two fragments of a small-format medieval French devotional manuscript, written in a *bâtarde* hand.

6.9
MS and Printed
Waste in a
Late 16th-Century
Cheap Binding

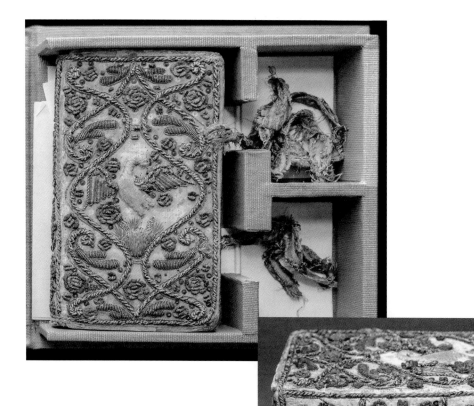

The Holy Bible: Containing the Olde Testament and the New. London: Printed by Robert Barker, Printer to the King's Most Excellent Majesty, 1635. Gift of Elizabeth M. Riley.

6.10
Luxury
Embroidered
Binding

This embroidered binding, which covers a copy of the Bible, was made in seventeenth-century England. Textiles such as canvas, silk, and velvet have been used for luxury European bookbinding since the medieval period.[11] But they were especially popular in England during the first half of the seventeenth century, and they are often found on copies of religious texts. Mirjam Foot points out that embroidered bindings were often made for women.[12] The example shown here was given to Katherine Underwood as a gift from her mother, as the contemporary ownership inscription on the Bible's front pastedown indicates. The binding is bound in cream silk satin (now faded), with a swan taking flight embroidered in silk and silver threads in the center of the design, which also includes a pineapple, stitched in yellow and green silk, amid flowers sewn in teal and rose silken thread. The binding's ties—cream silk edged in pink and embroidered in metallic thread—are torn but remain largely intact. The binding is adorned with sequins that have tarnished with age, but that would have flashed in candlelight, along with the metallic threads.

This wrapped-back binding, or *baobeizhuang*, was created in 1655 for the *Yuzhu taishang ganying pian* (御註太上感應篇), a traditional moralistic work, compiled by the Shunzhi Emperor Fulin (1638–1661). The binding has not been altered since the book was bound for this early Qing palace edition (i.e., a publication of the Qing imperial printing office).[13] As opposed to a Western-style codex, whose flat sheets are typically printed on both sides and then folded into folio, quarto, octavo, or duodecimo gatherings before being trimmed to form individual leaves, the sheets used to print this book were printed on just one side and then folded in half at their center columns, with the printed text on the outside and the blank sides hidden on the inside of the folded sheets. The binder piled the folded sheets together to form a text block, with the folded edges serving as the book's fore-edge. The binder then pierced the free edges with holes and threaded them with strips of sturdy, long-fibered paper twisted to form "spills," creating the back of the text block. The binder covered the back with a thin coating of paste, and attached a cover made from a single piece of durable paper. Alternatively, the binder could use a single piece of cloth, or could join separate pieces of cloth or paper with a strip of material to wrap them and the spine—again with a light coating of paste.

6.11
Wrapped-Back
Binding for Qing
Palace Edition
(包背裝)

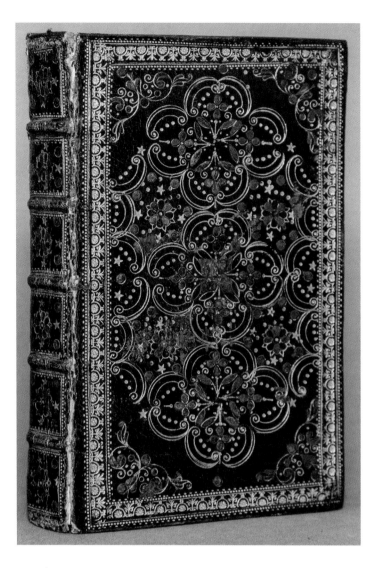

*The Gentleman's Calling.
Written by the Author of the
Whole Duty of Man*. London:
Printed by R. Norton for
Robert Pawlet, 1679. Bound
with *The Ladies Calling. In
Two Parts. By the Author of
the Whole Duty of Man*. . . .
[Oxford]: At the Theater in
Oxford, 1677.

6.12
Work of the
Queen's Binder?
A 17th-Century
Fine Binding from
England

This strikingly decorated seventeenth-century book, bound in black goatskin, encloses two texts: *The Gentleman's Calling* and *The Ladies Calling*. Its upper and lower covers prominently feature drawer-handle-style ornaments, tooled in gold, along with stylized gilt flowers, stars, dots, and arabesque corner pieces. The elaborate rolled border, also tooled in gold, contains a distinctive small floral pattern resembling a sunburst. The six compartments of the spine are tooled in gold with stars and flowers that echo the designs of the binding's covers. The covers and spine alike have been decorated in silver paint that has now tarnished. The book's front-free endpaper contains the ownership inscription in a seventeenth-century hand: "Sarah Crocker | Her Book."

The motif of round four-petaled flowers, springing from pairs of leaves, is a distinctive pattern associated with the Queen's Binder B.[14] Notably, one of the Queen's Binder B examples that Howard M. Nixon describes is also found on a copy of *The Ladies Calling*. RBS's binding appears to incorporate not only the same tools but also the roll used on that binding. Another Queen's Binder B binding described by Nixon and by past RBS faculty member Mirjam Foot makes use of the same tools and is decorated with black and silver paint.[15]

Scaligerana, ou, Bons mots: rencontres agreables, et remarques judicieuses & sçavantes de J. Scaliger; avec des notes de Mr. Le Fevre et de Mr. de Colomies; le tout disposé par ordre alphabetique en cette nouvelle edition. Cologne: n.p., 1695. Gift of Bruce McKittrick.

This seventeenth-century French imprint is quarter bound in parchment and marbled paper boards—a covering that became popular later in the eighteenth century for binding quarter- and half-bound books after marbled paper first came into use in Europe during the prior century. The innovation offered a less expensive alternative to full leather-covered bindings during a time when leather was increasingly expensive and needed for other purposes (including shoes and clothing).[16] But the marbled paper was also appealing for its beauty. For centuries, it embellished objects of everyday use, from the interior linings of trunks and other containers, such as boxes and wallets, to wrappings for commercial goods.

Invented well before 1000 CE in East Asia, marbling was practiced in the Middle East prior to 1500. Methods varied, but the technique entailed laying a sheet of paper onto the surface of a viscous bath, on top of which liquid colors were combed or stirred into various patterns. The bath contained substances such as gum tragacanth or carragheen moss, which allowed the colors to float on the surface of the water without sinking. Marbling was introduced in Europe toward the end of the sixteenth century, when European travelers in the Near East, Persia, and Turkey observed marbled papers and sent or brought samples home.

6.13
Marbled Boards

Shortly afterward, it began to be made in Europe—probably, first in Germany and then either in France or Italy (although it did not take root in the latter country until much later).[17] Most European seventeenth- and eighteenth-century marbled paper was produced either in Germany or France, which excelled at the art both in terms of quality and production. According to RBS faculty member David Pearson, marbled paper began to be produced in England and the Netherlands only in the eighteenth century.[18]

The marbled paper on this 1695 volume is contemporary with the production of the book's text, which is a compilation of the thoughts and opinions of Joseph Justus Scaliger (1540–1609). Scaliger was a learned Calvinist philologist and historian whose books were both admired for their formidable erudition and feared for their caustic criticism. The publisher of this edition identified it only with the single word, "Cologne," and even that may be false, given the inflammatory nature of the book's contents. Its acerbic remarks include criticism of the Jesuits. The book bears the bookplate of Aloys, Count von Harrach (1669–1748), an Austrian diplomat and nobleman.[19]

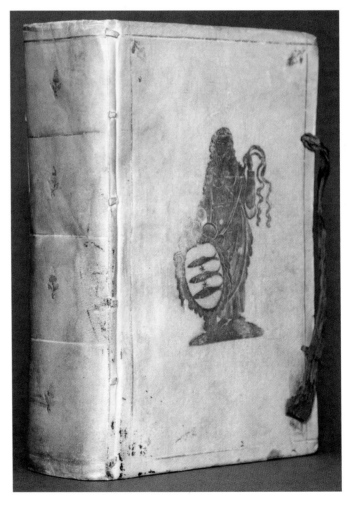

C. Julii Cæsaris quæ extant cum notis et animadversionibus Dionysii Vossii. . . . Amsterdam: P. & J. Blaeu, 1697.

Prize bindings were an important segment of the upmarket binding trade in eighteenth-century Netherlands. The books were distributed as prizes to students in the forty-odd Latin schools that existed in the republic. They were most often bound in parchment and stamped or tooled on the upper and lower covers with the arms of the city or town in which the school was located. The figure of a woman bearing a shield on the cover of this binding represents the arms of the town of Enkhuizen. According to past RBS faculty member Jan Storm van Leeuwen, the stamp used to impress the heraldic image on the upper cover would have been the property of the town, rather than of the binder;[20] it was lent out as needed. The earliest known prize binding with this stamp dates from 1657, and it was used throughout the century on other bindings awarded to the students of the Enkhuizen school.

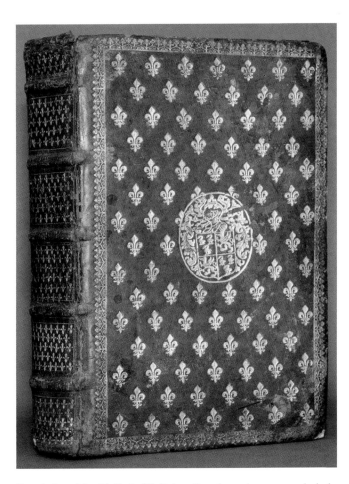

Dominicus Nani Mirabelli. *Polyanthea, hoc est, opus suavissimis floribus celebriorum sententiarum tam Graecarum quam Latinarum exornatum.* . . . Lyons: H. E. Vignon, 1600.

This French prize binding is an example of a *semé*, or semis, binding pattern, in which the surface of the leather is profusely decorated with repeated and regularly arranged small tools within a frame. The upper and lower covers also bear the armorial stamp of Thomas Morant, Baron du Mesnil-Garnier, a domain in

Normandy. In 1620, Morant instituted a prize program for the Jesuit Collège de Mont in Caen, and, as part of the program, he required that prizes be distributed to students in his name in perpetuity. And so, although the book's text is dated 1600, its binding was created after 1620. Albert Bruas, a nineteenth-century French historian of the Morant family, describes a similar prize binding with *fleur de lys semis* and with a 1692 inscription in his personal collection.[21]

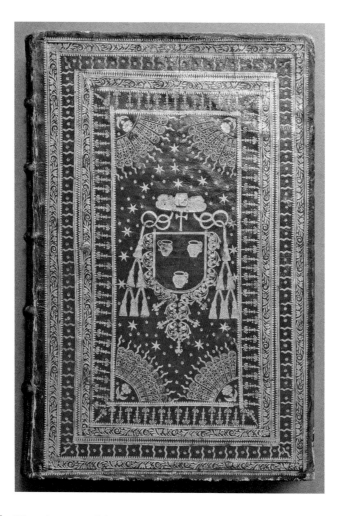

Don Blasio Altimaro. *De nullitatibus contractuum, quasi contractuum, distractuum, ultimarum, et quorumcumque actuum extraiudicalium. . . . Rubricae primae, pars quarta.* Naples: Caroli Porpora & Nicolai Abri, 1704.

6.16
Elaborately Tooled
Presentation
Binding with
Armorial Stamp

This large and luxurious early eighteenth-century bookbinding is from a six-volume set that was intended for presentation to Francesco Pignatelli (1652–1734), a cardinal of the Holy Roman Church, by the Italian author Don Blasio Altimaro, who likely hoped to gain financial support or other forms of patronage in return for his gift. It is fully bound in crimson goatskin and elaborately tooled in gold, with gilt edges and marbled pastedowns. RBS faculty member David Whitesell points out the presence of blind-scored lines dividing the upper and lower covers into four equal quadrants. These lines were made by the binder to help plot out the complex, symmetrical tooling design. The binder used two rolls and nearly a dozen hand tools to create the intricate pattern on the covers and the spine. The covers were stamped with Pignatelli's arms. The flat galero hat and tassels above his coat of arms indicate his high ecclesiastical rank.

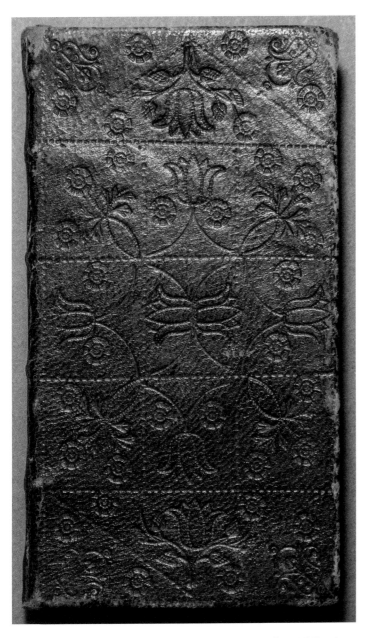

N. Brady and N. Tate. *A New Version of the Psalms of David Fitted to the Tunes Used in Churches.* London: Printed for the Company of Stationers, 1706.

This copy of *The Psalms of David*, printed in 1706, was bound in what is known as a somber binding. Somber bindings were made in England for about fifty years, between 1670 and 1720.[22] Their dark, sober covers appeared on bibles and devotional books, and they may have been used during periods of mourning or for the purpose of observing Lent.[23] Their distinctive covers of fine, black goatskin feature tooling in blind.[24] This specimen from RBS's collection is elaborately decorated with a combination of intertwining tulips and flowers within a dashed geometric design. Its edges, now worn, were stained black—a common feature of the style. This copy contains a contemporary ownership inscription: "Anna Grahame | Her Book."

6.17
A Somber Binding

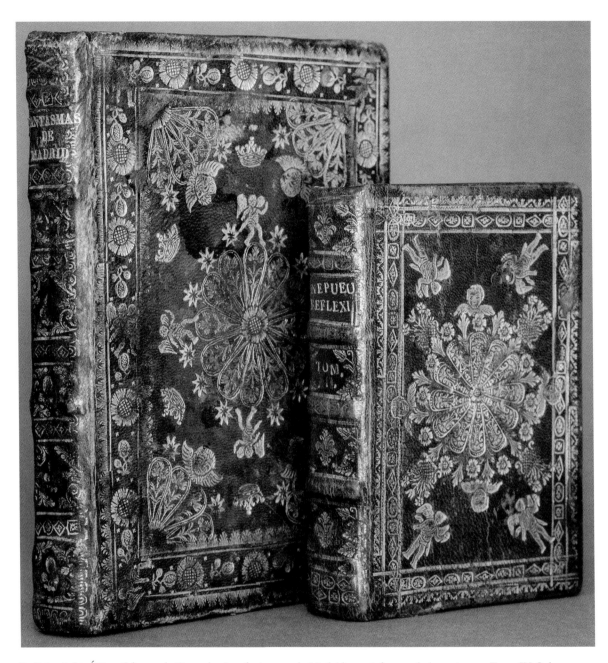

Left to right: Íñigo Gómez de Barreda. *Las fantasmas de Madrid, y estafermos de la corte. . . . Tomo IV.* Salamanca: Antonio Villargordo, 1763; François Nepveu. *Pensamientos: o Reflexiones christianas, para todos los dias de el año. . . . Tomo III. Iulio, Agosto, y Septiembre.* Barcelona: Maria Angela Martì Viuda, 1755.

6.18
Figurative Tools
and Gauffered
Edges

These two eighteenth-century Spanish books probably belonged to the same owner, who had them bound in a similar fashion. Both books are bound in goatskin decorated with a gold-tooled central fan motif, as well as several different tools depicting cupids. Additionally, there are gilt and gauffered edges. Red spine labels, such as the one featured here, became more prevalent as part of the design of European bookbindings during the first half of the eighteenth century. Both books bear evenly spaced holes on the outer portions of the upper and lower boards, which indicate that they originally featured either clasps or textile ties.

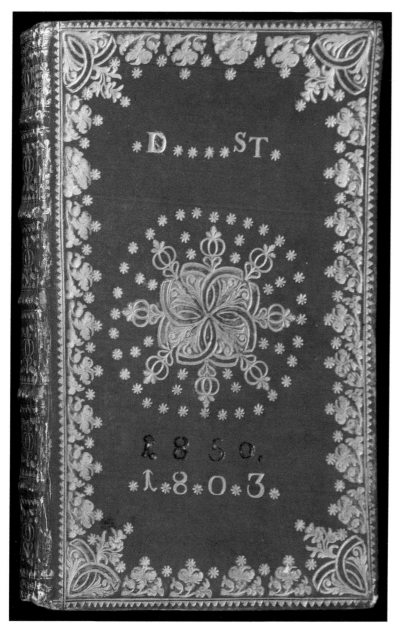

P. Sebastian Sailer. *Christliche Tageszeit in auferbaulichen seinen Bildern, zu Morgen, Wese, Reise, und Abend. . . .* Wien: [Kurzböck], [1769]. Bound with *Der Creuzweg Jesu Christi durck Betrachtungen in Versen entworfen.* Wien: Joseph Kurzböck, 1769.

This eighteenth-century Vienna imprint, containing two devotional texts, bears a somewhat later binding created in the nineteenth century. The red leather, of excellent quality, is gold tooled with a floral frame and central interlaced motif. The upper cover is tooled *D****ST* —probably a name in code—followed by two dates: 1803 and 1850. The second date was tooled in blind with much greater force than the initial date of 1803 in gold. (The precise significance of these dates remains unclear.) Tooling an owner's name on the binding was not particularly common after the eighteenth century, according to RBS faculty member David Pearson.

6.19
Sammelband
Tooled with
Dates and
Owner's Initials

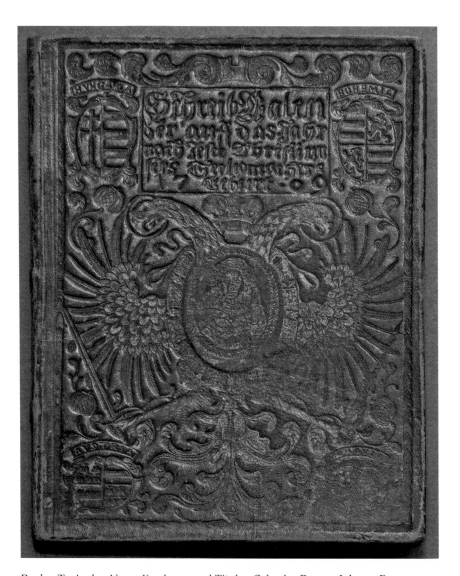

Paulus Turinsky. *Neuer Krackauer und Titular-Calender*. Brunn: Johann Franz
Swoboda, [1708]. Purchased with funds provided by the B. H. Breslauer
Foundation.

6.20
Early Trade
Binding in
Leather

Before the end of the eighteenth century, most European books were sold
in cheap or temporary bindings, typically made from parchment, paper, or
lightweight cardboard. Customers could then commission new bindings of their
choice for their copies. When sales of popular titles were certain, however, or
when books would be used immediately after purchase (e.g., almanacs, diaries),
the publisher or bookseller sometimes had texts bound in leather-covered boards
in advance of sale. This leather-bound almanac is a very early example of this
practice; its cover bears a title stamp "Schreib Calen | der auff das Jahr | [. . .]"
with space left below the stamp so that the year (in this case 1709) could be added
either in manuscript or with a letter palette. The upper cover is stamped in gold
with the double-eagle emblem of the Holy Roman Empire accompanied by arms
representing Hungary, Bohemia, Austria, and Moravia; the lower cover bears a
similar heraldic stamp in silver.

Bunyan, J[ohn].
*The Doctrine of the Law
and Grace Unfolded.*
London: Printed for W.
Johnston, 1760. Gift of
David Richardson.

This eighteenth-century copy of John Bunyan's *The Doctrine of the Law and Grace Unfolded* (London, 1760) is a scarce and early example of an English publisher's use of a plain textile as a covering material for a cheap bookbinding. Indeed, it is considered by some on RBS's faculty to be the earliest known example of its kind.

A form of a trade bookbinding, publishers' bindings were made at the order of the publisher in advance of retail sale, as opposed to books that were sold in sheets or in temporary bindings before being custom bound at the expense of owners. Trade bindings in leather and paper date as early as the seventeenth century onward.[25] Cloth-covered bindings in the form of canvas were introduced later, beginning in the 1760s, possibly as the result of a shortage of leather.[26] Canvas was certainly less expensive than leather while also being able to withstand heavy use.

This example appears on a book published by W. Johnston, whose name is associated with a number of the very earliest examples of bookbinding of this kind.[27] The binding is very plain and unadorned in its original brown linen canvas. It was an expedient and inexpensive form of binding—one in which the boards

6.21

An Early
Publisher's
Canvas-Covered
Binding

were attached to the text block with alum-tawed slips stabbed through the leaves' inner margin, a method sometimes referred to as being "stitched in the common manner."[28] RBS's copy belonged to the bookbinding historian Howard M. Nixon, who was able to find multiple copies of this book identically bound. His penciled notes are included on the binding's front-free endpaper facing a contemporary ownership inscription made by an individual named Samuel Tillow.

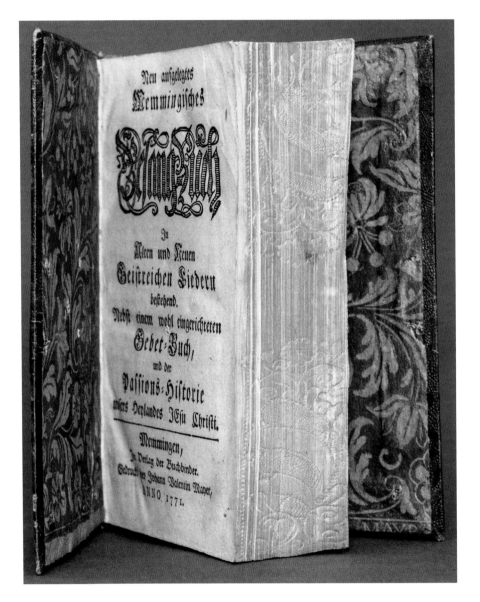

Johann Mayer. *Neu aufgelegtes Memmingisches Gesangbuch*. Memmingen: Johann Mayer, 1771.

6.22
Dutch Gilt
Endpapers

The striking Dutch gilt endpapers in this Bavarian hymnal are sometimes referred to as "Dutch flowered papers." Despite their name, these luxury, decorative papers were made in Germany and Italy; they were frequently imported into France and England through Holland, however, hence the term. Dutch gilt paper, which began to be made around 1700, emulated the rich brocade textiles of the time. They were only occasionally used as endpapers; more often, they were used as paper bindings for pamphlets, chapbooks, and works of music.[29]

According to Don Etherington, Dutch gilt paper was printed using wooden or metal relief blocks—or with engraved metal rollers—to apply a solution of gold size to the paper. Workmen then dusted gold onto the paper's surface after the size had dried to the appropriate tackiness. The size could be thickened with yellow ochre or red-colored lead to allow the gold to stand in relief on the paper's surface.[30] The example here was created using paper dyed pink. Other Dutch gilt papers sometimes featured multiple colors, which would have been applied by dabbing or stenciling. Note that the fore-edge is gilt and gauffered.

Wiener Kalenderl auf das Jahr 1777 [*Viennese Calendar for the Year 1777*]. Wien: Sebastian Hartl, [1776].

6.23 18th-Century Viennese Deluxe Miniature Binding

This miniature almanac, measuring 2.75 by 1 in., was created in Vienna in 1776. Its outer case—covered in pink glazed paper and stamped in silver—is embedded within a carved wooden case shaped and painted to look like a Viennese bread roll! (The case opens into two separate parts.) Luxury eighteenth-century almanacs were akin to fashion accessories, and this particular binding would have stood out as being unusual. At the same time, the wooden case serves a practical purpose, providing extra protection for the delicate book within. The almanac is bound in blind-embossed, glazed, cream-colored paper that has been hand painted with two figures: a musician with a bagpipe on the upper cover, and a woman holding flowers on the lower cover. The inside of the upper cover features a mirror—and the inside of the lower cover contains a pocket of Dutch gilt paper containing a folding table of various foreign currencies, with their equivalents in the local legal tender. The almanac itself is printed in red and black, and it features full-page intaglio illustrations for each month. This extraordinary little volume, with all of its bells and whistles, was essentially a calling card for a Sebastian Hartl, a Viennese bookbinder and bookseller. Hartl catered to the wealthy and sold other luxury goods in his shop, such as English hand powder (probably used for wearing gloves), as we see in the advertisement included at the end of the almanac: "Es ist auch das Englische Hand Pulwer in Comission bey Sebastian Hartl in der Singerstrassen bey den St. Stephans Thor in den Gewölb Paquet a 34 x."

The Four Medical Tantras (Tib. *rgyud bzhi*, རྒྱུད་བཞི་). N.p. [probably Beijing], n.d. [ca. 1750].

6.24
A Tibetan Text
Clothed in a Robe
and Belt

This binding contains a Tibetan *pecha* ("book" in Tibetan) known as *The Four Medical Tantras* (Tib. *rgyud bzhi*, རྒྱུད་བཞི་). It is wrapped within a cloth (*na bza'* or ན་བཟའ་, "robe") and tied with a cord (*ska rags* or སྐ་རགས་, "belt")—terms that, in Tibetan, echo language used for clothing worn by monastics. As Hildegard Diemberger has observed, "books were in fact addressed as honorific persons and not as mere objects."[31] In Tibet, Buddhist writings are often seen as living embodiments of religious teachers. The texts themselves have been transmitted—both orally and in writing—through long lineages of realized practitioners stretching back into the distant past. This particular text, which serves as the foundational work for the Tibetan medical tradition, is thought by many to have originated with the teachings of Śākyamuni Buddha before being subsequently translated into the Tibetan language.[32] It was produced and handled with great respect, as is indicated, in part, by the book's large size.

This particular text of *The Four Medical Tantras*, which was printed from blocks probably cut during the middle of the eighteenth century, contains printed Chinese lettering. The cord wrapping the cloth around the *pecha* is weighted with a Chinese coin that dates from the late nineteenth or early twentieth century, when this copy of the text was most likely printed.[33] The Chinese text reads "Guangxu tongbao" (光緒通寶)—Guangxu (1871–1908) being the second-to-last emperor of the Qing dynasty. The reverse side of the coin bears text in the Manchu language. The book was almost certainly made in Beijing, according to RBS faculty member Benjamin J. Nourse. And, as Geshe Ngawang Sonam pointed out when visiting RBS's collection, there is a long history of Tibetan lamas traveling to China who practiced medicine—including Changkya Rölpé Dorjé (1717–1786), who served as the principal Tibetan Buddhist teacher in the court of the Qianlong Emperor. The Chinese origin is therefore of particular interest.

Wooden sewing frame with text block.

In Europe and North America, from the hand-press period to the present, binders have used wooden frames to facilitate the sewing of gatherings. RBS's teaching collection includes several wooden sewing frames. This one is used for bookbinding demonstrations that illustrate how codices are sewn. Once all the folded gatherings of a book are assembled in their correct sequence by a bindery employee, the individual responsible for sewing the textblock "strings up" the frame with five lay cords that hang from the frame's cross bar. The sewer then fastens each sewing cord to a lay cord, securing each under the bed of the sewing frame with a brass key—or in the case of this frame, a wooden key. The gatherings are then sewn together through each fold and around the sewing supports (cords or tapes). Once the sewing is completed, the back of the book is pasted up, rounded, and backed. The rows of unsupported sewing at the head and tail of this particular example are kettle stitches.

6.25
Sewing Frame

Sewing techniques vary by time and region. When sewing structures are visible, they can prove extremely useful for dating and localizing bindings. While Western bindings made during the hand-press period were most often supported or sewn onto cords, unsupported sewing structures in which one gathering is sewn directly to its neighboring gatherings predominated in the Islamic world. Sewing frames were generally not used in East Asia.

Folding printed leaves into gatherings and sewing were among the last stages of book production to be mechanized. Women most often carried out these processes in European and North American binderies up until the twentieth century.

"Diced Russia" [full eighteenth-century reindeer skin].

6.26
18th-Century
Reindeer Skin

Among Rare Book School's many teaching collections is an eighteenth-century reindeer skin that was recovered among other cargo in 1973, when divers from the Plymouth Sound branch of the British Sub Aqua Club discovered the shipwreck of the Danish brigantine *Die Frau Metta Catharina von Flensburg*, which sank more than two hundred years ago in 1786. This skin was among many other bundles of hides that had been preserved in the black mud of the seabed. The cargo was documented specifically as "hemp and reindeer hide." According to the SHIPS Project: "In December 1786 the *Catharina* was carrying a cargo of hemp and reindeer hide to Genoa from Saint Petersburg when worsening weather compelled her to seek shelter in Plymouth Sound."[34] There was a trade in Russian reindeer skin at the time—particularly among the indigenous Sámi peoples of the Nordic countries and northwestern Russia, who were probably the source of this particular skin.[35]

Nicknamed "Rudolph" by Terry Belanger, the skin serves as an example of "diced Russia," a material used for binding books, as well as other purposes, such as upholstery. The act of dicing leather entails impressing its surface using one or two plates engraved with a lattice pattern.[36] Soaked in willow bark and tanned with birch oil, diced Russia is known for its ability to resist insects and water—although few skins are likely ever tested in the same way as was this one. RBS obtained the skin through the good offices of past RBS faculty member Nicholas Pickwood, who taught courses on bookbinding at the School for many years. Pickwood hand delivered the skin to Charlottesville in the winter of 2003.

Selection of examples from RBS's Leather Board Samples kit.

These detached leather-covered boards are from a teaching kit assembled for use in courses on the history of bookbinding. The kit includes seven boxes, each containing thirteen individual leather-covered boards dating from the eighteenth to the twentieth centuries. In her course, "Introduction to the History of Bookbinding," RBS faculty member Karen Limper-Herz has students use these boards to practice the identification of various forms of leather (e.g., goatskin, calfskin, sheepskin) and also to make rubbings, which are created by laying a thin sheet of paper onto the binding and then lightly rubbing a piece of soft graphite over the surface of the paper. Rubbings of bindings capture the three-dimensionality of tooling on leather and the actual scale of the tools in a way that is not easily replicated by two-dimensional reproductions (e.g., photographs). Learning to make a rubbing takes practice, however, and it is prudent for students to try out the technique on these boards that are already detached rather than on intact bindings!

6.27
Leather-Covered
Board Samples

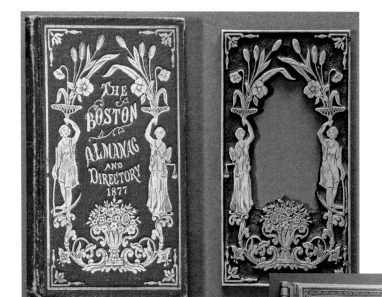

Left: *The Boston Almanac and Directory.*
Boston: Sampson, Davenport and Co, [1876],
with its brass stamping die, ca. 1877. Gift of
Todd Pattison.

Below: Theodore Child. *Art and Criticism:
Monographs and Studies.* New York: Harper &
Brothers, 1892, with its brass stamping die,
ca. 1892.

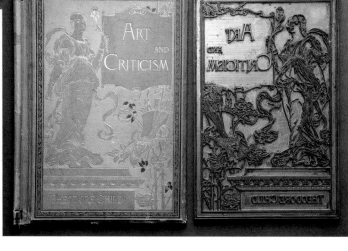

6.28
Brass
Stamping Dies
for Publishers'
Cloth-Covered
Bindings

In the late 1820s and early 1830s, bookbinders in England adapted iron printing presses to decorate bindings in a way that allowed flat cloth and leather binding cases to be stamped or embossed in only a single impression. Each case—first stamped in blind and then again in gold with brass stamping dies—would then be attached to a book block, thus forming an upper and lower cover, as well as a spine. The first gold-stamped cloth cases were produced in England in 1832, and the technology was adopted in the United States by 1834. Soon afterward, steam-powered cloth-stamping presses were introduced in the 1850s. Creating stamping dies was in itself a labor-intensive process. Stamping dies were cut in brass entirely by hand until first half of the nineteenth century. Even though powered cutting tools were introduced later in the century, intricate details still had to be cut by hand. The dies were often attached to stamping presses with screws. For example, two screw holes are visible in this *Boston Almanac* brass stamping die. As Todd Pattison points out in his RBS course on American publishers' bookbindings, most covers were decorated with a combination of separate dies assembled for stamping. The cover for *Art and Criticism* was produced using two dies: one for the floral border, and one, shown here, that was used to stamp the cover title and illustration.

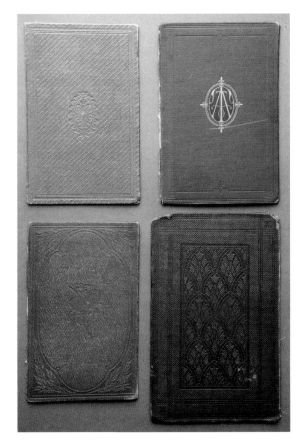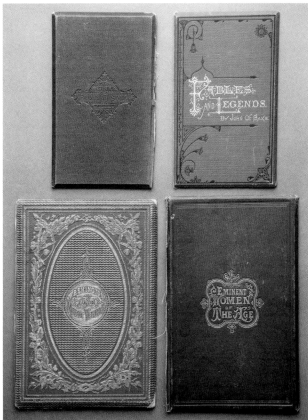

Sample boards from RBS's Gaskell Cloth Binding Boards and Tanselle Cloth Binding Boards teaching sets, updated to include categories from Andrea Krupp's *Bookcloth in England and America, 1823–50.*

Over the course of several decades, RBS staff salvaged and repurposed the boards of broken copies of nineteenth-century publishers' cloth-covered bindings to create teaching kits that instruct students in how to identify and classify nineteenth-century binding cloth grains. Why attend so closely to details as minute as bookcloth grain? As the late Sue Allen once pointed out, cloth grains are "historical, unique, and uncopyable": "Not only can we date bindings by a knowledge of grain development, but they are also an essential part of our tactile and visual experience of the book covers."[37]

Two of RBS's teaching sets are shown. The first is based on G. T. Tanselle's foundational article, "The Bibliographical Description of Patterns" (1970), in which he affirms that the two essentials in the bibliographical description of patterns are "a standard of terminology and a visual standard of reference."[38] The second kit is keyed to Philip Gaskell's 1972 classification scheme, which builds on Tanselle's work.[39] In both kits, the author, title, imprint, and date of the book in question are noted on the pastedown of each individual board, which is also labeled with corresponding identification information from Tanselle or Gaskell. In 2008, both sets of boards were updated to include additional cloth-grain nomenclature developed by the conservator Andrea Krupp and presented in her invaluable guide, *Bookcloth in England and America, 1823–50.*[40] Krupp's book draws on her work for The Library Company of Philadelphia's 19th Century Cloth Bindings

6.29
Nomenclature and Classifications for Bookcloth Grains

Database—a project that led Krupp and her colleagues to identify 160 new bookcloth grain patterns.[40] Krupp's field guide takes advantage of new levels of detail made possible by digital color photographic reproduction, which did not exist when Tanselle and Gaskell first published their research.

By assembling and identifying actual samples of bookcloth grains, these teaching kits allow RBS students to experience firsthand the visual and tactile quality of nineteenth-century bookcloth.

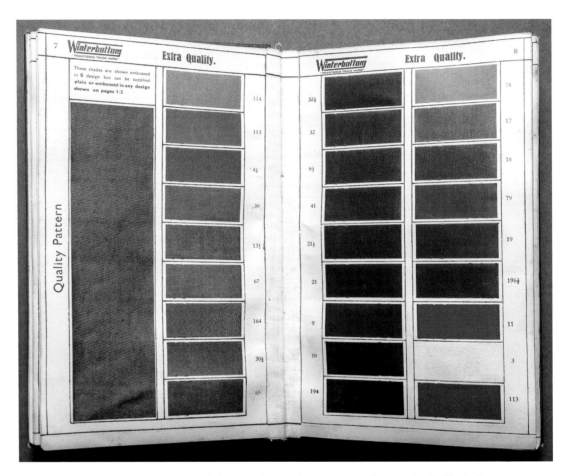

Book Cloth by the Winterbottom Book Cloth Co., Ltd. Manchester: Winterbottom Book Cloth Co., ca. 1935. Gift of Dorothy Tomlinson.

6.30
Binding Cloth
Sample Book

The Winterbottom Book Cloth Company, founded in 1891, dominated the book-cloth trade in the United Kingdom and United States, as well as Germany, for much of the twentieth century before closing in 1980. This 1935 pattern book provides samples of the different shades, qualities, and designs (or "grains") of bookcloth available through Winterbottom. William "Bill" Tomlinson, who wrote the definitive history of the firm and who worked there, explains how these sample books were an important part of Winterbottom's success, even if they were painstaking to produce: it took a semi-skilled bookbinder a whole day to assemble one pattern book. The pattern books are now very scarce, because Winterbottom required that clients return them to the firm before being issued a new one.

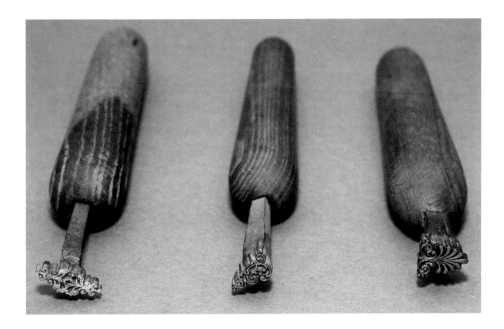

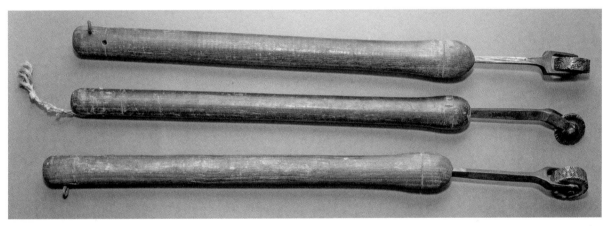

Three brass decorative tools and three brass rolls with wooden handles, ca. 1865. Gift of Anne De LaTour Hopper and Duane Hopper.

After her studies at the École de l'Union Centrale des Arts Décoratifs, Anne De LaTour Hopper (b. 1941) purchased a large collection of several hundred brass binding tools, rolls, pallets, and alphabets from an unidentified bookbinder in Paris who was leaving the trade. During her time spent working in various Paris binderies, and later in the bindery of James MacDonald in New York City, she did not have a chance to use these tools, and they remained in storage until Hopper and her husband donated the collection to RBS in 2019. Two of the rolls bear the mark "Baerel," one of the major Parisian engravers of binding tools in the nineteenth century. They are now used in bookbinding demonstrations and tooling exercises in the RBS course, "Introduction to the History of Book-binding," taught by Karen Limper-Herz.

6.31
Brass Decorative
Tools from a
Parisian Bindery

Francesco Petrarca. *Rime scelte.*
[London]: [T. Becket, William
Bulmer & Co.], 1801. Purchased
with support of the AKC Fund.

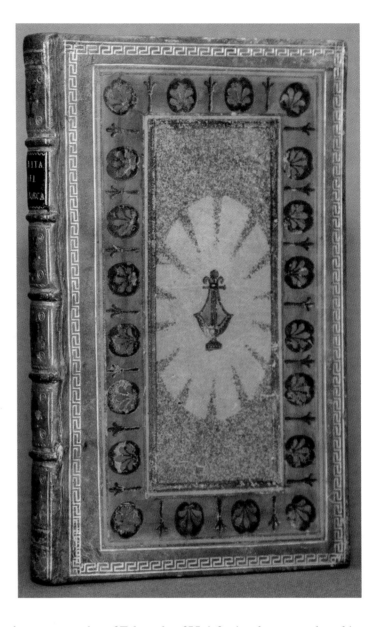

6.32
Etruscan Binding
in the Style of
Edwards of Halifax

RBS has long sought out examples of Edwards of Halifax bindings, produced by the binding and bookselling enterprise founded by William Edwards (1723–1808) in the English town of Halifax. The British firm became known for painted parchment and vellum bindings, fore-edge paintings, and calf bindings in a style known as Etruscan, of which this is an example. Etruscan bindings feature Greek vase and lyre ornamentation that imitate the patterns of terracotta urns from Greek antiquity. The designs were created by stenciling the panels of the binding's upper and lower covers. By sprinkling ink or a weak, leather-darkening acid solution through the stencil opening, the binder created a ray-like pattern emanating from the central lyre motif. The border of palmettes and tridents is also characteristic of bindings produced by the Edwards workshop.

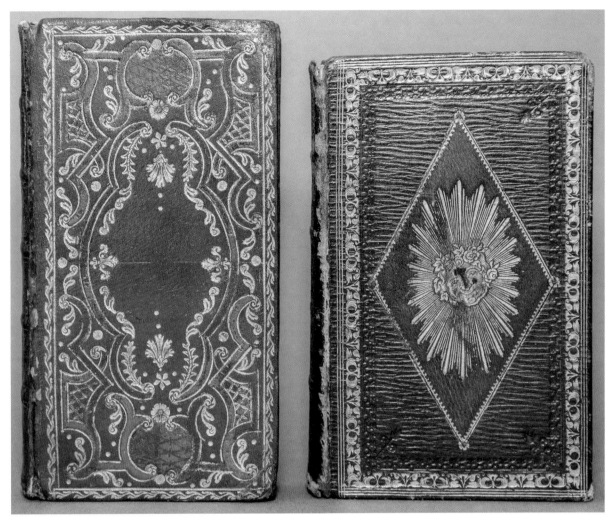

Left to right: *Il decameron di Messer Giovanni Boccacci cittadino Fiorentino* [vol. 2]. Amsterdamo [i.e., Naples]: n.p., 1703; George Coleman. *The Circle of Anecdote and Wit.* London: Printed for J. Bumpus et al., 1822.

These two decorated leather-covered bindings incorporate color into their designs, but in very different ways. The taller of the two is an eighteenth-century Italian binding that features a strapwork design tooled in gold and filled in with green paint applied by hand. Binders could also add color to their bindings by incorporating different materials into their designs—either in the form of onlays, which were cut to shape and placed on top of the existing surface—or in the form of inlays, which were placed in cut-out areas within the binding surface itself. The second example, a nineteenth-century English binding, features a diamond-shaped onlay of thinly pared red leather that has been tooled in gold where its edges meet the green straight-grain morocco underneath. Inlays were more difficult to execute than onlays, and therefore were presumably more expensive.[42] At the same time, onlays were more time consuming and costly to prepare than the hand painting seen on this Italian binding.

6.33
Decorating in
Color: Comparing
Two Techniques

John Galt. *Letters from the Levant*. London: Cadell & Davies, 1813. Cottonian binding made by the Southey family.

6.34
The Cottonian Bindings of Robert Southey and His Daughters

This copy of John Galt's *Letters from the Levant* was once part of the "Cottonian Library" assembled and rebound by Robert Southey (1774–1843) and his daughters: Edith May (1804–1871), Bertha (1809–1877), Katharine (known as "Kate"; 1810–1864), and Isabel (1812–1826).[43] Southey was appointed as Poet Laureate of the United Kingdom from 1813 until his death. During his life, at his home Greta Hall, he assembled a library that to a visiting friend presented a "strange patch-work of colours."[44] Southey, who had learned how to bind books, taught his daughters the craft, and, when the covers of books in their collection became sullied and worn, they turned their hands at creating new covers made from bright, color-printed cotton fabrics, likely intended for dressmaking.[45] They rebound between 1,200 and 1,400 volumes in this manner—a collection that they dubbed their "Cottonian Library." The name not only referenced the fabrics they used, but also played on the association of Sir Robert Cotton's famous library, which was one of the core collections of the British Museum Library, formed in 1753 (and now the British Library). The Southeys' plan was, in part, an economic one to save on the high cost of professional bookbinding; but the motivation also seems to have been aesthetic in nature, as the family embellished other covers of books they owned with paint

and calligraphic writing. As part of their own bookbinding activities, Edith May, Bertha, and Kate would amuse themselves by pairing certain fabrics with authors, "clothing a Quaker work or a book of sermons in sober drab, poetry in some flowery design, and sometimes contriving a sly piece of satire at the contents of some well-known author by their choice of covering."[46]

RBS's Cottonian binding comes come from a collection of books given to the Bodleian Library at the University of Oxford. In 1989 (and again in 1998), through the good offices of Michael Turner and R. J. Roberts, the Bodleian Library allowed Terry Belanger to choose unneeded material from a large collection of printed materials bequeathed to the Bodleian in the 1970s by the San Garde family. Belanger spotted the unwanted Cottonian volume on a low shelf—its bright fabric soiled, but still distinctly patterned. The School offers a fellowship to the Bodleian staff in ongoing recognition of this and the many other gifts made by the Bodleian to RBS for its teaching collection.

D. Mariano José De Zúñiga y Ontiveros. *Calendario manual para el año del señor de 1818.* México: Officina del Autor, calle del Espiritu Santo, [1817].

By no means elaborate in execution, the wrappers of this small Mexican almanac serve as an example of dabbed paper. The paper used for the book's wrappers was decorated, probably using a small natural sponge, with red, black, and yellow paint. Dabbed, or "daubed," paper was used in Spain and Italy for book covers and endpapers, with the red, black, and yellow combination a common choice. Dabbed papers were also adopted for use in Mexico, where this book was printed, and in the United States from the mid-eighteenth to the mid-nineteenth centuries.[47]

6.35
Dabbed Paper
Binding

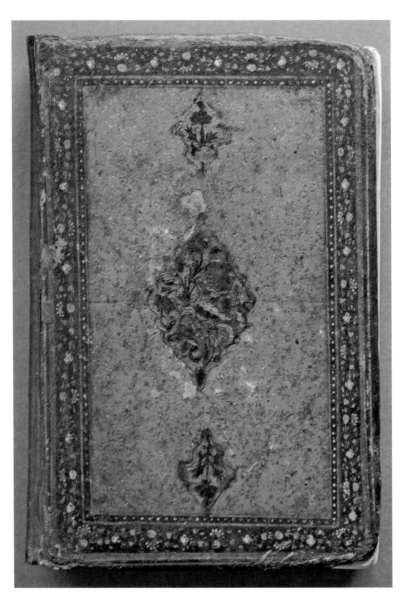

Lower cover. Ahmad al-Narāqi. *Wasilat al-najat* [*On Acts of Devotion*].
Iran, 1819.

6.36
Lacquered
Binding from
Qajar Iran

The upper and lower covers of this lacquered Islamic binding feature a central mandorla with two pendants, painted floral borders, and gold decoration. The binding structure, which does not include a flap, corresponds to Type III in the classification system devised by François Déroche. As Karin Scheper points out: "[o]ne of the major developments in Persia was the introduction of lacquer techniques for bindings" from the end of the fifteenth century onwards.[48] The first lacquer bindings were composed of heavily chalked leather; later examples, such as this one, were composed of paperboards fixed with gypsum or chalk. Lacquer bindings are usually considered "a special type at the higher end of the book trade."[49] The manuscript is a theological text by Ahmad al-Narāqi (1118–1245 AH, 1771–1829 CE), a poet associated with the court of Fath 'Ali Shah Qajar (1772–1834), the second Shah of Qajar Iran.[50]

[Walter Scott.] *Kenilworth; A Romance.* Edinburgh: Printed for Archibald Constable and Co.; and John Ballantyne, Edinburgh; and Hurst, Robinson, and Co., London, 1821.

Sir Walter Scott's novel *Kenilworth* (1821) was among the first three-decker novels produced in Britain. Multi-volume novels were common in the eighteenth century, and three-volume novels were popular well before 1821. The terms "three-decker" and "triple-decker" are reserved for novels that were printed and bound in three post-octavo volumes and sold at the fixed price of £1 11s. 6d., or "a guinea and a half." The high price, which amounted to about an entire week's wages of a skilled laborer, was not affordable for working-class readers, and was very expensive for most middle-class ones. Most copies were sold to circulating libraries, which charged readers an annual subscription at varying rates. For example, Mudie's Circulating Library charged a minimum of a guinea a year for one exchangeable volume, and two guineas per year for checking out up to four volumes at a time[51]—a model akin to modern-day subscription services offering access to limited-release films and television series. Usually, Victorian novels would only be printed and sold in cheaper, one-volume issues after they had made their debut and initial rounds in the library. This economic alliance between publishers and circulating libraries helped to guarantee that publishers would have steady commercial buyers for their wares, even as it ensured that there would be enough of a demand for new fiction at circulating libraries to attract subscribers.

6.37
Walter Scott's
Kenilworth and
the Three-Decker
Novel

The late scholar-bookseller Anthony Rota (1933–2010) traced the origins of this publishing model to John Murray's publication of Thomas Hope's *Anastasius* in 1819[52]—a novel that, priced at a guinea and a half, earned Murray and Hope a substantial profit of £1,135.[53] Yet, as Rota notes, it was Walter Scott's three-volume novel, *Kenilworth*—the first of Scott's three-volume novels sold at this high price—that made the publishing model popular. (For the sake of comparison, *Waverley*, first published in 1814, sold for the price of one guinea or £1.1.0.) The Waverley Novels were in extremely high demand in circulating libraries during the first decade of the three-decker's debut.[54] The three volumes of RBS's first-edition copy of *Kenilworth* are bound in their original paper-covered boards, although, as is common with three-deckers from this period, the spines have been rebacked with fragments of the original labels laid onto the new spines. Many novels were published in the three-decker format in Britain during the nineteenth century, including Charlotte Brontë's *Jane Eyre* (1847), Anthony Trollope's *Barchester Towers* (1857), and George Eliot's *The Mill on the Floss* (1860). By the end of the century, however, the model was no longer viable.

Left to right: Gaius Valerius Catullus. *Tibullus et Propertius*. Londini [London]: G. Pickering, 1824. Gift of Donald G. Davis Jr.; James Grahame. *The Sabbath, and Other Poems*. London: Published by Jones & Company, 1825. Gift of David Whitesell; *Novum Testamentum Græcum*. Londini [London]: Gulielmus Pickering, 1828. Gift of the University Research Library, UCLA.

Two of these three miniature books were published by William Pickering in the 1820s; they are bound in cloth prepared specifically for bookbinding. According to Michael Sadleir, nineteenth-century bookbinders had attempted using cloth chiefly intended for dressmaking on book covers—but, as he notes, "the use of ordinary unprepared fabrics, such as velvet, silk or calico, was not a simple matter. The glue came through easily, and the absence of 'body' or stiffness made difficult working. Some new fabric had to be invented."[55] William Pickering experimented with adapting cloth for bookbinding, which he began using in 1821 for his Diamond Classics series. By the end of the 1820s, other publishers were adopting the new practice.[56] By the 1830s, bookcloth was being manufactured with small, repeating, blind-embossed patterns, referred to as "graining," visible on some of the later cloth-covered bindings featured in this volume.

Pickering's early bindings, however, were bound in ungrained cloth. This scarce miniature copy of Catullus's *Tibullus et Propertius* (1824) appears in what is now a heavily soiled and stained cloth that was originally red (observable at the turn-ins and at the foot of the spine), in keeping with Pickering's series. The ink stains on its covers suggest that it may have been used as a schoolbook. RBS's miniature New Testament (1828), also published by Pickering, is likewise bound in a plain-weave purplish cloth documented as being used early on by Pickering; it has since faded to a brownish color. Both bindings are very plain in terms of their appearance, and both spines carry paper labels, as gold stamping on bookcloth was not yet an established practice.

In contrast, the third binding, a miniature copy of *The Sabbath* published by Jones & Company in 1825, was bound in a green silk likely intended for dressmaking. The leather label, blocked in gold, complements the gilt edges of the volume. Nearly two hundred years later, the cloth has worn away almost entirely around the hinges of the spine.

Charles Dickens (1812–1870) rose to fame as the author of *The Pickwick Papers*, a novel published in monthly part-issues from 1836 to 1837. *David Copperfield*, Dickens's eighth novel and one of his most highly regarded works, was issued from May 1849 to November 1850 in the form of twenty numbered parts in nineteen pictorial blue-green wrappers (the final part being a double number). It was illustrated by Hablot Knight Browne ("Phiz," 1815–1882), who had created etchings for most of *Pickwick*, as well as other Dickens novels issued in parts, such as *Dombey and Son* and *Bleak House*. Browne was extremely skilled at making steel etchings, deftly drawing with a needle through the wax-coated surface of the plates with a particular lightness of touch; he rose to fame largely owing to his illustrations for Dickens's writing.[57] Each part generally contained two engravings and sold for a shilling, except for the last double part, which was priced at two shillings. The parts also usually contained advertisements on their inner wrappers, as well as additional leaves inserted before and sometimes after the text for items ranging from Gowland's Lotion and Balsam Copaiba to wigs, overcoats, and mattresses. After the final number was published, readers could, if they wished, have the wrappers and ads removed from the individual parts, and have the text

6.38
Pickering's
Diamond Classics
and the Rise of
19th-Century
Bookcloth

6.39
A Book
Issued in Parts:
David Copperfield
(1849–1850)

Charles Dickens. *David Copperfield*. London: Bradbury and Evans, 1849–1850. Gift of Hans-Ulrich Scharnberg.

and illustrations (inserted in their proper places) bound up in a convenient cloth-covered binding.

Issuing books in parts was not a practice new to the nineteenth century. The method had been established in the late seventeenth century; some, but not all, books in parts included illustrations. One advantage of this form of publication was that it allowed publishers to distribute their total production cost over a greater span of time while receiving income as they issued and sold individual parts. It also was beneficial for readers, who could pay for books in smaller financial installments. In the nineteenth century, the model offered an alternative to the high cost of the three-decker novel. As Anthony Rota writes, the part-issue publication of *Pickwick* and other new fiction "was established as the inexpensive way to bring the three-decker novel into the home, by-passing Mudie's and other circulating libraries almost entirely."[58] The practice was popular among English novelists through around 1880, but, of course, all kinds of books were also published in parts, and the RBS collection includes twentieth- and even twenty-first century examples.

Left to right: Handkerchief box, France, ca. 1850. Gift of Vincent Golden; *Histoire naturelle des animaux les plus remarquables de la classe des mammifères. . . .* Tours: Alfred Mame et Cie, Imprimeurs-Libraires, 1860. Gift of Jan Storm van Leeuwen in memory of Sue Allen.

Alfred Mame founded his firm in Tours, France, in 1795. It soon grew into an extensive printing and bookselling enterprise including a vast industrial-scale bindery housing more than a thousand workers. This embossed and gilt paper-covered binding, featuring a chromolithographed paper inset, is characteristic of Mame's series for young Christian readers, the "Bibliothèque de la jeunesse chrétienne." The series was modestly priced, and schools often distributed the volumes as prize books. Mame's binders assembled the cartonnage binding on site; the decorated, gilt, and embossed paper was manufactured separately by another unidentified firm or firms in Paris whose papers were used to decorate other wares, including cartonnage boxes such as this handkerchief case. It was not uncommon for Mame to use the same colored or chromolithographed paper inset for the covers of different books: RBS's Storm Collection (named in honor of past RBS faculty member Jan Storm van Leeuwen) of cartonnage bindings includes several other volumes featuring the same lion.

6.40
Embossed and
Gilt Paper
Cartonnage
Binding

Sue Allen. *American Book Covers, 1830–1900: A Pictorial Guide to the Changes in Design and Technology Found in the Covers of American Books between 1830 and 1900.* Washington, DC: Library of Congress, Binding & Collection Care Division, Preservation Directorate, 1998.

6.41
Sue Allen's
*American Book
Covers, 1830–1900:
A Pictorial Guide*

This brochure, written and designed by the late Sue Allen (1918–2011), offers a timeline summarizing major changes in the design and manufacture of nineteenth-century American publishers' bindings. Allen was the foremost authority on nineteenth-century American bookbindings, and she taught courses at RBS over the period of four decades (1984–1985; 1991; 1994–2011). For many years, she used this particular brochure in class—often giving out extra copies of it as gifts to her students. She received the 1999 American Printing History Association laureate award in recognition of her many contributions to the field, which guided librarians and conservators in the selective preservation of bindings. Indeed, with the digitization (and consequent guillotining and destruction) of books in libraries, many nineteenth-century publishers' bindings were likely saved owing to Allen's instruction, which focused on the artistry, beauty, and social history of these artifacts.

[Isaac Clark Pray.] *Memoirs of James Gordon Bennett and His Times*. New York: Stringer and Townsend, 1855. Gift of Patricia Otto.

Published in New York in 1855, this copy of the *Memoirs of James Gordon Bennett and His Times* features a striking vignette stamped in gold on its cover. James Gordon Bennett (1795–1872) was the editor and publisher of the *New York Herald*, which he founded in 1835. The cover's illustration—which features a pile of books—was clearly made for this specific publication: the bottom-most book in the pile exhibits a date of 1835 and the topmost book in the stack is dated 1855— the same year as when the book was published.

6.42
Cover as Clue
to Content:
Gold Stamping
on Cloth

Book covers offered specific clues to their contents well before the mid-nineteenth century. There are occasional examples that precede the eighteenth century.[59] The activity was not commonplace, however, until certain developments in the nineteenth century—namely, the use of the Imperial Arming Press, which was introduced for bookbinding in 1832 shortly after Messrs. Cope & Sherwin came out with the Imperial printing press around 1828–1829.[60] Both the pressure exerted by the iron arming press and its cast-metal construction made it possible to stamp continuously heated brass dies into binding materials—such as cloth-covered book cases—quickly and efficiently, without cooling, as was the case with earlier and less robust wooden stamping presses.

Publishers seized on the possibilities of gold stamping by producing increasingly large and complex cover designs that were related to their books' contents and that were intended to attract the attention of prospective customers.

6.43
A Short-Lived
Fashion:
Printed Stripes
on Bookcloth

These three American nineteenth-century miniature books are each bound in cloth printed with a distinctive striped pattern—textiles that were probably intended for dressmaking or for use in domestic furnishing.[61] It may come as no surprise then that each of these three volumes—*The Moss-Rose: For a Friend* (Hartford, 1847), *The Golden Gift* (Hartford, 1848), and *The Young Lady* (Lowell, 1848)—were produced as gift books largely intended for women readers. The contents of the latter book, which specifically addresses "youthful females" in its preface, contains the following gift inscription in pencil: "Martha Chase | Take this as a gift | from a friend | George W. White."

Although these printed cloths were imported from Britain, they are more frequently found on American books dating from about 1845 through 1852.[62] To adapt the cloth for the purpose of bookbinding, it was starched (usually with soybean-flour paste) and calendered under great pressure with iron or steel rollers that worked the starch paste deep into the weave of the cloth. When hot, the rollers imparted a glossy finish. Grains—such as the fine ribbing visible on these covers—were frequently embossed into the cloth, to create additional, subtle patterns without the use of color; these were embossed on the cloth using a rolling press with designs engraved into the surfaces of the steel cylinders. After the cloth was adhered to a case—two boards and a spine—it could be further embellished: first blind stamped with heated brass dies, and then, once the gold leaf was applied to those areas, restamped to set the gold. The overall layered effect of the designs of these bindings is very distinct and unique to this short period in bookbinding history. These lively, colorful cloths, which convey a sense of nineteenth-century fashion, were eventually abandoned in favor of commercially made cloth for bookbinding—an industry, that as Andrea Krupp notes, "emphasized consistency, simplification, and standardization."[63]

Left to right: Reverend C. W. Everest. *The Moss-Rose: For a Friend.* Hartford: Brown and Parsons, 1847; Anna Ferguson. *The Young Lady.* Lowell: Nathaniel L. Dayton, 1848. Gift of Vincent Golden; J. M. Fletcher, ed. *The Golden Gift: A Token for All Seasons.* Hartford: Brockett, Fuller & Co., 1848.

Nathanial Hawthorne. *The Marble Faun: Or, the Romance of Monte Beni*. 2 vols.
Boston: Ticknor and Fields, 1860. Gift of the American Antiquarian Society via the
good offices of Vincent Golden.

6.44
Ticknor and
Fields's Signature
Binding Style in
Brown Cloth

In his study of the Boston-based publishing firm of Ticknor and Fields (founded in
1854), RBS faculty member Michael Winship describes how the firm established
a signature binding style, as typified in this 1860 copy of Nathaniel Hawthorne's
novel, *The Marble Faun*. In the late 1840s, Ticknor and Fields began to issue
most of its general trade books in a distinctive brown cloth-covered binding,
decorated with an "elaborate four-lobed arabesque design blind-stamped at the
center of the sides and sober gold-stamped lettering on the spine in panels of
blind-stamped double rule."[64] According to Winship, earlier versions of the
binding were bound with ribbed T-grain cloth (*T* being a code used to designate
this variety of bookcloth in the *Bibliography of American Literature*). This copy of
The Marble Faun is bound in a vertical-rib grain cloth.

Owen Meredith. *Lucile*. Boston: Ticknor and Fields, 1856. Gift of Peter S. Graham.

In addition to their sober, brown cloth-covered bindings, Ticknor and Fields found great success with their small, pocket-sized "Blue and Gold" books uniformly bound in gold- and blind-stamped blue cloth. The series proved to be extremely popular; it was frequently imitated by other American publishers. The first book in what came to be known as the Blue and Gold Series was a new edition of Tennyson's *The Poetical Works* published by Ticknor and Fields in 1856. According to RBS faculty member Jeffrey D. Groves, the American firm was likely inspired by the pocket edition of John Greenleaf Whittier's poems, which was published by the London firm of Routledge in 1853 and bound in blue cloth and stamped in gold with gilt edges. The blue cloth covers of Ticknor's series were blind stamped with a cartouche framed by a triple-ruled border. The spines were stamped with an elaborate gold frame, and the edges were trimmed and gilt. By studying the cost books of Ticknor and Fields, RBS faculty member Michael Winship has ascertained that each Blue and Gold binding cost the firm fourteen cents to produce in 1856. The books were priced at the very affordable seventy-five cents apiece, and the series eventually came to include forty-one titles in fifty-seven volumes.

This book, however, is not just an example of a series binding—it is also one of RBS's several hundred copies of the nineteenth-century verse novel *Lucile*, composed by the once-popular English poet Robert Bulwer-Lytton (1831–1891), who

6.45
Lucile in
Ticknor and
Fields's
Blue and Gold
Series Binding

wrote under the name of Owen Meredith. *Lucile* was first published in 1860 by Chapman & Hall in London and by Ticknor and Fields in Boston in this Blue and Gold edition. From 1860 to 1938, nearly a hundred American publishers brought out at least two thousand editions and issues of *Lucile*.[65] The reaction of one of the previous owners of this copy of *Lucile*, George B. Walker, exemplifies the book's rapturous reception among nineteenth-century readers. On the final page, he has written in pencil: "This poem speaks to my soul and stirs my heart!!!"

Anthony Trollope. *Orley Farm*. London: Chapman & Hall, [ca. 1874]; [Mary Elizabeth Braddon.] *Gerard, or The World, the Flesh, and the Devil*. London: Simpkin, Marshall, Hamilton, Kent & Co., 1892.

6.46
Yellowbacks
in Britain

In contrast to expensive three-decker novels, whose sale was largely restricted to circulating libraries, there were yellowbacks: inexpensive novels and other works presented in single volumes bound in poor-quality strawboard and sporting eye-catching, multi-color illustrations usually printed on glazed, bright yellow-coated papers (although varieties covered in papers dyed grey or pale pastel colors, such as pink, blue, and green, are also found). Yellowbacks usually sold for two shillings apiece in bookstalls, often within railway stations. Their texts were generally inexpensive stereotyped reprints of established works that had already made the rounds in circulating libraries or that had been previously sold in parts.[66]

Forerunners to yellowbacks appeared in the late 1840s, with Routledge introducing its Railway Library series in 1848. But it was not until the 1850s that the standard form was established with Chapman & Hall's series, Select Library of Fiction, one title of which is featured here: *Orley Farm* by Anthony Trollope, which was first published in twenty monthly parts in 1860 and 1861 that sold for a

shilling each. *Orley Farm* was later issued as a yellowback in 1867 for three shillings and then again in 1872 for the reduced price of half a crown, or two shillings and sixpence.[67] RBS's copy is an undated post-1872 reprint that had come out by 1874, a date suggested by the ownership inscription of William Trewhella: "4ᵗʰ March 1874." Alongside it is an 1892 yellowback, priced at two shillings and published by Simpkin, Marshall, Hamilton, Kent & Company: *Gerard, or The World, the Flesh, and the Devil*, which was written by Mary Elizabeth Braddon, author of the bestselling sensation novel, *Lady Audley's Secret* (1862). The book's intriguing cover illustration and lurid title, appearing on a bright red background, would have readily caught the eye of passersby in the railway book stall.

Maria Edgeworth. *Waste Not, Want Not, and Other Stories*. New York: James Miller, n.d.

RBS owns seventy-eight bindings impressed with decorative brass stamps made by John Feely (ca. 1819–1878). RBS acquired the bulk of this binding collection from RBS faculty member Todd Pattison and Sharon Pattison. John Feely was an Irishman who worked in London and then immigrated to the United States with his family around 1843. Feely specialized in creating metal stamps for book covers, as well as in making typographic ornaments, both of which he cut by hand on hard-rolled brass using a set of gravers akin to those used by wood engravers but made from harder steel. Unlike many die engravers of his day, Feely incised a portion of his stamp with either "JF" or "FEELY," as seen in this example. His depiction of a mother reading to her children, used to decorate a collection of stories by Maria Edgeworth, also contains his characteristic "serpentine"

6.47
John Feely,
Book Cover
Die Engraver

line motif, visible on the right- and left-hand sides of the stamped image. As described in Sue Allen's and Charles Gullans's article about Feely, he used this symmetrical winding line to fill in backgrounds. Although this book is undated, the presence of gold and reflective black stamping indicates that it was published in the 1870s after that aesthetic was introduced to publishers' cloth bookbindings in the United States.

Algernon Charles Swinburne. *Songs before Sunrise*. London: F. Ellis, 1871. Gift of Jerome McGann.

6.48
A Pre-Raphaelite
Publisher's
Binding

The poet, painter, and illustrator Dante Gabriel Rossetti (1828–1882) created this design for *Songs before Sunrise*, a book of poems written by his close friend, the English poet and critic, Algernon Charles Swinburne (1837–1909). The two were part of the Pre-Raphaelite circle—a coterie of writers, artists, and critics who rejected the contemporary standards of the Royal Academy of Art in favor of fourteenth- and fifteenth-century medieval Italian art and its richly detailed study of nature, which they embraced in a spirit of artistic revolution and renewal.

(The Pre-Raphaelites were concerned with political and social change, as well. *Songs before Sunrise* was written in support of the *risorgimento*, or the movement for Italian political unity.)

Rossetti created designs for publishers' bindings that covered a number of Pre-Raphaelite works, including, but not limited to, his own poetry, that of Swinburne, and *Goblin Market*, written by his sister, Christina Rossetti. Rossetti's designs, which are also tied to Aestheticism and the Arts and Crafts Movement, stand apart from typical commercial bookbinding designs of his contemporaries. The 1870s was a period that generally embraced larger decorative arts trends, such as Charles Eastlake's designs for furniture, etc.; books were frequently bound in brightly colored cloth, with titles appearing on covers in banners.[68] Black stamping, introduced in the late 1860s, was heavily used. Asymmetrical designs were popular, but they tended to fill the surface of the cover—along with titling—to catch the attention of prospective buyers.

This binding, reputed to be Rossetti's masterpiece, is the third in a sequence of bindings pertaining specifically to Italy—a special focus of the Pre-Raphaelites. It incorporates three rondels each on its upper and lower covers, echoing prior binding designs he made for his brother's translation of *The Divine Comedy: Hell* (1865) and Swinburne's *Atalanta in Calydon* (1865), as well as inset designs he made for the picture frame of his own painting, *Beata Beatrix*—a history noted by Jerome McGann, who donated his personal copy of this book, featured in the Rossetti Archive, to RBS.[69] Notably, there is no title on the cover—only on the spine of the book. The small rondels, which separately depict the stars, crescent moon, and rising sun, more subtly invoke the book's title. One can even detect a slight medieval influence: the rondels are vaguely akin to brass bosses in their positioning. At the same time, the minimal, asymmetrical design reflects Rossetti's interest in Japanese art—an influence more broadly visible in design during this period, though largely without the same degree of restraint. Rossetti's work illustrates how one can introduce a personal flavor and innovative element to design within mainstream publishing. The distinctive aesthetic sensibility of his designs announce—at least to those in the know—the close connections, personal associations, and ongoing dialogue of the Pre-Raphaelites. But they would have appeared striking even to the ordinary eye.

Herbert W. Morris.
*Harmonies of the Universe,
as Displayed in the Laws
of Nature, the Dominion
of Providence, and the
Dispensations of Grace.*
Philadelphia:
P. W. Ziegler & Co., 1878.
Gift of Todd Pattison.

6.49
The Look of
Creationism:
An 1870s
Publisher's
Binding

This copy of *Harmonies of the Universe*—a work by the Reverend Herbert W. Morris critiquing Darwin in defense of Creationist theory—is bound in an imposing publisher's bookbinding whose thick, three-dimensional covers and general heft are reminiscent of copies of the Bible published during the same period. According to RBS faculty member Todd Pattison, the book's covers are built up with several layers of binder's board beneath its outer layer of green cloth. Cut to resemble the grooved, decorative shape featured on the book's upper and lower covers, the separate layers of board were glued together and covered with a thinner board that held the whole together after being pressed into shape with a die. The cloth covering the binding was likely also stamped again with another die to ensure that the book's cloth was evenly pushed into the same grooved areas.

The decoration on the book's covers is particularly characteristic of the 1870s. Beveled boards (which, according to the late Sue Allen, appeared on American publishers' bookbindings during the late 1860s) were very popular during this decade. Gold leaf and reflective black stamping were also first used together during the 1870s. The stiff ribbon banners visible in each corner of the covers (e.g., containing the text "heaven and earth shall pass away," "but my word shall not pass away," etc.) were also elements typical of this decade of book design. This book's former owner, Mary W. Benedict of Ellington, New York, inscribed the flyleaf of her copy in 1882 with a quote from scripture, likely intended as a warning to those to whom she loaned it: "'The wicked borroweth and returneth not' | *Proverbs*."

Ryūkatei Tanekazu (柳下亭種員).
Shiranui monogatari [*The Tale of Shiranui*],
vol. 48. Tokyo: Enjudō (延壽堂), 1878.

Shiranui monotagari was one of the most popular works of serialized pictorial fiction, known as the *gōkan* genre, at the end of the Edo period (1853–1868) and in the early Meiji period. This is one installment of two fascicles of the work, which was issued in ninety installments between 1849 and 1885. *Gōkan* have colorful, dynamic, and aesthetically pleasing covers that combine as pairs to form unified compositions. These fascicles were illustrated by Ikkeisai [Utagawa] Yoshiiku (一蕙斎[歌川]芳幾). The red and purple aniline dyes immediately identify them as having been produced in the Meiji period, as such dyes were not available for use in Japan before the Meiji Restoration in 1868. Owing to their large print runs, these popular works are still readily available on the secondhand market for relatively low prices. The fascicles are also an example of the *chūhon* format, which refers to the size of a sheet of *mino* paper folded into quarters (i.e., two folds) that are then cut into two pieces. It is woodblock printed with pages in a pocket or pouch binding (*fukurotoji*), in which thin leaves have been folded in half and bound on the open edge. The leaves, when unfolded, are therefore twice the size of the individual pages.[70]

6.50
Woodblock-
Printed
Polychrome
Covers from
Early Meiji Japan

Henry D. Thoreau. *Walden*. With an introduction by Bradford Torrey. Illustrated with photogravures in two volumes. Vol. 1. Boston and New York: Houghton, Mifflin, and Company, 1897.

6.51
Sarah Wyman
Whitman,
Book Cover
Designer

Sarah Wyman Whitman (1842–1904) was a society hostess, painter, and stained-glass artist based in Boston. She became one of the most well-known American book cover designers at the end of the nineteenth century. Whitman worked primarily for the publisher Houghton Mifflin, and it is estimated that she designed between 250 and 300 covers for the firm. Her designs stripped away the heavy ornamentation of publishers' bookbindings. They were characterized instead by clarity, simplicity, and her own rustic lettering style. Whitman only signed a handful of her bindings. As the late Sue Allen once wrote: "[Whitman's] style was identity in itself."[71] Allen, who taught with a number of Whitman's books in her RBS course, considered Whitman's design for Thoreau's *Walden* among her most accomplished works—although it must be noted that the cloth was originally a much darker green.

The decorated cloth-covered bindings that Whitman designed for Houghton Mifflin were manufactured by the Riverside Bindery. In 1899, thirty to forty women workers at Riverside were still hand sewing text blocks for the firm.[72] In an article co-written with Elizabeth DeWolfe, RBS faculty member Todd Pattison points out that historians have privileged wealthy, extraordinary women designers like Whitman and Margaret Armstrong rather than researching the women folders, gatherers, and sewers who worked in American binderies throughout the nineteenth and early twentieth centuries.

Oscar Kuhns. *Switzerland. Its Scenery, History, and Literary Associations.* New York: Thomas Y. Crowell Co., ca. 1910. Gift of Linda Wilson.

6.52 Margaret Armstrong, Book Cover Designer

RBS's teaching collection includes hundreds of bindings designed by Margaret Armstrong (1867–1944) that were acquired from various sources. Armstrong hailed from an established and well-connected New York family. Her first book cover design was published in 1890 by the Chicago firm A. C. McClurg, and she subsequently designed more than three hundred book covers for several different American commercial publishers until 1913, after which she turned to other pursuits. Charles Gullans, who helped to establish the study of American cloth bookbinding design, judges that Armstrong was the "single most important woman in this branch of decorative design" at the turn of the twentieth century.

Armstrong sometimes signed her designs. This copy of Kuhns's guide to Switzerland is signed "MA" in the lower right-hand corner of the upper cover. The decorated bookcloth is stamped in gold, purple, white, and grey. Armstrong's designs were most often ornamental in nature and botanical in inspiration. This cover includes a dominant floral pattern, as well as a medallion of an Alpine landscape—one of the few examples of pictorial motifs found among her book covers. Armstrong also designed the cover's lettering, drawing on a style that she developed after 1895. The letters *A*, *E*, *F*, and *H* have their cross bars set very high, and the *R* features Armstrong's characteristic long and thick-to-thin swash tail.

Gustave Flaubert. *Salammbô*. Paris: Librairie de France, 1922. Gift of Jan Storm van Leeuwen.

6.53
Art Deco
Binding

From the 1920s to the 1950s, the art of bookbinding in France was dominated by individuals such as Rose Adler, who trained at the École de l'Union Centrale des Arts Décoratifs, and Pierre Legrain, who was not a trained binder but rather a decorator and designer of fine bindings. Their work was intended for a very limited, wealthy audience, and their bindings now sell for high five figures—well beyond RBS's annual acquisitions budget. Past RBS faculty member Jan Storm van Leeuwen was able to acquire this art deco style binding at a much lower price, however, because it is signed by the otherwise unidentified binder: "C. Grandgeorge." Covered in dark-green goatskin, the binding's symmetrical design features concentric, interlocking circles tooled in silver on circular, dark-red leather onlays, complementing the text of Gustave Flaubert's *Salammbô*, an historical novel about ancient Carthage. In one of the most striking scenes of the novel, the titular heroine encounters an enormous black python sacred to the goddess Tanit. Grandgeorge's design, similar to those of the more famous Pierre Legrain, most certainly echoes the scales of the serpent described by Flaubert.

Paperback books pervaded twentieth-century publishing. As their name would suggest, paperbacks consist of printed paper covers, which are adhered to spine of the text block. They generally contain at least 50 leaves.[73] Yet the distribution of paperbacks—particularly their mass manufacture and low cost—is just as much a part of their identity as their physical makeup. Paperbacks are printed in large runs, usually in the tens of thousands. Initially sized to fit on mass-produced racks, they were sold through periodical distributors in drug stores, grocery stores, bus stations, and airport terminals, while larger "trade" paperbacks were often sold through college stores and the general book market. Although there were earlier precedents in the nineteenth century, such as Hachette's paperbound volumes sold at railway stations in France and also Tauchnitz's series of English and American reprints, the form of the mass-market paperback as we know it today was established in Britain in 1935 when Allen Lane (1902–1970), who founded Penguin Books with his brothers Richard and John, harnessed the format to bring inexpensive reprints of literature and non-fiction to readers—an idea that was initially met with resistance.[74]

Penguins stood apart from the paperbacks of other publishers owing to their low price, portable format, scholarly presentation, and elegant design. The three horizontal stripes of color on the covers of Penguins were initially designed by Edward Young. Covers were color coded: literary fiction appeared in orange; mystery and crime fiction appeared in green; biography in blue; pink for travel; etc. Titling was presented in Eric Gill's sans serif typeface. The design was refined and reformed by Jan Tschichold, an innovative German calligrapher, typographer, and book designer who was hired by Penguin's Allen Lane in 1946 to improve on Young's work. Tschichold mandated that capitalized text be optically letterspaced, including the titling on the books' covers.[75] (During his three-year stint for Penguin, Tschichold personally critiqued and overhauled more than five hundred covers.) Tschichold redrew the Penguin logo, and he presented the publishers' name on the covers in Bodoni Ultra Bold, while also introducing a thin rule between the author's name and the title, as well as establishing the consistent use of visual spacing. The result was the revamped design seen here, which follows Tschichold's guidelines.

A practical comparison with an edition produced in the same year by Pocket Books helps to show just how distinctive the Penguin design was from other leading commercial mass-market paperbacks of the time. In 1953, *Jane Eyre*, which debuted as no. 960 in the Penguin list, was priced at two shillings sixpence (2/6). Penguin's cover is printed in just two colors—black and orange—making use of the cream paper cover as the background. It also features Tschichold's redesign of the Penguin logo, which remained in use, given its iconic status, until 2003.[76] The lower cover contains a black-and-white photo of Branwell Brontë's portrait of his three famous sisters, Charlotte, Emily, and Anne, along with a blurb that offers historical context for the novel without any mention of the novel's plot—elements consistent with Penguin's more scholarly approach to presenting classic literature.

The elegant design is a model of restraint when compared to the Cardinal Edition of *Jane Eyre*, published by Pocket Books, which was established in the

6.54
The Rise of
Mass-Market
Paperbacks:
Penguin & Pocket

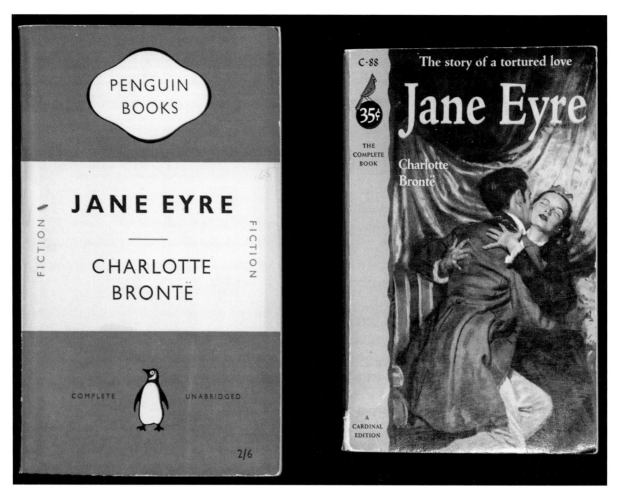

Left to right: Charlotte Brontë. *Jane Eyre*. Melbourne, London, Boston: Penguin Books, 1953; Charlotte Brontë. *Jane Eyre*. New York: Pocket Books, Inc., 1953.

United States in early 1939. Number C-88 in the Cardinal Edition series, this cover of *Jane Eyre* is marketed as a mainstream novel. Illustrated in color by Tom Dunn, the cover features an image of a man and woman locked in a passionate embrace with the following slogan: "The story of a tortured love." The cover text is presented in yellow, pink, and black, with the price prominently displayed in white on a black circle: 35¢. The blurb on the lower cover contains tropes suggestive of twentieth-century gothic romances, including mention of the "web of mystery" at Thornfield and a "horrifying revelation" threatening Jane's "one hope for happiness." In the United States, mass-market paperbacks were often sold adjacent to colorful magazines, and so their covers had to be more eye catching, given the competition.[77] In the 1950s, Penguin began incorporating more visual elements on its covers with an eye to its competitors, but it retained its classic cover for titles, such as *Jane Eyre*, on its general list. By the 1960s, the typographical design had been replaced with an image of George Richmond's portrait of Brontë on the book's cover.

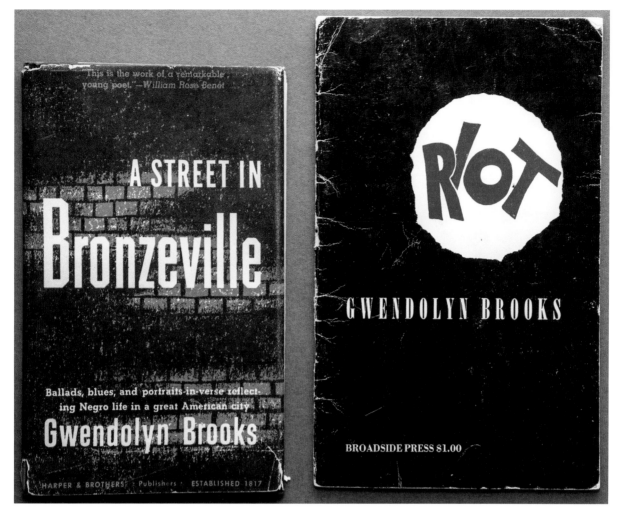

Gwendolyn Brooks. *A Street in Bronzeville*. New York: Harper & Brothers, 1945; *Riot*. 2nd printing. Detroit: Broadside Press, 1970.

In his RBS lecture, "From Poet to Publisher: Reading Gwendolyn Brooks by Design," RBS faculty member Kinohi Nishikawa compares the physical form of Brooks's first book of poetry, *A Street in Bronzeville*, published by Harper & Brothers in 1945, with her later chapbook *Riot*, published by Broadside Press in 1969. Like most debuting writers, Brooks (1917–2000) had little control over the design of the dustjacket for *Bronzeville*. The back of the dustjacket for first printing of the first edition includes an advertisement, "Buy War Bonds!," with an endorsement from Brooks. Nishikawa points out, however, that given the ambivalent attitude towards the war effort expressed in her poems, it is probable that Brooks did not write the statement that bears her signature. The second printing of *Bronzeville* was issued after the end of the war, and the war bond statement was replaced by blurbs of praise for the collection. In letters to her publisher, Brooks took care to mention that she was very pleased with this later design of the dustjacket.

Although Brooks was generally satisfied with Harper's treatment of her poems, she decided to leave the firm to support a Black publisher: Detroit's Broadside Press,

6.55
A Poet and
Her Book Covers

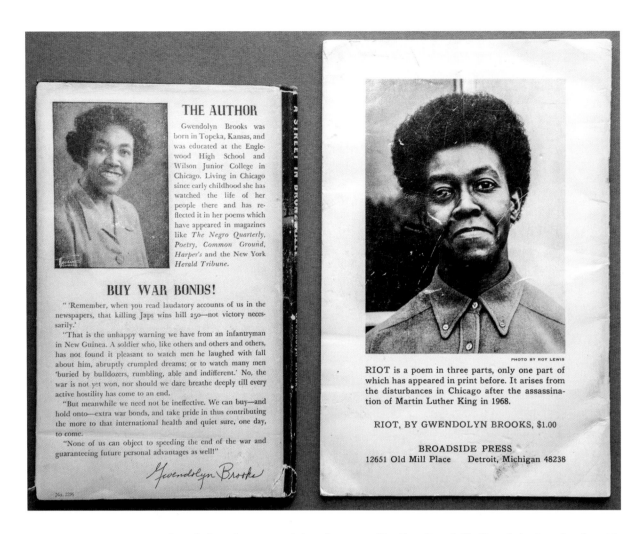

THE AUTHOR

Gwendolyn Brooks was born in Topeka, Kansas, and was educated at the Englewood High School and Wilson Junior College in Chicago. Living in Chicago since early childhood she has watched the life of her people there and has reflected it in her poems which have appeared in magazines like *The Negro Quarterly*, *Poetry*, *Common Ground*, *Harper's* and the New York Herald Tribune.

BUY WAR BONDS!

" 'Remember, when you read laudatory accounts of us in the newspapers, that killing Japs wins hill 250—not victory necessarily.'

'That is the unhappy warning we have from an infantryman in New Guinea. A soldier who, like others and others and others, has not found it pleasant to watch men he laughed with fall about him, abruptly crumpled dreams; or to watch many men 'buried by bulldozers, rumbling, able and indifferent.' No, the war is not yet won, nor should we dare breathe deeply till every active hostility has come to an end.

"But meanwhile we need not be ineffective. We can buy—and hold onto—extra war bonds, and take pride in thus contributing the more to that international health and quiet sure, one day, to come.

"None of us can object to speeding the end of the war and guaranteeing future personal advantages as well!"

Gwendolyn Brooks

No. 2296

PHOTO BY ROY LEWIS

RIOT is a poem in three parts, only one part of which has appeared in print before. It arises from the disturbances in Chicago after the assassination of Martin Luther King in 1968.

RIOT, BY GWENDOLYN BROOKS, $1.00

BROADSIDE PRESS
12651 Old Mill Place Detroit, Michigan 48238

founded and managed by the poet Dudley Randall. Brooks's first book with Broadside was the chapbook *Riot*, which she wrote in response to the assassination of Dr. Martin Luther King Jr. According to Randall, Brooks donated the book to Broadside, and all proceeds went directly to the press.[78] Priced at $1.00, the softbound format of the chapbook was much more affordable than a hard-cover book, and it was visually aligned with the Black Arts Movement and Chicago's Southside community. The cover design was created by the Black artist Cledie Taylor, and the book includes a frontispiece reproduction of Jeff Donaldson's painting *Alla Shango*. A commanding photographic portrait of Brooks by Black photographer Roy Lewis graces the back of the chapbook.

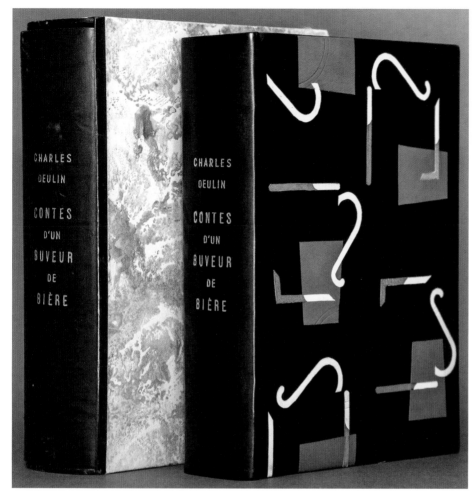

Above: Charles Deulin. *Contes d'un buveur de bière; dix hors-textes en couleurs de Noël Dum.* Paris: Éditions du Panthéon, 1947. Binding by Anne De LaTour Hopper, ca. 1968. Gift of Anne De LaTour Hopper and Duane Hopper.

These two bindings (also see overleaf) were created by Anne De LaTour Hopper (b. 1941) during her studies in bookbinding at the École de l'Union Centrale des Arts décoratifs in Paris. Hopper purchased unbound copies of fine press books from the bookstalls on the banks of the Seine and then used them to create custom bindings inspired by the geometric patterns in vogue in mid-twentieth-century France. Both bindings feature onlays as well as gold and blind tooling. The *Contes d'un buveur de bière*, bound in extremely fine calf, has full calf and silk doublures and endpapers, while *Visages radieux*, bound in goatskin, has full turquoise goatskin doublures and endpapers. Hopper, who participated in an oral history project led by RBS staff in 2021 and 2022, noted that she was particularly proud of the cabochon featured on the center of the spine of *Visages radieux* and of her skill in paring leather for onlays. RBS's collection includes only a few fine bindings from the twentieth century—examples that are even more valuable for teaching purposes, because of the information and insights Hopper contributed in her oral-history interviews.

6.56
Fine Bindings
from Mid-
Century France

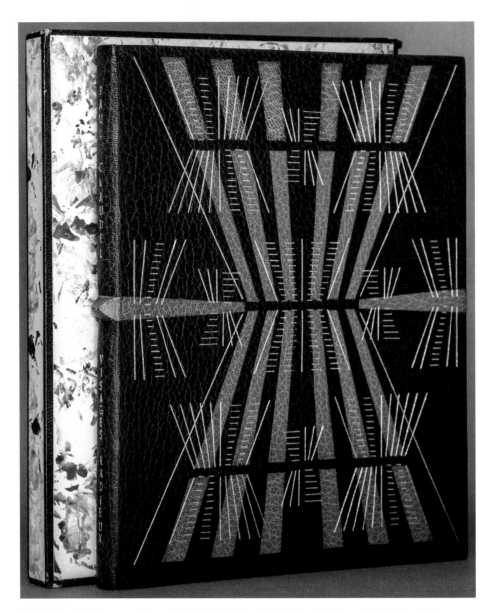

Paul Claudel. *Visages radieux*. Paris: Egloff, [1945]. Binding by Anne De LaTour Hopper, ca. 1968. Gift of Anne De LaTour Hopper and Duane Hopper.

Karli Frigge. Three marbled
paper specimens, ca. 1990.
Gift of Jan Storm van Leeuwen.

"Marbling belongs to bookbinding, and in the old days all young bookbinders had to learn it."[79] So writes the world-renowned Dutch artist and bookbinder Karli Frigge, who was apprenticed to the craft at the age of sixteen. An innovator, Frigge has experimented with traditional methods, creating new genres of marbling, which displayed for their beauty as often—if not even more frequently—than used for the purposes of bookbinding. Frigge's marbles have been collected and gathered into books that showcase her unique artistry, and she has self-published a number of specimen books of her work, which has been exhibited in various museums and galleries throughout the world.

The three marbles shown here have been cut down from larger printed sheets per Frigge's usual practice. The bouquet marble (made with green and teal pigments) is formed in a traditional style—what Frigge refers to as "classical"— and it is labor intensive to form. Frigge writes: "You need to make three different combs and use them in this order: first you comb a feather marble. Then you comb that to a comb-shaped marble. Finally, with the double-sliding comb, you comb the bouquet marble."[80] The streamer marble, one of Frigge's stunning innovations, has mystified even those who have closely studied her work.[81] She recently described the process under the heading "Dear Mistakes"—which suggests that she discovered the process by accident. It is based on a feather marble that she created by "compressing and expanding the paint" by dragging the paper back in forth over the surface of the bath.[82]

Frigge's use of color is particularly distinctive. She prefers to work with clear, pure colors. "Every morning," she writes, "I try to persuade my colours to float, and to make them glow—poetry of lines and hues. My marbled papers must not be garish.... The eye must be able to pass over them lightly, without having to blink."[83]

6.57
Contemporary
Marbling by
Karli Frigge

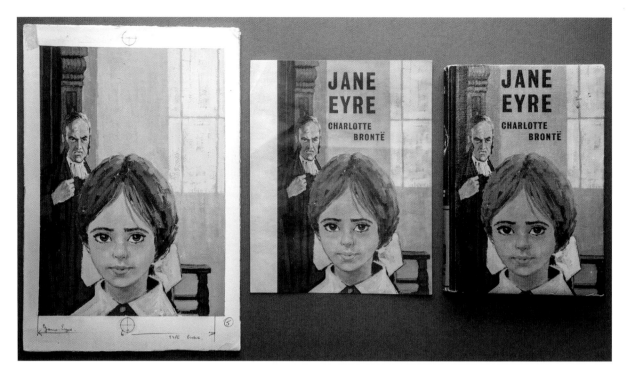

Left to right: Gouache painting and proof for Purnell's Bancroft Classics abridged edition of *Jane Eyre*. N.p., n.d.; Charlotte Brontë. *Jane Eyre*. Abridged. First published in the Bancroft Classics series in 1967. Maidenhead, U.K.: Purnell, 1975.

6.58
Original
Cover Art:
Jane Eyre
Abridged for
Children

This original artwork, painted in gouache on cardboard, was created for a 1967 edition of *Jane Eyre* abridged for children (number thirty-one in Purnell Books's "Bancroft Series"). It features an image of young Jane being scolded by Mr. Brocklehurst, who supervises Lowood School. The selection foregrounds the childhood of Charlotte Brontë's famous heroine—an aspect of the novel that would have been of special interest to this edition's young audience. The ownership inscription of a young child, "Megan Elliott," appears in purple colored pencil on the book's front pastedown.

The painting, which measures approximately 10 by 7 in., was reproduced at a scale of approximately 75 percent and measures 8.5 by 6 in., as we see in the proof that accompanies the artwork. (Under low magnification, one can discern the tell-tale roseate pattern of a four-color halftone composed in cyan, magenta, yellow, and black ink—CMYK.) The upper cover of the book measures only 5.5 by 8 in., and the additional paper at the edges was needed for the turn-ins of the book's boards. Purnell commissioned colorful, original cover art for all of the books in its series.

Sample cover designs for paperback editions of novels by Ursula K. Le Guin: *The Beginning Place*. Bantam, 1983 (artist unidentified); *A Wizard of Earthsea*. Bantam, 1984 (art by Yvonne Gilbert).

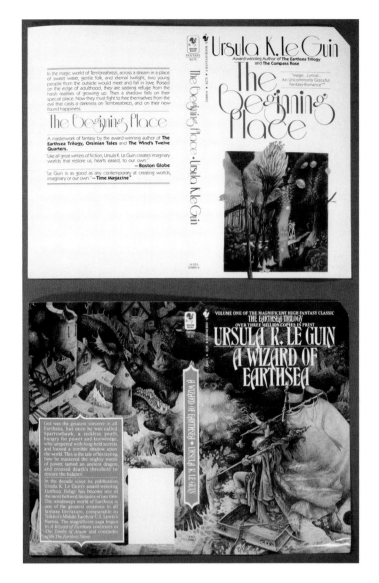

Bantam Books, founded in 1945, was one of the most successful paperback publishers in the United States. The firm invested a great deal of time in designing eye-catching pictorial covers. RBS recently acquired a small archive of paperback covers and promotional materials issued by Bantam in the late 1970s and early 1980s, including these two cover designs for novels by renowned speculative fiction author Ursula K. Le Guin (1928–2018). Bantam purchased the paperback rights to her novel, *A Wizard of Earthsea*, in 1975. This particular cover was designed by British artist Yvonne Gilbert and was issued in 1984, when Bantam's publicity and marketing team decided that the novel was due for a refresher to make it more appealing to a new generation of readers. Bantam acquired *The Beginning Place*, one of Le Guin's lesser-known works, in 1981. Although this cover, issued by Bantam in 1983, is similar in style to Gilbert's design for *A Wizard of Earthsea*, it is not listed among her works.[84] Bantam distributed both covers among its account holders for marketing and publicity purposes, and also to gain feedback on which designs would be more popular with readers.

6.59
Paperback
Cover Design

Madonna. *Sex*. Photographed by Stephen Meisel, art directed by Fabian Baron, edited by Glenn O'Brien, and produced by Callaway. New York: Warner Books, 1992.

6.60
Metal Covers
and Spiral Spine:
Madonna's *Sex*

Some bindings do not stand up to repeated use. RBS owns two copies of Madonna's controversial 1992 photobook, *Sex*. In the first copy, the spiral binding is warped, and the leaves have fallen out and are no longer in their original order. In 2017, RBS purchased a second copy sealed in its original printed silvered Mylar package so that students could see how the book appeared when it first hit the market. The Mylar wrapper emulated condom packaging while also protecting the book from "unpaying browsers," as one *New York Times* critic put it.[85] Madonna led the book project using her production company, Maverick, and exercised complete creative control. Preceded by a massive media campaign, *Sex* sold out quickly after being printed in nearly a million copies in five languages on three continents. It ranks eighteenth on the American Library Association's list of most frequently challenged books for 1990–1999. As a publishing venture, *Sex* was certainly unique and remains unparalleled: how many metal-bound books have appeared on the mass market since 1992?[86]

VI. Endnotes

1. Foot, Mirjam M. *Bookbinders at Work: Their Roles and Methods*. London; New Castle, DE: The British Library and Oak Knoll Press, 2006, 1. Also: Foot, Mirjam. *The History of Bookbinding as a Mirror of Society*. London: The British Library, 1998.

2. David Pearson notes that the earliest surviving European decorated binding is the Stonyhurst Gospel, ca. 700. See Pearson, David. "Bookbinding." In *The Oxford Companion to the Book*. Eds. Michael F. Suarez, S.J., and H. R. Woudhuysen, 147. Oxford: Oxford University Press, 2010. See also Pickwood, Nicholas. "Binding." In *The St Cuthbert Gospel: Studies on the Insular Manuscript of the Gospel of St John (BL, Additional MS 89000)*. Eds. Claire Breay and Bernard Meehan, 41–64. London: The British Library, 2015.

3. Practices varied by country, and pasteboard began to replace wooden boards as early as the fifteenth century, even as wooden boards continued to be used in some areas well past 1600. As Nicholas Pickwood writes: "By the early years of the fifteenth century, thin boards made from sheets of paper pasted together (paste-laminate boards, or pasteboards, copied from Islamic books) were used in both Spain and Italy, and by the end of the century, the use of thick wooden boards had begun to give way to these pasteboards, followed in the first half of the sixteenth century by paper boards made in paper mills." Pickwood, Nicholas. "Bookbinding." In *A Companion to the History of the Book*. 2nd ed. Eds. Simon Eliot and Jonathan Rose, 1:121. 2007. Chichester, U.K.: Wiley-Blackwell, 2020. In addition, as Mirjam Foot points out, "there are Romanesque bindings with leather boards and there are medieval bindings of limp parchment." Foot, Mirjam. Correspondence with Barbara Heritage, 21 May 2022.

4. Pickwood notes that wooden boards continued to be used through the eighteenth century by "binders working in the Germanic tradition," and particularly for "old-fashioned theological libraries." Wooden boards elsewhere became "increasingly restricted to liturgical books (especially lectern bibles), where their traditional appearance may have been thought appropriate." Pickwood, "Bookbinding," 1:121.

5. Szirmai notes: "Virtually all English bindings and at least the major part (*c.* 75 per cent) of Dutch bindings are bound in oak boards. In Germany and the Lake Constance area the preference is just the other way around: here beech prevails with *c.* 90 per cent." The use of wood is not so clear in France. Philippa Marks indicates that French binders largely preferred oak, as did the English, while Italians and Germans largely relied on beech. Szirmai cautiously cites Carvin's claim that "at least two thirds" of French boards were made from beech "whereas oak is rather infrequent." See Szirmai, *Archaeology of Bookbinding*, 216; and see Marks, P. J. M. *The British Library Guide to Bookbinding*. Toronto: University of Toronto Press, 1998, 36.

6. Foot, M[irjam] M. "Bookbinding 1400–1557." In *The Cambridge History of the Book in Britain: Volume III, 1400–1557*. Eds. Lotte Hellinga and J. B. Trapp, 110. Cambridge: Cambridge University Press, 1999.

7. We are grateful to past RBS faculty members Mirjam Foot, Nicholas Pickwood, and Jan Storm van Leeuwen, as well as present RBS faculty member Karen Limper-Herz, for their collective expertise in analyzing this particular artifact.

8. Pearson, David. "panel." In *The Oxford Companion to the Book*. Eds. Michael F. Suarez, S.J., and H. R. Woudhuysen, 2:999. 2 vols. Oxford: Oxford University Press, 2010.

9. Pickwood, Nicholas. "The Interpretation of Bookbinding Structure: An Examination of the Sixteenth-Century Bindings in the Ramey Collection in the Pierpont Morgan Library." *The Library*, 6th s., 17, no. 3 (September 1995): 217.

10. See "cover linings" in Ligatus's Language of Bindings Thesaurus (LoB): <https://www.ligatus.org.uk/lob/concept/1266>; accessed 22 May 2022.

11. David Pearson documents the earliest surviving English embroidered binding as the cover of the fourteenth-century Felbrigge Psalter. But Mirjam Foot points out that embroidered textile bindings may have been used in Europe as early as the eleventh and twelfth centuries owing to evidence in the records of Cistercian monasteries. See

Foot, *History of Bookbinding as a Mirror of Society*, 61–62. See Pearson, David. "textile bindings." In *The Oxford Companion to the Book*. Eds. Michael F. Suarez, S.J., and H. R. Woudhuysen, 2:1198. 2 vols. Oxford: Oxford University Press, 2010.

12. Foot, *History of Bookbinding as a Mirror of Society*, 162.

13. For more information about the Qing palace edition and imperial publishing, see Shaw, Shiow-Jyu Lu. *The Imperial Printing of Early Qing China, 1644–1805.* [Taibei]: Chinese Materials Center, 1983.

14. Howard M. Nixon points out that a similar tool used by the Queen's Binder A has more elongated leaves as opposed to those on the tool of Queen's Binder B—a detail that Mirjam Foot confirmed for us with respect to this particular binding in RBS's collection. See "Queen's Binder B, c. 1675" in Nixon, Howard M. *Five Centuries of English Bookbinding.* London: Scholar Press, 1979, 100. Also see "Queens' Binder B" in Nixon, Howard M. *English Restoration Bookbindings: Samuel Mearne and His Contemporaries.* London: British Museum Publications, 1974, plate 68.

15. See "List of Figures" and plate 67 in Nixon, Howard M. and Mirjam Foot. *The History of Decorated Bookbinding in England.* Oxford: Clarendon Press, 1993, xvii.

16. Wolfe, Richard J. *Marbled Paper: Its History, Techniques, and Patterns. With Special Reference to the Relationship of Marbling to Bookbinding in Europe and the Western World.* Philadelphia: University of Pennsylvania Press, 1990, 21.

17. There has been an ongoing discussion around where marbling first originated in Europe. Although individuals such as Gabriel Magnien speculated that marbling was done in Venice prior to 1600, Richard J. Wolfe writes: "There is no evidence indicating that any sort of marbling took place in Venice (or Europe, for that matter) in the decades prior to 1600." Later he adds: "Though it is not known in what sequence the craft actually migrated to these adjacent lands . . . in all probability [Italy] was the next country after Germany to receive this art." Wolfe continues: "Marbled decoration . . . never became an extensive or integral part of bookmaking and

bookbinding in Italy. Only infrequently does one encounter marbled and other types of decorated endpapers in Italian leather-covered bindings of the late seventeenth and early eighteenth centuries; when they occasionally do appear, such papers can be identified as French or German in origin." See Wolfe, *Marbled Paper*, 20, 48. David Pearson writes that European marbling probably originated in Germany, followed by France. See Pearson, David. "marbling." In *The Oxford Companion to the Book.* Eds. Michael F. Suarez, S.J., and H. R. Woudhuysen, 2:913. 2 vols. Oxford: Oxford University Press, 2010.

18. Pearson, "marbling," 913.

19. Aloys Thomas Raimund Graf Harrach. See documentation provided by University of Pennsylvania Library: <https://commons. wikimedia.org/wiki/File:Exlibris_of_Aloys_ Thomas_Raimund_Graf_Harrach_(1669- 1748)_bookplate,_GC7_H748oR_728v_ (cropped).jpg>; accessed 10 March 2022.

20. Large decorative tools that are armorial in nature are often referred to as tools and stamps; but they should not be confused with the earlier large square or rectangular panel stamps or with later industrial stamps used in mechanized binding.

21. Bruas, Albert. *Les De Morant, Barons et Marquis du Mesnil-Garnier. Recherches historiques et généalogiques sur une famille normande aux xviie et xviiie siècles.* Angers: Lachèse et Dolbeau, 1892, 23.

22. Nixon and Foot, *History of Decorated Bookbinding in England*, 76.

23. Nixon, *English Restoration Bindings*, 45.

24. Lucy Kelsall describes examples bound in dark-brown leather, as well. See Kelsall, Lucy. "A Sombre Binding." In *PMC [Paul Mellon Centre] Notes*, no. 18, 31: <https://issuu. com/paulmelloncentre/docs/pmcnotes_18>; accessed 26 April 2022.

25. David Pearson notes: "Before the middle of the 18th century, the term [publishers' binding] should be used with caution, if at all, as 'publishers' in the modern sense did not exist, and the distinction between trade bindings and publishers' bindings is hardly meaningful." See Pearson, David. "trade binding." In *The Oxford Companion to the*

Book. Eds. Michael F. Suarez, S.J., and H. R. Woudhuysen, 2:1213. 2 vols. Oxford: Oxford University Press, 2010.

26. Bennett, Stuart. *Trade Bookbinding in the British Isles, 1660–1800*. New Castle, DE: Oak Knoll Press, 2004, 93.

27. Nicholas Pickwood writes: "The earliest datable examples of canvas used as a cheap substitute for leather have been found on five copies of Bunyan's The doctrine of the law and grace unfolded . . . sixth edition corrected and amended (W. Johnston, London, 1760)." Pickwood, Nicholas. "Bookbinding in the Eighteenth Century." In *The Cambridge History of the Book in Britain: Volume V: 1695–1830*. Eds. Michael F. Suarez, S.J., and Michael L. Turner, 286. Cambridge: Cambridge University Press, 2009.

28. RBS's copy is both stabbed and sewn. The stab holes are clearly visible as such with paper surrounding them. Sewing is visible in the center of the G gathering. We believe the book was first sewn before being stabbed.

29. Rickards, Maurice. *The Encyclopedia of Ephemera: A Guide to the Fragmentary Documents of Everyday Life for the Collector, Curator, and Historian*. Ed. Michael Twyman with Sally de Beaumont and Amoret Tanner. London: The British Library, 2000, 117.

30. Roberts, Matt T. and Don Etherington. "Dutch gilt papers (Dutch flowered papers)." Bookbinding and the Conservation of Books: A Dictionary of Descriptive Terminology: <https://cool.culturalheritage.org/don/>; accessed 6 March 2022.

31. See "inlays (decorative components)" in Ligatus's Language of Bindings Thesaurus (LoB): <https://www.ligatus.org.uk/lob/concept/3533>; accessed 23 April 2022.

32. RBS faculty member Benjamin J. Nourse observes that there is much debate surrounding the authorship of the *Four Tantras*. According to Nourse, "most accept the text as the word of the Buddha that was transmitted to Tibet from India and compiled in the twelfth century by Yutok Yönten Gönpo (Tib. *g.yu thog yon tan mgon po*). Some also assert that it was hidden during the Tibetan empire and later discovered in the eleventh century by the treasure revealer Drapa Ngönshé (*grwa pa mngon shes*), and

subsequently passed down to Yutok. There is a minority opinion that Yutok was more heavily involved as author himself." The debate is discussed in Frances Garrett's article, "Buddhism and the Historicising of Medicine in Thirteenth-Century Tibet." Asian Medicine 2, no. 2 (2006): 204–224: <https://doi.org/10.1163/157342106780684756>, accessed 31 March 2022. Also see Gyatso, Janet. "The Authority of Empiricism and the Empiricism of Authority: Medicine and Buddhism in Tibet on the Eve of Modernity." *Comparative Studies of South Asia, Africa and the Middle East* 24, no. 2 (2004): 83–96.

33. Some sources also describe this coin a "charm," suggesting that it may have held some special spiritual significance. See British Museum catalogue entry for 1883,0802.3335 "coin; charm": <https://www.britishmuseum.org/collection/object/C_1883-0802-3335>; accessed 25 March 2022.

34. See "Metta Catharina": <http://www.shipsproject.org/Wrecks/Wk_Catharina.html>; accessed 16 March 2022.

35. Neil Kent's book, *The Sámi Peoples of the North*, discusses a trade in Russian reindeer skin. It is the first comprehensive history of the Sámi peoples of the Nordic countries and northwestern Russia. It cites the *Metta Catharina* wreck as one among many examples of this trade. Kent, Neil. *The Sámi Peoples of the North: A Social and Cultural History*. London: Hurst & Co., 2018, 9.

36. See "dicing (techniques)" in Ligatus's Language of Bindings Thesaurus (LoB): <https://www.ligatus.org.uk/lob/concept/1288>; accessed 18 May 2022.

37. Allen, Sue. "Preface." In Krupp, Andrea. *Bookcloth in England and America, 1823–50*. New Castle, DE; London; New York: Oak Knoll Press, The British Library, The Bibliographical Society of America, 2008, vii.

38. Tanselle, G. T. "The Bibliographical Description of Patterns." *Studies in Bibliography* 23 (1970): 72. Tanselle's article was preceded by works about bookcloth by Jacob Blanck (in the *Bibliography of American Literature*), John Carter, Martha Hartzog, and Michael Sadleir.

39. Gaskell, *New Introduction to Bibliography*, 240–245.

40. Krupp, *Bookcloth in England and America.*

41. The Library Company of Philadelphia. 19th Century Cloth Bindings Database: <https://digital.librarycompany.org/islandora/object/Islandora:CLTH1>; accessed 15 March 2022. See also the University of Alabama and the University of Wisconsin-Madison website, Publishers' Bindings Online, 1815–1930: The Art of Books: <https://bindings.lib.ua.edu/designers2.html>; accessed 26 April 2022.

42. Diemberger, Hildegard. "Holy Books as Ritual Objects and Vessels of Teaching in the Era of the 'Further Spread of the Doctrine.'" In *Revisiting Rituals in a Changing Tibetan World.* Ed. Katia Buffetrille, 11. Leiden: Brill, 2012.

43. Isabel Southey died at an early age, and it is unclear whether she had much of a role in binding books for the Cottonian Library. Edith May was a friend of Dora Wordsworth. Information about these women is located via Romantic Circles: <https://romantic-circles.org>; accessed 13 March 2022.

44. Dowden, Edward. *Southey.* New York: Harper and Brothers, 1880, 104–105. Dowden was an Irish poet and critic.

45. Michael Sadleir writes: "The textiles first used on any scale for book-binding purposes were dress materials, chiefly silks and satins, and these made their appearance during the eighteen-twenties as covering for works whose principal aim was elegance rather than durability." Sadleir, Michael. *The Evolution of Publishers' Binding Styles, 1770–1900.* The History of Bookbinding Technique and Design, edited by Sidney F. Huttner. New York and London: Garland Publishing, 1990, 39.

46. Southey, Reverend Charles Cuthbert, ed. *The Life and Correspondence of Robert Southey.* 6 vols. London: Printed by Longman, Brown, Green, and Longmans, 1850, 6:16–17.

47. Loring, Rosamond B. *Decorated Book Papers: Being an Account of Their Designs and Fashions.* 4th ed. Ed. Hope Mayo, 69. Cambridge: Houghton Library, Harvard College Library, 2007.

48. Scheper, Karin. *The Technique of Islamic Bookbinding: Methods, Materials and Regional Varieties.* 2nd rev. ed. Leiden: Brill, 2018, 261.

49. Scheper, *Technique of Islamic Bookbinding*, 261.

50. We are grateful to RBS faculty member Marianna Shreve Simpson and Mohsen Ashtianyn (Associate Research Scholar, Ehsan Yarshater Center for Iranian Studies, Columbia University) for their assistance in identifying the correct author and title of this manuscript.

51. Griest, Guinevere L. *Mudie's Circulating Library and the Victorian Novel.* Trowbridge, U.K.: David & Charles, 1970, 38–39. First published by the Indiana University Press.

52. Rota cites the publication date as 1818 instead of 1819. Rota, Anthony. *Apart from the Text.* Pinner, U.K.; New Castle, DE: Private Libraries Association and Oak Knoll Press, 1998, 163.

53. As William St Clair observes, this large sum was partially the result of readers' mistaken belief that the novel had written by Lord Byron. St Clair, William. *The Reading Nation in the Romantic Period.* Cambridge: Cambridge University Press, 2004, 610.

54. St Clair, *Reading Nation in the Romantic Period*, 245–46.

55. Sadleir, *Evolution of Publishers' Binding Styles*, 39–40.

56. Although Archibald Leighton is often credited with the introduction of bookcloth in 1825, Sadleir offers very strong evidence that Pickering's clothbound "Diamond Classics" preceded Leighton's—and this 1824 copy in the RBS collection helps to support that case. Sadleir, *Evolution of Publishers' Binding Styles*, 41–43.

57. While a teenager, Browne had won prizes from for his etchings from the Society of Arts, but he was still relatively unknown when he began illustrating the *Pickwick Papers.* See Lester, Valerie Browne. *Phiz: The Man Who Drew Dickens.* London: Chatto & Lindus, 2004.

58. Rota, *Apart from the Text*, 195.

59. Mirjam Foot discusses how, by the 1700s, "binding and tool design were more regularly devised to reflect the literary contents of the book within." She describes Edwards of Halifax bindings, as well as covers decorated by the bookbinder Roger Payne, among other examples. Foot, *History of Bookbinding as a Mirror of Society*, 67–68.

60. "Imperial Arming Press, 1830s–1890s." American Bookbinders Museum: <https://bookbindersmuseum.org/collections/equipment/imperial-press-english-1832/>; accessed 13 March 2022.

61. See Krupp, *Bookcloth in England and America*, 6. Also Lock, Margaret. *Bookbinding Materials and Techniques, 1700–1920*. Toronto: The Canadian Bookbinders and Book Artists Guild, 2003, 104.

62. For the timespan during which printed cloth was used on American bindings, see Allen, *American Book Covers, 1830–1900*. Margaret Lock notes that American and Canadian bookbinders "bought virtually all their bookcloth" from Britain until 1883. She also comments on the prevalence of the cloth on American bindings. See Lock, *Bookbinding Materials and Techniques*, 101, 104.

63. Krupp, *Bookcloth in England and America*, 7.

64. Winship, Michael. *American Literary Publishing in the Mid-Nineteenth Century: The Business of Ticknor and Fields*. Cambridge: Cambridge University Press, 1995, 123.

65. Huttner, Sidney F. *The Lucile Project: Recovering the Publication History of a Single 19th Century Book*: <http://sdrc.lib.uiowa.edu/lucile/>; accessed 15 March 2022. Sidney F. Huttner, who leads The Lucile Project, curated a 1995 RBS exhibition with Elizabeth Stege Huttner on Owen Meredith's book.

66. There were some exceptions of works that were first printed in yellowback form.

67. Topp, Chester W. *Victorian Yellowbacks & Paperbacks, 1849–1905: Volume III, Joseph Camden Hotten and Chatto & Windus; Chapman & Hall*. Denver: Hermitage Antiquarian Bookshop, 1997, 345.

68. See the Delaware Art Library's feature "Timeline of Publishers' Bindings: 1870–1879" within "The Cover Sells the Book: Transformations in Commercial Book Publishing, 1860–1920": <https://delartlibrary.omeka.net/exhibits/show/-the-cover-sells-the-book---tr/timeline-1870s>; accessed 15 March 2022. See also the University of Rochester's online exhibition, "Beauty for Commerce: Publishers' Bindings, 1830–1910," curated by Andrea Reithmayr: <https://rbscp.lib.rochester.edu/3345>; accessed 15 March 2022.

69. Jerome McGann wrote a detailed description for the binding, noting is history. See "Binding Design: Songs before Sunrise": <http://www.rossettiarchive.org/docs/sa124.rap.html>; accessed 15 March 2022.

70. We are grateful to RBS E. Ph. Goldschmidt Fellow (2019) William Fleming for his detailed description of this book.

71. Allen, Sue. *The Book Cover Art of Sarah Wyman Whitman*. Boston: The Society of Printers, 2012, 4.

72. Pattison, Todd and Elizabeth DeWolfe. "Female Labor and Industrial Growth in Nineteenth-Century American Bookbinding." In *Suave Mechanicals: Essays on the History of Bookbinding*. Vol. 7. Ed. Julia Miller, 497. Ann Arbor, MI: The Legacy Press, 2022.

73. In the British trade, books containing fewer than 96 pages were considered to be pamphlets or brochures bound in paper wrappers. Glaister, Geoffrey Ashall. "paperback." In *Encyclopedia of the Book*. 2nd ed. New Castle, DE; London: Oak Knoll Press and The British Library, 1996, 359–360.

74. Allen Lane conceived of the idea while serving as the managing director of The Bodley Head, whose board initially rejected the Lanes' proposal. Penguin Books became a separate company in 1936 after its phenomenally successful launch in 1935. See Baines, Phil. *Penguin by Design: A Cover Story, 1935–2005*. London: Penguin Books, 2005, 12–13.

75. Baines, *Penguin by Design*, 50–51.

76. Shaffi, Sarah. "How the Penguin Logo Has Evolved through the Years." Penguin Books, 16 September 2020: <https://www.penguin.co.uk/articles/2020/september/penguin-books-logo-history-edward-young-allen-lane.html>; accessed 15 March 2022.

77. Even Penguins published in the United States were sometimes marketed with colorful color illustrations between 1942 and 1947. Baines, *Penguin by Design*, 41.

78. Cited in Boyd, Melba Joyce. *Wrestling with the Muse: Dudley Randall and the Broadside Press*. New York: Columbia University Press, 2003, 166.

79. Frigge, Karli. *Marbled Paper*. Buren, Netherlands: Antiquariaat Frits Knuf, 1985, [iii].

80. Frigge, Karli. *The Magic of Marbling*. Joppe, Netherlands: Karli Frigge, 2020, 19.

81. See Berger, Sidney E. *Karli Frigge's Life in Marbling*. Newton, PA: Bird & Bull Press, 2004, 35.

82. Frigge, *The Magic of Marbling*, 54–55.

83. Frigge, *Marbled Paper*, [xvii].

84. The Internet Speculative Fiction Database, which provides a detailed list of all the reprint editions of Le Guin's books, is an important resource for helping track the publishing history of works of speculative fiction. See "Ursula K. Le Guin": <http://www.isfdb.org/>; accessed 7 March 2022.

85. James, Caryn. "The Empress Has No Clothes." *The New York Times*, 25 October 1992.

86. We extend our thanks to long-time RBS summer staffer, Christine Schott (Associate Professor of English, Erskine College), for compiling a teaching aid including press coverage on the initial release of *Sex*.

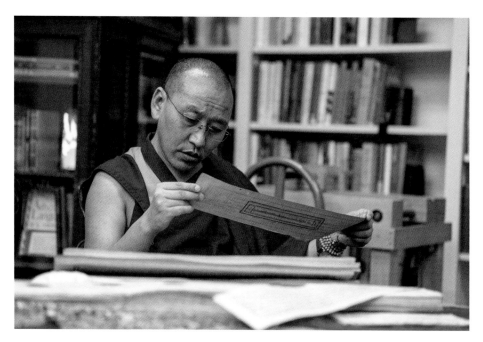

Geshe Ngawang Sonam examines a Tibetan *pecha* from the RBS collections during a research consultation with RBS curatorial staff. Photograph by Shane Lin, 2019.

VII. MARKS IN BOOKS:
INDIVIDUAL AND INSTITUTIONAL
INTERVENTIONS

Readers and other individuals active in the lifecycle of a book leave their own traces on its binding and within its leaves. Such marks help us understand how individuals—readers, but also publishers, binders, and booksellers—and larger institutions intervene in the material text and the book as object. As Roger Stoddard affirms in his foundational exhibition catalogue, *Marks in Books, Illustrated and Explained* (1985), these interventions are "eloquent of manufacturing processes, specific of provenance, telling of human relations, and suggestive of human thought."[1] In his essential guide on provenance (i.e., the marks of ownership in books), RBS faculty member David Pearson notes that such copy-specific information is of increasing value to custodians of books, as it makes books "recognizably unique and distinguishable."[2] According to Pearson, in the age of digital surrogates, any evidence showing how readers interacted with their books is of even greater "cultural value."[3]

The more obvious and readily recognizable marks of ownership, sale, and use include bookplates, labels, tickets, and stamps. Within the leaves of a book, one can also discover readers' and publishers' manuscript interventions such as inscriptions, annotations, and proofreading marks. Another, more ambivalent example of marks in books are those interventions made by individuals, by religious orders, or by the state that were intended to remove, destroy, or obscure portions of the text in acts of expurgation or censorship. Last, but not least, there are the more recent and creatively minded acts of readers and artists who repurpose and transform preexisting texts through the practices of altered bookmaking.

Korean typographic edition of the Chinese philosophical work *Chung sŏl* (Ch. *Zhongshuo*, 中說). Printed from the Korean *kapchinja* (甲辰字) bronze movable-type font of 1484. On loan from the Albert and Shirley Small Special Collections Library, University of Virginia. Formerly in the Guanhailou Collection of Xia Wei and Soren Edgren.

7.1
Four Centuries of Provenance: An Exemplar from East Asia

This Korean typographic edition is a Chinese philosophical work *Chung sŏl* (Ch. *Zhongshuo*, 中說) that was printed from the Korean *kapchinja* (甲辰字) bronze movable-type font of 1484. It contains no less than twelve seals impressed by nine collectors who documented their ownership in the book. The seals of Manase Shōrin (曲直瀨正琳, 1565–1611), Kojima Hōso (小島寶素, 1797–1848), Mukōyama Kōson (向山黄邨, 1826–1905), Yang Shoujing (楊守敬, 1839–1915), Nakayama Kyūshirō (中山久四郎, 1874–1961), and Obama Toshie (小汀利得, 1889–1972) are seen here, while those of Fu Zengxiang (傅增湘, 1872–1950), Sorimachi Shigeo (反町茂雄, 1901–1991), and Soren Edgren (b. 1942) are found elsewhere in the volume. Tanaka Keitarō (田中慶太郎, 1880–1951), who acquired the book from Fu and sold it to Nakayama, did not leave a seal mark. The portrait of Yang Shoujing at the age of seventy was tipped into the enclosures of some of his rarest books. This edition is one of only two known copies.

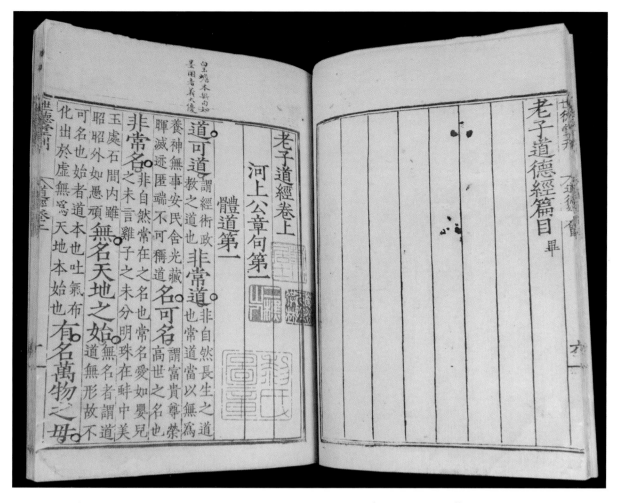

Jiajing period (1522–1566) edition of three Daoist philosophers. *Laozi* (老子), *Zhuangzi* (莊子), *Liezi* (列子). Suzhou: Shidetang, 1533. (Image from *Laozi*, vol. 1 of two bound vols.) On loan from the Albert and Shirley Small Special Collections Library, University of Virginia. Formerly in the Guanhailou Collection of Xia Wei and Soren Edgren.

This fine Jiajing period edition, printed in 1533, features the works of three Daoist philosophers: *Laozi* (老子), *Zhuangzi* (莊子), and *Liezi* (列子). It not only contains the ownership seals of Li Jian (黎簡, 1747–1799), Li Xialing (李遐齡, 1768–1823), and Li Gonglin (李供林, 1898–1979), but also has annotations made by Li Jian in 1794. His original manuscript commentary is found in *Laozi* (35 lines), *Zhuangzi* (440 lines), and *Liezi* (64 lines). Li was considered the most outstanding Qing dynasty landscape painter from Guangdong. Later in life he was strongly drawn to Daoism, and so these marginal annotations, written just five years before his death, are of particular interest.

7.2
Annotation by
a Qing Dynasty
Landscape Painter

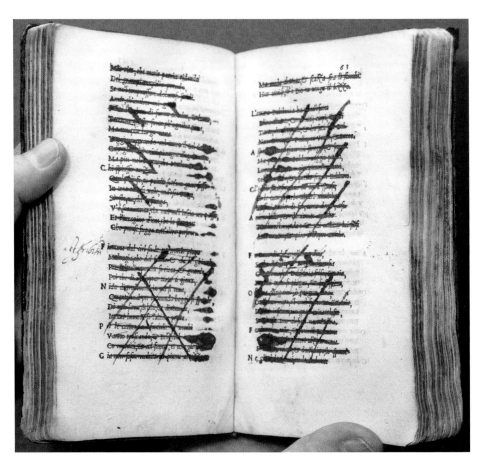

Francesco Petrarch. *Il Petrarcha*. Fiorenza: P[er] li heredi di Filippo di Giunta, L'anno M.D.XXII. del mese di luglio [July 1522].

7.3 Censorship: The Case of Petrarch

This 1522 illustrated copy of Petrarch's poems, *Il Petrarcha*, is still housed in its contemporary binding, which features a blind-embossed emblem of a poet laureate in profile. Inside, it bears some remarkable marks of use: portions of the text of Petrarch's "Babylonian Sonnets" have been heavily censored in manuscript in iron-gall ink, including *"Fiamma dal Ciel," "L'avara Babilonia,"* and *"Fontana di dolore"* (137–139, per Petrarch's numbering), as well as *"De l'empia Babilonia"* (114 in Petrarch's numbering). In the margins, a censor has written "est p[ro]hibitu[m]" ("it is prohibited"), doing so in accord with the *Index librorum prohibitorum* [*List of Prohibited Books*] of 1559, which had deemed the poems heretical.[4]

The sonnets, written by Petrarch in the mid-fourteenth century, attacked the Avignon papacy, a period from 1309 to 1377 during which the papal court was based at Avignon, in southern France, rather than in Rome. As RBS faculty member Peter Stallybrass has documented, even before the Reformation, these four sonnets were often written out separately within manuscripts that designated the poems as attacks on what was often referred to as the "Babylonian Captivity of the Papacy" in its French exile.[5] Yet, as Stallybrass notes with irony, it was after the Reformation when Petrarch was "transformed": not as a "prophet of a restored Roman papacy" but instead as its "most virulent critic—a Protestant before his time."[6] By the same token, RBS Director Michael Suarez makes a case in his

RBS courses for how censorship is a means of saving books from a worse fate: that of complete destruction by burning, or other means. In this sense, censorship can be seen as a pro-forma task that ensured that a book could continue to reside in a library—an apparently open act of disapproval that, in the end, ensured the survival of the book and, in the larger scheme, the integrity of the library housing it.

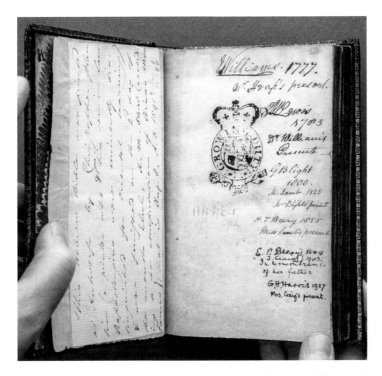 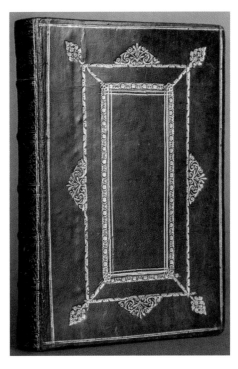

[Hamishah humshe Torah.] חמשה חומשי תורה. [Antwerp: Christopher Plantin, ca. 1573.]

This sixteenth-century Hebrew Bible is bound with the New Testament in Syriac in a late seventeenth- or early eighteenth-century English decorated binding of black goatskin. It features an almost unbroken record of English ownership dating from 1698 to 1927 and spanning eleven different owners. The final leaves contain a manuscript table of contents in English and in Hebrew, as well as stenographic notes written in pencil. The first owner's name inscribed in the book is that of John Russell (1698). Next follows a name written in yet-to-be-deciphered stenography (1708). On the next leaf, pictured here, eight additional owners wrote their names following the model set down by J. Williams (1777), who includes the note: "Mr. Heap's present." Almost all the following owners took care to transcribe the names of those who gave them the book. We have identified two of the book's nineteenth-century owners: H. J. Breay (1855) was likely The Reverend H. J. Breay, while E. P. Breay (1884) was a woman known for founding a home for blind children in Kilburn, England.[7] The same leaf is also marked with an ink stamp for "growing duty," a tax on luxury goods that was introduced in England in 1701–1702. The stamp was put into the book when it first entered England from the continent in the early eighteenth century.

7.4
A Printed
Torah Rich in
Provenance

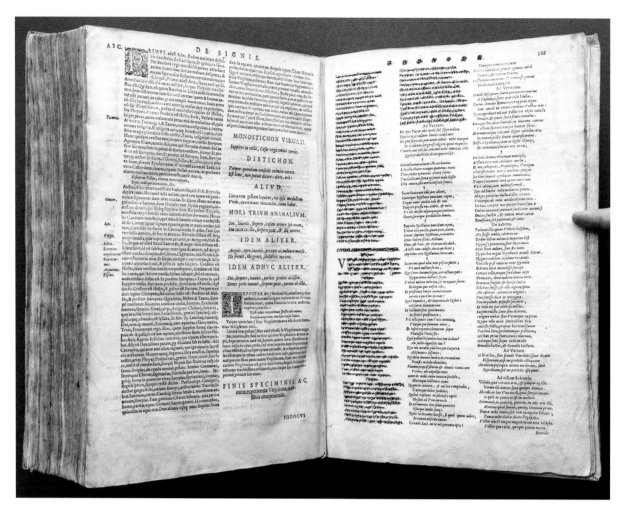

P. Virgilii Maronis poetae Mantuani universum poema. . . . Venice: Ioannem Gryphium, 1584.

7.5
Expurgated
Poems Attributed
to Virgil

In this sixteenth-century Venetian folio edition of the works of Virgil, there are two sets of excisions. The first excision occurs in a section of Virgil's Sixth Eclogue, in which the god Silenus sings a song about unhappy love and metamorphosis. It is not clear why this passage was cut out, and it may have been removed owing to damage or to a stain on the paper. The second excision is a more obvious act of expurgation and censorship. In the signature CC (leaves 385–87), a lengthy section made up of *Priapeia*, or songs dedicated to the fertility god Priapus, has been cut out entirely, leaving only stubs as evidence. The final portion of the songs, printed on the same leaf (388r) as non-priapic text, has been crossed out in ink. RBS was able to identify the expurgated leaves by examining a digitized and unexpurgated copy of the book from the Staatliche Bibliothek Regensburg. Renaissance scholars attributed the minor poems in the *Priapeia* to Virgil, but unlike the poet's major work, the Priapic poems were obscene. They are found in 68 of the 132 editions of Virgil published in Venice during the Renaissance.[8] The *Priapeia* were placed on the *Index librorum prohibitorum* of the Roman Catholic Church in 1583.

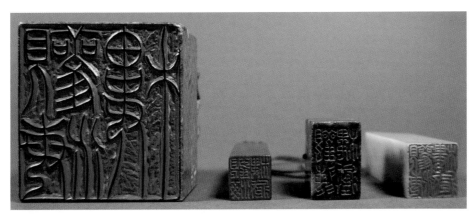

Seals and side/top views. Guanhailou Collection *ex libris* seals (觀海樓藏書印) on loan from the personal collection of Soren Edgren.

Seals began to be used in China in the sixth century, if not earlier, to designate ownership. Unlike Western bookplates, seals appear not just within books, but also on works of calligraphy, as well as graphic works, such as paintings, drawings, and prints. Displayed here are four personal *ex libris* seals that were created for RBS faculty member Soren Edgren's Guanhailou Library and that are also used for instruction at RBS. Each seal bears a different design made by a highly skilled artisan. As displayed left to right: *Shoushan* stone cut by Yu Weiguo (b. 1953), who also carved the mythical animal on top; *Shoushan* stone cut by Zhou Jianguo (b. 1956); *Qingtian* stone cut by Chen Fengzi (1912–2008); and *Qingtian* stone cut by Qian Juntao (1906–1998). Edgren uses these as teaching examples in his RBS courses.

7.6
Ex Libris Seals
for the
Guanhailou
(觀海樓) Collection

7.7
A Monastic
Publication
from Tibet with
an Unusual
Provenance

This copy of *Dispelling Mental Darkness: An Ornament for the Seven Treatises on Valid Cognition* (Tib. *tshad ma sde bdun gyi [rgyan yid kyi mun] sel*, ཚད་མ་སྡེ་བདུན་གྱི་རྒྱན་ཡིད་ ཀྱི་མུན་སེལ་) features no less than seven ownership seals. Owing to their age and wear, however, they are difficult to decipher. According to Geshe Ngawang Sonam, the black color of the seals suggests that they are not modern. The *pecha*'s colophon informs readers that woodblocks were cut at Kumbum Jampa Ling Monastery (Tib. *sku 'bum byams pa gling*), located in Amdo, Tibet—not far from where His Holiness the Fourteenth Dalai Lama was later born. Both the paper and letterforms themselves are typical of work produced by nineteenth-century Amdo printing houses, according to RBS faculty member Benjamin J. Nourse.

The text itself is a famous commentary by the first Panchen Lama, Khedrup Gelek Pelzang (Tib. མཁས་གྲུབ་རྗེ་དགེ་ལེགས་དཔལ་བཟང་), on a foundational Buddhist text on logic and epistemology: the *Pramāṇavārttika* (Sansk. प्रमाणवार्त्तिक) by Dharmakīrti (ca. 600–660 CE). The ownership seal is used three times on the same leaf on both covers of the *pecha*—a placement that may seem redundant or overzealous, but that may have held a particular meaning for its owner. Opening prayers in Tibetan Buddhist practice are repeated three times as a rule—not only for the sake of thoroughness, but also as a form of blessing, as the number three is associated with the "three jewels": the Buddha, the *dharma*, and the *sangha*.

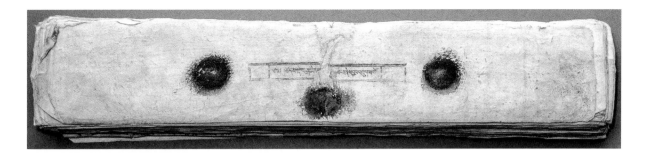

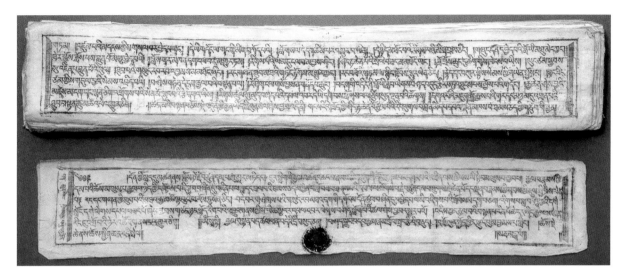

Dharmakīrti; commentary by Khedrup Gelek Pelzang (Tib. མཁས་གྲུབ་རྗེ་དགེ་ལེགས་དཔལ་བཟང་). *Dispelling Mental Darkness: An Ornament for the Seven Treatises on Valid Cognition* (Tib. *tshad ma sde bdun gyi [rgyan yid kyi mun] sel*, ཚད་མ་སྡེ་བདུན་གྱི་རྒྱན་ཡིད་ཀྱི་མུན་སེལ་). Amdo, Tibet: Kumbum Jampa Ling Monastery, ca. 1850.

Disbound boards. Top row, left to right: Edward Jesse. *An Angler's Rambles*. London: John Van Voorst, 1836; George Parker. *Humorous Sketches; Satyrical Strokes, and Attic Observations*. London: Printed for the author and sold by S. Hooper, [n.d.]. Bottom: *Book of Common Prayer*. Oxford: Clarendon Press, 1828. Gift of Robert Milevski.

7.8
Binders' Tickets

With the permission of the academic libraries where he was working, preservation administrator Robert Milevski retrieved the boards of nineteenth-century books that had been guillotined before being scanned for digitization or microfilming. Milevski wanted to preserve examples of publishers' bookcloth and binders' and booksellers' tickets as research aids for identifying where books were made and marketed, and how they were purchased and used.[9] As Maurice Rickards points out: the use "of binder's tickets is a predominantly British practice, though examples are found in Europe and North America, where the stationer's, bookseller's, and printer's label also appear."[10] Designed to be inconspicuous, binders' tickets are rarely more than a few square centimeters in size. They could be printed via intaglio, letterpress, or lithography. These three boards from the first half of the nineteenth century in England bear tickets from these binderies (top row, left to right): Westleys & Co. in London; Lubbock in Newcastle; and (bottom) John Bird in London. The first, Westleys & Co, operated up until the 1900s and produced a number of variants of its binders' tickets.[11]

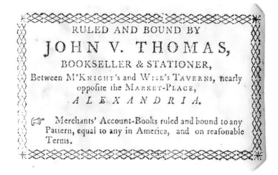

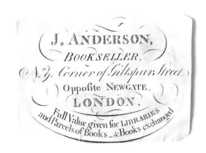

Booksellers' tickets. Above, left: Paul and Isaac Vaillant of London. Above, right from the top: W. H. & O. H. Morrison of Washington, DC; John V. Thomas of Alexandria, VA; and J. Anderson of London. Gift of James M. Goode.

Like binders' tickets, booksellers' tickets were predominantly an English-language practice in Britain and the United States from the eighteenth century onward.[12] They were printed via copperplate engraving and letterpress—and later on, via lithography. They are most often found adhered to the pastedowns on the inside covers of books. Booksellers' labels attest to the myriad activities carried out by these businesses, including stationery, engraving, and even binding. The tickets shown for the American booksellers W. H. & O. H. Morrison (ca. 1860) of Washington, DC, and John V. Thomas (ca. 1790) of Alexandria, Virginia, indicate that both acted as booksellers and stationers, with Thomas offering ruling and binding services. The other two tickets are from the London booksellers Paul and Isaac Vaillant (ca. 1731 to 1780),[13] who specialized in French books, and J. Anderson (ca. 1790), who also dealt in the secondhand book trade.

7.9
Booksellers'
Tickets

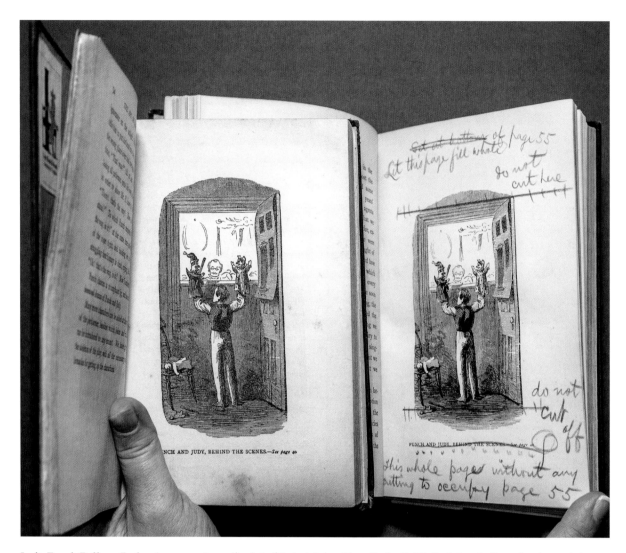

Left: Frank Bellew. *Parlor Amusements; or the Art of Entertaining.* New York: G. W. Carleton & Co., 1879 (copyright 1878 on t.p.); London: S. Low, Son & Co., 1879. Right: Frank Bellew. *The Art of Amusing.* New York: Carleton, 1869; London: S. Low, Son & Co., 1869. Gift of Scott Fennessey.

7.10
The Carleton Copy of *The Art of Amusing* (1869) with Blue-Pencil Editing

Illustrated by artist and cartoonist Frank Bellew (1828–1888), *The Art of Amusing* was intended for domestic entertainments, such as games, charades, tricks, and private theatricals. It was first published in New York by Carleton in 1866 just after the Civil War, and the title appeared on Carleton's list through 1877. The book was often sold and marketed along with Carleton's *The Art of Conversation*, *The Habits of Good Society*, and *The Arts of Writing, Reading, and Speaking*.

This 1869 copy was marked up in blue pencil and purple ink for a new edition of the book that was planned in 1877. Provisionally titled "That Pleasant Evening," the revised version seems to have been first slated for publication in 1877 by G. W. Carleton & Co. (In 1871, Carleton partnered with G. W. Dillingham, and the company was renamed G. W. Carleton & Co.—hence the change with respect to the publisher's title.) Revisions include the removal of fifty pages of text (chapters

XIII, XIV, and XV), as well as substantial modifications to the placement and size of illustrations and also the removal of certain paratextual elements (e.g., the table of contents). These substantial modifications aside, the book was largely printed from the same plates as before. The new version, ultimately titled *Parlor Amusements; Or the Art of Entertaining*, was submitted for copyright in 1878. A side-by-side comparison of the two books shows different stages of the editorial process. The mark-up in blue pencil in RBS's 1869 copy provides instructions for shifting an illustration facing page forty to a new position in the later edition. In an initial stage of editing, it appears that this illustration was going to be cut down in size and placed at the bottom of page fifty-five. That initial editorial decision was revised, however, and, although the image was moved, it was left to stand it its entirety.

Notably, RBS's copy of *The Art of Amusing* contains additional markings in pencil by its subsequent owner: "Louie Carleton"—that is Louise Carleton (1872–1925), the daughter of the book's publisher, G. W. Carleton (1832–1901). Louie, still a child when receiving the book, practiced writing her name in pencil on its pages, and she decorated its rear endpapers with drawings. The volume ended up with her son, who died in Charlottesville in 1998. In 2005, the book was taken to Blue Whale Used & Rare Books, whose owner, Scott Fennessey, donated it to RBS for classroom instruction.

7.11 Bookplates Designed by a Bookplate Collector

Bookplates, also known as *ex libris*, can be an important part of placing a book's ownership and use in time and location. Bookplates are labels, usually bearing the owner's name or initials as well as a decorative or pictorial motif. They may also include armorial elements. The first example in Europe is thought to be the famous 1450 "Igler," or hedgehog, bookplate of Johannes Knabensberg.[14] The earliest bookplates were generally printed from engraved plates, but as time passed, they were reproduced by other means, including wood engraving and lithography. In the twentieth century, there was a revival of interest in bookplates and a proliferation of societies of bookplate collectors across the globe.

Shown here are several examples designed by Sara Eugenia Blake (1886–1973), a Tufts University librarian who collected and designed bookplates. Many of Blake's plates were produced via etching, and she created them for her friends and family, often borrowing pictorial and decorative elements from other artists.[15] James M. Goode (1940–2020) was an avid bookplate collector whose collection included this assemblage of Blake's bookplates, which was framed for exhibition hosted by Rare Book School and the Albert and Shirley Small Special Collections Library in 2010.

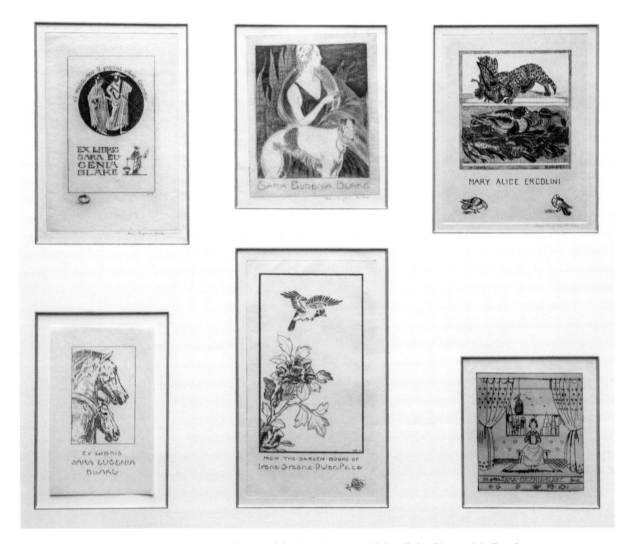

Six twentieth-century etched bookplates designed by Sara Eugenia Blake. Gift of James M. Goode.

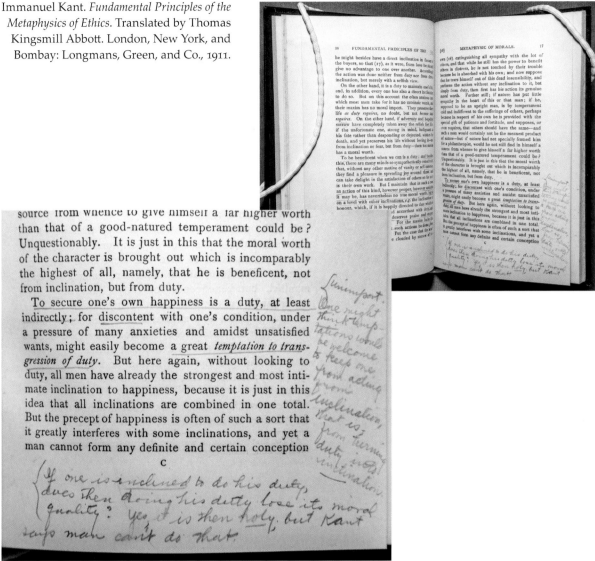

Immanuel Kant. *Fundamental Principles of the Metaphysics of Ethics.* Translated by Thomas Kingsmill Abbott. London, New York, and Bombay: Longmans, Green, and Co., 1911.

Helena Belle Carpenter of Enosburg Falls, Vermont, was a student at Middlebury College who read and annotated this copy of Kant's *Fundamental Principles of the Metaphysics of Ethics.* In the college yearbook for 1914, Carpenter is described as a "model student" who "elects Advanced Ethics . . . merely for mental discipline!" Carpenter's annotations align with the usual forms of marginalia: correction, supplement, and commentary.[16] On the half-title, she adds in pencil "written in 1788" to contextualize Kant's philosophy. On page seventeen, she argues with Kant in the margins, noting: "If one is <u>inclined</u> to do his duty, | does then doing his duty lose its moral | quality? Yes, it is then <u>holy</u>; but Kant | says man can't do that." In addition to containing underlining and notes in its margins, the book also bears Carpenter's printed bookplate, reading: "This Book is the Property of Helena B. Carpenter." The bookplate is numbered "45" in Carpenter's handwriting, which also appears on the verso of the front flyleaf, where she inscribed her name and "Middlebury, Feb. 1913." Readers' interventions in the text are now an important and growing part of the study of the history of the book.

7.12

Marks of Reading from a Model Student

Carlos P. Romulo. *I Saw the Fall of the Philippines*. Garden City, NY: Doubleday, Doran & Company, Inc., 1943. Gift of the University of Virginia Library.

**7.13
Military
Censorship:
*I Saw the Fall
of the Philippines***

The Filipino soldier and journalist Carlos P. Romulo (1899–1985) witnessed the Japanese invasion of his country firsthand in 1941 and 1942. He wrote his account of the conflict shortly thereafter when he arrived in the United States. By the time his book was first published in 1942, Romulo had already become the first non-American to win the Pulitzer Prize in Correspondence—an honor he was awarded in 1942. Nevertheless, *I Saw the Fall of the Philippines* was subject to the activities of the U.S. Office of Censorship, an emergency wartime agency set up by the federal government on 19 December 1941 to aid in the censorship of all communications coming into and going out of the United States, including its territories and the Philippines. Journalists were required to submit their stories to the War Department before filing them.

The War Department censored content on a total of twenty-four pages of Romulo's book; the publisher notes its preliminaries that "The War Department has requested that certain statements in this book be deleted. This request arrived too late to permit the book to be reset. These deletions are indicated by heavy black lines" (viii). The censors blacked out not only references to ongoing military activities in the region, but also mention of a past act of torture committed by the American military during the Philippine-American War (1898–1902). On pages 48 and 49, Romulo, who served as an aide of General Douglas MacArthur (1880–1864), recalls an episode from his childhood: "One night when I was supposed to be asleep I heard an uncle of mine, Pascual Pena, describing my grandfather's torture by [redacted] soldiers giving him the water cure."[17]

The censored text on page 240, pictured here, appears to be related to an official directive sent to MacArthur, who by then had been transferred to Melbourne. Lieutenant General Jonathan Wainwright (1883–1953) took over the defense of Bataan after MacArthur was sent to Australia. This copy was personally inscribed by Romulo to his friend, Tulio M. Cordero, in Philadelphia, Pennsylvania, in 1962.

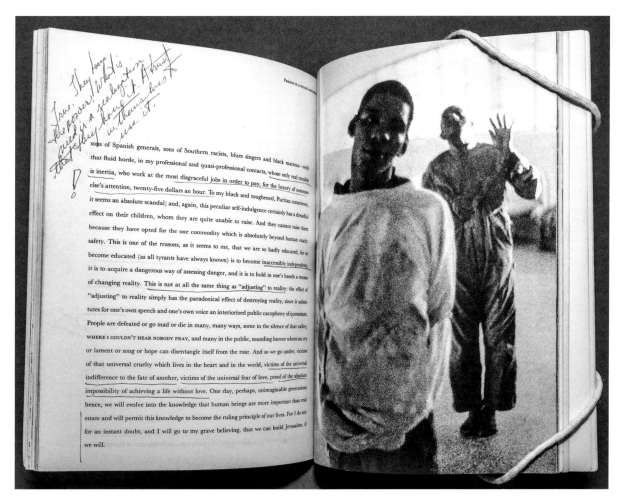

Photographs by Richard Avedon and text by James Baldwin. *Nothing Personal*. New York: Dell Publishing Company, 1965.

In 1964, James Baldwin and Richard Avedon were both at the height of their fame when they collaborated on *Nothing Personal*, published in a large format by New York's Atheneum Press with four short pieces by Baldwin and large, full-bleed photographs by Avedon. The two men had been friends since high school, which they attended together at DeWitt Clinton in the Bronx in the late 1930s. This copy of *Nothing Personal* is from the smaller, inexpensive reprint edition published by New York's Dell Publishing in 1965. The third of Baldwin's essays is copiously underlined and annotated in pen by James H. Funston, who inscribed his name on the front flyleaf and who is listed as a biology instructor at The College of the Holy Cross in 1971. Funston underlines several sections, including the sentence "All lives are connected to other lives. . . ." When Baldwin criticizes those privileged few "whose only real trouble is inertia," and who work "at the most disgraceful jobs" to pay psychiatrists twenty-five dollars an hour for therapy, Funston exclaims in the margins: "True. They have | the power! What is need[ed] | is a realization | that they have it. A trust | in themselves to | use it!" The facing photograph by Avedon is captioned "Patients in a mental institution"; it depicts individuals in the East Louisiana State Mental Hospital.

7.14

An Annotated Photobook

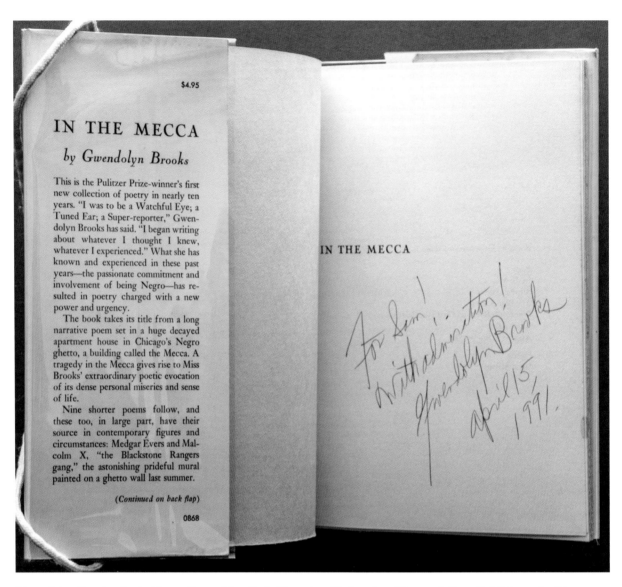

Gwendolyn Brooks. *In the Mecca: Poems*. New York; Evanston, IL; London: Harper & Row, Publishers, [1968].

7.15
Inscription from
One Poet Laureate
to Another

Inscribed copies of books are those that have been signed or autographed by the author, usually with a sentiment or message, for another person.[18] This copy of *In the Mecca* was inscribed by the poet Gwendolyn Brooks to the poet Sam Cornish (1925–2018). Brooks was the poet laureate of the state of Illinois from 1968 until her death in 2000; Cornish was the poet laureate of the city of Boston and an instructor at Emerson College. Though the book was published in 1968, Brooks's inscription is dated 1991. No doubt Brooks met Cornish and signed his book when she gave a talk at Emerson College in April of that same year. Brooks frequently inscribed copies of her books. Her biographer Angela Jackson states that: "As long as there were people with books to sign, Gwendolyn signed them and talked to people about her writing."[19]

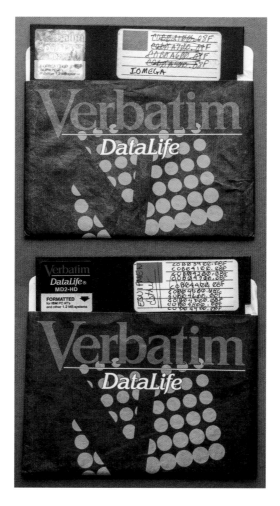

Verbatim DataLife 3½ in. diskettes, ca. 1990. Gift of Sarah G. Kent.

In his book *Bitstreams*, RBS faculty member Matthew G. Kirschenbaum describes consulting some of the 150 floppy disks in author Tony Morrison's papers at the Firestone Memorial Library. Most were 3½ in. formats with handwritten labels; some were the larger, earlier 5¼ in. diskettes. "Despite their being nearly thirty years old, the stored data had proven legible."[20] At RBS, course participants— many of whom routinely handle the born-digital materials of contemporary authors in special collections—examine legacy storage formats such as these 3½ in. Verbatim diskettes that formerly belonged to UVA IT staffer Sarah G. Kent. In the early 1990s, Kent worked as a programmer analyst for an architectural and engineering firm in Greenville, South Carolina. The disk labeled "GCS" in Kent's handwriting is a backup of a FoxPro database that she created to calculate the cost of renovating the Greenville County School buildings. The other two disks are labeled in another person's handwriting. Kent believes that she had reused these disks to create backups for her IBM 386 PC and her Macintosh Classic. The handwritten labels on these digital storage devices are an interesting remnant of manuscript culture, while at the same time, the term "palimpsest," normally applied to manuscripts, has been adopted to describe overwritten digital storage media.[21]

7.16 Digital Palimpsests with Manuscript Labels

Above left: *Neopostmodrinism, or, Dieser Rasen ist kein Hundeklo, or, Gub²rzub² Number 6, or, The Incognita of Rita's Deep Time Coexisting within Central Discoveries of the Thermodynamic Dichotomy of Western Thought: Observed Impregnant Meanings & Transhistorical Justifications.* [Mount Horeb, Wisconsin]: Perishable Press, 1988. No. 113 of 125 copies. Gift of Terry Belanger. Above right and next page: Three working proof copies as described. Gift of Terry Belanger.

7.17
Set of Inscribed
Copies of
Gabberjab
Number 6

In 1991, the artist, printer, papermaker, teacher, and poet Walter Hamady (1940–2019) gave Terry Belanger a remarkable set of four copies of Gabberjab 6—each elaborately inscribed to him. Three of the four copies were working proofs. Like many of Hamady's other artist's books, Gabberjab 6 (a.k.a. *Gub²rzub² Number 6*), titled *Neopostmodrinism, or, Dieser Rasen ist kein Hundeklo*, is letterpress printed on a variety of handmade papers. In this case, some of the book's leaves are also printed on cloth appropriated from a hospital (with handmade sheets of a similar green shade that appear to have been made from similar cloth). Hamady's book makes use of collage, found objects, rubber stamping, blind embossing, die cuts, and perforations, among other techniques and objects. It is full of self-referential (and playful) bibliographical terminology; for example: "HALF TITLE PAGE SIGNATURE 3 OR THE BASTARD TITLE"; "TABLE OR CHAIR OF | CONTENTs"; "(FORE) […] | (EDGE) […] | (PLAY)"; etc. Certain features seem designed to flummox easy description. For example, RBS's copy, numbered 113 in the colophon, is designated "copy no. 98" via a metal medallion preceding the book's half-(bastard)title.

In 2010, Belanger donated the set to RBS. The three proof copies, taken from Hamady's Perishable Press files, show this incredibly intricate book in the making. One of the working copies is a prototype binding model, fashioned on August 8, 1988, that Hamady inscribed as follows to Belanger: "TERRY – THIS ONE TO USE | TO DISPLAY THE COVER | ----- | WSHH 13 IX 91." (Belanger doubtlessly explained to Hamady how useful it is to have at least *two* copies of a book for an exhibition: one to display the cover, another to exhibit the contents.) Another copy, bound in a cover with a sticker reading NOT FOR SALE, is labelled in red pencil as "#141 X PROOF" and contains detailed notes for registering the book's multi-color letterpress printing. It is inscribed: "FOR PRO | FES SOR | TBB ELA | NGE RFR| OMW SHH." Yet another proof,

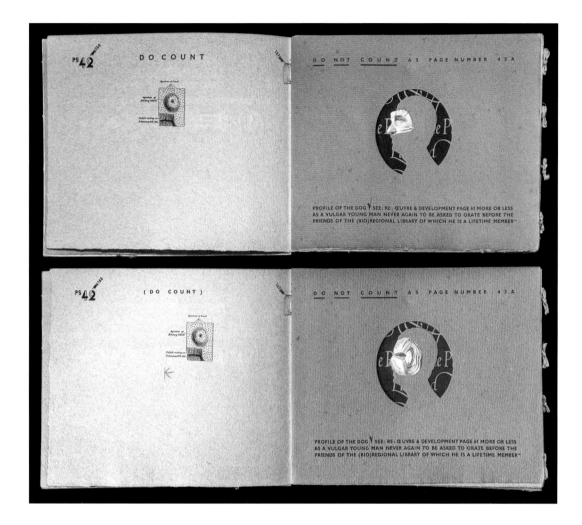

inscribed "4 TB | 1991 | WSHH," is documented in Hamady's hand as #144 "proof out of series." Its cover is also labeled "NOT FOR SALE," and it was originally signed and dated by Hamady on February 9, 1989—well after the edition was out. It is replete with Hamady's markup as well and bears the signatures of Marta Gómez and Kent Kasuboske, who assisted with production.

RBS's complete copy—no. 113 of 125—contains even more numerous and eccentric instances of Hamady's inscriptions, perhaps as a tongue-in-cheek bonus for his bibliographically minded friend. Hamady not only inscribed the book's opening leaf "(TB) [image of eye] (WINK)" and the verso of the leaf facing the half-title: "signed again 18 october 1991 walter shh." Hamady also added an additional piece of collage to the inside board of the book's inner cover ("18 OCT 91 | [arrow] ADDED FOR TB") and wrote on the inside of the front pastedown (which was not pasted down in this case) in red pencil: "KEEP FOLDED DOWN * | TERRY – DO I DARE FUTZ | WITH THIS ANY MORE?" A few days later, he added an inscription at the book's end: "Signed Again For Terry Belanger this sunny | 21 X 91 at 12:15 exactly—a loud two | engine airplane flying NW—Walter | Samuel Semi-Hittite Haatoum Hamady." We have yet to find a more complex or inventive series of presentation inscriptions made to a recipient.

Neil Gaiman. *The Graveyard Book*. With illustrations by Dave McKean. New York: HarperCollins Publishers, 2008.

7.18 Altered Book This copy of Neil Gaiman's novel, *The Graveyard Book*, includes deliberate markings in colored crayons, as well as stickers, pasted-in cuttings from magazines and computer printouts, and pencil flip-book drawings. These alterations to Gaiman's text may have been part of a class project: the reader has penciled in a numbered list of alterations under the heading "Altered Book" on the front flyleaf. The various interventions seem to have little to do with the narrative; for example, on page 262, a happy face is drawn over the description of the two child protagonists fleeing villains. A magazine cutout of a dog wearing sunglasses is pasted on the heading of chapter two, preceded by a small sticker of a spaniel on the vignette at the close of chapter one. (No dogs appear in either chapter.) And here, the original text and illustrations are ornamented with a bee sticker, a cutout of a dog, and yellow-crayon coloring that highlights the printed letters with a name: "e l l e n r o y s e." But then, the point of an altered book is not to reflect the content of a text, but rather to modify it to create new meanings. In recent years pedagogical practice has encouraged young readers to alter books as an exercise in creativity and meaning-making[22]—a project akin to Tom Phillips's ever-continuing postmodern experiment in painting, cut-up, and collage as exemplified in his "treated Victorian novel," *A Humument*.

1. Stoddard, Roger. *Marks in Books: Illustrated and Explained.* Cambridge: The Houghton Library, Harvard University, 1985, 1.

2. Pearson, David. *Provenance Research in Book History: A Handbook.* New rev. ed. Oxford; New Castle, DE: The Bodleian Library and Oak Knoll Press, 2019 (1994), 5.

3. Pearson, *Provenance Research*, 6.

4. The antiquarian bookseller Hosea Baskin identified the censorship in this copy in his description for the book, acquired by RBS in 2011. The first *Index* was issued by the University of Paris in 1544. In 1559, the *Index* was compiled by the central Catholic Church and contained wide-ranging bans on non-Catholic writers. Harris, Neil. "Index Librorum Prohibitorum." In *The Oxford Companion to the Book.* Eds. Michael F. Suarez, S.J., and H. R. Woudhuysen, 2:816. 2 vols. Oxford: Oxford University Press, 2010.

5. Hindson, Ed, and Dan Mitchell. "Great Schism." In *The Popular Encyclopedia of Church History.* Eugene, OR: Harvest House, 1982, 164.

6. Stallybrass, Peter. "Petrarch and Babylon: Censoring and Uncensoring the Rime, 1559–1651." In *For the Sake of Learning: Essays in Honor of Anthony Grafton.* Eds. Ann Blair and Anja-Silvia Goeing, 2:582. 2 vols. Leiden: Brill, 2016.

7. The Reverend H. J. Breay is mentioned in *The Church of the People. 1864.* Vol. VII. London and Oxford: Kent and Co. and W. R. Bowden, [1864]. Miss E. P. Breay is listed in 1869 as the founder of the Home for Blind Children in Kilburn in the North of London. See Burdett-Coutts, Angela Georgina. *Woman's Mission: A Series of Congress Papers on the Philanthropic Work of Women.* New York; London: Charles Scribner's Sons and Sampson Low, Marston & Co., 1893.

8. Kallendorff, Craig. *Virgil and the Myth of Venice: Books and Readers in the Italian Renaissance.* Oxford: Clarendon Press, 1999, 84.

9. Milevski, Robert J. "A Primer on Signed Bindings." In *Suave Mechanicals: Essays on the History of Bookbinding.* Vol. 1. Ed. Julia Miller, 162–245. Ann Arbor, MI: The Legacy Press, 2013.

10. Rickards, *Encyclopedia of Ephemera*, 53.

11. Rickards, *Encyclopedia of Ephemera*, 53.

12. Rickards, *Encyclopedia of Ephemera*, 62.

13. Dow, Gillian. "Anglo-French Relations and the Novel in the Eighteenth Century." In *The Cambridge History of the Novel in French. Part II: The Eighteenth Century: Learning, Letters, Libertinage.* Ed. Adam Watt, 163. Cambridge: Cambridge University Press, 2021.

14. Johnson, Fridolf. *A Treasury of Bookplates from the Renaissance to the Present.* New York: Dover Publications, 1977, iii.

15. Meyer, Kendra. Guide to the Samuel X. Radbill Collection of Sara Eugenia Blake Bookplates. The Grolier Club of New York: <https://www.grolierclub.org/default.aspx?p=v35ListDocument&ID=756962313&listid=11461&listitemid=150503&ssid=322536&dpageid=&listname=>; accessed 9 March 2022.

16. Jackson, H. J. *Romantic Readers: The Evidence of Marginalia.* New Haven: Yale University Press, 2005, 300.

17. RBS faculty member Cheryl Beredo describes the "water cure" and other brutal acts of torture committed by the U.S. in the Philippine War in her study, *Import of the Archive: U.S. Colonial Rule of the Philippines and the Making of American Archival History.* Sacramento, CA: Litwin Books, 2013.

18. Carter, *ABC for Book Collectors*, 149.

19. Jackson, Angela. *A Surprised Queenhood in the New Black Sun: The Life & Legacy of Gwendolyn Brooks.* Boston: Beacon Press, 2017, 162.

20. Kirschenbaum, Matthew G. *Bitstreams: The Future of Digital Literary Heritage.* Philadelphia: University of Pennsylvania Press, 2021, 71.

21. Bengtson, Jason. "Preparing for the Age of the Digital Palimpsest." *Library Hi Tech* 30, no. 3 (2012): 513–522.

22. Song, Young Imm Kang. "Altered Book Journaling for the Visual Generation." *International Journal of the Image* 2, no. 1 (2012): 67–82.

AFTERWORD

It is a privilege for Rare Book School to share with you this catalogue documenting some highlights from our teaching collection and, crucially, the core pedagogical philosophy of *hands-on history* that this collection helps make possible.

The library and archive, though partial and imperfect, function as the world's memory, the means by which humanity can have a living history and a continuing consciousness of itself. The fate of our textual treasures in the decades to come depends on those who will safeguard and explain the riches of our written inheritance. Our mission of education enables conservators and collectors, curators and educators, archivists and booksellers to work together more purposefully and professionally so that history will not be dismissed as a dead letter, but will become more and more a vital force in advancing the common good.

History comes alive at Rare Book School through the books and manuscripts, the photographs and printed ephemera that our students study. Crucially, they learn together in small groups, establishing friendships forged in uncommon enthusiasms and creating communities of learned professional practice. Guided by a highly gifted and generous faculty, those who benefit from our classes soon come to realize that they are also supported by a larger community of staff, alumni, trustees, and donors (many of them collectors) who are essential to the School's ongoing commitment to educational excellence. It is through the strength of community that our students, trusted keepers of the past, come to know themselves as vital stewards of the future.

Throughout this colorful conspectus of the Rare Book School collections, the discerning reader will discover evidence of our ongoing commitment to building a more welcoming and inclusive comity of students and faculty, to diversifying our courses and teaching materials for the global century, and to the historically informed, experiential learning that is the hallmark of our School. In both word and image, this catalogue will, I hope, also give you a sense of the optimism, intelligence, and energy of the Rare Book School community—our investment in study, service, and creative outreach to new, broader communities. That investment takes place not only at our home base in the University of Virginia in Charlottesville, but also at the twenty partner institutions (libraries, universities, and museums) in whose impressive collections we cooperatively offer courses. The richness of those collections has in many instances been beautifully delineated in any number of exhibition catalogues that are also worthy of study.

In A. S. Byatt's novel *Possession*, one of the protagonists recalls the moment that led him toward a life spent in libraries and archives: "when my father first handed me the handwritten pages [of a Victorian autograph letter], I felt…that the dead man had touched me from the past." This encounter—in which the young man touches a manuscript and, in turn, is touched by the historical, human presences it embodies—is powerfully transformative. Students at Rare Book School learn through hands-on instruction to read historical texts with new eyes and a new sensibility: what the poet George Herbert called "quick-eyed love." Together, they come to see how the material choices and labor of individuals help to make transmissible meanings that we can recognize and attend to across the ocean of time. Our students thus become more powerful communicators, more professional stewards, and more passionate advocates for the central importance of archives and libraries and the record of human aspiration and achievement that they comprehend.

Yet, even as we celebrate the School's collections and educational method in these highly various and engaging pages, our sense of urgency is great because education of the kind that our School provides is absolutely requisite for the thoughtful curation and communication of our documentary heritage to future generations. The long-term efficacy of special-collections stewardship—and, hence, of primary-source scholarship—is inextricably linked to the educational mission of Rare Book School. We are also committed both to help animate the work of veteran collectors and to inculcate the joys of collecting to students who might not yet fully apprehend that they stand on the threshold of a great adventure.

Fostering the future of collecting is essential for the future vitality and dynamic growth of the historical record. Without inscriptions, manuscripts, and books, there is no history, and little concept of humanity's striving over time. Thanks to the generosity of our friends, the skillful teaching of our superlative faculty, the dedication of our students, and the great labors of the Rare Book School staff, we continue to flourish as an international center of excellence in bibliographical and book-historical education. The *Building the Book* exhibition at the Grolier Club, expertly curated by Barbara Heritage and Ruth-Ellen St. Onge, is a resonant example of this excellence.

The aim of bibliography—the close study of textual artifacts, whether inscriptions, manuscripts, printed pages, or digital materials—is to recognize and recover the human presences in every recorded text. The object lessons of *Building the Book*, then, are not only about textual artifacts of many kinds, but also about the communities of labor central to their making and interpretation. The history of the human spirit lives in libraries and archives around the globe. As this exhibition catalogue eloquently demonstrates, the safeguarding of that history through unparalleled education is the great mission of our School.

The continued endurance of human memory in the still-tenuous record of our common past requires what Edmund Burke called "a partnership between those who are living, those who are dead, and those who are yet to be born." Teaching those who come to Rare Book School how they might best preserve, protect, and interpret the historical record, we have come to understand that the

stakes are high, because the library and archive are essential instruments for the future of democracy.

We are resolutely committed to the central importance of preserving history and communicating the truths of our common past through the power of textual artifacts. The great aim of Rare Book School is to teach all who wish to learn how best to preserve and illuminate the record of humanity's endless striving to know more about ourselves and our world.

<div align="right">

Michael F. Suarez, S.J.
Executive Director
Rare Book School at the University of Virginia
Charlottesville, Virginia
June 2022

</div>

GLOSSARY

à la poupée: a method of creating multicolored intaglio prints in which different colors are directly applied to relevant parts of the printing plate and then printed in a single impression, as opposed to in separate impressions; French for "with the doll."

albumen print: photographic prints created by covering photographic paper first in an egg-white mixture, followed by silver nitrate, to create light-sensitive salts that are exposed to light through a glass-negative plate, thereby creating an image.

antiphonal: a liturgical book containing antiphons—short, sacred verses sung before or after a chanted psalm or canticle.

aquatint: an intaglio printing process in which an acid-resistant powder (such as rosin) is applied (and often melted) to a metal printing plate (usually copper); then the plate is submerged in an acid bath. The acid eats into parts of the metal not protected by the rosin, thus creating a fine, granular, network-like pattern that appears as an area of ink or watercolor wash when printed.

arabesque: elaborate, geometric designs that were inspired by Islamic art and that feature plants and curvilinear line motifs; popular in European art beginning in the Renaissance and up until the nineteenth century.

arming press: in bookbinding, a press used to stamp text and decorative designs onto book covers with equipment, such as brass stamping dies; also known as a blocking press.

bâtarde: a mixed style of script—for example, combining a gothic book hand (*textualis*) with a cursive secretary hand; French for "bastard."

baren: a disc-shaped, handheld Japanese printing tool used to rub and burnish the back sheet of a piece of paper against the inked surface of a relief woodblock.

Baxter print: a mixed-method illustration process developed by London-based artist George Baxter (1804–1867) that entailed creating a key image via an intaglio plate (or, on occasion, a lithographic printing surface), with additional layers of color created by a series of impressions made from relief woodblocks.

blind tooling: in bookbinding, the process of impressing finishing tools, bearing an image or design, into a book's cover in order to leave a debossed mark without the use of metal foil, ink, colored leaf, or other materials.

blocking: the process of impressing a design into a book cover with an engraved block and blocking press; primary, a English term, see stamping.

bone folder: a small, handheld tool—usually made from carved bone or plastic with dull edges—that is used to crease, score, fold, and burnish materials, such as paper.

Book of Hours: a Christian devotional book containing the Hours of the Virgin—prayers recited at eight fixed times each day (Matins, Lauds, Prime, Terce, Sext, Nones, Vespers, and Compline).

bookplate: an ownership label usually bearing the owner's name or initials, as well as a decorative or pictorial motif associated with the book's owner; also known by the Latin term *ex libris*.

boss: a raised protective fitting, usually featuring a dome-shaped piece of metal or spike or stud, applied to the exterior surface of the boards of a bookbinding to prevent the covering material from being damaged.

brocade: a rich, decorative fabric frequently made from colored silks woven with raised designs and frequently incorporating silver or gold thread.

burin: a metal- and wood-engraving tool, with a square- or diamond-shaped metal tip obliquely cut to a fine point, that is used to create small, V-like trenches into the surface of a metal plate (usually copper) or woodblock.

burr: the rough edge left when the jet is broken off from a type piece. Also used to describe the small, ragged ridges of raised metal created by engraving metal with a burin or drypoint needle, as well as rocking the surface of a mezzotint printing plate.

cabochon: in binding, a convex decorative feature created by building up layers of supporting material which are then covered with a layer of leather. Also used to describe rounded, polished gems applied to treasure bindings.

calendering: in bookbinding, the process of passing paper or cloth through iron or steel rollers, sometimes with heat, to compress and smooth it, or to impart patterns, such as grain patterns found on bookcloth; used after starching to work starch deep into the weaves of a cloth.

carragheen: a type of seaweed from which the stabilizer of the same name is derived that is sometimes used in place of gum tragacanth as a size to prepare the bath in the production of marbled paper.

cartonnage: a handmade covering material, used for bookbinding, consisting of a thick sheet of paper with long fibers that has been sized with gelatin; it is sometimes laminated with paste to create stiffer boards for bookbinding.

cartouche: a decorative element frequently found on maps and typically representing a scroll or shield bearing an inscription.

chapbooks: small, cheaply made booklets, usually produced from a single, folded printed sheet, that were traditionally sold in the British Isles and in North America by peddlers known as chapmen, hence the name.

chase: a cast-metal frame into which pages of set type and images—the forme—are locked into place to prevent individual sorts of type from shifting during the printing process.

chiaroscuro: in printmaking, using two or more relief blocks—one a dark key block and the other(s) providing color in the form of subdued tones in the style of Renaissance wash drawings; Italian for "light-dark."

chromolithography: a planographic process for printing color that was developed in the mid-nineteenth century and that entailed overprinting impressions from multiple, separate lithographic stones or plates—one for each color.

circulating library: a for-profit library system frequently operated by booksellers and publishers that was popular in the eighteenth and nineteenth centuries in Europe and North America and that charged readers fees (e.g., annual subscription rates or a fixed rate per volume).

clasp: in bookbinding, a metal fastening fitted (e.g., with metal hardware or straps) at the edges of the bookboard to keep the book's covers closed.

cloth grain: small, repeating patterns, often floral, geometric, or abstract in design, calendered or embossed into bookcloth for decorative effects.

codex: a book made from sheets gathered and affixed together along one edge (the spine) so as to allow the opposite edge to be opened and either side of each leaf read.

coir: a fiber taken from the outer husk of a coconut that was used to make ink brushes in East Asia.

collotype: a planographic method of photographic printing in which a plate, covered with photosensitive gelatin solution, is exposed to light through a negative, thus hardening the darker areas of the image on the plate, which in turn holds more ink for printing darker areas and producing tone.

colophon: a note located in a book, usually at its end, made by a scribe, publisher, or printer that conveys information about the book's production.

cords: in bookbinding, twisted strands of vegetable fibers that serve as the supports on which gatherings of leaves are sewn; cords are also used as the cores for endbands.

Cottonian Library: the name given to a private collection of books owned by the former British poet laureate Robert Southey (1774–1843) that he and his daughters covered in a variety of brightly printed cotton fabrics.

countermark: in papermaking, a watermark that is usually positioned on the opposite side of the paper mould from the main watermark and that provides information about the papermaker or mill, in some cases with a year of manufacture; usually formed from wire and sewn on top of the mould cover.

cuneiform: an ancient Near Eastern script with wedge-shaped characters, surviving mostly on clay tablets.

dabbed paper: in bookbinding, paper upon which ink or paint has been applied with a soft material like a sponge that is often used for covers or endpapers.

Demotic: an ancient Egyptian cursive script written from right to left and used between the seventh century BCE and fifth century CE.

dhāraṇī: in Buddhism, a verbal formulation that may or may not have a semantic meaning; in some instances, it may describe the essential points of a longer text in which it appears, while in others its recitation may bring about protection; Sanskrit for "mnemonic device" or "code."

diced Russia: in bookbinding, an extremely durable type of vegetable-tanned skin made in the area around St. Petersburg from horses, bovine calves, reindeer calves, and other animals, and tanned with willow bark and curried with birch oil. It is decorated with a distinctive lattice-like, cross-hatched pattern created with tools, such as ribbed rollers, and is known for its ability to resist insects and water. Also referred to as "Russia leather."

die: in bookbinding, an engraved decorative stamping tool, usually made from brass, that is heated and used to impress designs into leather-, cloth-, and paper-covered boards.

divided lay: a way of organizing type cases such that capital and lowercase letters are separated into upper and lower cases, respectively.

dorana: a plant local to Sri Lanka, the oil of which (along with that of *hal*) is used to preserve ola leaf manuscripts; Latin: *Dipterocarpus glandulosus*.

double paper mould: also known as a "two-sheet," "divided mould," or "end-to-end two-sheet mould," papermaking equipment that allowed two sheets of paper to be formed simultaneously.

doublures: in bookbinding, decorative linings made from silk, leather, and other exotic materials that were placed on the inner boards of luxury books in the position usually occupied by pastedowns; French for "lining." (Note: the term "doublure" does not describe a structural feature, but rather an ornamental one; some, but not all doublures, are separate pastedowns, while others are endleaves serving as pastedowns, etc.)

drypoint: an intaglio-printing method involving the use of a needle-like tool to incise a plate directly, thereby lifting metal and creating burrs that, when inked, create a drawn, scratched-looking impression.

dug re chag: a bast fiber indigenous to the Himalayas that is used exclusively for papermaking; Latin: *Wikstroemia chamaejasme*.

duplicator: a twentieth-century copying machine that functions similarly to a rotary relief printing unit but on a smaller scale.

échoppe: a kind of etching needle; a pencil-like metal instrument with its end cut off at an angle to create a sharp but rounded point that was used for drawing on ground-covered plates.

Edwards of Halifax bindings: bindings produced by the English firm founded by William Edwards, which became known for painted vellum bindings, fore-edge paintings, and Etruscan calf bindings.

E Ink: a technology used in the 2007 Amazon Kindle and other similar devices to simulate the appearance of ink and paper on a digital screen.

electrotyping: developed in the 1830s, a process in which a wax impression of a plate is coated with a conductive material, especially graphite, so that copper can be deposited via electrolysis to form a new relief surface whose back was filled with lead alloy for strengthening.

emblem books: a literary genre that was popular in the sixteenth and seventeenth centuries in Europe and that consisted of published collections of emblems, or allegorical illustrations with explanatory text.

endband: in bookbinding, components often consisting of colored threads wound around a small core cord, attached at the head and tail of the spine, originally for protection and later for decoration.

endgrain wood: the grain of wood cut across the growth rings of a tree or shrub; the hardness of the wood allowed for wood engravers to achieve much finer detail than with woodcuts. Necessarily smaller in size than woodblocks made from plank wood, endgrain pieces had to be joined together into composite blocks to create large images.

endleaves: in bookbinding, any leaves located at either end of the bookblock of a codex (i.e., between the text and covers) that are intended for the protection and structural fortification of the leaves of text. Also known as "endpapers."

engraving: an intaglio printing process which entails directly incising a plate with a burin to scoop out metal from below the surface of the plate; not to be confused with etching, which requires the use of acid, or with wood engraving, a relief printing process.

erratum sheet: an addendum to a book, typically inserted into a book as part of its preliminaries or included at its end, that lists corrections to errors, such as misprints and other mistakes.

etching: an intaglio printing process in which etching needles are used to draw images into wax- or rosin-covered metal plates (usually made of copper), thereby exposing the metal beneath; the plates are then submerged in acid, which eats away at the exposed areas of metal. The depth of the acid's bite determines the resulting depth of line in the plate and how much ink the plate will hold when it is printed.

Etruscan: a bookbinding style, popular in the late-eighteenth and early nineteenth centuries in Britain, involving stained or marbled leather and Neoclassical decorations.

expurgation: a form of censorship in which certain passages of a published text deemed problematic have been removed, or, in other cases, have been rewritten to conceal the activity of censorship.

fascicles: the separate pieces of a larger work issued in installments, typically bound together upon completion of the publication.

fengni: Chinese clay discs from the Eastern Han dynasty bearing the impression of seals.

fillet: in bookbinding, a metal hand-tool with a wheel whose edge is engraved with one or more lines to create decorative frames and panels.

flexography: a method of relief printing involving the use of a flexible rubber, plastic, or polymer plate that can be affixed to flat or curved plates and rollers.

flong: in stereotyping, damp papier-mâché that is beaten onto a relief surface; the resulting cast—flong—serves as a mould that is filled with type metal so as to create a relief-printing plate.

folio: a sheet of parchment, paper, or other substrate that is folded in half once to create two leaves and four pages; the term is often used generically to describe a large book. The terms "quarto," "octavo," and "duodecimo" similarly refer to successively folded sheets—or, in broad usage, to smaller-sized books.

fore-edge: in bookbinding, the edge positioned directly opposite to the spine of a codex-format book.

fore-edge flap: a cover extension used in bookbinding to fold over and protect the fore-edge; a feature commonly found in Islamic bookbindings.

forme: an arrangement of the loose components (e.g., printing types, blocks, etc.) of pages that have been assembled into a locked arrangement within a chase for printing on the bed of a relief printing press.

foundry: a production facility for metal casting (e.g., type).

Four Treasures: the four fundamental components of the classical Chinese scholar's studio: inkstone, brush, ink stick, and paper.

Fraktur: a German blackletter typeface derived from a calligraphic script frequently associated with sixteenth-century texts; today, it carries associations Nazi Germany owing to its 1933 endorsement by the regime.

frontispiece: in book design, an illustration placed immediately before the title page, often facing it.

furniture: in printing, wooden or metal spacing material used to secure arranged type within a forme. In bookbinding, an umbrella term for any type of hardware—including but not limited to bosses, corner pieces, title frames, rubbing strips, and studs—attached to a binding for protection or decoration.

gauffering: in bookbinding, a decorating technique in which engraved tools are heated and impressed into a bookblock's edges (usually, but not always, decorated with metal leaf) to create designs and patterns.

Ge'ez: the liturgical language of the Ethiopian Orthodox Church.

gevil: the Hebrew word for a type of parchment made from the whole hide (as opposed to a split hide) that is prepared for writing on the hair-side only.

gilt: a thin layer of gold leaf applied to bookbindings for decorative purposes.

gōkan: a Japanese term that refers to a genre of serialized pictorial fiction printed in the late Edo and early Meiji periods.

gradual: a liturgical book comprising all the sung parts of the Roman Catholic Mass.

grain, graining: small, repeating, blind-embossed patterns found on cloth bindings that were popular in the nineteenth century.

graver: a tool consisting of a square- or diamond-shaped point used to create small, V-shaped trenches in the surface of endgrain woodblocks; nearly identical to burins used for engraving metal plates, gravers usually have handles tilted at an angle with respect to their blades.

gum tragacanth: a natural gum derived from dried tree sap that was used to make the bath viscous in the production of marbled paper.

hal: a plant local to Sri Lanka, the oil of which (along with that of *dorana*) is used to preserve ola leaf manuscripts; Latin: *Vateria copallifera*.

halftones: a relief printing process in which a screen is placed between the camera's lens and a gelatin-coated, light-sensitized metal plate, resulting in an image composed of small, equally spaced dots of varying sizes. Once the negative image is hardened, the surface is etched, resulting in the dots standing in relief. The plate is mounted to a block to make the whole type high for printing on a relief press, and the resulting visual image is tonal.

hand-press period: a period of time lasting approximately from 1450 to 1830, during which printing technology in the West, by and large, was conducted by hand-operated printing presses before the introduction of mechanized printing presses.

hard drive: a device composed of a substrate and a magnetic medium on which data is stored.

historiated initial: a large initial that illustrates, within the body of the letter, a scene described in the related text; often featuring people or animals,

historiated initials help tell a story rather than existing for purely ornamental purposes.

hyakuman: Japanese for "one million"; used in reference to the *hyakumantō pagodas*.

illuminated manuscript: a type of luxury handwritten book or document decorated with hand-painted features, such as paintings, miniatures, initials, and borders, often using precious metals and pigments. Although the term is often used with reference to medieval bookmaking, modern examples exist and continue to be made.

indenture: an official document created for two or more parties; typically written on a single piece of parchment, indentures are cut so that each piece is marked by a patterned edge that interlocks with the other to guarantee authenticity.

India paper: a type of machine-made paper inspired by handmade paper from India and measuring about a third of the thickness of usual European book papers.

ink stick: a type of solid ink made from soot and animal glue traditionally used in East Asia for calligraphy and brush painting; the ink is made liquid by grinding the ink stick into a inkstone using a small amount of water. One of the proverbial "Four Treasures" of the classical Chinese scholar's studio.

inkstone: a kind of mortar, usually made from stone, used for holding water and grinding ink. One of the proverbial "Four Treasures" of the classical Chinese scholar's studio.

inlay: in bookbinding, a decorative component consisting of a small piece of material, usually of the same thickness as that of the primary covering material (e.g., leather), that is cut to shape and placed into cut-out areas within the covering's surface.

intaglio printing: a printing process in which ink is forced into lines incised or etched below the surface of a printing plate; the ink is transferred from the cavities of the printing surface to dampened paper under high pressure exerted by a rolling press.

iron-gall ink: a dark-purple or black liquid ink produced by mixing an extract of crushed oak galls—gallotannic acid—with an iron-sulphate solution known as copperas; it was widely used in Europe and the Middle East from the eleventh through the twentieth centuries.

ivory: material derived from animal horns or tusks; in bookmaking, it was fashioned in thin sheets that, when joined together, functioned as erasable tablets.

jet: a shaft of metal protruding from a hand-cast piece of type, or sort, when it is taken out of the mould; jets were routinely broken off and recycled for type metal as part of the process of dressing the type.

jigsaw printing: a printing technique in which the plate is cut into sections, each of which is inked separately, before being brought together to produce a polychrome print.

kabinja: a fifteenth-century Korean font upon which the seventeenth-century *musinja* typeface was based.

kaishu: Chinese standard script.

kyem shog: a fiber used to make paper currency in Tibet in the early twentieth century.

lacquer binding: a Near Eastern method of decorating bookbindings by means painting scenes on leather or pasteboard, which is then covered with several layers of lacquer or varnish.

laid paper: paper made using handheld papermaking moulds whose covers bear horizontal laid wires and vertical chain wires.

leporello: a book format in which leaves are joined together end-to-end to unfold outward, as opposed to the traditional format in which folded leaves are hinged together along a single edge. Also known as "accordion" or "concertina" bindings.

letterpress: a term often used synonymously with relief printing and relief-printed texts.

ligature: a written or printed character formed by combining two or more letters to save space and/or to reduce aesthetically unpleasing gaps.

line-block process: a printmaking method invented in the 1870s in which a zinc or copper plate was covered with light-sensitive gelatin that hardened with exposure to light so that the unhardened part of the plate could be washed away and lightly etched to leave a relief image.

Linotype: a machine invented in the late-nineteenth century by Ottmar Mergenthaler that casts and typesets from hot metal complete lines of type in the form of "slugs"; Linotype machines were frequently used to set type for newspapers and mass-market paperbacks through the 1970s, when letterpress printing began to decline.

lishu: Chinese clerical script.

lobe: a small arc or foil often found in arabesque designs.

lotka: the Nepali word for a plant native to the Himalayas, the inner white bark of which provides bast fiber for papermaking.

mandorla: a pointed, oval-like shape frequently used in Christian, Islamic, and Buddhist art; Italian for "almond."

manga: in nineteenth-century Japan, a drawing manual or copybook used by students training to be painters; the term is now used to describe Japanese sequential art (e.g., comic books and graphic novels).

metalcut: a relief printing technique that uses a metal instead of a wooden block; in fifteenth-century Europe, metalcuts in the dotted manner (i.e., in a style known as manière criblée) were made by punching dots and stars into a metal surface.

mezzotint: a form of intaglio printing involving the use of a handheld mezzotint rocker to roughen the texture of the metal printing plate (usually made of copper) by raising small burrs along its surface, which, when printed, result in a very rich, velvety black, as well as various tone gradations when the burrs are leveled or removed.

micrometer: a device that incorporates a calibrated screw that can be used for taking detailed measurements of small distances, angles, and objects; in bibliography, micrometers can be used for measuring paper to within one-thousandth of an inch (1 mil.).

mimeograph: a machine that duplicates typescript texts via stencil, allowing for their quick and cheap reproduction.

miscellany: a volume containing a collection of assorted writings composed by one author or by multiple, different authors; miscellanies generally served to preserve writings that were too short in length for separate, stand-alone publication.

Monotype: a hot-metal system for mechanically casting and setting type that produces individual sorts of metal type for relief printing; not to be confused with Linotype, which produces lines of set type in the form of "slugs."

morocco: in bookbinding, a term used toward the end of the eighteenth century to refer to sumac-tanned goatskins originating from Africa; the word had been previously used in the eighteenth century to describe skins made from hairsheep that were imported into England from Morocco, but which were inferior in quality to the high-quality goatskin used at the time, generally known as "Turkey leather." The term "morocco" later supplanted "Turkey leather" with reference to high-quality goatskin. The skins—and these terms—are still often confused.

mould (or mold): in typefounding, the device used to cast individual sorts of type. In hand papermaking, the mesh-covered frame used for forming sheets from a suspension of fibers in water.

musinja: a Korean font of bronze movable type cast in 1668 and used for government publications; modeled after *kabinja*.

numismatics: the study of coins, medals, currency, and their history.

offset: the unintended transfer of oil-based printer's ink onto another surface; offsetting could occur in a variety of instances: when freshly printed sheets transferred ink onto neighboring sheets in a stack; when books were bound before the ink was completely dry, or even (according to John Carter) when books were stored in a damp environment. Not to be confused with offset printing.

offset printing: an indirect printing technique whereby an inked surface transfers a text or image onto a second surface, which is then used to print the substrate; the technique can be used for relief and intaglio printing, but it is more generally associated with lithography.

ola leaf: a palm leaf traditionally used as substrate for Buddhist manuscripts in Southeast Asia.

onlay: in bookbinding, a decorative component consisting of a piece of a material cut to shape and placed directly on top of a primary covering material; onlays generally vary in color from a binding's primary covering material, and they are frequently decorated with gold tooling.

Oriya: an officially recognized language spoken by approximately fifty million people in the Indian state of Odisha.

orthography: a term used to denote the linguistic study of spelling.

pagoda: tower-like structures associated with Buddhist monasteries and temples in East and Southeast Asia; they are derived from the *stūpas* of ancient India which were used to hold sacred Buddhist relics and that served as monuments to Śākyamuni Buddha. Small-scale *stūpas* are commonly placed on Buddhist altars.

palimpsest: the reuse of a parchment manuscript in which earlier writing has been scraped away or erased; palimpsests were made as the result of writing material shortages in the Middle Ages. The term is now also used to describe overwritten digital media.

papercut: technique used by artists to cut images or designs into paper by hand.

paper-pulp painting: a technique developed by twentieth-century book artists that entailed the application of colored paper pulp onto the surface of a freshly formed handmade sheet of paper.

papyrus: the principal substrate and writing medium used in the ancient Mediterranean world; it was created from the white pith of the stem of the eponymous plant.

parchment: a thin, strong, cream-colored substrate (in some instances translucent, in others opaque) that is made by first soaking animal skin in a lime solution to degrease and dehair it, and then by scraping it thin and drying it under tension; usually made from calf-, sheep-, or goatskin.

pastedown: in bookbinding, the part of the endleaf that is pasted to the inside of a cover or to the inner board after the book is covered. Note: pastedowns that are not conjugate to an adjacent endleaf unit are referred to as "separate pastedowns."

pecha: the Tibetan word used to describe books consisting of oblong-shaped, loose leaves of paper housed between separate covers of wood or stiffened paper (or another firm material) that is wrapped in cloth and secured with a cord; the term also refers to Tibetan books more generally.

Penguin Classics: a series of paperbacks launched by Sir Allen Lane in 1946 that increased the readership of classic literary works by producing inexpensive books with intelligible translations and eye-catching covers.

photomechanical printing: in printmaking, a technology in which a photographic image is transferred to a light-sensitive surface which is then processed to create either a relief, intaglio, or planographic printing surface: halftone or line cut (relief); photogravure (intaglio); and collotype (lithographic).

photopolymer printing plates: a printing material invented in the 1970s and increasingly used toward the end of the twentieth century. An image is projected through a photographic negative onto the photosensitive plastic plate, which hardens when exposed to UV radiation; the unhardened parts are washed away to leave a raised relief surface that can be strengthened with further exposure to light before being inked and printed.

planography: term describing printing processes, such as lithography, screen printing, or monotype, that make use of flat surfaces, as opposed to relief or intaglio printing, in which the printing surface is raised or incised to capture ink.

platen press: used for relief printing, the platen press configures two flat planes; a platen delivers pressure to a sheet of paper (or other substrate) on a corresponding flat, inked typeform or printing plate. With some smaller platen presses, the platen is positioned vertically, moving backwards and forwards as opposed to up and down.

pochoir: French for "stencil."

Pocket Books: an American publisher founded by Robert de Graff in 1939 that

is credited for introducing the mass-market paperback to the United States.

pothi: ancient Indian palm-leaf manuscripts bound together with cord strung through one or two holes made to the leaves. The format, which was frequently used for religious texts, influenced the Tibetan *pecha*.

pouch-binding (*fukurotoji*): a binding technique used in Japanese bookmaking; stacks of double-wide paper are bound together by sewing the loose edges opposite each fold either with thread or with tightly wrapped slips of paper.

prajñāpāramitā: a body of Buddhist sūtras teaching the perfection of wisdom as realized through emptiness; Sanskrit for "perfection in wisdom."

Pre-Raphaelite: a movement of nineteenth-century English artists and writers who rejected contemporary artistic standards embraced by the Royal Academy of Art in favor of fourteenth- and fifteenth-century Italian art and its richly detailed study of nature.

prize bindings: a distinctly bound book awarded to students as a prize, most likely by a school, college, or university. Prize bindings frequently feature the arms or emblem of the institution awarding them, as well as the date and occasion of the student's accomplishment (usually either in the form of an inscription or bookplate located on the front endpapers).

progressive proofs: in printing and printmaking, a series of proofs that demonstrate and help ensure the correct successive stages of color separations and their progressive overlap, from the first color to the final multicolor image resulting from their printed overlay.

provenance: any marking in a book indicating its ownership history or origin.

psalter: a liturgical book containing psalms; one of the most frequently illustrated texts of the Middle Ages in Europe.

quill pen: a type of pen, widely used in the West from about 700 to 1850. Quill pens were made by cleaning, trimming, and hardening bird feathers (often goose, but also crow, turkey, swan, and raven) and then by cutting and slitting the end to allow the crevice to hold ink.

quire: a term initially used to indicate a gathering of four folded parchment or paper sheets to form eight leaves or sixteen pages; later, the term came to signify any kind of gathering within a codex-format book. In papermaking, it refers to 24/25 sheets, a twentieth part of a ream of paper, 480/500 sheets.

quoin: a short wedge used to help lock the forme tightly in the chase.

railway library: series of inexpensive books marketed to rail travelers; also lending libraries located in railway stations.

rebacking: in book conservation, the technique of lifting the original covering material on the book's spine and replacing it with a new covering material that extends beneath the original covering material at the joints.

recto: a term referring to the right-hand page (i.e., the upper side of a leaf) of a codex-format book.

reed pen: a writing instrument made from the hollow stems of grasses (e.g., bamboo); the end was cut at an angle, forming a point that was then split to hold ink. Developed in ancient times, reed pens were used by scribes in Greece and Egypt, as well in China and Japan. They are still widely used in the Middle East for calligraphy.

relief printing: a category of printing, sometimes generally referred to as "letter-press," which transfers ink to paper via a raised surface, as opposed to intaglio processes, in which ink sits below the printing surface, or planographic surfaces that transfer ink via a flat surface.

restrike: a print made with an original printing surface (e.g., block, plate, stone) some time after the original print run.

rocker: a handheld tool with a wide, curved, finely toothed steel "blade" used to distress the surface of a mezzotint plate.

rolling press: used for intaglio printing, rolling presses consist of two rollers through which a press bed, bearing an inked plate, dampened paper, and packing, are fed so as to squeeze them together under high pressure and thus transfer the ink from the incised trenches of the plate to the paper.

roulette: a tool used for stippling intaglio plates; the roulette's small textured wheel creates a dotted texture in the plate, then when printed, results in a fine, tonal quality to the image's shading.

Sammelband: a term used to describe a single book containing several thematically connected pamphlets or longer works; German for "anthology."

samta: wooden tablets with a recessed, black-inked writing surface that were covered in a thin layer of oil and ash and that were used for note-taking in Tibet.

SanDisk memory cards: data storage devices that operate like the hard disk drive of a personal computer.

scraper: a tri-edged tool used to remove burrs or to otherwise smooth the surface of an engraved plate.

scroll: a format for making books that makes use of either a single rolled portion of a substrate (e.g., parchment, papyrus, silk) or a number of joined pieces; often, the roll is wound onto a central spindle or rod.

seals: small textual or pictorial designs used to designate ownership; similar to bookplates in concept, but stamped directly onto the page of a book or piece of art; especially common in ancient China.

secretary hand: a cursive script developed in fourteenth-century France before spreading to England, where it survived into the seventeenth century; originally used for official documents, hence the name.

semé: in bookbinding, a style of decoration created with many small, repeating tools arranged within a frame.

shank: a square piece of metal upon which the shape of the letter rests to form a piece of type.

shokali: reading stands used to keep loose leaves of *pechas* open so as to free the reader's hands.

shooting stick: along with a mallet, a tool used to drive quoins into place.

signature: a term associated with codex-format books; signatures may take the form of letters and/or numbers, and they are sequentially printed in the tail margin of the first leaf of each gathering or section of a book—an often, at the bottom of additional leaves in each gathering—as a guide to the binder who assembled the gatherings together to form the text block; the term is often used as a substitute for "quire" and "gathering."

silk: along with other fabrics, silk was used as a substrate for printing images via wooden blocks in ancient China before spreading to the West, where it was used as a covering material for bookbinding and occasionally used for printing broadsides and other ephemera.

somber binding: in bookbinding, a style of decoration popular from the late-seventeenth to early eighteenth centuries that entailed use of black-stained leather, sometimes with black leaf edges; somber bindings are frequently found on bibles and devotional books.

spills: thin "nails" created by twisting paper, often used to hold pages together in wrapped-back bindings.

starching: in bookbinding, the process of coating or filling bookcloth with dyed starch (typically soybean flour) to render it durable, water-resistant, and capable of being blocked.

stay: a kind of sewing guard, made from a narrow strip of material (e.g., parchment, leather) used to protect the center-most opening of a gathering to prevent the sewing (or tackets) from tearing the leaves.

steel-facing: the process by which copper plates are engraved or etched, and then electroplated with a thin coating of iron.

stele: large, vertical stone tablets bearing inscriptions, ornamentation, or both.

stenography: the practice of writing in shorthand, a system which relies on abbreviations or special symbols to write quickly.

stereotyping: a technique for reproducing relief surfaces in cast metal using plaster or a papier-mâché flong.

strapwork: in bookbinding, a type of decoration that resembles strips of leather that have been cut and twisted into elaborate forms.

stūpa: a tower-like structure, first built in ancient India in the form of raised mounds, that serves as a monument to Śākyamuni Buddha, and that contains relics and other sacred religious texts.

substrate: a term used to refer to the material (e.g., paper, parchment, silk) upon which a text or image appears.

suminagashi: the ancient Japanese method of creating marbled paper by mixing a solution of ink and pine resin into water and manipulating it to create designs that are then transferred to a sheet of paper.

sura: the name for a chapter of the Qur'an; for example, *al-faitha* (Turkish: *serlehva*), the first *sura*.

sūtra: in Buddhism, a sacred text from the scriptural canon used to describe points of doctrine; often longer and more detailed than a Hindu sūtra.

tackets: in bookbinding, leather, parchment, or vegetable-cord thongs used to hold single-quire bindings together.

tak: Korean for the paper-mulberry plant, which was used to produce a thin paper.

taoban: a Japanese printmaking technique in which separate blocks are cut to print each color of the design.

tawing: the process of treating animal skins with alum—as opposed to tannic acid—to create leather that is usually white.

témoin: the folded corner of a bookblock leaf that has not been properly cut and that, when unfolded, extends beyond the book's trimmed edge.

text block: the collected leaves of a book; in the case of codex-format books, the textblock comprises leaves of text sewn together before the endleaves or binding have been attached.

textualis/textura: gothic bookhand used in manuscripts.

three-decker novel: a novel printed and bound in three Post-size octavo volumes and sold at the fixed price of £1 11*s.* 6*d.*, or "a guinea and a half."

tickets: small, printed labels typically used by bookbinders to identify their work or by booksellers to indicate that a book was sold by their business.

trade paperback: a book that is slightly larger and of higher quality than a mass-market paperback; trade paperbacks were typically sold in bookstores, as opposed to supermarkets and drugstores.

Turkey leather: the name given to high-quality, fine-tanned goatskins imported from Africa at one time, via Turkey—hence the name.

turn-in: in bookbinding, the portion of the covering material that is folded over one or more edges of the book's boards.

tympan: in printmaking, the frame where paper is positioned on a hand press and held in place by the frisket.

type case: a subdivided tray for storing individual pieces of type (sorts), and for accessing it during type composition; type cases consist of smaller compartments, or "boxes."

typefounder: someone who casts metal type; also, the term is occasionally used to refer to someone who designs typefaces.

vellum: calfskin subjected to the same processes used to create parchment.

verso: a term referring to the left-hand page (i.e., the lower side of a leaf) of a codex-format book.

waste: in bookbinding, whole or partial sheets of unneeded printed material or manuscript leaves that are later reused in bookbinding structures; while printed waste often came from spoiled sheets in printing houses, manuscript waste usually came from bound manuscripts that were discarded for one reason or another.

watermark: in papermaking, a watermark is usually positioned on the right-hand side of the paper mould and that is usually formed from wire and sewn on top of the mould cover. The design is often figurative and symbolic.

wax tablet: Eastern Mediterranean substrates made by filling recessed wood tablets with wax; created in a variety of sizes (e.g., *pugillares*, or handheld tablets) and sometimes joined together into diptychs, triptychs, and polyptychs.

wiigwaas: birch bark used by the Anishnaabeg (Ojibwe and Algonquin) and Cree to create scrolls inscribed with pictographs recording sacred texts; used as memory aids in oral teaching.

woodcut: in printing and printmaking, an image carved into a block of wood that has been sawn along the grain (plank side), as opposed to across it (endgrain), as in wood engraving.

wove: paper made on a handheld mould covered with a woven-wire screen or a paper-machine cover.

wrapped-back binding: a bookbinding process, known as *baobeizhuang* in China, in which only one side of each sheet is written or printed on and then folded in half such that the blank side faces inside. Thus the folds form the fore-edge, and the unfolded edges are bound together.

xylography: a term used to describe printing that makes use of wooden blocks; the term is inclusive of both woodcut and wood engraving.

yellowback: an English binding genre; bindings whose boards are made from strawboard, frequently covered in glazed, yellow-coated paper featuring printed, eye-catching illustrations and advertisements; typically sold at railway bookstalls.

zip disk: magnetic floppy disks used as digital storage media introduced by the firm Iomego in the 1990s.

SOURCES

Carter, John. *ABC for Book Collectors*. 9th ed. Eds. Nicolas Barker and Simran Thadani. New Castle, DE: Oak Knoll Press, 2016.

Encyclopædia Britannica: <Britannica.com>; accessed 9 July 2022.

The Oxford Companion to the Book. Eds. Michael F. Suarez, S.J., and H. R. Woudhuysen. 2 vols. Oxford: Oxford University Press, 2010.

Roberts, Matt T. and Don Etherington. *Bookbinding and the Conservation of Books: A Dictionary of Descriptive Terminology*. Drawings by Margaret R. Brown. Conservation OnLine: <https://cool.culturalheritage.org/don/>; accessed 9 July 2022.

Tate Britain. Art Terms: <https://www.tate.org.uk/art/art-terms>; accessed 9 July 2022.

University of the Arts London. Ligatus: Language of Binding: <https://www.ligatus.org.uk/lob/>; accessed 9 July 2022.

Glossary prepared by Barbara Heritage, Ruth-Ellen St. Onge, and Alexander Pawlica.

WORKS CITED

INTRODUCTION

Dugdale, Kyle. "Bibliographical Architectures." In "Objects of Study: Teaching Book History and Bibliography Among the Disciplines." Eds. Barbara Heritage and Donna A. C. Sy. 2022. Unpublished MS.

I. OVERVIEW

Bresciani, Umberto. *Confucian Holy Places*. Gaeta: Passerino Editore, 2021.

Daley, Jason. "Five Things to Know about the Diamond Sutra, the World's Oldest Dated Printed Book." *Smithsonian Magazine*: <https://www.smithsonianmag.com/smart-news/Five-things-to-know-about-diamond-sutra-worlds-oldest-dated-printed-book-180959052/>; accessed 12 February 2022.

de Hamel, Christopher. *A History of Illuminated Manuscripts*. 2nd ed. London: Phaidon Press, 1994.

Derillo, Eyob. "Traveling Medicine: Medieval Ethiopian Amulet Scrolls and Practitioners' Handbooks." In *Toward a Global Middle Ages: Encountering the World through Illuminated Manuscripts*. Ed. Bryan C. Keene, 121–124. Los Angeles: J. Paul Getty Museum, 2019.

Déroche, François and Annie Berthier. *Manuel de codicologie des manuscrits en écriture arabe*. Paris: Bibliothèque nationale de France, 2000.

"Diamond Sutra." *Encyclopedia Britannica*: <https://www.britannica.com/topic/Diamond-Sutra>; accessed 12 February 2022.

Edgren, J. S. "The History of the Book in China." In *The Oxford Companion to the Book*. 2 vols. Eds. Michael F. Suarez, S.J., and H. R. Woudhuysen, 1:353–365. Oxford: Oxford University Press, 2010.

Edgren, Soren. "Mukujōkō-kyō jishin'in-darani." In *A Matter of Size: Miniature Bindings and Texts from the Collection of Patricia J. Pistner*. Curated by Patricia J. Pistner and Jan Storm van Leeuwen. Ed. George Ong, 88. New York: The Grolier Club, 2019.

Frampton, Stephanie Ann. *Empire of Letters: Writing in Roman Literature and Thought from Lucretius to Ovid*. Oxford: Oxford University Press, 2019.

Franklin, Benjamin. *The Autobiography of Benjamin Franklin*. Eds. Leonard W. Labaree, Ralph L. Ketcham, Helen C. Boatfield, and Helene H. Fineman. New Haven, CT: Yale University Press, 1964.

Gacek, Adam. *Arabic Manuscripts: A Vademecum for Readers*. Leiden and Boston: Brill, 2009.

Ikeda, Mayumi. "The Fust and Schoeffer Office and the Printing of the Two-Colour Initials of the 1457 Mainz Psalter." In *Printing Colour 1400–1700: History, Techniques, Functions and Receptions*. Eds. Ad Stijnman and Elizabeth Savage, 65–75. Leiden: Brill, 2015.

Kirschenbaum, Matthew G. *Bitstreams: The Future of Digital Literary Heritage*. Philadelphia, PA: University of Pennsylvania Press, 2021.

Kornicki, Peter. "The Hyakumantō darani and the Origins of Printing in Eighth-Century Japan." *International Journal of Asian Studies* 9, no. 1 (2012): 43–70.

McBride, Richard II. "Practical Buddhist Thaumaturgy: The 'Great Dhāraṇī on Immaculately Pure Light' in Medieval Sinitic Buddhism." *Journal of Korean Religions* 2, no. 1 (March 2011): 33–73.

McKillop, Beth. "The History of the Book in Korea." In *The Oxford Companion to the*

Book. Eds. Michael F. Suarez, S.J., and H. R. Woudhuysen, 1:366–373. 2 vols. Oxford: Oxford University Press, 2013.

Mori, Ikuo. "What Is a One Million Pagoda?" Trans. Melissa M. Rinne. Kyoto National Museum: <https://www.kyohaku.go.jp/eng/dictio/kouko/hyakuman.html>; accessed February 12, 2022.

Nakamura, Hajime. *Indian Buddhism: A Survey with Bibliographical Notes*. Delhi: Motilal Banarsidass Publishers, 1980.

Powers, Martin J. and Katharine R. Tsiang, eds. *A Companion to Chinese Art*. Chichester, West Sussex: Wiley Blackwell, 2016.

Romano, Frank, with Miranda Mitrano. *History of Desktop Publishing*. New Castle, DE: Oak Knoll Press, 2019.

Scheper, Karin. *The Technique of Islamic Bookbinding: Methods, Materials and Regional Varieties*. 2nd rev. ed. Islamic Manuscripts and Books. Vol. 8. Leiden: Brill, 2018.

Shailor, Barbara A. *The Medieval Book*. 1988. Toronto: University of Toronto Press, 2002.

Smith, Margaret M. *A Millennium of the Book: Production, Design & Illustration in Manuscript & Print, 900–1900*. Eds. Robin Myers and Michael Harris, 23–44. Winchester, U.K. and New Castle, DE: St. Paul's Bibliographies and Oak Knoll Press, 1994.

Stone, Brad. *The Everything Store. Jeff Bezos and the Age of Amazon*. New York: Little Brown and Co., 2013.

Swain, Joseph P. *Historical Dictionary of Sacred Music*. 2nd ed. London: Rowman & Littlefield, 2016.

Tsien, Tsuen-Hsuin. *Paper and Printing*. Vol. 5, part 1: *Chemistry and Chemical Technology*. In Needham, Joseph.

Science and Civilisation in China. 3rd rev. printing. Cambridge: Cambridge University Press, 1987.

"Vajracchedikāprajñāpāramitāsūtra." In *The Princeton Dictionary of Buddhism*. Eds. Robert E. Buswell Jr. and Donald S. Lopez Jr, 953. Princeton, NJ; Oxford: Princeton University Press, 2014.

Vinkler, Balint. "Krakkói borkivitelünk a 16. Század végén (1589–1600)." *Agrártörténeti szemle Historia Rerum Rusticarum*. Szerkesztöség: Magyar Mezögazdasági Múzeum: <http://real-j.mtak.hu/2677/1/UJ%20LV.%20evfolyam%202014.%20 1-4.%20szam%20kihajtos%20terkeppel-2.pdf>; accessed 12 February 2022.

"What Is a Rubbing?" Chinese Stone Rubbings Collection, East Asian Library, University of California, Berkeley: <https://www.lib.berkeley.edu/EAL/stone/rubbings.html>; accessed 12 February 2022.

"Willem Vrelant." Getty Museum Collection: <https://www.getty.edu/art/collection/person/103K95>; accessed 24 May 2022.

Wiltshire, Alex and John Short. *Home Computers: 100 Icons that Defined a Digital Generation*. Cambridge, MA: The MIT Press, 2020.

Wong, Dorothy. *Buddhist Pilgrim-Monks as Agents of Cultural and Artistic Transmission: The International Buddhist Art Style in East Asia, ca. 645–770*. Singapore: National University of Singapore, 2018.

Wood, Frances and Mark Barnard. *The Diamond Sutra: The Story of the World's Earliest Dated Printed Book*. London: The British Library, 2010.

Xiao, Dongfa, ed. *From Oracle Bones to E-Publications: Three Millennia of Publishing in China*. Beijing: Foreign Languages Press, 2009.

II. SUBSTRATES

Alcock, N. W. *Old Title Deeds: A Guide for Local and Family Historians*. First published in 1986. 2nd ed. Chichester, U.K.: Phillimore, 2001.

Baker, Cathleen A. *From the Hand to the Machine. Nineteenth-Century American Paper and Mediums: Technologies,*

Materials, and Conservation. Ann Arbor, MI: The Legacy Press, 2010.

Baker, Cathleen A. "The Wove Paper in John Baskerville's Virgil (1757): Made on a Cloth-Covered Laid Mould." In *Papermaker's Tears: Essays on the Art and Craft of Paper*. Vol 1. Ed. Tatiana

Ginsberg, 2–44. Ann Arbor, MI: The Legacy Press, 2019.

Barrett, Timothy D. *European Hand Paper-making: Traditions, Tools, and Techniques.* Ann Arbor, MI: The Legacy Press, 2018.

Barry-Arredondo, Christopher. "The 'Talking Paper': Interpreting the Birch-Bark Scrolls of the Ojibwa Midewiwin." Thesis. State University of New York at Buffalo, 2006.

Basbanes, Nicholas A. *On Paper: The Everything of Its Two-Thousand-Year History.* New York: Alfred A. Knopf, 2013.

Beal, Peter. *A Dictionary of English Manuscript Terminology: 1450–2000.* Oxford: Oxford University Press, 2008.

Bidwell, John. "The Size of the Sheet in America: Paper-Moulds Manufactured by N. D. Sellers of Philadelphia (1977)." In *Paper and Type: Bibliographical Essays.* Charlottesville: The Bibliographical Society of the University of Virginia, 2019, 193–226.

Bidwell, John. "The Study of Paper as Evidence, Artifact, and Commodity (1992)." In *Paper and Type: Bibliographical Essays.* Charlottesville: The Biblio-graphical Society of the University of Virginia, 2019, 3–18.

Bidwell, John. "Wove Paper in England and France (1999)." In *Paper and Type: Bibliographical Essays.* Charlottesville: The Bibliographical Society of the University of Virginia, 2019, 33–40.

Bischoff, Bernhard. *Latin Paleography: Anti-quity and the Middle Ages.* Trans. Dáibhí Ó Cróinín and David Ganz. 1990. Cambridge: Cambridge University Press, 2003.

Bloom, Jonathan. *Paper before Print: The History and Impact of Paper in the Islamic World.* New Haven: Yale University Press, 2001.

"'Books and Beasts' Medieval Manuscript Mystery Solved." Cambridge University Library [ca. 2015]: <https://www.lib.cam.ac.uk/news/books-and-beasts-medieval-manuscript-mystery-solved>; accessed 21 February 2022.

Boudalis, Georgios. *The Codex and Crafts in Late Antiquity.* New York City: Bard Graduate Center, 2018.

Bovey, Alixe. "Book of Hours." In *The Oxford Companion to the Book.* Eds. Michael F. Suarez, S.J., and H. R. Woudhuysen,

1:550–552. 2 vols. Oxford: Oxford University Press, 2013.

Bulow-Jacobsen, Adam. "Writing Materials in the Ancient World." In *The Oxford Handbook of Papyrology.* Ed. Roger S. Bagnall. Oxford: Oxford University Press, 2011.

Burchard, Hank. "Artist's Bookkeeping." *The Washington Post*, 6 January 1995: <https://www.washingtonpost.com/archive/lifestyle/1995/01/06/artists-bookkeeping/532eac54-1136-4ad6-9b59-0d76a0543063/>; accessed 12 February 2022.

Capua, Rebecca. "Papyrus-Making in Egypt." March 2015. The Metropolitan Museum of Art: <https://www.metmuseum.org/toah/hd/pyma/hd_pyma.htm>; accessed 12 February 2022.

Carter, John. "Watermark." In *ABC for Book Collectors.* 9th ed. Eds. Nicolas Barker and Simran Thadani. New Castle, DE: Oak Knoll Press, 2016.

Chamberlain, Daven Christopher. "Paper." In *The Oxford Companion to the Book.* Eds. Michael F. Suarez, S.J., and H. R. Woudhuysen, 1: 79–87. 2 vols. Oxford: Oxford University Press, 2010

de Looze, Laurence. *The Letter and the Cosmos: How the Alphabet Has Shaped the Western View of the World.* Toronto: University of Toronto Press, 2016.

Edgren, Soren. "paper, East Asian." In *The Oxford Companion to the Book.* Eds. Michael F. Suarez, S.J., and H. R. Woudhuysen, 2:1000. 2 vols. Oxford: Oxford University Press, 2010.

Field, Dorothy. *Handmade Paper in Nepal. Tradition and Change.* Washington, DC: Hand Papermaking, 1998.

Fine, Ruth. *The Janus Press: Fifty Years.* Burlington, VT: University of Vermont Libraries, 2006.

First Archivists Circle. *Protocols for Native American Archival Materials.* 2007: <https://www2.nau.edu/libnap-p/protocols.html>; accessed 12 February 2022.

Fisher, William Edward Garrett. "Paper: India Paper." In *The Encyclopædia Britannica: A Dictionary of the Arts, Sciences, Literature, and General Information.* 11th ed. New York: The Encyclopædia Britannica Co., 1911.

Frampton, Stephanie Ann. *Empire of Letters: Writing in Roman Literature and Thought from Lucretius to Ovid.* Oxford: Oxford University Press, 2019.

Galey, Alan. "The Enkindling Reciter: E-Books in the Bibliographical Imagination." *Book History* 15 (2012): 210–247.

Gaskell, Philip. *A New Introduction to Bibliography.* First published by Oxford University Press in 1972. Reprinted with corrections in 1974. Winchester, U.K. and New Castle, DE: St Paul's Bibliographies and Oak Knoll Press, 1995.

Ginsberg, Tatiana, ed. *Papermaker's Tears: Essays on the Art and Craft of Paper.* Vol. 1. Ann Arbor, MI: The Legacy Press, 2019.

Green, James N. and Peter Stallybrass. "Benjamin Franklin: Writer and Printer." The Library Company of Philadelphia: <http://librarycompany.org/BFWriter/writer.htm>; accessed 12 February 2022.

Helman-Ważny, Agnieska. *The Archaeology of Tibetan Books.* Leiden: Brill, 2013.

Horniman Museum and Gardens, "Writing Tablet," Horniman Museum and Gardens: <https://www.horniman.ac.uk/object/30.3.60/3/>; accessed 12 February 2022.

Hunter, Dard. *Papermaking: The History and Technique of an Ancient Craft.* Unabridged republication of the second edition of Hunter's work as published by Alfred A. Knopf in 1947. New York: Dover Publications, 1978.

"India Paper." In *The Reader's Guide to the Encyclopædia Britannica: A Handbook Containing Sixty-six Courses of Systematic Study or Occasional Reading.* London: The Encyclopedia Britannica Co., 1913.

Koretsky, Elaine. *Traditional Paper Sheet Formation around the World, 1976–2002.* 2002. 41 minutes. Narrated and produced by Elaine Koretsky. Carriage House Paper: <www.carriagehousepaper.com>; accessed 12 February 2022.

Little, Geoffrey, ed. "What is the History of Electronic Books / L'histoire du livre électronique, une discipline en devenir." Special issue of the *Papers of the Bibliographical Society of Canada* 51/1 (2013): 11–17.

National Library of Sri Lanka. "Ola Leaf Manuscripts Collection." National Library of Sri Lanka: <http://www.natlib.lk/collections/olaleaf.php>; accessed 12 February 2022.

Newton, Casey. "The Everything Book: Reading in the Age of Amazon," *The Verge.* 17 December 2014: <https://www.theverge.com/2014/12/17/7396525/amazon-kindle-design-lab-audible-hachette>; accessed 12 February 2022.

Ovenden, Richard. "papyrus." In *The Oxford Companion to the Book.* Eds. Michael F. Suarez, S.J., and H. R. Woudhuysen, 2:1003. 2 vols. Oxford: Oxford University Press, 2010.

PAC Sri Lanka. "Traditional Paper and Manuscript Preservation." Strategic Programme on Preservation and Conservation (PAC). IFLA: <https://www.ifla.org/node/93083>; accessed 12 February 2022.

Pakhoutova, Elena and Agnieszka Helman-Ważny. "Illuminated: The Art of Sacred Books." Rubin Museum of Art (2012): <https://rubinmuseum.org/images/content/Illuminated_final.pdf>; accessed 12 February 2022.

"Parchment." *Language of Bindings, Ligatus*: <https://www.ligatus.org.uk/lob/concept/1485>; accessed 12 February 2022.

Penn Arts & Sciences. "Birch Bark Scrolls." *Digital Partnerships with Indian Communities. Virtual Museum*: <https://www.sas.upenn.edu/dpic/Drum/Welcome/VirtualMuseum/Artifacts/Scrolls>; accessed 12 February 2022.

"The Pitt Estate in Dean Street: No. 72 Dean Street." In *Survey of London.* Ed. F. H. W. Sheppard. Vols. 33 and 34. London: 1966, 213–214. *British History Online*: <http://www.british-history.ac.uk/survey-london/vols33-4/pp213-214>; accessed 29 May 2022.

Pliny the Elder. *Naturalis Historia.* Ed. Karl Friedrich Theodor Mayhoff. Leipzig: Teubner, 1906.

Povey, K. and I. J. C. Foster. "Turned Chain-lines." *The Library* 5, no. 3 (December 1950): 184–200.

Rickards, Maurice. *The Encyclopedia of Ephemera: A Guide to the Fragmentary Documents of Everyday Life for the Collector, Curator, and Historian.* Ed. Michael Twyman with Sally de Beaumont and Amoret Tanner. London:

The British Library, 2000.

Solomon, Johnny. "Jewish Prayer at Home and in the Synagogue." *Discovering Sacred Texts*. The British Library: <https://www.bl.uk/sacred-texts/articles/jewish-prayer-at-home-and-in-the-synagogue>; accessed 12 February 2022.

Stein, Wendy A. "The Book of Hours: A Medieval Bestseller." The Metropolitan Museum of Art: <https://www.metmuseum.org/toah/hd/hour/hd_hour.htm>; accessed 12 February 2022.

Stern, David. *The Jewish Bible. A Material History*. Seattle, WA: University of Washington Press, 2019.

Stinson, Timothy. "Knowledge of the Flesh: Using DNA Analysis to Unlock Bibliographical Secrets of Medieval Parchment." *The Papers of the Bibliographical Society of America*, vol. 103, no. 4 (2009): 435–53.

Stinson, Timothy. "Sheep: What DNA Can Reveal about Medieval Manuscripts and Texts." Rare Book School Lecture 504, 15 October 2007. Rare Book School: <https://rarebookschool.org/programs/lectures/>; accessed 12 February 2022.

Stone, Brad. *The Everything Store. Jeff Bezos and the Age of Amazon*. New York: Little Brown and Co., 2013.

Szirmai, J. A. *The Archaeology of Medieval Bookbinding*. Aldershot, U.K.: Ashgate Publishing, 1999.

Tsien, Tsuen-Hsuin. *Paper and Printing*. Vol. 5, part 1: *Chemistry and Chemical Technology*. In Needham, Joseph. *Science and Civilisation in China*. 3rd rev. printing. Cambridge: Cambridge University Press, 1987.

Tsien, T[suen]-H[suin]. *Written on Bamboo and Silk*. Chicago: University of Chicago Press, 2004.

Vander Meulen, David. Correspondence with Barbara Heritage, 30 May 2022.

Vander Meulen, David. *Where Angels Fear to Tread: Descriptive Bibliography and Alexander Pope*. Washington, DC: Library of Congress, 1988.

Warkentin, Germaine. "In Search of 'The Word of the Other': Aboriginal Sign Systems and the History of the Book in Canada." *Book History*, vol. 2 (1999): 1–27.

III. FORMATS

Audubon, Maria R. *Audubon and His Journals*. New York: Charles Scribner's Sons, 1899.

Bhoi, Panchanan. "Scribe as Metaphor: Patterns of Processing and Writing Palm Leaf Manuscripts." *Indian Anthropologist* 40, no. 1 (Jan–June 2010): 71–92.

Boudalis, Georgios. *The Codex and Crafts in Late Antiquity*. New York City: Bard Graduate Center, 2018.

Chance, Linda H. and Julie Nelson Davis, "The Handwritten and the Printed: Issues of Format and Medium in Japanese Premodern Books." *Manuscript Studies* 1, no. 1 (2016): 90–115.

Cuneiform Digital Library Initiative. A joint project of the University of California, Los Angeles, the University of Oxford, and the Max Planck Institute for the History of Science, Berlin: <https://cdli.ucla.edu/>; accessed 12 February 2022.

Ellis, Markman. "The Spectacle of the Panorama." *Picturing Places*. British Library, 6 April 2017: <https://www.bl.uk/picturing-places/articles/the-spectacle-of-the-panorama#>; accessed 12 February 2022.

Fries, Waldemar H. *The Double Elephant Folio: The Story of Audubon's* Birds of America. Chicago: American Library Association, 1973.

Gaskell, Philip. *A New Introduction to Bibliography*. First published by Oxford University Press in 1972. Reprinted with corrections in 1974. Winchester, U.K. and New Castle, DE: St Paul's Bibliographies and Oak Knoll Press, 1995.

Green, James N. and Peter Stallybrass. "Benjamin Franklin: Writer and Printer." The Library Company of Philadelphia: <http://librarycompany.org/BFWriter/writer.htm>; accessed 12 February 2022.

Helman-Ważny, Agnieszka. *The Archaeology of Tibetan Books*. Leiden: Brill, 2014.

Kallendorf, Craig. "The Ancient Book." In *The Oxford Companion to the Book*. Eds. Michael F. Suarez, S.J., and H.R.

Woudhuysen, 1:25–35. 2 vols. Oxford: Oxford University Press, 2010.

Low, Susan M. *An Index and Guide to Audubon's* Birds of America. New York: Abbeville Press, 1988.

Michel, Cécile. "Cuneiform Fakes: A Long History from Antiquity to the Present Day." *Fakes and Forgeries of Written Artefacts from Ancient Mesopotamia to Modern China.* Eds. Cécile Michel and Michael Friedrich, 25–60. Berlin: De Gruyter, 2020.

Miller, Angela L. "The Panorama, the Cinema and the Emergence of the Spectacular." *Wide Angle* 18, no. 2 (1996): 34–69.

Ovenden, Richard. "codex." In *The Oxford Companion to the Book.* Eds. Michael F. Suarez, S.J., and H. R. Woudhuysen, 1:618. Oxford: Oxford University Press, 2010.

Pagels, Elaine. *The Gnostic Gospels.* New York: Vintage Books, 1979.

Pistner, Patricia and Jan Storm Van Leeuwen. *A Matter of Size: Miniature Bindings and Texts from the Collection of Patricia J. Pistner.* Curated by Patricia J. Pistner and Jan Storm van Leeuwen. Ed. George Ong. New York: The Grolier Club, 2019.

Roberts, C. H. and T. C. Skeat. *The Birth of the Codex.* Oxford: Oxford University Press, 1987.

Roberts, Matt T. and Don Etherington. "Quire." In *Bookbinding and Conservation of Books: A Dictionary of Descriptive Terminology*: <https://cool.

culturalheritage.org/don/dt/dt2766. html>; accessed 17 January 2022.

Schaeffer, Kurtis R. *The Culture of the Book in Tibet.* New York: Columbia University Press, 2009.

Shailor, Barbara. *The Medieval Book: Illustrated from the Beinecke Rare Book and Manuscript Library.* First published in 1988 by Yale University Library. Toronto: University of Toronto Press, 2002.

Simpson, St John. "Fake Antiquities Made for Unsuspecting Collectors." The British Museum Blog: <https://blog. britishmuseum.org/fake-antiquities-made-for-unsuspecting-collectors/>; accessed 15 December 2021.

Solomon, Johnny. "Jewish Prayer at Home and in the Synagogue." *Discovering Sacred Texts.* The British Library: <https://www.bl.uk/sacred-texts/articles/jewish-prayer-at-home-and-in-the-synagogue>; accessed 15 December 2021.

Stern, David. *The Jewish Bible. A Material History.* Seattle, WA: University of Washington Press, 2019.

Szirmai, J.A. *The Archaeology of Medieval Bookbinding.* Aldershot, Hants: Ashgate Publishing, 1999.

Victoria and Albert Museum. Catalogue entry for *On the Slates*: <https://collections. vam.ac.uk/item/O1293849/on-the-slates-artists-book-coolidge-clark/>; accessed 24 March 2022.

IV. LETTER-FORMS

Andrews, Martin. "Linotype." *The Oxford Companion to the Book.* Eds. Michael F. Suarez, S.J., and H. R. Woudhuysen, 2:884–885. 2 vols. Oxford: Oxford University Press, 2010.

Baskerville, John. Letter to Robert Dodsley. In *The Correspondence of Robert Dodsley, 1733–1764.* Ed. James E. Tierney. First published in 1988. Cambridge: Cambridge University Press, 2004, 146.

Becker, David P. *The Practice of Letters: The Hofer Collection of Writing Manuals 1514–1800.* Cambridge, MA: Harvard College Library, 1997.

Berkson, William. "Readability and Revival: The Case of Caslon." *Printing History.* New Series. Number 10 (2011): 3–24.

Bishop, William. "Pens, Pencils, Brushes and Knives." *The Calligrapher's Handbook.* Ed. C. M. Lamb. 2nd ed. New York: Pantaloc, 1968.

Bolzoni, Lina. *The Gallery of Memory: Literary and Iconographic Models in the Age of the Printing Press.* Trans. Jeremy Parzen. 1995. Toronto: University of Toronto Press, 2001.

Brown, Michelle P. *A Guide to Western Historical Scripts from Antiquity to 1600.*

London: The British Library, 1990.

Bulow-Jacobsen, Adam. "Writing Materials in the Ancient World." *The Oxford Handbook of Papyrology.* Ed. Roger S. Bagnall. Oxford: Oxford University Press, 2011.

Carpenter, John T. "Chinese Calligraphic Models in Heian Japan: Copying Practices and Stylistic Transmission." *The Culture of Copying in Japan: Critical and Historical Perspectives.* Ed. Rupert Cox, 156–195. London and New York: Routledge, 2008.

Cinamon, Gerald. "Anna Simons." *German Graphic Designers during the Hitler Period. Biographical and Bibliographical References.* 2013: <http://www.germandesigners.net/designers/anna_simons>; accessed 12 February 2022.

Clayton, Ewan. "John Baskerville the Writing Master: Calligraphy and Type in the Seventeenth and Eighteenth Centuries." In *John Baskerville: Art and Industry of the Enlightenment.* Eds. Caroline Archer-Parré and Malcolm Dick, 113–132. Liverpool: Liverpool University Press, 2017.

de Hamel, Christopher. *Cutting Up Manuscripts for Pleasure and Profit.* The Sol. M. Malkin Lecture in Bibliography [Rare Book School]. First published in 1995. Third printing. Charlottesville: Book Arts Press, 2000.

de Hamel, Christopher. *A History of Illuminated Manuscripts.* 2nd ed. London: Phaidon Press, 1994.

Derolez, Albert. *The Paleography of Gothic Manuscript Books: From the Twelfth to the Early Sixteenth Century.* Cambridge: Cambridge University Press, 2003.

De Vinne, Theodore Low. *A Treatise on Title-Pages, with Numerous Illustrations in Facsimile and Some Observations on the Early and Recent Printing of Books.* New York: The Century Co., 1902.

Dowding, Geoffrey. *An Introduction to the History of Printing Types: An Illustrated Summary of the Main Stages in the Development of Type Design from 1440 Up to the Present Day; An Aid to Type Face Identification.* London and New Castle, DE: The British Library & Oak Knoll Press, 1998. First published in 1961 by Wace and Co., London.

Eliason, Craig. "'Transitional' Typefaces: The History of a Typefounding Classification." *Design Issues* 31, no 4 (Autumn 2015): 30–43.

Finlay, Michael. *Western Writing Implements in the Age of the Quill Pen.* Wetheral, Carlisle, Cumbria: Plain Books, 1990.

Gaskell, Philip. *A New Introduction to Bibliography.* First published by Oxford University Press in 1972. Reprinted with corrections in 1974. Winchester, U.K. and New Castle, DE: St Paul's Bibliographies and Oak Knoll Press, 1995.

Gubele, Rose. "Utalotsa Woni – 'Talking Leaves': A Re-examination of the Cherokee Syllabary and Sequoyah." *Studies in American Indian Literatures,* vol. 24, no 4 (Winter 2012): 47–76.

Heal, Ambrose. *The English Writing-Masters and their Copy-Books 1570-1800. A Biographical Dictionary & A Bibliography. With an Introduction on the Development of Handwriting by Stanley Morison.* Hildesheim: Georg Olms Verlagsbuchhandlung, 1962.

Hindman, Sandra. Description for "Choir Book" (Gradual): <https://www.textmanuscripts.com/medieval/gradual-choir-book-141593>; accessed 8 March 2022.

Hopkins, Richard L. *Tolbert Lanston and the Monotype: The Origin of Digital Typesetting.* Tampa: University of Tampa Press, 2012.

James, Kathryn. *English Paleography and Manuscript Culture, 1500–1800.* New Haven: Beinecke Rare Book & Manuscript Library, Yale University, 2020.

Kelly, Rob Roy. *American Wood Type 1828–1900. Notes on the Evolution of Decorated and Large Types and Comments on Related Trades of the Period.* 1969. Saratoga, CA: Liber Apertus Press, 2010.

Lepore, Jill. *A is for American: Letters and Other Characters in the Newly United States.* New York: Alfred A. Knopf, 2002.

Li, Wendan. *Chinese Writing and Calligraphy.* Honolulu: University of Hawai'i Press, 2009.

Maret, Russell. "A Flexible Matrix: An Analysis of the Typeface Used in the *Theuerdank,* 1517." In *Visionaries and Fanatics and Other Essays on Type Design, Technology, and the Private Press.* Ann Arbor, MI: The Legacy Press, 2021, 71–79.

Middleman, Arielle and Todd Pattison. "Benjamin Bradley and the 'Profitable Stroke': Binding *Six Months in a Convent* and the Need for Copy-Specific Cataloging of Nineteenth-Century Publishers' Bindings." In *Suave Mechanicals: Essays on the History of Bookbinding.* Vol. 3. Ed. Julia Miller, 418–481. Ann Arbor, MI: The Legacy Press, 2016.

Morison, Stanley. *A Tally of Types. With Additions by Several Hands.* Ed. Brooke Crutchley. Cambridge, U.K.: Cambridge University Press, 1973.

Mosley, James. "Cast Ornaments in the 18th Century: Some Examples and an Appeal." London: 2003. Unpublished teaching handout, included in RBS's "Irish Gentleman" teaching kit.

Mosley, James. "The Early Career of William Caslon." *Journal of the Printing Historical Society* 3 (1967): 66–82.

Mosley, James. "*Lettres à jour:* Public Stencil Lettering in France." *Typefoundry: Documents for the History of Type and Letterforms*: <https://typefoundry.blogspot.com/2010/03/lettres-jour-public-stencil-lettering.html>; accessed 12 February 2022.

Mosley, James. *A Specimen of Printing Types by William Caslon, London 1766. A Facsimile with an Introduction and Notes by James Mosley.* London: Printing Historical Society, 1983.

Nickell, Joe. *Pen, Ink, and Evidence: A Study of Writing and Writing Materials for the Penman, Collector, and Document Detective.* Lexington, KY: The University Press of Kentucky, 1990.

"Pen." *The Grove Encyclopedia of Materials and Techniques in Art.* Ed. Gerald W. R. Ward, 481–482. Oxford: Oxford University Press, 2008.

Pollard, Alfred W. *Fine Books.* New York: G. P. Putnam's Sons, 1912.

Reed, Talbot Baines. *A History of The Old English Letter Foundries. With Notes Historical and Bibliographical on the Rise of the Progress of English Typography.* London: Faber and Faber, 1952.

Simons, Anna. "Lettering in Book Production." *Lettering of To-day.* Ed. C. G. Holme, 57–89. London and New York: The Studio Limited.; Studio Publications, 1937.

Simons, Anna. "Vorwort." *Titel und Initialen für die Bremer Presse.* Munich: Bremer Presse, 1926.

Stokes, Roy. *Esdaile's Manual of Bibliography.* Ed. Stephen R. Almagno. 6th ed. Lanham, MD: The Scarecrow Press, 2001.

Strange, Edward F. "The Writing-Books of the Sixteenth Century." *Transactions of the Bibliographical Society*, vol. 3 (January 1895 to June, 1896): 41–70.

Updike, Daniel Berkeley. *Printing Types: Their History, Forms, and Use.* Vol. 2. Cambridge: Harvard University Press, 1922.

V. PRINTING SURFACES

RELIEF

American Photoengravers Association. *The Art of Photoengraving.* N.p.: American Photoengravers Association, 1952.

Andrews, Martin. "lithography." In *The Oxford Companion to the Book.* Eds. Michael F. Suarez, S.J., and H. R. Woudhuysen, 2:888–889. 2 vols. Oxford: Oxford University Press, 2010.

Bain, Iain. "A Technical Note on the Blocks." *The Mattioli Woodblocks.* London: Hazlitt, Gooden & Fox; London: Bernard Quaritch; Amsterdam: Antiquariaat Junk, 1989, [9–10].

Brokaw, Cynthia. *Commerce in Culture: The Sibao Book Trade in the Qing and Republican Periods.* Harvard East Asian Monographs 280. Cambridge: Harvard University Asia Center, 2007.

Chow, Kai-Wing. *Publishing, Culture, and Power in Early Modern China.* Stanford: Stanford University Press, 2004.

Depaulis, Thierry. "Jean Michel Papillon's contribution to the *Encyclopédie.*" *Recherches sur Diderot et sur l'Encyclopédie*, vol. 53, no. 1 (2018): 85–112.

Edgren, J. S. "The History of the Book in China." In *The Oxford Companion to the Book.* Eds. Michael F. Suarez, S.J., and H. R. Woudhuysen, 1:353–365. 2 vols. Oxford: Oxford University Press, 2010.

The Electrotype and Stereotype Handbook. Cleveland, OH: International

Association of Electrotypers & Stereotypers, Inc., ca. 1955.

"Etching, Relief." *The Grove Encyclopedia of Materials and Techniques in Art*. Ed. Gerald W. R. Ward, 210–211. Oxford: Oxford University Press, 2008.

Gascoigne, Bamber. *How to Identify Prints: A Complete Guide to Manual and Mechanical Processes from Woodcut to Inkjet*. New York: Thames and Hudson, 1986.

Gaskell, Philip. *A New Introduction to Bibliography*. First published by Oxford University Press in 1972. Reprinted with corrections in 1974. Winchester, U.K. and New Castle, DE: St Paul's Bibliographies and Oak Knoll Press, 1995.

Glaister, Geoffrey Ashall. *Encyclopedia of the Book*. 2nd ed. Intro. Donald Farren. New Castle, DE; London: Oak Knoll Press and The British Library, 1996.

Guggi, Nadja. "stereotyping." In *The Oxford Companion to the Book*. Eds. Michael F. Suarez, S.J., and H. R. Woudhuysen, 2:1178–1179. 2 vols. Oxford: Oxford University Press, 2010.

"Henry Davis Minot Papers." Massachusetts Historical Society Collection Guide to the Collection: <https://www.masshist.org/collection-guides/view/fa0286>; accessed 25 February 2022.

Heritage, Barbara. "Collecting Litho Jam Jar Labels and Teaching Wood-Engraved Elephants: Rare Book School's Printing Surfaces Collection." *Printing History*, n.s. 6 (2009): 3–14.

Kainen, Jacob. *John Baptist Jackson: 18th-Century Master of the Color Woodcut*. Washington, DC: United States Government Printing Office, 1962.

Kipphan, Helmut, ed. *Handbook of Print Media: Technologies and Production Methods*. Berlin: Springer Verlag, 2001.

Kornicki, Peter. *The Book in Japan: A Cultural History from the Beginnings to the Nineteenth Century*. Honolulu: University of Hawai'i Press, 2001.

Leclerc, Christophe. *Gustave Doré: le rêveur éveillé*. Paris: L'Harmattan, 2012.

Lin, Maria. "Japanese Woodblocks." RBS Teaching Guide. Charlottesville, 2017.

"Lola Ridge." In *Gale Literature: Contemporary Authors*. Farmington Hills, MI: Gale, 2000. *Gale Literature Resource Center*: <https://link.gale.com/apps/doc/H1000082869/GLS?u=viva_uva&sid=bookmark-GLS&xid=3f5a24bd>; accessed 18 February 2022.

Moser, Barry. "Bookwright." Northampton, MA: 2022. Unpublished manuscript.

Muir, Percy. *Victorian Illustrated Books*. 1971. London: Portman Books, 1989.

Musinsky, Nina. "Masterpieces in Miniature." New York: Musinsky Rare Books, 2017. Bookseller description.

Partridge, C. S. *Electrotyping: A Practical Treatise on the Art of Electrotyping by the Latest Known Methods*. Chicago: The Inland Printer Co., 1899.

"Photopolymer Platemaking by Hand." Letterpress Commons: <https://letterpresscommons.com/platemaking-diy/>; accessed 27 February 2022.

Polk, Ralph W. *The Practice of Printing*. Peoria, IL: The Manual Arts Press, 1926.

Raphael, Sandra. "Mattioli's Herbal" *The Mattioli Woodblocks*. London: Hazlitt, Gooden & Fox; London: Bernard Quaritch; Amsterdam: Antiquariaat Junk, 1989, [3–8].

Ray, Gordon N. *The Art of the French Illustrated Book, 1700 to 1914*. 1982. New York: The Pierpont Morgan Library in association with Dover Publications, 1986.

Robertson, Gordon L. *Food Packaging: Principles and Practice*. 2nd ed. Boca Raton, FL: CRC Press, 2006.

Rousmanière, Nicole Coolidge and Matsuba Ryoko, eds. *The Citi Exhibition: Manga*. London: Thames & Hudson, The British Museum, 2019.

Schanilec, Gaylord. *My Colorful Career*. Newtown, PA: Bird & Bull Press, 1996. Foreword by Henry Morris.

Scott, David A. and Donna Stevens. "Electrotypes in Science and Art." *Studies in Conservation* 58, no. 3 (July 2013): 189–198.

Selected Mattioli Wood Engravings. Santa Barbara, CA: VLT Gardner Horticultural & Botanical Books, [n.d.].

Smith, Margaret M. "factotum." In *The Oxford Companion to the Book*. Eds. Michael F. Suarez, S.J., and H. R. Woudhuysen, 2:713. 2 vols. Oxford: Oxford University Press, 2010.

Smith, Margaret M. "photomechanical printing; photoengraving; process

engraving." In *The Oxford Companion to the Book*. Eds. Michael F. Suarez, S.J., and H. R. Woudhuysen, 2:1023. 2 vols. Oxford: Oxford University Press, 2010.

Strauss, Walter L. *Chiaroscuro: The Clair-Obscur Woodcuts by the German and Netherlandish Masters of the XVIth and XVIIth Centuries*. Greenwich, CT: New York Graphic Society, 1973.

Svoboda, Terese. "Why Has the Poet Lola Ridge Disappeared? On the Historical Erasure of Political Women Artists." Lit Hub. April 6, 2018: <https://lithub.com/why-has-poet-lola-ridge-disappeared/>; accessed 18 February 2022.

Takaaki, Kaneko. "The Printing Blocks of Woodblock-Printed Books" *The World of the Japanese Illustrated Book*: <https://pulverer.si.edu/node/1217>; accessed 12 February 2022.

Wakeman, Geoffrey. *Victorian Book Illustration: The Technical Revolution*. Newton Abbot, U.K.: David & Charles, 1973.

Watson, William Patrick. "The Mattioli Woodblocks: A Remarkable Survival." *The Mattioli Woodblocks*. London: Hazlitt, Gooden & Fox; London: Bernard Quaritch; Amsterdam: Antiquariaat Junk, 1989, [1–2].

Weiner, A. B. R. "electrotyping." In *The Oxford Companion to the Book*. Eds. Michael F. Suarez, S.J., and H. R. Woudhuysen, 2:694. 2 vols. Oxford: Oxford University Press, 2010.

Weiner, A. B. R. "flong." In *The Oxford Companion to the Book*. Eds. Michael F. Suarez, S.J., and H. R. Woudhuysen, 2:725. 2 vols. Oxford: Oxford University Press, 2010.

William, Graham. *Thomas Bewick Engraver & the Performance of Woodblocks*. Charing, U.K.: The Florin Press, 2021.

Yang, Hu and Yang Xiao. *Chinese Publishing*. Cambridge: Cambridge University Press, 2012.

INTAGLIO

Delano-Smith, Catherine and Roger J. P. Kain. *English Maps: A History*. Toronto and Buffalo: University of Toronto Press, 1999.

Gascoigne, Bamber. *Milestones in Colour Printing 1457–1859: With a Bibliography of Nelson Prints*. Cambridge: Cambridge University Press, 1997.

Goldstein, Carl. *Print Culture in Early Modern France: Abraham Bosse and the Purposes of Print*. Cambridge: Cambridge University Press, 2012.

Harley, J. B., "Introduction" to John Ogilby. *Britannia. London 1675*. Amsterdam: Theatrum Orbis Terrarum, 1970.

Hunnisett, Basil. *Engraved on Steel: The History of Picture Production Using Steel Plates*. Aldershot, England: Ashgate, 1998.

Hunnisett, Basil. *Steel-Engraved Book Illustration in England*. London: Scolar Press, 1980.

Ivins Jr., William M. *How Prints Look: Photographs with Commentary*. Expanded edition revised by Marjorie B. Cohn. Boston: Beacon Press, 1987.

Join-Lambert, Sophie and Maxime Préaud, eds. *Abraham Bosse: Savant Graveur: Tous, vers 1604–1676, Paris*. Paris; Tours: Bibliothèque nationale de France, Musée des beaux-arts de Tours, 2004.

Metzger, Christof. "The Iron Age: The Beginnings of Etching about 1500." In Jenkins, Catherine, et al. *The Renaissance of Etching*, 25–63. New York: The Metropolitan Museum of Art, 2019.

Orenstein, Nadine M. and Ad Stijnman. "Bitten with Spirit: Etching Materials and Techniques in the Sixteenth Century." *The Renaissance of Etching*. Eds. Catherine Jenkins, Nadine M. Orenstein and Freyda Spira, 15–24. New York: The Metropolitan Museum of Art, 2019.

Prideaux, S. T. *Aquatint Engravings: A Chapter in the History of Book Illustration*. London: Duckworth & Co., 1909.

Stijnman, Ad. *Engraving and Etching 1400–2000: A History of the Development of Manual Intaglio Printmaking Processes*. London and Houten, Netherlands: Archetype Publications in association with HES & de Graaf Publishers, 2012.

Stijnman, Ad and Elizabeth Savage. *Printing Colour 1400–1700: History, Techniques, Functions, and Reception*. Leiden: Brill, 2015.

Verner, Coolie. "Copperplate Printing." *Five Centuries of Map Printing*. Ed. David Woodward, 51–75. Chicago and London: University of Chicago Press, 1975.

Wax, Carol. *The Mezzotint: History and Technique.* New York: Harry N. Abrams, 1990.

PLANOGRAPHIC

Blair, Sheila S. and Jonathan Bloom. "The Islamic World." In The Oxford Illustrated History of the Book. Ed. James Raven, 195–220. Oxford: Oxford University Press, 2020.

Johannsen, Albert. *The House of Beadle and Adams and its Dime and Nickel Novels: The Story of a Vanished Literature.* Norman: University of Oklahoma Press, 1950–1962.

LeBlanc, Edward [T.]. "Davy Crockett's Boy Hunter." The Edward T. LeBlanc Dime Novel Bibliography: <https://dimenovels. org/Item/61021/Show>; accessed 10 February 2022.

LeBlanc, Edward T. "Series. Beadle's Frontier Series." The Edward T. LeBlanc Dime Novel Bibliography: <https://dimenovels. org/Series/97/Show>; accessed 10 February 2022.

Roper, Geoffrey. "The History of the Book in the Muslim World." In *The* Oxford Companion to the Book. Eds. Michael F. Suarez, S.J., and H. R. Woudhuysen, 1:321–339. 2 vols. Oxford: Oxford University Press, 2010.

Twyman, Michael. *A History of Chromolithography: Printed Colour for All.* London and New Castle, DE: The British Library, Oak Knoll Press, 2013.

Twyman, Michael. *Lithography, 1800–1850.* London: University of Oxford Press, 1970.

PHOTOGRAPHY, STENCIL, AND DIGITAL

Blake, William. *William Blake: The Complete Illuminated Books.* Intro. David Bindman.
London: Thames & Hudson in Association with the William Blake Trust, 2000.

Hawthorne, Julian. *Nathaniel Hawthorne and His Wife: A Biography.* 2 vols. Boston and New York: Houghton, Mifflin, and Co., 1891.

Image Permanence Institute. "Gelatin Dry Plate." *Graphics Atlas*: <http:// graphicsatlas.org/identification/?process_ id=303>; accessed 12 February 2022.

Mills, Victoria. "Photography, Travel Writing, and Tactile Tourism: Extra-Illustrating *The Marble Faun.*" In *Travel Writing, Visual Culture, and Form, 1760–1900.* Eds. Mary Henes and Brian H. Murray, 68. Basingstoke, U.K.: Palgrave Macmillan, 2016.

Silvia, Adam. "Photographically Illustrated Books and Photobooks," Library of Congress (2017): <https://www.loc. gov/rr/print/coll/photographically-illustrated-books-and-photobooks.html>; accessed 25 June 2022.

"Songs of Innocence and of Experience (Composed 1789, 1794)": <http://www. blakearchive.org/work/songsie>; accessed 15 May 2022.

Stanford Department of Special Collections and University Archives. Guide to the Maurice Garbell Papers M2144. Online Archive of California: <https://oac.cdlib. org/findaid/ark:/13030/c8oc52m3/entire_ text/>; accessed 12 February 2022.

Williams, Susan S. *Confounding Images: Photography and Portraiture in Antebellum American Fiction.* Philadelphia: University of Pennsylvania Press, 1997.

Wyman, Mark. *DP: Europe's Displaced Persons, 1945–1951.* Philadelphia; London: Balch Institute Press; Associated University Press, 1988.

VI. BINDINGS

Allen, Sue. *American Book Covers, 1830–1900: A Pictorial Guide to the Changes in Design and Technology Found in the Covers of American Books between 1830 and 1900.* Washington, DC: Library of Congress, Binding & Collection Care Division, Preservation Directorate, 1998.

Allen, Sue. *The Book Cover Art of Sarah Wyman Whitman.* Boston: The Society of Printers, 2012.

Allen, Sue. "Book-Cover Stamps Engraved by John Feely, 1842–1877." In Allen, Sue and Charles Gullans. *Decorated Cloth in America. Publishers' Bindings 1840–1910.*

UCLA Center for 17th- and 18th-Century Studies. Los Angeles: William Andrews Clark Memorial Library, 1994, 9–52.

American Library Association Office for Intellectual Freedom. "100 Most Frequently Challenged Books 1990–1999." *Banned & Challenged Books*: <https://www.ala.org/advocacy/bbooks/frequentlychallengedbooks/decade1999>; accessed 8 March 2022.

Baines, Phil. *Penguin by Design: A Cover Story, 1935–2005*. London: Penguin Books, 2005.

Bennett, Stuart. *Trade Bookbinding in the British Isles, 1660–1800*. New Castle, DE: Oak Knoll Press, 2004.

Berger, Sidney E. *Karli Frigge's Life in Marbling*. Newton, PA: Bird & Bull Press, 2004.

"Bibliography." *Ursula K. Le Guin*: <https://www.ursulakleguin.com/bibliography>; accessed 25 June 2022.

Bruas, Albert. *Les De Morant, Barons et Marquis du Mesnil-Garnier. Recherches historiques et généalogiques sur une famille normande aux xviie et xviiie siècles*. Angers: Lachèse et Dolbeau, 1892.

Boyd, Melba Joyce. *Wrestling with the Muse: Dudley Randall and the Broadside Press*. New York: Columbia University Press, 2003.

Carter, John. *ABC for Book Collectors*. 9th ed. Eds. Nicolas Barker and Simran Thadani. New Castle, DE: Oak Knoll Press, 2016.

Carter, Sebastian. "Tschichold, Jan." In *The Oxford Companion to the Book*. Eds. Michael F. Suarez, S.J., and H. R. Woudhuysen, 2:1221. 2 vols. Oxford: Oxford University Press, 2010.

"Cover Linings." Ligatus's Language of Bindings Thesaurus (LoB): <https://www.ligatus.org.uk/lob/concept/1266>; accessed 22 May 2022.

"Dabbed Paper." Ligatus Language of Bindings Thesaurus: <http://w3id.org/lob/concept/4320>; accessed 8 March 2022.

Davis, Kenneth C. *Two-Bit Culture: The Paperbacking of America*. Boston: Houghton Mifflin Co., 1984.

Déroche, François and Annie Berthier. *Manuel de codicologie des manuscrits en écriture arabe*. Paris: Bibliothèque nationale de France, 2000.

Deveaux, Yves. *Dix siècles de reliure*. Paris: Watelet, Pygmalion, 1981.

Devauchelle, Roger. *La reliure: Recherches historiques, techniques et biographiques sur la reliure française*. Préface par Albert Labarre. Paris: Éditions Filigranes, 1995.

"Dicing (Techniques)." Ligatus's Language of Bindings Thesaurus (LoB): <https://www.ligatus.org.uk/lob/concept/1288>; accessed 18 May 2022.

Diehl, Edith. *Bookbinding: Its Background and Technique*. New York: Hacker Art Books, 1979.

Diemberger, Hildegard. "Holy Books as Ritual Objects and Vessels of Teaching in the Era of the 'Further Spread of the Doctrine.'" In *Revisiting Rituals in a Changing Tibetan World*. Ed. Katia Buffetrille, 9–41. Leiden: Brill, 2012.

Dowden, Edward. *Southey*. New York: Harper and Brothers, 1880.

Drinkwater, Hollie, Garret Sumner, and María Helena Vargas. "BPG Greek-Style Bindings." *Book and Paper Group Wiki*. American Institute for Conservation: <https://www.conservation-wiki.com/wiki/BPG_Greek-Style_Bindings>; accessed 7 March 2022.

Duff, Gordon E. *The Printers, Stationers, and Bookbinders of Westminster and London from 1476 to 1535*. Cambridge: Cambridge University Press, 1906.

Edgren, J. S. "wrapped-back binding." In *The Oxford Companion to the Book*. Eds. Michael F. Suarez, S.J., and H. R. Woudhuysen, 2:1271. 2 vols. Oxford: Oxford University Press, 2010.

Fleming, William. *Japanese Books. Teaching Aid*. RBS internal document prepared in 2019.

Foot, Mirjam M. *Bookbinders at Work: Their Roles and Methods*. London and New Castle, DE: The British Library and Oak Knoll Press, 2006.

Foot, Mirjam M. "Bookbinding 1400–1557." In *The Cambridge History of the Book in Britain: Volume III, 1400–1557*. Eds. Lotte Hellinga and J. B. Trapp, 109–127. Cambridge: Cambridge University Press, 1999.

Foot, Mirjam M. *The Henry Davis Gift. A Collection of Bookbindings*. London and New Castle, DE: The British Library and Oak Knoll Press, 2010.

Foot, Mirjam. *The History of Bookbinding as a Mirror of Society*. The Panizzi Lectures,

1997. London: The British Library, 1998.

Frigge, Karli. *The Magic of Marbling*. Joppe, Netherlands: Karli Frigge, 2020.

Frigge, Karli. *Marbled Paper*. Buren, Netherlands: Antiquariaat Frits Knuf, 1985.

Frigge, Karli. *Marbled Plants*. Decorated Papers, Volume II. Buren, Netherlands: Frits Knuf, 1988.

Frost, Gary. *A Crafted Typology of the Codex: Book Modelmaking as an Approach to Material Book Study*. Ann Arbor, MI: The Legacy Press, 2021.

Garrett, Frances. "Buddhism and the Historicising of Medicine in Thirteenth-Century Tibet." *Asian Medicine* 2, no. 2 (2006): 204–224: <https://doi.org/10.1163/157342106780684756>; accessed 31 March 2022.

Griest, Guinevere L. *Mudie's Circulating Library and the Victorian Novel*. Trowbridge, U.K.: David & Charles, 1970. First published by the Indiana University Press.

Gullans, Charles. "The New Generation: Sarah Whitman and Frank Hazen." *Decorated Cloth in America. Publishers' Bindings 1840—1910*. UCLA Center for 17th- and 18th-Century Studies. Los Angeles: William Andrews Clark Memorial Library, 1994, 53–96.

Gullans, Charles and John Espey. *Margaret Armstrong and American Trade Bindings. With a Checklist of Her Designed Bindings and Covers*. Los Angeles: Department of Special Collections; University Research Library; University of California, 1991.

Gyatso, Janet. "The Authority of Empiricism and the Empiricism of Authority: Medicine and Buddhism in Tibet on the Eve of Modernity." *Comparative Studies of South Asia, Africa and the Middle East* 24, no. 2 (2004): 83–96.

Haemmerle, Albert. *Buntpapier. Herkommen Geschichte Techniken Beziehungen zur Kunst. Unter Mitarbeit von Olga Hirsch*. München: Verlag Georg D. W. Callwey, 1961.

Harris, Neil. "part issue." In *The Oxford Companion to the Book*. Eds. Michael F. Suarez, S.J., and H. R. Woudhuysen, 2:1007. 2 vols. Oxford: Oxford University Press, 2010.

Hepworth, Paul and Karen Scheper. "Lacquer." Terminology for the conservation and description of Islamic manuscripts: <https://islamicmanuscriptconservation.org/terminology/materials-lacquer-en.html>; accessed 25 June 2022.

Heritage, Barbara. "Brontë and the Bookmakers: *Jane Eyre* in the Nineteenth-Century Marketplace." Doctoral dissertation, University of Virginia, 2014: <https://libraetd.lib.virginia.edu/public_view/9306sz64n>; accessed 15 March 2022.

"Imperial Arming Press, 1830s–1890s." American Bookbinders Museum: <https://bookbindersmuseum.org/collections/equipment/imperial-press-english-1832/>; accessed 13 March 2022.

"Inlays (Decorative Components)." Ligatus's Language of Bindings Thesaurus (LoB): <https://www.ligatus.org.uk/lob/concept/3533>; accessed 4 March 2022.

James, Caryn. "The Empress Has No Clothes." *New York Times*, 25 October 1992.

Kallendorff, Craig. *Virgil and the Myth of Venice: Books and Readers in the Italian Renaissance*. Oxford: Clarendon Press, 1999.

Kelsall, Lucy. "A Sombre Binding." In *PMC [Paul Mellon Centre] Notes*, no. 18, 29–37: <https://issuu.com/paulmelloncentre/docs/pmcnotes_18>; accessed 26 April 2022.

Kent, Neil. *The Sámi Peoples of the North: A Social and Cultural History*. London: Hurst & Co., 2018.

Krupp, Andrea. *Bookcloth in England and America, 1823–50*. New Castle, DE; London and New York: Oak Knoll Press, The British Library and The Bibliographical Society of America, 2008.

Lester, Valerie Browne. *Phiz: The Man Who Drew Dickens*. London: Chatto & Lindus, 2004.

Lock, Margaret. *Bookbinding Materials and Techniques, 1700–1920*. Toronto: The Canadian Bookbinders and Book Artists Guild, 2003.

Loring, Rosamond B. *Decorated Book Papers: Being an Account of Their Designs and Fashions*. 4th ed. Ed. Hope Mayo. Cambridge: Houghton Library, Harvard College Library, 2007.

Lundblad, Kristina. *Bound to Be Modern. Publisher's Cloth Bindings and the Material*

Culture of the Book 1840—1914. Trans. Alan Crozier. New Castle, DE: Oak Knoll Press, 2015.

Marks, P. J. M. *The British Library Guide to Bookbinding.* Toronto: University of Toronto Press, 1998.

Marks, P. J. M. "The Edwards of Halifax Bindery." *British Library Journal* 24, no. 2 (1998): 184–218.

Martinique, E. "Chinese Traditional Bookbinding: A Study of its Evolution and Techniques.", *Asian Library Studies* 19 (1983): 10.

McGann, Jerome. "Binding Design: Songs before Sunrise": <http://www.rossettiarchive.org/docs/sa124.rap.html>; accessed 15 March 2022.

McLean, Ruari. *Jan Tschichold: A Life in Typography.* New York: Princeton Architectural Press, 1997.

McLean, Ruari. *Victorian Publishers' Book-Bindings in Cloth and Leather.* London: Gordon Fraser, 1974.

"Metta Catharina": <http://www.shipsproject.org/Wrecks/Wk_Catharina.html>; accessed 16 March 2022.

Middleton, Bernard C. *A History of English Craft Bookbinding Technique.* 1963. 2nd suppl. ed. London: The Holland Press, 1978.

Milevski, Robert J. "A Primer on Signed Bindings." In *Suave Mechanicals: Essays on the History of Bookbinding.* Vol. 1. Ed. Julia Miller, 162–245. Ann Arbor, MI: The Legacy Press, 2013.

Miller, Julia. *Books Will Speak Plain: A Handbook for Identifying and Describing Historical Bindings.* 2nd ed. Ann Arbor, MI: The Legacy Press, 2014.

Nevins, Iris. *Traditional Marbling.* Sussex, NJ: I. Nevins, 1985.

Nishikawa, Kinohi. "From Poet to Publisher: Reading Gwendolyn Brooks by Design." RBS Lecture Thursday 16 July 2020: <https://rarebookschool.org/rbs-online/from-poet-to-publisher-reading-gwendolyn-brooks-by-design/>; accessed 7 March 2022.

Nixon, Howard M. *English Restoration Bindings: Samuel Mearne and His Contemporaries.* London: British Museum Publications, 1974.

Nixon, Howard M. *Five Centuries of English Bookbinding.* London: Scolar Press, 1979.

Nixon, Howard M. and Mirjam M. Foot.

The History of Decorated Bookbinding in England. Oxford: Clarendon Press, 1993.

Nourse, Benjamin J. Correspondence with Barbara Heritage. 31 May 2022.

Oldham, J. Basil. *Blind Panels of English Binders.* Cambridge: Cambridge University Press, 1958.

Otteson, Natasha. "17th Century Armenian Bookbinding Traditions." *The University of Iowa Libraries*: <https://blog.lib.uiowa.edu/speccoll/2021/03/18/17th-century-armenian-bookbinding-traditions/>; accessed 7 March 2022.

Pattison, Todd. *B-75 American Publishers' Bookbindings, 1800–1900. Course Workbook.* Charlottesville: Rare Book School, June 11–15, 2018.

Pattison, Todd and Elizabeth DeWolfe. "Female Labor and Industrial Growth in Nineteenth-Century American Bookbinding." In *Suave Mechanicals. Essays on the History of Bookbinding.* Vol. 7. Ed. Julia Miller, 461–506. Ann Arbor, MI: The Legacy Press, 2022.

Pearson, David. "Bookbinding." In *The Oxford Companion to the Book.* Eds. Michael F. Suarez, S.J., and H. R. Woudhuysen, 1:147–155. 2 vols. Oxford: Oxford University Press, 2010.

Pearson, David. *English Bookbinding Styles, 1450–1800: A Handbook.* London and New Castle, DE: The British Library and Oak Knoll Press, 2005.

Pearson, David. "Dutch gilt paper." In *The Oxford Companion to the Book.* Eds. Michael F. Suarez, S.J., and H. R. Woudhuysen, 2:684. 2 vols. Oxford: Oxford University Press, 2010.

Pearson, David. "inlay." In *The Oxford Companion to the Book.* Eds. Michael F. Suarez, S.J., and H. R. Woudhuysen, 2:821. 2 vols. Oxford: Oxford University Press, 2010.

Pearson, David. "marbling." In *The Oxford Companion to the Book.* Eds. Michael F. Suarez, S.J., and H. R. Woudhuysen, 2:913. 2 vols. Oxford: Oxford University Press, 2010.

[Pearson, David.] "onlay." In *The Oxford Companion to the Book.* Eds. Michael F. Suarez, S.J., and H. R. Woudhuysen, 2:985. 2 vols. Oxford: Oxford University Press, 2010.

Pearson, David. "panel." In *The Oxford*

Companion to the Book. Eds. Michael F. Suarez, S.J., and H. R. Woudhuysen, 2:999. 2 vols. Oxford: Oxford University Press, 2010.

Pearson, David. *Provenance Research in Book History: A Handbook*. New Castle, DE: Oak Knoll Press; [Oxford, England]: Bodleian Library, University of Oxford, 2019.

Pearson, David. "textile bindings." In *The Oxford Companion to the Book*. Eds. Michael F. Suarez, S.J., and H. R. Woudhuysen, 2:1198. 2 vols. Oxford: Oxford University Press, 2010.

Pearson, David. "trade binding." In *The Oxford Companion to the Book*. Eds. Michael F. Suarez, S.J., and H. R. Woudhuysen, 2:1213. 2 vols. Oxford: Oxford University Press, 2010.

Peyré, Yves and H. George Fletcher. *Art Deco Bookbindings: The Work of Pierre Legrain and Rose Adler*. New York: Princeton Architectural Press, New York Public Library, 2004.

Pickwoad, Nicholas. "Binding." In *The St Cuthbert Gospel: Studies on the Insular Manuscript of the Gospel of St John (BL, Additional MS 89000)*. Eds. Claire Breay and Bernard Meehan, 41–64. London: The British Library, 2015.

Pickwoad, Nicholas. "Bookbinding." In *A Companion to the History of the Book*. 2nd ed. Eds. Simon Eliot and Jonathan Rose, 111–128. First published in 2007. Chichester, West Sussex: Wiley-Blackwell, 2020.

Pickwoad, Nicholas. "Bookbinding in the Eighteenth Century." In *The Cambridge History of the Book in Britain: Volume V: 1695–1830*. Eds. Michael F. Suarez, S.J., and Michael L. Turner, 268–290. Cambridge: Cambridge University Press, 2009.

Pickwoad, Nicholas. "The Interpretation of Bookbinding Structure: An Examination of the Sixteenth-Century Bindings in the Ramey Collection in the Pierpont Morgan Library." *The Library*, 6th ser., 17, no. 3 (September 1995): 217.

Pickwoad, Nicholas. "Tacketed Bindings—A Hundred Years of European Bookbinding." In *"For the Love of Bookbinding": Studies in Bookbinding History Presented to Mirjam Foot*. Ed.

David Pearson, 119–167. London and New Castle, DE: The British Library and Oak Knoll Press, 2000.

Reithmayr, Andrea. "Beauty for Commerce: Publishers' Bindings, 1830–1910." University of Rochester: <https://rbscp.lib.rochester.edu/3345>; accessed 15 March 2022.

Roberts, Matt T. and Don Etherington. "calendered cloth." Bookbinding and the Conservation of Books: A Dictionary of Descriptive Terminology: <https://cool.culturalheritage.org/don/>; accessed 6 March 2022.

Romantic Circles: <https://romantic-circles.org>; accessed 13 March 2022.

Rota, Anthony. *Apart from the Text*. Pinner, U.K. and New Castle, DE: Private Libraries Association and Oak Knoll Press, 1998.

Sadleir, Michael. *The Evolution of Publishers' Binding Styles, 1770–1900*. Part of The History of Bookbinding Technique and Design, a series edited by Sidney F. Huttner. New York and London: Garland Publishing, 1990.

Scheper, Karin. *The Technique of Islamic Bookbinding: Methods, Materials and Regional Varieties*. 2nd rev. ed. Leiden: Brill, 2018.

Shaffi, Sarah. "How the Penguin Logo Has Evolved through the Years." Penguin Books, 16 September 2020: <https://www.penguin.co.uk/articles/2020/september/penguin-books-logo-history-edward-young-allen-lane.html>; accessed 15 March 2022.

Shaw, Shiow-Jyu Lu. *The Imperial Printing of Early Qing China, 1644–1805*. [Taibei]: Chinese Materials Center, 1983.

"Sombre Binding." In *The Oxford Companion to the Book*. Eds. Michael F. Suarez, S.J.. and H. R. Woudhuysen, 2:1166. Oxford: Oxford University Press, 2010.

[Southey, Robert and Charles Cuthbert Southey, ed.] *The Life and Correspondence of Robert Southey*. Vol. 6 of 6. London: Printed by Longman, Brown, Green, and Longmans, 1850.

Squires, Claire. "20c The History of the Book in Britain from 1914." In *The Oxford Companion to the Book*. Eds. Michael F. Suarez, S.J., and H. R. Woudhuysen, 1:188–193. 2 vols. Oxford: Oxford University Press, 2010.

St Clair, William. *The Reading Nation in the Romantic Period.* Cambridge: Cambridge University Press, 2004.

Storm van Leeuwen, Jan. *B-10 Introduction to the History of Bookbinding Course Workbook.* Charlottesville: Rare Book School, 2017.

Storm van Leeuwen, Jan. *Dutch Decorated Bookbinding in the Eighteenth Century. Volume 1. General Historical Introduction Noord Holland.* 't Goy-Houten: Hes & De Graaf Publishers, 2006.

Storm van Leeuwen, Jan. "Laurels for Ton: Some Aspects of Publisher's Bindings Made for and by the Firm of Mame in Tours." *Quaerendo* 42 (2012): 258–273.

Tanselle, G. T. "The Bibliographical Description of Patterns." *Studies in Bibliography* 23 (1970): 71–102.

"Timeline of Publishers' Bindings: 1870–1879" within "The Cover Sells the Book: Transformations in Commercial Book Publishing, 1860–1920": <https://delartlibrary.omeka.net/exhibits/show/-the-cover-sells-the-book---tr/timeline-1870s>; accessed 15 March 2022.

Todd, William B. and Ann Bowden. *Walter Scott: A Bibliographical History, 1796–1832.* New Castle, DE: Oak Knoll Press, 1998.

Topp, Chester W. *Victorian Yellowbacks & Paperbacks, 1849–1905: Volume III, Joseph Camden Hotten and Chatto & Windus; Chapman & Hall.* Denver: Hermitage Antiquarian Bookshop, 1997.

Touchette, Jess. "Dutch Gilt Paper." In *The Binder's Art: Techniques in the History of Decorative Bookbinding.* Exhibition at Saint Louis University: <https://pius.slu. edu/special-collections-exhibits/exhibits/show/binder-s-art/decorative-papers/dutch-gilt-paper>; accessed 6 March 2022.

University of Alabama and the University of Wisconsin-Madison. Publishers' Bindings Online, 1815–1930: The Art of Books: <https://bindings.lib.ua.edu/designers2.html>; accessed 26 April 2022.

"Ursula K. Le Guin." The Internet Speculative Fiction Database: <http://www.isfdb.org/>; accessed 7 March 2022.

Verdure, Elizabeth. *Cartonnages Romantiques 1840-1870: un âge d'or de la reliure du livre d'enfant.* Lyon: Éditions Stéphane Bachès, 2008.

Wainwright, Oliver. "The Beauty of Penguin Books." *The Guardian,* 30 October 2012: <https://www.theguardian.com/books/2012/oct/30/beauty-penguin-books>; accessed 15 March 2022.

Wikimedia Commons and University of Pennsylvania Libraries. Bookplate of Aloys Thomas Raimund Graf Harrach: <https://commons.wikimedia.org/wiki/File:Exlibris_of_Aloys_Thomas_Raimund_Graf_Harrach_(1669-1748)_bookplate,_GC7_H7480R_728v_(cropped).jpg>; accessed 10 March 2022.

Wolfe, Richard J. *Marbled Paper: Its History, Techniques, and Patterns. With Special Reference to the Relationship of Marbling to Bookbinding in Europe and the Western World.* Philadelphia: University of Pennsylvania Press, 1990.

VII. MARKS IN BOOKS

Als, Hilton. *The Way We Live Now.* New York: Taschen, 2017.

Beredo, Cheryl. *Import of the Archive: U.S. Colonial Rule of the Philippines and the Making of American Archival History.* Sacramento, CA: Litwin Books, 2013.

Bengtson, Jason. "Preparing for the Age of the Digital Palimpsest." *Library Hi Tech* 30, no. 3 (2012): 513–522.

Burdett-Coutts, Angela Georgina. *Woman's Mission: A Series of Congress Papers on the Philanthropic Work of Women.* New York and London: Charles Scribner's Sons and Sampson Low, Marston & Co., 1893.

Carter, John. *ABC for Book Collectors.* 9th ed. Eds. Nicolas Barker and Simran Thadani. New Castle, DE: Oak Knoll Press, 2016.

The Church of the People. 1864. Vol. VII. London and Oxford: Kent and Co. and W. R. Bowden, [1864].

Couture, Karen. "Gwendolyn Brooks Visit. Poetry Reading." *Emerson College Archives and Special Collections*: <https://digitalcollections.emerson.edu/

uncategorized/IO_6e50dbcf-a650-4dad-85f7-84ac a1c85e83/>; accessed 9 March 2022.

Dow, Gillian. "Anglo-French Relations and the Novel in the Eighteenth Century." In *The Cambridge History of the Novel in French. Part II: The Eighteenth Century: Learning, Letters, Libertinage*. Ed. Adam Watt, 152–169. Cambridge: Cambridge University Press, 2021.

Fölster, Max Jakob. "Introduction to the History, Use and Function of Chinese Book Collectors' Seals." *Manuscript Cultures*, no. 8 (2015): 25–52.

Goode, James M. *Three Centuries of the American Bookplate*. Upper Marlboro, MD: James M. Goode, 2010.

Hackel, Heidi Brayman. *Reading Material in Early Modern England: Print, Gender, and Literacy*. Cambridge: Cambridge University Press, 2005, 138; cited by Pearson, *Provenance Research*, 19.

Harris, Neil. "Index Librorum Prohibitorum." In *The Oxford Companion to the Book*. Eds. Michael F. Suarez, S.J., and H. R. Woudhuysen, 2:816. 2 vols. Oxford: Oxford University Press, 2010.

Hindson, Ed and Dan Mitchell. "Great Schism." In *The Popular Encyclopedia of Church History*. Eugene, OR: Harvest House, 1982.

Jackson, Angela. *A Surprised Queenhood in the New Black Sun: The Life & Legacy of Gwendolyn Brooks*. Boston: Beacon Press, 2017.

Jackson, H. J. *Romantic Readers: The Evidence of Marginalia*. New Haven: Yale University Press, 2005

Johnson, Fridolf. *A Treasury of Bookplates from the Renaissance to the Present*. New York: Dover Publications, 1977.

Kallendorff, Craig. *Virgil and the Myth of Venice: Books and Readers in the Italian Renaissance*. Oxford: Clarendon Press, 1999.

Kirschenbaum, Matthew G. *Bitstreams: The Future of Digital Literary Heritage*. Philadelphia: University of Pennsylvania Press, 2021.

Meyer, Kendra. Guide to the Samuel X. Radbill Collection of Sara Eugenia Blake Bookplates. The Grolier Club of New York: <https://www.grolierclub.org/default.aspx?p=v35ListDocument&ID=75692313&listid=11461&listitemid=150503&ssis=322536&dpageid=&listname=>; accessed 9 March 2022.

Milevski, Robert J. "A Primer on Signed Bindings." In *Suave Mechanicals: Essays on the History of Bookbinding*. Vol. 1. Ed. Julia Miller, 162–245. Ann Arbor, MI: The Legacy Press, 2013.

Office of Censorship. Code of Wartime Practices. For the American Press. Edition of June 15, 1942. United States Government Printing Office. Washington, D.C., 1942: <https://babel.hathitrust.org/cgi/pt?id=umn.31951d035922921&view=1up&seq=3>; accessed 15 March 2022.

Pearson, David. *Provenance Research in Book History: A Handbook*. 1994. New rev. ed. Oxford and New Castle, DE: The Bodleian Library and Oak Knoll Press, 2019.

Phillips, Caryl. "Nothing Personal: James Baldwin, Richard Avedon, and the Pursuit of Celebrity." *ariel* 48, nos. 3–4 (2017): 13–28.

Rickards, Maurice. *The Encyclopedia of Ephemera: A Guide to the Fragmentary Documents of Everyday Life for the Collector, Curator, and Historian*. Ed. Michael Twyman with Sally de Beaumont and Amoret Tanner. London: The British Library, 2000.

Song, Young Imm Kang. "Altered Book Journaling for the Visual Generation." *International Journal of the Image* 2, no. 1 (2012): 67–82.

Stallybrass, Peter. "Petrarch and Babylon: Censoring and Uncensoring the Rime, 1559–1651." In *For the Sake of Learning: Essays in Honor of Anthony Grafton*. Eds. Ann Blair and Anja-Silvia Goeing, 2:582. 2 vols. Leiden: Brill, 2016.

Stoddard, Roger. *Marks in Books, Illustrated and Explained*. Cambridge: The Houghton Library, Harvard University, 1985.

Sweeney, Michael S. *Secrets of Victory: The Office of Censorship and the American Press and Radio in World War II*. Chapel Hill and London: The University of North Carolina Press, 2001.

INDEX

stylus: 25, 41, 44
Suarez, Michael F., S.J.: xi, xvi, xx, 83, 240, 261–263
substrate(s): xiii, xiv, xv, 21–50, 51, 56, 101, 269, 277, 278
suminagashi: 277
sura: 14, 277
Sutliff, Mary Louisa: vii
sūtra: 2, 4, 5, 20, 55, 72, 275, 277
Swinburne, Algernon Charles: 212, 213
Sy, Donna A. C.: xx, 281, 308
Syria: 39, 75
Szirmai, J. A.: 25, 53, 67, 230
T'aejong: 7
tackets: 52, 277
tak: 3, 277
Tamil: 44, 50
Tang dynasty: 4, 20, 70
tanned: 169, 188, 267, 273, 278
Tanselle, G. Thomas: ix, 191, 192, 232
taoban: 107, 277
Tauchnitz: 150
Tausig, Hans and Eva-Maria: 12, 29
tawed, tawing: 165, 169, 171, 184, 277
Taylor, Cledie: 222
Teller, Thomas: 118
témoin: 64, 67, 277
text block: 43, 162, 173, 184, 187, 219, 276, 278
textualis/textura: 12, 265, 278
Thomas, John V.: 247
Thomas, Nina: xxi
Thompson, Susan Otis: ix
Thoreau, Henry D.: 216
three-decker novel: 199, 200, 202, 210, 278
Tibet, Tibetan: xiii, 25–27, 34, 41, 55, 100, 115, 126, 186, 232, 236, 244, 245, 271, 274–276
Tichenor, Irene: xii, xxi
tickets: 237, 246, 247, 278
Ticknor and Fields: 208, 209, 210
Tillow, Samuel: 184
Tilopa: 115

Titian: 109
Todd, William B.: 150
Tomlinson, Dorothy: 192; William: 192
Toomer, Jean: 122
Torah: 39, 54, 75, 241
trade binding(s): 182, 183, 231; paperback: 219, 278
Trapp, Joseph: 87
Trenck, Friedrich von der: 139
Trewhella, William: 211
Trianon Press: 153, 154 160
Trinity College, Dublin: 10
Trollope, Anthony: 200, 210
Tschichold, Jan: 219
Turkey: 175, 278
Turkey leather: 273, 278
turn-in(s): 201, 226, 278
Turner, Michael: 197
Twinrocker Handmade Paper: 33
two-sheet papermaking mould: 41, 50, 278
tympan: 278
type case(s): 78, 268, 278
type mould: viii, 80, 82, 99
typefounder: 78, 278
U. S. Office of Censorship: 252
Ulrich, Hans: 146
Underwood, Katherine: 172
École de l'Union Centrale des Arts Decoratifs: 193, 218, 223
Union College: viii
University of Texas at Austin: x
University of Virginia (UVA): x, xi, xv, xvi, xxi, 100, 255, 261, 308
Vaillant, Paul and Isaac: 247
Van Vliet, Claire: 46
Vander Meulen, David: xx, 44, 45, 50
vellum: 9, 73, 194, 268, 278
verso: 23, 135, 251, 257, 278
Vienna: 181, 185
Virgil: 32, 242
Vrelant, Willem: 12
W. H. & O. H. Morrison: 247
Wainwright, Jonathan: 252
Walsdorf, Jack: ix

Wang Chieh: 5
Wang Zhen: 6
War Department (U.S.): 252
Warren, Charles: 142
waste: 10, 161, 170, 171, 278
Watchmen: 64
watermark(s): viii, xiv, 32, 36, 37, 45, 50, 59, 132, 267, 278
wax tablet(s): xvii, 21, 23, 25, 278
Wedgeworth, Robert: x
Wells, Darius: 91
Wenzong Emperor: 4
Westleys & Co.: 246
Whatman, James: 31, 32, 49
White, George W.: 206
Whitesell, David R.: xvii, 167, 178, 200
Whitman, Sarah Wyman: 216
Wiegand, Willy: 96
wiigwaas: 30, 278
Wilding, Nick: 106
Willett, Edward: 148, 149
Williams, Roger: xxi
Williams, William Carlos: 122
Wilson, Linda: 217
Windle, John: xx, 153, 154
Winfrey, Oprah: 19
Winkler, Andreas: xx, 49
Winship, Michael: 208, 209
Winterbottom Book Cloth Co.: 192
Wise, T. J.: 45
Wittenborg, Karin: x
Wolfe, Heather: xx
wood engraving: 103, 111, 112, 116, 118, 130, 132, 142, 249, 266, 269, 278, 279
wood pulp: 33, 42
wood type: viii, 6, 82, 85, 91, 92, 98
woodblock(s): xv, 3, 5, 7, 26, 27, 100–105, 107, 112, 114–117, 126, 135, 142, 215, 244, 265, 266, 268, 270
woodcut(s): viii, 8, 76, 87, 102–112, 115, 122, 133, 135, 268, 278, 279
World War II: 64, 96, 155
WorldCat: 119
wove paper: viii, 27, 31, 32,

ABOUT THE AUTHORS

Barbara Heritage is the Associate Director & Curator of Collections of Rare Book School at the University of Virginia. She holds a PhD from UVA, and she has worked in the field of rare books for more than twenty years. Her essays have appeared in *Studies in Romanticism*, *The Papers of the Bibliographical Society of America*, *Printing History*, and *RBM: A Journal of Rare Books, Manuscripts, and Cultural Heritage*, as well as in collected volumes. An internationally recognized authority on the writings of Charlotte Brontë, she was recently commissioned by the Brontë Society to write "The Archaeology of the Book" for *Charlotte Brontë: The Lost Manuscripts* (2018). Her article on Brontë's fair-copy manuscript of *Shirley* is forthcoming in *Studies in Bibliography*. She is also currently co-editing a new edition of *Shirley* with Tim Dolin as part of the Cambridge Edition of the Novels and Poems of Charlotte, Emily, and Anne Brontë; in addition, she's creating bibliographical descriptions for all of the sisters' principal published works as part of the Cambridge University Press edition.

An active member of the bibliographical community, Heritage is the past Secretary of the Bibliographical Society of America, and she is the current chair of BSA's New Scholars Program. She also serves as the Secretary of the Antiquarian Book School Foundation, where she helped initiate CABS-Minnesota's Diverse Voices Fellowship. In 2017, she co-chaired with Donna A. C. Sy "Bibliography Among the Disciplines," an international conference funded by the Andrew W. Mellon Foundation. A private collector, she won first place in the Bibliographical Society of the University of Virginia's book collecting contest as a graduate student. She has been a member of the Grolier Club since 2009. In 2018, she appeared on PBS as part of *The Great American Read*.

Ruth-Ellen St. Onge is the Associate Curator & Special Collections Librarian of Rare Book School. She holds a MISt and a PhD from the University of Toronto. Her doctoral research on publishers of poetry in nineteenth-century France was funded in part by a Social Sciences and Humanities Research Council (SSHRC) Doctoral Fellowship (2009–2011). St. Onge's current research interests include the history of publishing in France and North America, contemporary comic books and graphic novels, and photobooks. In 2018, she curated the Rare Book School exhibition "Comics in Circuit." She has published articles in the academic journals *Sequentials, Revue de recherche en civilisation américaine, Revue française d'histoire du livre,* and *Mémoires du livre / Studies in Book Culture,* and she has contributed book chapters to the scholarly collections *The Canadian Alternative: Canadian Cartoonists, Comics, and Graphic Novels* (University Press of Mississippi, 2018) and *Mythologies du superhéros: histoire, physiologie, géographie, intermédialités* (Presses Universitaires de Liège, 2014). St. Onge is past President of the Bibliographical Society of Canada (BSC) and former Interim Editor of the *Papers of the Bibliographical Society of Canada.* Leading up to and during her time on the Executive Council of the BSC, she chaired or co-chaired four scholarly conferences: "Book Historical and Biblio-graphical Praxis in Canada / La praxis de l'histoire du livre et de la bibliographie du Canada" (2017); "Canada 150. Bound by Three Oceans: Reading, Writing, Printing & Publishing in Canada since 1867 / Un pays relié d'un océan à l'autre: Lire, écrire, imprimer & publier au Canada depuis 1867" (2017, funded by a SSHRC Connection Grant); "Gatherings: Communities of Print and the Book / Rassemblements: les communautés du livre et de l'imprimé" (2016); and "Print & Capital / Le capital de l'imprimé" (2015). She currently serves on the Board of the Americas Chapter of the Fine Press Book Association.

COLOPHON

Building the Book
from the Ancient World to the Present Day
How Manuscript, Printed, and Digital Books Are Made

Barbara Heritage • Ruth-Ellen St. Onge

The Legacy Press • 2022

The primary typefaces are Adobe Caslon Pro and Palatino Linotype.
The Legacy Press books are manufactured by Sheridan Books, Inc.,
located in Chelsea, a few miles from the publisher's home office
in Ann Arbor, Michigan.